D1592948

Desire

Divine & Demonic

MICHELE STEPHEN

Desire

Divine & Demonic

BALINESE MYSTICISM

IN THE PAINTINGS OF

I KETUT BUDIANA AND

I GUSTI NYOMAN MIRDIANA

HAWAI'I University of Hawai'i Press
Honolulu

This publication has been supported by La Trobe University
Internet: http://www.latrobe.edu.au

10 09 08 07 06 05 6 5 4 3 2 1

LIBRARY OF CONGRESS CATALOGING-IN-PUBLICATION DATA

Stephen, Michele.
Desire, divine and demonic : Balinese mysticism in the paintings of I Ketut Budiana and I Gusti
Nyoman Mirdiana / Michele Stephen.
 p. cm.
Includes bibliographical references and index.
ISBN 0-8248-2859-3 (hardcover : alk. paper)

1. Balinese (Indonesian people)—Religion. 2. Bali Island (Indonesia)—Religious life and customs.
3. Religion in art. 4. Budiana, I Ketut, 1950– 5. Mirdiana, I Gusti Nyoman. I. Title.

BL2120.B2S84 2005

294.5'09598'6—dc22 2004019928

*University of Hawai'i Press books are printed on acid-free paper and meet the guidelines
for permanence and durability of the Council on Library Resources.*

Book design and composition by Diane Gleba Hall

Printed by The Maple-Vail Book Manufacturing Group

Contents

Acknowledgments vii

Introduction I

1. Defining Balinese Mysticism:
 A Problematic Enterprise 5

2. Fire, Destruction, and the Power of the Mother:
 The Paintings of I Ketut Budiana 29

3. Mythic Transformations of Desire:
 The Paintings of I Gusti Nyoman Mirdiana 49

4. The Influence of Tantric Thought 73

5. Balinese Ritual in a Dynamic Universe 98

6. Visualizing Pure Realms 133

Notes 139

Bibliography 165

Index 173

Color plates follow pages 38, 70, and 86

Acknowledgments

THIS BOOK, like most, owes a great deal to many others who have contributed their resources, knowledge, and talents to it. Fieldwork in Bali from June 1996 to May 1999 was conducted under the auspices of the Lembaga Ilmu Pengetahuan Indonesia (LIPI) and funded by a large grant from the Australian Research Grants Council. The school of Humanities, La Trobe University, provided funding for translation of texts in 2001, 2002, and 2003. Funds for photographing the artworks were provided by the Department of Sociology/Anthropology, La Trobe University. My thanks to all these bodies for their generous assistance and sponsorship. Color plates 1–24 are based on photographs by the La Trobe University Photography and Digital Imaging Unit. My thanks to the photographer, Andrew Stanish, for his superb work.

The idea for this book originated with an exhibition of paintings by I Ketut Budiana and I Gusti Nyoman Mirdiana, titled "Desire, Divine and Demonic," held at Kazari Gallery, Melbourne, Australia, in November 2000. It was during preparations for this exhibition, and through my discussions with the gallery owners, Jo Maindonald and Robert Joyce, as well as the responses of those viewing the

exhibition, that I was encouraged to shape my ideas about Balinese art and religion into a book. Since its inception, Kazari Gallery has played a pioneering role in inspiring and educating the Australian public concerning the diverse artistic traditions of Asia. A special acknowledgment is due Jo and Robert for including in their aesthetic vision the arts of Bali.

To Gilbert Herdt, whose intellectual and personal friendship over many years has been such an important influence, and with whom I share a deep love of Asian art, my thanks for reading an early draft of this book and encouraging me to develop it to completion. I am indebted to Hildred Geertz for her generous response to my earliest efforts to investigate Balinese culture and for challenging my assumptions about the nature of Balinese knowledge. Her work, especially as it has stressed transformations against hierarchical order in Balinese cosmological notions, has strongly influenced the approach I develop here. I am indebted to my colleague in Asian studies at La Trobe, Greg Bailey, for introducing me to key texts relating to Indian Hinduism and for many stimulating discussions of Indian parallels with Balinese thought. Leo Howe's detailed and most insightful reader's report has contributed importantly to the final shaping of the book for publication, especially in helping me to frame my arguments. I also thank an anonymous reader for a philological critique that not only saved me from several factual errors but drew my attention to relevant material I had overlooked.

For introducing me to I Ketut Budiana and for many conversations on all things Balinese, a special thanks to Michelle Chin. My thanks to Rhonda Noble, who curated an exhibition, "The Riches of Balinese Art," held in 1999 at the La Trobe University Gallery, featuring paintings by I Gusti Nyoman Mirdiana and Dewa Nyoman Batuan. Seven of Mirdiana's paintings were acquired for the university's permanent collection at the request of the vice-chancellor, Michael Osborne. The interest shown in this exhibition was another significant influence on the direction my research was to take.

In Bali, my friend and colleague Luh Ketut Suryani and her family have helped me in a great many ways, generously welcoming me into their home, lives, and culture. In 1996 Suryani and I began joint research on an ethnopsychiatric study of Balinese dreams. As part of the project, I wanted to explore the role of dreams in art, but my interest in art and mysticism took on its own dynamic and went off in an unintended direction. Now that I have followed this quest to an end (of sorts), I am freed to return to the original topic and our joint project.

Among the many Balinese to whom Suryani introduced me, the most important for this present work was the late Ida Bagus Sutarja, a Brahmana scholar and mask maker from the village of Mas. Sutarja, in our ongoing discussions over more than three years, revealed to me a view of Balinese religion and mysticism that challenged most of what I had read in the anthropological literature. His erudition—and the impression left by the extraordinary masks he created—sparked my enthusiasm to follow as far as I possibly could the new vistas he opened up to me. To Dewa Nyoman Batuan and his extended family, in whose midst I lived for three years, I am indebted for their kindness, their hospitality, and all they have taught me about Balinese life. I thank Mangku I Gusti Made Barat, Mangku I Made Gina, and the people of Pengosekan village for their many kindnesses and for allowing me to participate in their community and family rituals. To Agung Rai, founder of ARMA Museum, my thanks for numerous discussions about Balinese art. I also wish to thank the staff at the Gedong Kirtya *lontar* library for their assiduous efforts in locating and copying manuscripts for me.

A special acknowledgment is due I Nyoman Suarka of Udayana University, Bali. His translations of texts from Kawi to Indonesian, his explanations of these texts, and his informative answers to my many questions about Balinese religion and mysticism have been a major contribution to my research in Bali and to this book. My interpretations of this material are of course my own, but without Pak Suarka's assistance in translating a large body of texts relevant to my interests, I would not have been able to develop the arguments presented here.

I Ketut Budiana and I Gusti Nyoman Mirdiana, the two artists whose works form the heart of this book, have made such an enormous contribution that I hardly know how to thank them. Through our several years of friendship and work together, I have come to feel that Budiana and Mirdiana are not merely contributors but rather partners in a project brought to fruition in this book. Mirdiana joins me in making a special tribute and farewell to the magic white dog, Timpal—our loved companion and friend in Bali whose life spanned almost exactly the eight years of work on which this book is based.

For careful guidance and expert editorial assistance in the final shaping of the manuscript for publication, I wish to thank Pamela Kelley, Don Yoder, and the production team at University of Hawai'i Press.

To my husband, John, who has made an immeasurable contribution to this book—indeed to everything I undertake—my gratitude and love. His courage, strength, and generosity of spirit in the face of extreme adversity never cease to inspire me.

Finally, I wish to thank the many Balinese too numerous to name—priests, scholars, healers, artists, performers, educated elite, ordinary men and women—who graciously and generously shared their knowledge and experience with me. I hope this book will serve in some small way as a return for all I have received from them.

Introduction

BALI IS A tiny island in the vast island nation of Indonesia. It has long been famed among Western scholars, travelers, artists, and musicians for its extraordinarily rich cultural and artistic life and the profusion of its religious rituals and ceremonies.[1] Although exposed to more than a century of direct foreign influence —and more recently to waves of mass tourism—Bali nevertheless retains a distinctive cultural and religious life. Now incorporated in the bureaucratic and economic structures of the modern state of Indonesia, Balinese nevertheless continue to live lives that are guided by local custom and leaders and centered on communal and family-based religious rituals. Religion, still an important aspect of Balinese life, has largely remained free of centralizing bureaucratic control, and each village community *(desa)*, along with the neighborhoods *(banjar)* that compose it, the temple associations *(pamaksan)*, and other local groups, take responsibility for organizing and conducting their own religious activities, as does each family.[2] Although Indonesia as a whole is now predominately Islamic in faith, Bali continues to adhere to Hindu teachings that were first introduced to the region sometime early in the first millennium AD.[3] Since that time many different elements have been incorporated into

Balinese religious life, which has developed its own unique forms and expressions to the point that most modern scholars of Balinese religion describe it as something very different from the Hinduism found in India.

In the voluminous anthropological literature on Bali that has emerged during the second half of the twentieth century, five statements in particular about its religion have come to receive wide currency:[4]

1. Balinese religion aims to achieve on earth a mirroring of a divine cosmic order where hierarchical structure, harmony, and balance prevail.
2. Balinese religion is primarily a matter of praxis—ritual performance—rather than speculative philosophy or inner experience.
3. Balinese religion consists of a complex mixture of beliefs and rituals derived from many different sources: a thin layer derived from Hinduism rests on top of a deep foundation of primitive animistic beliefs.
4. Balinese religion can best be understood in its own terms. To look for parallels in Indian sources, as did previous generations of Dutch and European scholars, simply imposes external models on Balinese understandings, which are very different.
5. Balinese religion, like Balinese culture, is multiplex, various, and dependent on local context. No neat explanatory framework or conceptual pattern can account for the endless variety of its specific forms.

Certainly not all scholars of Bali would agree with these assertions, and acceptance of one does not necessarily imply adherence to all five. Nevertheless they represent the opinions of leading scholars in the field and have been, and continue to be, very influential. But in my view, although these statements contain much truth and cannot be dismissed out of hand, they are subtly misleading. Furthermore, I believe they may coalesce into a popular image of Balinese religion that creates a distorted view of it—one that greatly underestimates the philosophical complexity of its beliefs and practices and, furthermore, distances it in the eyes of many from the great religious tradition to which it belongs: Hinduism.[5] It seems strange that local variants of Buddhism in Southeast Asia, as in Burma, Thailand, or Cambodia, have been respected as authentic and spiritually elevated religious practices and doctrines, yet Hinduism in Bali has been regarded as markedly different from the Indian traditions from which it derives. I suggest that a large part of the reason may lie in a greater familiarity with Buddhism among Western scholars and thus a greater respect for its teachings.

Although it is not my intention in this book to reexamine systematically these assumptions about Balinese religion, my arguments as a whole cut across the grain of such conventional wisdom. This book sets out to do three things: to identify a number of mystical themes central to Balinese religion that, although not unknown to Western scholars, have rarely been emphasized by anthropologists and have more often been presented as disparate elements than seen as a cohesive core; to demonstrate the striking parallels between these core themes and Indian Tantric thought; and to show how these mystical themes are expressed in Balinese myth, written texts, and ritual performance. On this basis I will argue that Balinese religion, as it is practiced today, is a unique and creative local expression of

Hindu Shivaitic Tantric philosophy. That is to say: the cultural forms of expression are distinctively Balinese, but the recurring themes they embody closely parallel classic Hindu concepts of the cosmos and the forces that constitute it.

The data I draw upon consist of four elements: visual art; Balinese mythology in oral tradition and written texts; Balinese texts outlining esoteric teachings; and my own and others' observations of ritual practice. To show that we are dealing with living understandings, not historical relics, I have chosen as my starting point the works of two contemporary Balinese artists painting in traditional styles. Although to those unfamiliar with Bali it may seem a strange enterprise to use the works of contemporary artists to explore key ideas in Balinese religion, much of this book is devoted to showing why this is not so. My own anthropological observations of Balinese culture and ritual began in 1996.[6] Although my approach is that of a cultural anthropologist, I will draw upon textual materials and the work of philologists, as well as visual art.

The focus of this book is Balinese religion—or rather certain elements of it—that can be discerned in contemporary Balinese thought and practice. Yet at the same time it is concerned with the continuity these elements have with the past. Over the last century or more, Bali has not only been subjected to external forces for change. It has engaged in internal processes of reexamining and recreating its own religious identity, partly if not largely as a result of external pressures. Out of this internal struggle has emerged a new, officially authorized, and state-supported Balinese religion: *"agama Hindu."*[7] Yet alongside it, or perhaps despite it, most Balinese continue their ritual life in many ways that are clearly continuous with ideas and practices that owe little to reformist efforts and even less to foreign influence. In a recent study Leo Howe describes this new official religion as "in part a continuation, and in part a reconceptualization, of precolonial customary knowledge and ritual practice *(adat)*."[8] A difficulty for the outside observer arises in deciding what in contemporary Balinese religious thought represents continuity with the past and what constitutes reformist views. I will argue against any easy assumption that local practice at the village level represents continuity whereas philosophical or theological views necessarily represent the reformist influence.

Yet it is evident that making such distinctions is a delicate task and there may not always be clear-cut answers. Anthropologists' increasing awareness over the last two decades or so of the importance of historical change and the local contextualization of knowledge has brought a new awareness of culture as discourse rather than structure. In acknowledging the complexity of discourse concerning religion in present-day Bali that is so clearly depicted by Howe, I think it is still possible to discern in this ferment of contestation, negotiation, and recreation elements that derive from the past but continue to shape in important ways current practice. The term "traditional" has now fallen into disrepute, as it seems to indicate an unreflective notion of an unchanging past. Nevertheless it still provides a useful shorthand term for those aspects of the culture that are not owed to the Western and colonial domination that reached Bali in the mid-nineteenth and early twentieth centuries.[9] In this sense, my topic is traditional Balinese religion as it continues into the present. My aim is to identify a specific cluster of mystical ideas that have their origins in the precolonial past; that are not owed to modern reformist views yet can be traced in contemporary thought; that are expressed in mythology and sacred texts; and above all that can be shown to provide the conceptual basis of the seemingly endless variety of Balinese ritual life.

The intimate relationship between art and religion in Balinese culture is reflected in Chapter 1, which also explores some of the problems of defining Balinese "mysticism." Chapter 2 focuses on the work of I Ketut Budiana, a contemporary Balinese artist renowned for his mysterious and mystical subjects. In a detailed examination of the imagery of twelve of his paintings I explore his recurring themes. Chapter 3 pursues similar themes in the very different works of I Gusti Nyoman Mirdiana, a young artist whose mythological subject matter leads into a discussion of Balinese mythology. Chapter 4 summarizes the themes depicted by the two artists and discusses how representative their ideas might be of Balinese mystical thinking more generally. This question raises the issue of parallels with Indian Tantrism as it has been redefined in recent studies by Indologists. Chapter 5 explores further Indian parallels with Balinese mythology and ritual in order to show that much of Balinese ritual practice can be reinterpreted as an embodiment of the mystical themes noted in earlier chapters. Chapter 6, drawing the arguments together, concludes that the diverse forms of Balinese religious life can be understood as rich, localized expressions of classic tenets of Shivaite Tantric philosophy.

This book offers a journey though the inner worlds of two contemporary Balinese artists, revealing how their very different works reflect a shared symbolism, mythology, and cultural belief system. It also contends that the cosmos depicted in their works is representative of widely shared Balinese beliefs—revealing a kernel of understanding that can help to illuminate Balinese religion in general. It further suggests the continued importance of exploring parallels—and differences—between Balinese religion and Indian Tantric thought, Shaktism, and classic Indian mythology.

My arguments are at best preliminary; they point to the need for more research and comparative work. Although a great deal has already been written about Balinese religion, there is still much more to be learned. My hope is that this book, by challenging some long-standing assumptions, will stimulate reassessments of existing knowledge and spur new research leading in new directions.

Defining Balinese Mysticism

A Problematic Enterprise

CONVENTION HAS IT that Balinese religion is primarily concerned with achieving balance, harmony, and order in this world to match a divine order determined from above.[1] Yet the briefest glance at Balinese paintings, sculpture, architecture, or the performing arts reveals a different picture—one of dynamic energy, of seething, curling, surging, burgeoning forms, of details and decorative motifs endlessly replicated and variegated, so that the eye, and the mind, quail before the sheer profusion of creative endeavor. The crowded shapes of Balinese art seem almost too much, even a kind of vulgar profusion, a cavalier showing off, a loud boasting of creativity. But when you visit Bali and are confronted by the sheer luxuriance of the physical landscape, the unbelievably intense green of the rice fields, the impossibly precisely sculptured rice terraces, the majestic volcanoes, the thick forests of great trees hung with toiling vines, you begin to realize that no human creation could be so presumptuous as to affect simplicity in the midst of all this overwhelming natural abundance. To the visitor, Bali presents not a sense of hierarchical order and balance but rather a seductive assault on the senses. Nor is everything the eye meets with beautiful.

Bali also indulges in the excessively ugly and the monstrous, both in its physical and human environment and in its artistic forms. Everywhere one encounters representations of horrific and bestial figures with great bulging eyes and bellies, sharp fangs, and lolling tongues—and the most horrifying are to be found in the precincts of temples. Nor is this simply a first impression. The more closely one looks, the more disturbing are the images— hideous female monsters, draped in entrails and smeared with blood, caught in the act of tearing apart and devouring a baby, are among the usual figures to be found guarding the entranceway to village temples. Grotesque giants and demonic shapes loom beside the gateways to sacred places. Indeed as one becomes more accustomed to these grotesqueries, one tends not to notice the absence of representations of peaceful or benign deities. True, if you look hard you might find some, but the vast majority are grotesque and menacing. Even in the performing arts, the graceful and pretty *legong* dancer is far outnumbered by fierce, heavy, stomping male figures, animal monsters, giants, and all kinds of frightening goblins and witches. This predominance of the monstrous—and the total impression of a fierce surging energy and dynamism—might well give one reason to pause and question the received scholarly wisdom about balance and hierarchy. The traditional aesthetics of Bali belie any such concern and point in a very different direction.

I begin by turning to the works of two contemporary Balinese artists who paint in traditional styles. My aim in doing so is to show that the themes I wish to identify are part of contemporary Balinese thought and culture, not forgotten doctrines preserved in dusty antique texts. I Ketut Budiana is an artist at the height of his career, famous in Bali and gaining an international reputation, whose paintings hang in museums and private collections throughout the world. I Gusti Nyoman Mirdiana, scion of a famous family of artists, represents the younger generation and is just beginning to make his mark. I have selected these two artists not because they are in any way more "traditional" than others—indeed Budiana's works have little to suggest the traditional to Western eyes. Nor do I imply that these artists stand apart from the ferment of influences and ideas that surround Balinese in the modern world.[2] Nor do I assume that they in any way reject the officially supported Balinese religion, *agama Hindu,* or that they are even concerned to draw distinctions between the different streams of contemporary religious thought and practice. It is simply that working with these two artists led me to a greater awareness of the themes discussed in this book. I did not set out to study Balinese mysticism. My fieldwork involved discussions with many other artists, performers, priests, healers, ordinary villagers, and educated elite. I have selected these two artists because their works epitomize for me understandings of Balinese mysticism that emerged from my engagement with a wide range of Balinese from many different walks of life and levels of social standing.

Mark Hobart counsels his fellow anthropologists: "If we are untidily implicated in the lives of the people we work with and study, perhaps we should start by recognizing the inescapability of this implication."[3] So I will begin by acknowledging my own engagement in the works and lives of these artists. I have known Budiana and Mirdiana for over six years. During this time we have worked together on various projects, including the exhibition that provided the impetus for this book. I went to Bali in 1996 not to study art, in fact, but to undertake an anthropological study of dreams in Balinese culture. This was to be a kind of sequel to my earlier research on dreams in Papua New Guinea.[4] One aspect I wished to

explore in depth was the role of dreams as a source of artistic inspiration. Many of the works I found in galleries, museums, and catalogs of Balinese painting seemed to have arisen out of dream or dreamlike states. In particular the paintings of one artist, Ketut Budiana, stood out and instantly captured my attention. These works resembled dream landscapes containing nightmare images of surrealistic horror and strange fantasy. Naturally I was interested when a mutual friend offered to introduce me to the artist. Budiana was not at all the wild-eyed mystic I half expected. His smooth, unlined face and supple movements belied his almost fifty years. He was soft-spoken, with a gentle unassuming manner, yet all the while his dark eyes sparkled with a playful irony. Even though I could muster only a little Indonesian and Budiana refused to speak English, we managed to communicate. Soon we became friends and he asked me to help him prepare some written material in English for an exhibition catalog of his paintings. This gave me the opportunity to engage with his work more deeply.

Despite my initial assumptions based on the dreamlike appearance of Budiana's paintings, I was to find they owe little to what we know of as dreams, that is to say, sleep dreams. His amazing surrealistic canvases are not the improvisations of the dream mind but in fact creative variations on traditional Balinese motifs and designs. Budiana did not usually paint imagery seen during sleep, he explained, but rather images glimpsed in waking states of contemplation and meditation. Dreams, in his view, represent a lower kind of knowledge and thus are not a suitable medium from which to create art. Rather he aims to transcend the limited personal sources available through dreaming.

The other artist, I Gusti Nyoman Mirdiana, I met in an even more indirect way. Toward the end of 1996 I was looking for a research assistant to help me with my dream project. (The previous assistant had decided the work was too tedious.) Mirdiana was introduced to me by his uncle, Dewa Nyoman Batuan, himself a well-known artist, in whose house compound I was staying. All I had been told was that Mirdiana was a talented dancer who specialized in modern pop music. Slapping the boy on the back, Batuan remarked impishly to me, "Big shoulders, small brain!"—hardly the recommendation I was looking for. Mirdiana had just turned twenty-one. Tall, well built, and handsome, he looked more like the local football hero than a dancer. No one mentioned he was an artist, which would have made me think more favorably about hiring him, but anthropologists are not in a position to reject the pressing suggestions of their patrons. Evidently we were made for each other; at least Batuan, the boy's uncle, thought so. I consoled myself with the thought that, like his predecessor, the young man would quickly tire of the tasks required of him and thus spare me the embarrassment of having to dismiss him. So he came to work for me in October 1996. I soon discovered that he was not only highly intelligent, and mature beyond his years, but possessed an exquisite artistic sensibility.

Perhaps because of his youth and his lack of previous association with foreigners, Mirdiana had no preconceptions about what I needed to know about Balinese culture. He answered my questions simply, and honestly, always responding to what I asked, not what he thought I should hear. In this way he became an invaluable guide and informant. As our work together progressed, he of his own accord began to paint some of the stories and myths we were collecting. It was then I began to appreciate his talent as an artist. Although I often talked with him about dreams and frequently urged him to paint some wonderful dream he

recounted to me, he would never agree to do so. Like Budiana, he explained that dreams came spontaneously from memories of past experiences, and this was not what he was seeking. Although his paintings were quite unlike Budiana's in most respects, I could sense, nevertheless, that both artists were dealing with similar concepts—that they were representing a cluster of shared cultural understandings, not purely idiosyncratic visions.

In working with Budiana and Mirdiana, both separately and together, to prepare material for various exhibitions, I found I was learning a great deal about Balinese religion that was not only new to me but challenged or even contradicted much of what I had read in the general literature on the topic. Focusing on one or two paintings alone led nowhere. But when I began to see the individual works in relation to each other, I could discern a pattern. The paintings dealt over and over again, although in very different ways, with the same basic themes that pointed to a coherent view of the cosmos and the powers that constituted it. I began to realize that this view was the same, albeit expressed in different ways, as that emerging from accounts given to me by other knowledgeable Balinese, including artists, scholars, performers, and priests.[5] Directed by these informants to the written sources of spiritual authority, the *lontar* texts, I discovered their oral accounts supported in even greater detail. With new eyes I returned to published translations of Balinese texts by European scholars and found the same themes (although not necessarily explicitly recognized by the translators).

I have chosen visual representations as my starting point for a number of reasons. In the first place, the paintings enable me as a cultural analyst to identify themes, ideas, and symbols that originate from the artist's own cultural understanding, not mine. In this way I can strive to avoid simply imposing my own criteria of significance and thus become more sensitive to the Balinese cultural categories and concepts that inform the works. Since these are living artists personally well known to me, I was able to question them closely about the imagery they use and what it might mean. My method was to examine each element that comprises the painting, including the colors used and the placement of the different figures. I never asked the artist directly what the work as a whole "means." Usually this would elicit little more than an embarrassed mumble or else a kind of pat answer that evidently owes much to the officially propagated doctrines of *agama Hindu*. Instead I carefully followed each element of the composition, asking what it is and why it is depicted in that particular way. In this way I found that very different ideas emerged.

Focusing on actual works of art—in this case twelve paintings by each artist—has the further advantage that the accuracy of my descriptions and interpretations can be measured against the paintings reproduced here. My aim is to enable readers to judge for themselves the match between the two: are the themes I describe in fact represented in the paintings? Furthermore, by exploring several works by the same artist I can follow the permutations whereby particular themes are developed and intertwined with others, so that a consistent view or philosophy is revealed. This grounding of the discussion in a concrete form of representation independent of my own ethnographic descriptions is especially needed since I am trying to identify themes that have been little emphasized in the anthropological literature. The artists' imagery, of course, speaks a language of its own and my written commentary cannot hope to capture all the nuances of emotion, all the levels of meaning, conveyed there. My perspective is not that of the art critic or art historian but that of the anthropologist who seeks to understand the cultural conceptions and cultural knowledge represented in artworks.

This intention, however, is not really at odds with Balinese attitudes to art, or with these artists' view of their own works, since religion and culture are inseparable in Balinese thought. Using art as a means of approaching Balinese religion is appropriate because the very role of the Balinese painter, sculptor, or architect is to bring into being that otherwise invisible world. The first task of this book is to explore the mystic worlds pictured by the two artists. The important question of how representative their works are of Balinese thinking in general I will put aside for now, but I will return to it in Chapter 4.

Neither Budiana nor Mirdiana paints in an entirely traditional mode. Both use their art to explore ideas in ways that are not laid down in the classic canons of Balinese art. Art critics and art historians are always eager to identify schools and styles, but there is perhaps a more interesting question: how does the artist categorize his or her own work? On one occasion I was discussing with Budiana the distinction usually made between the "classical style" of Balinese painting and the "traditional style." The former, usually applied to works produced in Bali prior to European influence, is sometimes termed the Kamasan style (referring to a village community where such paintings are still produced); the latter term is applied to works incorporating Balinese topics and themes but combining them with new influences and ideas derived from abroad.[6] I protested that "traditional" seemed a misleading term for works that drew heavily upon foreign sources. Budiana disagreed. He pointed out that "classical" indicates a style that does not change despite outside influence, whereas "traditional" denotes a style that continues to employ Balinese techniques, themes, and concerns but blends and integrates them with outside influences. For Budiana, the essence of Balinese "tradition" is that it is ever changing yet retains a unique Balinese character. "Classical" Balinese painting is fixed in time, by contrast, and one cannot deviate in any way from its conventions or techniques without it becoming something else.

"Traditional" Balinese painting, in this view, is always in the process of becoming—a view we might usefully extend to Balinese religion. Much like the cosmos Budiana envisages in his paintings, it is in essence a process of continuous transformation yet always centered around a core that is uniquely Balinese. To specify the nature of this core is no easy matter. Budiana would, I think, respond to this difficulty by observing that ultimately art is a matter of feeling, not logic. One senses if a painting is still rooted in uniquely Balinese concepts and values, or if it owes so much to external influences that it belongs to some genre quite foreign to Balinese aesthetics. This, of course, is much easier for a Balinese to decide than for an outsider, and it is not my place here to argue about such distinctions. My point is simply that in Budiana's terms the works discussed in this book represent traditional Balinese painting in the sense just defined.[7] Likewise Mirdiana sees himself as a traditional Balinese painter. His subject matter is overtly more traditional than Budiana's, and his style is clearly linked to the *wayang* style of his famous grandfathers, Kobot and Barat,[8] yet it has many modern influences and is uniquely his own.

No Balinese artist working today exists outside the modern situation where "art" is produced and marketed for profit, mainly to sell to foreigners.[9] Art has, like so many other aspects of Balinese culture, become a commodity. Paintings especially, which can be easily transported or even carried away by the visitor, are easily adapted to tourist tastes and demands. There are huge numbers of paintings produced for sale for the tourist market, often by artists who are capable of much better work. At both the top and the bottom end of the art

market, many artists produce what they think will sell—that is, what will appeal to foreign tastes. Many talented Balinese painters, especially younger artists, have adopted contemporary Western abstract styles and techniques along with Western ideas and values concerning the role of art and the artist in society. At this point, Balinese tradition becomes submerged and, I believe, lost.

In becoming a commodity, art has also been secularized. In the past, art served religion in Bali.[10] There is no doubt in the minds of these two artists, and many others like them, that it continues to do so, even if not all Balinese artists today would agree. The intimate relationship between art, culture, and religion in Bali was expressed by one of my Balinese friends in the metaphor of a tree.[11] The rich foliage, flowers, and fruit of the tree, with their diverse shapes and colors, represent the amazing variety and manifold forms of Balinese art and culture, each unique, different, incomparable in its own beauty. Yet the wide ramifications of these multiple cultural forms branch out from a single solid trunk that supports them all—*adat,* the social rules and conventions that bind Balinese society. Below the ground, out of sight, are the roots from which the whole organism draws sustenance and support—*agama,* religion. The flamboyant canopy of the tree with its rich flowers and fruit so engages our attention that we are likely to give little thought to the roots, hidden deep beneath the ground, from which they all grow.[12]

The tree metaphor implies a common source for the immense cultural diversity found in Bali—suggesting that despite their apparent differences, the cultural forms express a core of underlying religious meaning. Few Western scholars have failed to realize the close connection between art and religion in Bali. The problem, at least for the Western observer, is that Balinese religion itself seems so diverse and impossible to reduce to any clear-cut set of beliefs and practices.

What Constitutes "Balinese Religion"?

Although much has been written on the topic, it is hard to find a clear statement of what constitutes Balinese religion. Fredrik Barth, in a recent anthropological study, presents a sensitive outline of the problems of definition.[13] He emphasizes the "decentered" and "embedded" nature of Balinese religion, even with respect to the new state-authorized version of it.[14] Barth highlights the problems involved in comparing Balinese Hinduism with Islam. Unlike Islam, it lacks a centralized structure of authority and a holy book. But Barth acknowledges: "Yet it would make little sense to deny its character as a great tradition. It has successfully reproduced a Hindu heritage of theology, philosophy, literature, and arts for seven hundred years after contact with the originating Hindu centers was broken."[15]

Most Balinese today regard themselves simply as Hindu, but Western scholars have long insisted that Balinese Hinduism is very different from the Hinduism found in India. Michel Picard vividly describes the puzzled dismay of an emerging Balinese intellectual elite as, in the 1920s and 1930s, they struggled to come to terms with judgments made by Western scholars that their religion consisted of little more than a conglomerate of primitive beliefs and practices with a few scattered elements of Hinduism added for good measure. One Balinese author exclaimed in evident horror: "According to the opinion of foreigners we do not

have a religion and do not worship God (Widi), but we are like madmen who worship anything they happen to come across."[16] Confronted with the negative opinions of foreign "experts," Balinese attempting to come to terms with Western ideas could not help but begin to question their own beliefs. Picard describes the debates these early Balinese intellectuals engaged in on apparently basic matters—what should be the name of their religion, what gods did it worship, what was its relationship to Indian Hinduism—presumably convincing Western observers of the chaotic nature of Balinese beliefs.[17]

Hindu teachings were first brought to Bali sometime early in the first millennium AD.[18] Thus beliefs and practices described today as Balinese Hinduism have had a very long time to develop in situ and over the centuries have accommodated different waves of external influences stemming from India, China, and Java, including Buddhist influences, as well as incorporating pre-Hindu animistic beliefs. The archaeologist Bernet Kempers explains that in Bali the terms "Hinduism" and "Hindu Bali" refer to "the complex phenomenon of 'Balinese religion,' and to an entire way of life. It has a Śivaitic as well as a Buddhist aspect, but there are reminiscences of earlier Indonesian ideas and usages as well."[19] Some Western scholars refer to different "layers" of Balinese culture—as if the various influences to which Bali has been subject might be peeled away to reveal an original bedrock that is early animistic belief. Miguel Covarrubias, in an influential book first published in 1937 and still in print, sweepingly asserts: "Like the Catholicism of some American Indians, Hinduism was simply an addition to the native religion, more as a decoy to keep the masters content, a strong but superficial veneer of decorative Hinduistic practices over the deeply rooted animism of the Balinese natives."[20] Many later writers have evidently been content to follow his judgment that Hinduism is merely a decorative veneer.[21]

In spreading from India, Hinduism and Buddhism incorporated local cults and beliefs along the way. Yet the impression usually given in the scholarly literature is that Balinese Hinduism is widely divergent from its Indian sources. It is, of course, only to be expected that over such a long period of time Hinduism has undergone a distinctive process of development in Bali. Yet so too has Hinduism in India—or rather the many strands that constitute it.[22] Furthermore, it is hard to know the specific nature of Hindu teachings originally introduced from India and later indirectly via Java. The history of development is complex. All we can really say for certain on the basis of existing evidence is that Balinese Hinduism is necessarily different from that of Indian Hinduism today.[23]

Hinduism in Bali is sometimes said to be grafted onto a "Pacific" or "Indonesian" structure of belief.[24] Thus, for example, if we take the three temples usually to be found in every Balinese village—said to be devoted to the Hindu deities Brahma, Wisnu, and Siwa—we find that ordinary people do not seem to be worshipping these gods there but are more concerned with a host of other supernatural beings of local origin.[25] The open structure of a Balinese temple, consisting essentially of a walled open space housing several small shrines, appears to owe more to indigenous Pacific structures like the Polynesian *mare* than to Indian models.[26] Although Balinese believe in reincarnation and the determining influence of your moral actions in this world on your fate in the next life *(karma pala),* one finds in Bali that reincarnation is always believed to take place within the same family, with only a brief interval between rebirths, so that a man might expect to be reborn as his own great-grandchild.[27] The Balinese are famous for their elaborate cremation ceremonies, yet these are very different

from Indian mortuary rites and retain many elements suggesting that in Bali cremation has been overlaid onto earlier second-burial practices found in many other parts of Indonesia.[28] Ordinary Balinese in their daily lives seem preoccupied with fears of harm from witches and black magic and with propitiating many kinds of nature spirits, demons, and especially ancestral spirits. If the observer focuses on public performance of ritual and the participants' general understanding of it, one might well conclude that Hinduism's influence on Bali is essentially superficial: a thin layer over a deep foundation of earlier ancestor worship and animistic cults.

Hildred Geertz acknowledges this confusing mixture of beliefs and symbolic elements, but she also points to a Balinese synthesis—a creative recombining rather than random jumble of unrelated elements:

> The people of Bali today call their religion "Balinese Hinduism" after a major strand in a complexly woven web of symbols, ideas, and ceremonies. The names of Hindu deities, demons, and heroes—Siva and Durga, Vishnu and Brahma, Rama and Ravana, Arjuna and his brothers, Ganesha, and others—appear frequently in the prayers, songs, dramas, temple carvings, and paintings. A knowledge of their original significance can help only partially in interpreting contemporary Balinese religious life, for they have been absorbed and reinterpreted within Balinese thought and ritual. Blended with indigenous cosmological conceptions, with important augmentations from Tantric Buddhism, and even, in the present century, with indirect influences from Islam and Christianity, these Hindu traces today have very different meanings than in India.[29]

As Geertz's comments indicate, the insistence of earlier scholars such as Goris, Korn, Hooykaas, and Swellengrebel—that Balinese culture must be studied and interpreted in its own terms without imposing Indian models—is only to be commended.[30] They were writing in reaction to a pioneering generation that had devoted its energies almost entirely to searching for the Indian sources of Balinese religion. Enthusiasm to balance the original overemphasis on India can, however, lead to assumptions that Indian parallels are valueless and that Hinduism in Bali is but skin deep—a view that, in my opinion, is equally misleading. Some anthropologists, including Boon, Geertz, Lansing, and Howe,[31] have taken very seriously the influence of Indian Hinduism in Bali. Howe reminds us that Indian influences have been extensive in many aspects of Balinese culture and social structure:

> By the nineteenth century these included institutions of divine kingship, an elevated priesthood using Shivaite liturgy, a framework of categories similar to the Indian *varna* system, a hierarchical social structure resembling the caste systems of India, ranked descent groups practicing endogamous or hypergamous marriage, widow immolation amongst the highest ranks, numerous Sanskrit-derived words in the Balinese language, and so forth.[32]

The relationship between Indian sources and Indonesian texts is now being reassessed by philologists. Max Nihom, for example, challenges the view of many textual scholars that "the literary products of classical Indonesia are better characterized as indigenous and sovereign products whose indebtedness to Indian antecedents is largely in the nature of cultural borrowings substantively superseded by native developments."[33] Nihom contends that the Indonesian textual data can provide important evidence to reconstruct the intellectual history of Tantrism in India and the history of Shivaism as well.[34] His careful philological investigations indicate that Indonesian texts, including those found in Bali, may in fact represent a tradition closer to the original sources than can be found today in India. Helen Creese, citing many recent works including Nihom's, has drawn attention to a new trend in Old Javanese studies toward a more balanced appreciation of Indian and Indonesian elements:

> Pioneering scholars of Old Javanese invariably looked to India for origins in order to legitimize Javanese literary works in ancient Indian traditions. The twentieth century saw a shift away from this approach and a search instead for indigenous roots and examples of "local genius." Some of the recent work in Old Javanese literature has again focused the lens on India, this time, however, not as the elusive point of origin that earlier generations had pursued, often fruitlessly, but instead as a source of traditions and ideas that served to enrich cultural innovation.[35]

The effects of this change in relation to Balinese textual studies will be taken up in Chapter 4.

The Confusing Profusion of Balinese Ritual Life

Another common assumption frequently made about Balinese religion is that it is primarily concerned with ritual practice and places little emphasis on speculative philosophy or inner experience. Clifford Geertz's oft-quoted statement that Balinese religious life is characterized by "orthopraxy not orthodoxy" is, on the surface, well justified.[36] Although I will later have cause to challenge his assertion, it is nevertheless a good place from which to start. My aim in this section is to outline Balinese ritual life—as I have observed it myself in practice in the late 1990s and as it has been presented in the anthropological literature to date—without attempting to offer any new interpretations or explanations.[37] In Chapter 5 I will return to the topic, showing how the apparently random profusion of ritual forms can be understood to express certain implicit underlying themes.

Trying to define Balinese religion in terms of doctrine or devotion to particular gods and divine forces does not take us very far. One needs to watch Balinese, day after day, week after week, month after month, throughout a calendrical cycle of one year at least. Then, because it is all so complicated, one needs to observe the cycle over again, still mesmerized by the sheer abundance of ritual life. Balinese religion is not primarily a credo; it is indeed a way of life and of acting in the world. Geertz's comments concerning the lack of interest in doctrine and the almost obsessive concern with ritual performance, comments based on the Bali

he observed in the 1950s, applied equally well to the late 1990s. To the outside observer, such as myself, the majority of Balinese still seem largely uninterested in defining the gods they are worshipping or analyzing the rich symbolism of their rituals. Yet they continue to devote an enormous amount of time, energy, and resources to ensuring that their ritual duties are faithfully performed. First visiting Bali in 1994, I had expected that Balinese religion might be on the wane. But my immediate, and enduring, impression is that of the extraordinary vitality and enthusiasm which infuses ritual life in the present.

The daily life of Balinese is shaped by the five *yadnya* (sacrifices): offerings and rituals for the gods *(dewa yadnya),* for the chthonic forces *(bhuta yadnya),* for the ancestors *(pitra yadnya),* for human beings *(manusa yadnya),* and for sages and religious teachers *(resi yadnya).*[38] Every day, in each Balinese household, offerings *(banten)* consisting of small, intricately woven palm-leaf containers holding flowers, rice, fruit, and other fragrant ingredients are placed at various points around the house and the yard, including the kitchen, the well, and the entryway. Sticks of incense are lit and placed with the offering, and prayers are murmured while wafting the perfumed smoke toward the sky. Women usually prepare the offerings and place them at the required spots and shrines about the house compound. In a large, prosperous compound comprising several related nuclear families, such as the one in which I lived, hundreds of *canang* (the basic form of offering) may be offered daily. At one level, these small offerings are understood as a kind of spiritual protection for the household, giving recognition to a host of unseen supernatural entities or forces. These entities include potentially dangerous and disruptive forces *(bhuta kala)* present in the world around us, supernatural guardians *(pengungan karangan)* that protect the yard, potentially harmful entities such as *tonya,* which are believed to inhabit nearby streams or rivers, as well as higher powers emanating from above, from the *dewa* or gods, including the deified ancestors. The aim of the householder is to ensure a positive relationship with all these powers, both chthonic and divine, so that the health and prosperity of the whole family are protected.

At another level of understanding, the numerous offerings are recognized to be not so much gifts to gods or demons as the means to focus human attention on the spiritual aspect of existence.[39] Thus they are meant to illuminate the bond between the individual spirit *(jiwa/atma)* and its source, which might be variously referred to in Bali today as Sang Hyang Widi (a name designating the high god), Tuhan (the Lord), Tunggal (the One), Acintya (the Inconceivable), or Siwa (Shiva).[40] The Balinese woman going about her daily ritual of making household offerings is unlikely to be able to articulate the metaphysical principles upon which such beliefs rest. Yet in her graceful actions—performed as elegantly as a temple dance, each movement a moment of quiet contemplation—of laying out small gifts of food, prayer, and incense for the spirit forces surrounding her, she expresses them. The simple daily acts of offering are themselves quiet moments of meditation.[41]

Offerings made in each household every day for the chthonic and divine forces are multiplied and extended on special occasions. So numerous are these occasions that Balinese always seem to be engaged in some form of ritual activity, great or small. The human life cycle—from conception to birth, through childhood and adolescence, to marriage—requires a complex series of ceremonies *(manusa yadnya)* that are performed within the household. Each requires large quantities of appropriate offerings *(banten)* to the *bhuta kala* and the *dewa,* as well as to the spiritual aspects of the person for whom the ceremony is conducted.[42] Death sets in motion another series of ceremonies culminating in the *pitra yadnya,* the

lengthy rituals, including cremation *(ngaben)*, required to transform the dead into deified ancestors.[43] Each Balinese house compound possesses a house temple *(sanggah, pemrajan)* devoted principally to the worship of the family ancestors.

There are many occasions on which sacrifices are performed on a community level. A Balinese village community usually possesses at least three temples *(pura)* where communal worship is offered: the Pura Puseh, the Pura Desa, and the Pura Dalem.[44] The Pura Puseh is associated with Dewa Wisnu, a manifestation of the protective and sheltering aspect of divine powers. The Pura Desa or village temple represents the continuity of the village group and thus is associated with Dewa Brahma, a manifestation of divine creative power. The Pura Dalem, often referred to as the "death temple," is associated with Siwa, and his wife Durga, in the form of the destroyer or dissolver of life. People do not so much direct their worship to these gods personally, however, as to a cluster of spiritual forces and entities associated with each temple and specific locality. Balinese in general do not seem to think of named personal gods or spirit entities as we tend to think they should. Rather they are aware of supernatural forces of various kinds that require respect and honoring. All these forces are believed to emanate from the one source but possess, as it were, different levels. Balinese speak of higher and lower powers; but all can influence human beings and all must be respected.

Each temple has its priest *(pemangku)* who cares for it and makes offerings there on a small scale every day. People bring offerings at Purnama (full moon), Tilem (dark moon), and Kajeng Kliwon—a ritually significant correspondence of calendrical dates that occurs every fifteen days. The most important ritual event that takes place in each temple is the *odalan.* Once every 210 days (a year in the Javo-Balinese calendar), a Balinese temple observes a special period of worship, the *odalan,* lasting from one to several days.[45] During this time the temple is the site of constant activity, as every household prepares elaborate offerings, people dress in their best, and all come to pray and receive holy water. The gods and spirits associated with the temple are invited to descend and bless the village congregation with their presence. The divine guests are feasted and entertained with dance performances, shadow puppet theater, music, singing, and recitation of sacred texts. Other dramas and dances are staged for the enjoyment of the human audience. The activities continue far into the night, and usually a kind of nighttime fair selling drinks, snacks, clothing, and toys, and offering various forms of gambling, establishes itself on the periphery of the temple grounds.

The *odalan* is a time when everyone enjoys the festive atmosphere and the community as a whole feels a special closeness to the divine powers on which it depends. It is a time when anger and personal animosity should be put aside, when people try to cleanse their minds and spirits and open themselves to the pure, bright presence of their divine guests. In the inner courtyard of the temple, people pray in a group, offering flowers and incense, the prayers punctuated by the silver tone of the priest's handbell. Then everyone receives holy water poured on their heads and then into their hands for them to drink. Tucking flowers into their hair and pressing seeds of consecrated rice on their foreheads, they rise from their prayers, fresh and cleansed of spiritual dirt and defilement. The incense, the chiming bells, the gamelan music, the beautifully decorated temple shrines, the lavish displays of fruit, flowers, and sweet cakes, the smiling faces of the crowd—all combine to create in the inner court of the temple *(jeroan)* an atmosphere of peaceful joy in which the gods might well be felt to be present. In the outer courts, the *jaba tengah* and *jaba,* people sit around in groups

15

chatting informally while watching the various dance performances given there, or listening to the gamelan orchestras, as they wait to pray and receive holy water. At the entrance to the temple people buy snacks to eat, join in gambling games, and meet with friends. The whole occasion is one of relaxed gaiety with nothing of the serious piety Westerners might expect of a religious occasion.

Prior to the temple festival, sacrifice must be made in the form of special rituals for the *bhuta kala,* the dangerous disruptive chthonic forces. The rituals for the *bhuta kala (caru)* are offered at midday on the day of the temple festival, which usually begins in the evening, or on the day before the festival in the case of extended celebrations. *Caru* offerings are placed on the ground close to the village crossroads, the priest (*pemangku* or *pedanda,* depending on the size of the ceremony) presents the offerings with prayer and incense, while the congregation kneels on the ground to pray. At the conclusion, the offerings, which have been laid out on the ground, are broken up and tossed about by a group of worshippers— who whirl around in a lively dance representing the *bhuta kala* come to claim their feast. These offerings, people explain, are necessary to remove all disruptive unseen forces lurking around the village. This is the first step in purifying the area so that the divine powers may later descend to occupy their seats in the temple. Ordinary people are inclined to speak of the *bhuta kala* as if they were simply evil spirits that can be removed by offering bribes of food. Indeed it is difficult for Balinese to communicate to outsiders the exact nature of these powers since, as we shall find in later chapters, complex understandings of the cosmic order are involved—rendering a direct translation of the term into English virtually impossible. For the ordinary villager, however, what is important is that the *caru* ritual has, by whatever means, cleansed the area.

Since every village *(desa)* possesses at least three temples and often others as well, including irrigation society temples, agricultural temples, and district and state temples,[46] villagers not only participate in at least three temple festivals every 210 days but usually attend festivals in other villages or at those six temples that serve all Bali (the *sad kayangan*), such as Pura Besakih. In addition to these temple-based ceremonies, many seasonal or calendrical religious rites are observed. The most important are Galungan, Kuningan, and Nyepi.[47] Galungan is a time of celebration and feasting in each household and involves various temple observances as well. Families buy new clothes for the festivities and spend freely on food for family feasting and offerings for the gods. High bamboo poles *(penjor)* hung with elaborate decorations of plaited palm leaf are erected in front of each house, lining the village streets in a stately parade.

Galungan begins with Panampahan, a day on which pigs, ducks, and chickens are slaughtered to make the delicacies, especially *lawar,* enjoyed on such special occasions and to provide the meat required for offerings. On Galungan day, the family dresses in its best and partakes of all the delicacies that have been prepared; elaborate offerings are made within the household and even grander offerings are taken to the temples. On the third day, Manis Galungan, families visit each other and a festival atmosphere prevails. At this time, and over the next several days, many Barongs, accompanied by gamelan orchestras and groups of laughing youths, are to be seen on the roads and passing through villages, receiving donations of money and other offerings as they go. The Barong is a mythological creature of great significance to the Balinese. He is impersonated by two men wearing a costume and mask

resembling a cross between a shaggy bear and a Chinese lion-dog. He can be both majestic and comic and is clearly venerated by his people. The Barong's connection with the high god, Siwa,[48] is discussed in later chapters. Here it is sufficient to note that villagers see him as a guardian and protector and that his passing by the gates of village houses at Galungan is believed to remove inauspicious influences.

Ten days after Galungan there are three days of similar celebration referred to as Kuningan. Special foods are prepared for the family, especially yellow rice *(kuning);* new decorations *(tamiang)* are placed about the house, along with elaborate offerings, while others are taken to the temples. On the day of Kuningan, everyone visits each of the temples in their community to take offerings and pray. This must be done before midday. On the third day, Manis Kuningan, people rest, visit friends, and enjoy family outings.

Many explanations of Galungan and Kuningan have been offered by Western scholars. Some have suggested that these observances were originally celebrations marking the year's end at a time when they were calculated by the Hindu-Balinese year of twelve months instead of the Javo-Balinese calendar.[49] Barbara Lovric, quoting several *lontar* texts to support her arguments, maintains that Galungan is directed primarily to the chthonic forces, the *bhuta kala,* and constitutes a *bhuta yadnya,* or sacrifice to these demonic forces.[50] Galungan and Kuningan are usually described as a time when the presence of the ancestors is invoked by each family and offerings are made to them. Jan Swellengrebel suggests that the festival might be described as "an All Souls' Day on which one also celebrates All Saints."[51] Other explanations emphasize the ethical significance of Kuningan as a celebration of order over chaos *(dharma* versus *adharma),* a view upheld by the state-supported official religion, *agama Hindu.* Although these interpretations are not necessarily mutually contradictory, it is disconcerting to find so many competing explanations for these key ritual events. For most Balinese, Galungan together with Kuningan is an enjoyable holiday season of celebration. It is also a time when people feel a special closeness with the spirit entities surrounding them, especially their deified ancestors and the gods. The season as a whole is a reaffirmation of the positive forces that not only give life but protect and succor.

Galungan and Kuningan are celebrated once every Javo-Balinese year of 210 days. Nyepi, the day of silence, by contrast, falls once every Saka year (the Hindu-Balinese calendar of twelve months). It is preceded by a series of *caru* rituals directed to the chthonic forces, the *bhuta kala,* as well as purification ceremonies where the sacra of each temple, including the Barong masks and costumes, are taken to the sea for cleansing.[52] The complex calendrical system observed in Bali, which consists of several different calendars and their various conjunctions, results in many days of ritual importance marked by household and temple observances.[53] These include the *tumpek* days, six of which occur in a 210-day year and are devoted to special observances directed to metal objects, plants, domestic animals, musical instruments, and costumes used in sacred dance/drama. A separate day is devoted to the puppets used in the shadow puppet theater; the remaining *tumpek* day forms part of the Kuningan celebrations.[54] On Saraswati day, special offerings are made to Saraswati, the goddess of knowledge, as well as to books and works of art such as paintings. Siwaratri requires special devotions to Siwa, and there are many other observances that vary from area to area, such as Pagerwesi (iron wall), which is given greater importance in northern Bali than in the south.[55] Given the complexities of this astounding ritual cycle and its endless local variations

and embellishments, it is perhaps little wonder that scholars continue to puzzle over the significance of its various elements and that few have attempted to discern in it any cohesive pattern.[56] As Mark Hobart remarks in an essay on Balinese concepts of good and evil: "On few matters is a simple summary so impossible. For the Balinese have absorbed Hindu, Buddhist, Tantric, Old Javanese and other, including apparently indigenous, religious ideas and have mixed them into a textual and practical tradition which has so far baffled description."[57]

For the outside observer, Balinese ritual seems an unending, indeed exhausting, round of constant activity. For Balinese it constitutes the very fabric of their existence, orchestrating daily and seasonal events according to a rhythm where the lives of the individual, the family, and the community are linked to the unseen powers that are felt to shape material existence. People are constantly made aware of these forces, and the need to respect and acknowledge them, simply through the everyday actions required of them. And when something goes wrong—an illness, quarreling among family members, mishaps, misfortune of any kind—such adversity indicates that one's relationship with the unseen world *(niskala)* is disturbed or lacking in some way and the help of experts might be needed to determine what must be done to repair it.

Balinese live with a deep sensitivity to—and desire to be on goods terms with—a wide range of natural and supernatural forces and entities, especially their human ancestors. Surrounded by hosts of unseen powers with a dual potential for harm or good, Balinese always hope to realize the positive potential through their constant ritual efforts. Though ever attentive to these unseen powers, Balinese rarely conceptualize them in personal terms. Even the family ancestors are not thought of, or worshipped, as specific persons but rather as a collectivity.

The average person is content to follow the prescribed rituals in the hope that life will progress smoothly, without mishap, protected by ancestral and other well-disposed supernatural powers. Clearly beliefs are not the determining characteristic of this religion. Yet certain fundamental beliefs are held by most Balinese: a belief in reincarnation (the idea that after a period of time human souls will be born again in human bodies), in the law of *karma pala* (according to which one's moral actions in this life influence future lives), and in the importance of *dharma* (right action and moral order) over *adharma* (moral chaos). Most Balinese today are convinced of the ultimate reunion of the human spirit with its divine source, achieving liberation *(moksa)* from the cycle of rebirths. Very few, however, expect to attain this themselves in this life or indeed for many lives to come. *Moksa* is the aim of only the spiritually elevated person or sage. (Although the widespread ability to articulate these beliefs may be largely the result of the officially supported efforts to propagate the tenets of *agama Hindu,* I think they are implicit in and central to earlier ideas expounded in Balinese philosophical texts.) Balinese are fond of observing that there are many paths but all lead ultimately to god. For the average man or woman, faithful performance of ritual duties is their path. Theirs is not to ask why, but to follow the directions laid down by others.

In addition to disruptive supernatural entities, most Balinese are also convinced that certain people possess the power to harm others via mystical means. Belief in sorcery and witchcraft is a well-known aspect of Balinese life,[58] although such matters are secret and always spoken about in hushed and guarded tones. Sometimes called the "left-hand way" *(pengiwa),* mystical power to inflict disease and death is believed to be granted to supplicants who pray to the terrible goddess Durga and meditate upon her in the graveyard. Those who

are successful in their quests become *leyak,* powerful beings attributed with the ability to change shape, taking on all kinds of animal and monstrous forms, including that of the terrible Durga herself. Although women are believed to have a natural affinity for such activities, men too can acquire these powers, using them to attack rivals and enemies.[59] There are also those who possess the power necessary to confront and combat the witches *(leyak).* The Balinese traditional healer, the *balian,* may obtain his or her powers in different ways, in some cases by studying the sacred texts devoted to medicine *(usada)* or by direct inspiration from supernatural sources. It is also believed that these knowledgeable persons who can combat witchcraft must themselves possess knowledge of how to inflict disease and harm. Although the *balian'*s role as healer is usually stressed in ordinary conversation, Balinese are keenly aware that these powers are double-edged. The importance of such beliefs in Balinese life has long been recognized. But on the whole, as Hildred Geertz points out,[60] they have often been regarded as peripheral to religious life and indicative of the continued prevalence of earlier, more primitive, animistic beliefs. In Geertz's view: "A major impediment in Western understanding of Balinese thought is the long and pervasive Christian tradition that defines 'religion' as central and serious, and 'magic' as peripheral and trivial."[61]

For many Balinese who make no claims to special religious or esoteric knowledge, Clifford Geertz's observation that Balinese religion is one of "orthopraxy not orthodoxy" is well supported. When one turns to those whose role it is to deal with the unseen world, however, the situation is different. Here we encounter a new obstacle to understanding: Balinese religious experts are accustomed to using their deeper knowledge to help laypersons deal with the practical difficulties of their lives, but the knowledge on which their advice is based is usually imparted only to initiates who undergo the appropriate rituals and lengthy periods of study.[62] In other words: specialist religious knowledge is esoteric knowledge.

Religious Knowledge and Sacred Texts

There are various kinds of religious specialists in Bali who possess different types of knowledge and perform different roles: temple caretaker priests *(pemangku),* puppeteer priests *(dalang),* exorcist priests *(senguhu),* and Brahmana priests *(pedanda).*[63] The traditional healer, or *balian,* also performs various ritual tasks in addition to healing the sick, and there are, as well, *balian* who act as spirit mediums, allowing families to contact and converse with the spirits of their deceased relatives and ancestors. The authority of these different specialists is based essentially on two sources: one is direct, spontaneous communication with the unseen realm *(niskala)* in states of trance and possession;[64] the other is the study of written texts. Of the two, knowledge of the written texts is by far the most respected as a basis for religious understanding. While this might be said to reflect the view of the Brahmana elite, who in the past represented the group who had the greatest control over this resource, in my experience it represents the view of the majority since the most widely respected sources of ritual knowledge are those persons, by no means all Brahmana, who study the written texts.

Balinese *lontar* texts do not constitute an organized body of theology but a vast and varied literature on all kinds of subjects. Inscribed on narrow strips of palm leaf tied together with string, they are fragile and, in Bali's tropical climate, do not last forever.[65] In order for texts to survive, they must be hand copied every few generations. Usually the private possessions

of priestly and noble families, *lontar* are carefully guarded heirlooms. Until the foundation in the 1920s of the Gedong Kirtya library of manuscripts under the auspices of the Dutch colonial government, no central or public collection of such texts existed. Even the most learned Brahmana priest was unlikely to have read texts other than those possessed by his family or his teacher (who in any case was usually a member of his own family). Nor was there any single text or group of texts that possessed a higher authority generally recognized among the learned.

Lontar deal with a wide range of subjects: hymns and prayers, ritual, cosmology, mysticism, mythology, astrology, ethics and law, medicine, grammar, architecture and art, history, genealogies, literature including epics and poetry, popular tales, and manuals dealing with magic.[66] No one person would study all these fields, and different families were likely to specialize in a certain field, such as medicine, astrology, or architecture, while Brahmana families would preserve the ritual and priestly manuals and mystical texts. There was no system, however, beyond the vagaries of family and local history, in determining how manuscripts were inherited and preserved within particular family lines. No Balinese approached these texts as a whole corpus as a Western scholar might seek to do. The Balinese student would be guided by others, usually teachers or elders, to certain texts. There are texts for *pemangku* (temple priests), for *dalang* (puppeteer priests), for *pedanda* (Brahmana priests), for *tukang banten* (experts on offerings), for *balian* (healers), for *undagi* and *sanggin* (architects and artists), and for students of *desti* and *pengiwa* (black magic). No *balian,* for example, could study every medical text in existence, but only specific ones, usually those few possessed by his own family.[67] Today anyone can consult collections of *lontar* held at the Gedong Kirtya and the Pusat Dokumentasi Budaya Bali in Denpasar if they possess the linguistic skills to read the Kawi, Sanskrit, and High Balinese in which the texts are written.

The *lontar* are an unfixed source of riches that different people draw on in different ways. We must be aware of different levels and streams of knowledge, therefore, even among those who are able to read them. Furthermore the texts themselves are enigmatic works that cannot simply be taken at their surface level. They require careful interpretation—and this may vary among individuals or from teacher to teacher. Knowledgeable Balinese often commented to me that many texts, especially the more mystical ones, contain only part of the information the student requires: the full teaching must be given via the oral instructions of a teacher.[68] Commenting on the special character of Balinese *lontar* as a source of spiritual authority, Fredrik Barth observes that

> these fascinating and important texts add significantly to the Bali-Hindu stream of tradition, but not as a literary heritage allowing reference, comparison, and a critical scholarship of establishing a shared authentic knowledge. On the contrary, they are separate, independent sources of authority to their priestly possessors, at best read for their unique and place-and-person-specific knowledge, each sacred and powerful and unchallengable in its particular validity.[69]

Clearly the very nature of these Balinese sacred texts tends to support the view that Balinese religion lacks internal coherence.

Some *lontar* have been translated and published in English. The Dutch scholar Christi-
aan Hooykaas has produced an extensive body of careful translation and textual analysis of
the religious and mystical texts, for example, while other scholars have tended to focus on
historical and literary works.[70] Although Hooykaas' works are difficult to read, even for Bali-
nese experts, and no clear interpretation of Balinese religion emerges from them, they do
make available to scholars much important material. In later chapters I will have frequent
occasion to refer to them.

For all their vagaries from the point of view of the Western scholar, the *lontar* texts
remain for Balinese the highest source of spiritual knowledge and power. We must approach
them as Balinese do, however, not with the idea of gaining a systematic or comprehensive
orthodoxy of theology but as repositories of deep and mysterious insights into other reali-
ties. In the Balinese view, the *lontar* do not simply convey information: the script in which
they are written, the very shapes of the sacred letters *(aksara),* and above all the mystic
sounds they represent are themselves visual and audible symbols that resonate at a mysti-
cal level, reaching beyond the intellect to influence the spirit and soul of the student.[71]

The evident division of Balinese culture, even today, between those who are able to read
the *lontar* texts, who are a minority, and those who cannot, the majority, also seems, at first
glance, to support the layered view of Balinese religion. Many writers have argued, or
assumed, that the activities of laypeople and *pemangku* are a totally separate matter from the
rituals and understandings of the *pedanda,* the literate scholar/priests whose role and func-
tion is usually assumed to derive from Indian prototypes.[72] Swellengrebel, for example, in
enumerating the features of Balinese culture that can be attributed to indigenous cultural
elements as opposed to those of Hindu or Hindu-Javanese origin, lists under the former "the
system of family, village, and regional temples and the rituals performed there."[73] He also
includes, under the heading of indigenous elements, the offerings given at temples. Evi-
dently this would relegate a great deal of Balinese religious life to a "popular religion"
owing little if anything to Hinduism. Linda Connor has argued for a class of "peasant intel-
lectuals" whom she sees as opposed to a traditional literati.[74] This position, however, has
been strongly contested by Barbara Lovric, who insists that the traditional Balinese elite and
peasants shared the same cultural world and values.[75] Whether explicitly stated or not, the
same view underlies recent studies of Balinese kingship and precolonial politics.[76] Balinese
peasants were not in the past ruled primarily by force: they inhabited a world that was made
safe and meaningful through the ritual actions of their priests and kings, which would have
been impossible without a sharing of the same assumptive worlds.

Mary Zurbuchen and Raechelle Rubinstein have separately shown that it is misleading
to think, as did earlier scholars, of traditional Balinese society as sharply divided on the basis
of literacy.[77] They demonstrate that literacy permeated many levels of Balinese society and
show that the study even of the most sacred texts was by no means confined to Brahmana
scholars and priests or the gentry. Rubinstein refers to "vocational literacy," pointing out that
many others, including healers, artists, architects, and performers, needed to be able to read
the *lontar* texts. Even those philosophical and mystical *tutur* texts that are prefaced by
warnings not to reveal their contents are in fact not forbidden to those who have taken the
trouble to acquire the appropriate skills to study them. According to Zurbuchen: "Although
this doctrine has often been interpreted as forbidding people of common caste access to the

lontars, many Balinese literati nowadays concur that the aja wéra-type injunctions commonly found in the manuscripts are meant to restrict certain types of knowledge, invariably mystic, magic, or esoteric in nature, to those persons who have studied enough to receive them, regardless of caste."[78] Those who sought to read the sacred texts, regardless of their social status, were required to undergo special purification rituals and initiation, as well as to seek oral instruction from a guru.[79]

Textual knowledge is, in my experience, of the greatest importance in determining who possesses ritual and mystical knowledge. Zurbuchen and Rubinstein,[80] however, make it clear that commoners are not barred from reading the sacred texts and that literacy depends rather on vocational needs.[81] Personal inclination and taste also matter: not all members of the Brahmana caste are interested in pursuing a religious or scholarly vocation, while commoners may be drawn by their own inner feelings and ambitions to seek out religious knowledge. Those who need textual knowledge to pursue their professions may choose to acquire only the minimum necessary or elect to steep themselves as deeply as possible in the sacred literature. This, however, is not to suggest that access is freely available to anyone. The knowledge contained in the texts is not only powerful; it is dangerous if incorrectly approached or used. Many are the tales told of persons who have become seriously ill or even insane as a result of their improper engagement with the texts. Rubinstein describes a hierarchy of literacy: Sanskrit at the top, Balinese at the bottom, and Kawi in between.[82] Since the Brahmana priest *(pedanda)* is considered to be the apex of the religious hierarchy, he is also the apex of the literacy pyramid, possessing some knowledge of Sanskrit as well as Kawi and literary Balinese. Rubinstein concludes that

> esoteric, specialist texts utilized in religious and magical activity are
> believed to be invested with supernatural potentiality and access to them
> has been restricted. They have been shrouded in secrecy, because their
> teachings have been considered to pose mystical dangers for the unquali-
> fied. However, contrary to many nineteenth and twentieth century inter-
> pretations of literacy in Bali, including those of some Balinese, access to
> these texts has not been confined to *pedanda,* unordained Brahmana or
> the *triwangsa* in general, and no radical dichotomy has existed between
> a literate elite and an "illiterate peasantry."[83]

My own experience of contemporary practice accords with these observations. Although it often seemed to me that much was deliberately hidden or simply not disclosed, my Balinese informants always insisted that mystical knowledge was available to those who really wanted to obtain it.

Religion and the Role of the Artist

Balinese artists carving statues and painting decorations for temples and palaces, architects, mask makers, carvers of the shadow puppets, sculptors who build the elaborate animal-shaped coffins and high towers *(bade)* for cremation ceremonies—all learn from oral tradition and

instruction and from practical experience. Those artists with the most extensive and thorough knowledge, however, are also conversant with the textual sources of that knowledge.[84] To represent them correctly, artists need to know the myths, the epics, the folktales, the histories, the symbolism of the esoteric texts, the iconography of the deities, the intricacies of calendars and astrological systems. These are highly complex matters requiring expert knowledge. Less talented and less knowledgeable individuals might follow the directions of others, providing labor for the mechanical tasks, but simply to sketch a scene from one of the epics or myths requires extensive knowledge of the subject matter and the conventions of representation. Domestic and sacred architecture is governed by intricate ritual requirements and rules that are laid down in the sacred texts.[85] In short, all aspects of artistic production, including the performing arts, are determined by principles and regulations set forth in the *lontar* texts. This is not to say there is a strict conformity to be observed. The texts themselves are various, as are their interpretations, and always adapted to local and practical needs. Nevertheless, artistic production of any but the roughest kind requires consultation with experts who are conversant with the appropriate texts. This is true even of the offerings produced for domestic and communal ritual. Although most adult women are proficient in making a wide range of offerings—and the local experts, *tukang banten,* usually rely on information acquired orally—the *lontar* texts explicate and list in detail the offerings required for specific rituals. Thus it is to the women of Brahmana households that people look for help with determining what offerings are required for special occasions.

At a practical level, painters, sculptors, builders, and other craftsmen need very specific kinds of knowledge in order to produce the required objects. At another level, these productions must also be ritually correct. Since supernatural forces or beings have no material substance or body, to be present in the material world they must be given bodies to inhabit— and this is the artist's role. Important objects, such as the sacred masks used in temple performances, require special rites *(pasupati)* to invest them with mystical power. In this way "works of art"—a statue, a mask, a painting, once consecrated—are believed to be animated by spiritual entities or powers.[86] There are *lontar* books devoted to mystical diagrams and drawings *(rarajahan)* that are themselves believed to be the means of materializing specific supernatural powers and mystical forces for the ritual expert to command. Many of Budiana's paintings incorporate symbols and motifs inspired by these traditional "magic drawings."

Other objects created by the artist are not intended to be the actual vehicles of divine forces but rather to embellish the temple or ritual. Budiana explained that the aim is to attract attention, evoking appropriate feelings and experiences in the participants. Thus artists use their talents to create objects and performances of beauty, or of terror, to impress the observer. Art brings the invisible, nonmaterial *niskala* realm into being, giving its entities and forces material form, thereby bringing into human awareness the spiritual realm, so that people are drawn to it and seek to be guided by it.

At this point it becomes clear why the master artist in Bali needs to possess ritual power. Of course, there are conventionalized ways to depict the realm of gods and supernatural forces. But if the work is truly to interest and inspire others, the artist must infuse new life into the conventional forms. The highest expression of praise I commonly heard from Balinese, especially artists, concerning a work of art was that "it has *jiwa*"—that is to say, the painting, sculpture, or mask is alive, animated by spirit. This does not necessarily mean

a work is beautiful, finely crafted, or professionally executed. It points, rather, to an intangible but unmistakable quality: it is no longer mere matter. A work possessing *jiwa* seems to command attention, dominates, radiates a kind of power. It attracts the eye; it seems to move as you look at it; it breathes life. The Balinese artist aims at nothing less than bringing to life, or realizing in material form, the cosmic forces that surround us. It is not simply that art in Bali primarily serves religion; rather we might say that religion *is* art.

Artists and performers are expected to use their talents for the benefit of the whole community, not simply for personal gain or satisfaction. An important concept in Balinese communal life is that of *ngayah:* service freely given to the community, usually for ritual purposes. Everyone contributes according to their abilities and capacities. All ritual events, where circumstances allow, involve music, dance, shadow puppet theater, singing, recitation of sacred texts, as well as elaborate offerings, prayers, and ritual actions by priestly officiates. Many sensory modalities are employed to bring the world of the spirit into perceptible form, and all members of the community participate in the process. Some are dancers, some sing, some play music, some make offerings, some construct the statues, paint the decorative hangings, build the funeral *bade* (towers) and the many ritual objects required. Balinese ritual is not a spectacle watched passively but a drama in which everyone has a part to play. *Ngayah,* the labor contributed by each person, is itself an act of worship in which all contribute to the ritual aim of creating a link between the material world and the divine realm.

Western writers often note that the Balinese language has no word for "artist." According to Urs Ramseyer:

> The idea of art as such does not exist in Balinese. People carve or paint masks, carve statues or statuettes, play in a *gong, angklung* or *gèndèr wayang* ensemble or dance the *lègong, topèng* or *baris.* Aesthetic considerations and emotional values, like the artistic activities themselves, relate to single, individual genres which do not exist as independent art forms but primarily as ritual work *(karya).*[87]

This concept of art as "ritual work" *(karya)* is also reflected in the terms used to describe different kinds of specialists, who are referred to as *tukang,* or workers possessing specific skills. Even master carvers of masks are described as *tukang ukir;* a carpenter is a *tukang kayu,* an expert maker of offerings is a *tukang banten,* and so on. The terms do not distinguish between what we would categorize as artists, craftsmen, and skilled laborers. For Balinese, all are *tukang* and all are respected for their skills and their contributions to ritual life.[88] Yet the carver or painter or puppet maker should not be seen as occupying a lowly position. I found that many *pedanda*—the most respected religious authorities whose position is based on professional knowledge of the written texts—were also carvers and mask makers (or had been before their priestly role left no time for such activities). The *dalang,* the puppeteer priest, who must have extensive knowledge of the classic epic and ritual literature, usually makes his own puppets, carving them from specially prepared leather and then painting and gilding them himself.

Even the usual distinction between the visual arts and the performing arts is difficult to maintain in Bali, since the maker of a mask is also likely to be the dancer wearing it. How,

Balinese ask, is the mask maker to know what is required if he has no direct experience of the dance? Likewise the *dalang* is both performer and maker of his puppets. The painter or sculptor is often a musician or dancer as well who puts down his brushes and chisels to join the performers. Most Balinese seem to possess multiple talents, and such is the rule rather than the exception. Once again, this is made comprehensible through the idea of "ritual work." One contributes what one can, when one can, and must be prepared to step in and take over when needed. Ritual work is about helping and working with others, not about individual achievement or personal ambition. There are many different ways in which people can use their abilities in the service of ritual. Those with more talent and more knowledge provide leadership and example, but all can participate in some capacity.

It is often said that in Bali everyone is an artist. But as one of Ramseyer's Balinese informants wisely commented, there may be many artists in Bali, but "not so many good artists."[89] In other words: many Balinese give their time and energies to artistic activities required by ritual without thought of producing anything that might be considered an expression of individual talent or distinguishing themselves as "artists." Should they in fact succeed in creating an object or performance that stands out above the rest as something of special value, this will be attributed not so much to personal ability as to spiritual power. Unique skills and knowledge, outstanding performance of any kind, are not seen as the result of personal qualities but the product of a special closeness to the divine origins of such powers. As persons with special talents and knowledge, both Budiana and Mirdiana willingly contribute to the ritual life of their communities. This is not a kind of tax or corvée imposed by the community but an act of worship performed by the artist.

Although the paintings discussed in the following chapters are not intended to be religious icons or devotional objects, they nevertheless lead us deep into Balinese mysticism and philosophy. They were not made primarily to cater to Western tastes or with commercial ends in view. Observing the paintings, a university-trained Balinese scholar of the *lontar* texts commented that they were something special, *"seni murni"*—that is to say, pure art created without thought of gain.[90] Although the term *"seni murni"* is Indonesian and has no exact equivalent in Balinese, the concept does: this is the very essence of *ngayah,* or ritual work. My Balinese colleague stopped in astonishment in front of Mirdiana's *Barong and Rangda* (Plate 23), caught his breath for a moment, and then exclaimed in quiet wonder: "This is exactly what I have seen so often in states of inner concentration *(batin)* and now I see here before me in this painting!" If Balinese art is "the mirror of religious thought," as one of Ramseyer's artist informants explained,[91] then the paintings about to be discussed clearly serve that end.

Modern Developments and Religious Change

Writing of Bali in the 1950s, Clifford Geertz identified a movement he called "internal conversion"—a process whereby flexible local religious practices are gradually turned into dogma as a religion becomes bureaucratized.[92] Fifty years on, it might be argued that I am just observing some of the effects of this continuing process, mistaking these for a core of traditional mystical beliefs, when in fact they are modern creations.

Budiana and Mirdiana might well be the present-day counterparts of those young Bali-
nese Geertz observed to be so eager to rationalize and reform their religion. There is today
a powerful reformed Hindu view and the Parisada Hindu Dharma—a government-sponsored
body that aims to provide more rationalized, modernized forms of doctrine that can be stan-
dardized and taught even to schoolchildren.[93] There are now government-sponsored *lontar*
libraries and collections, increased publishing of traditional Balinese texts in Indonesian
(a trend already noted by Geertz in the 1950s), plus religious education available in schools
and colleges, as well as university courses in Balinese and Old Javanese letters and literature.
Today those who seek esoteric knowledge but possess no traditional means of access can
nevertheless acquire such knowledge if they desire it. Most young people, however, would
prefer to study English, Japanese, or some European language that will secure them a place
in the tourist industry, rather than spend their time and energy learning how to read Kawi,
Sanskrit, and Balinese manuscripts. There are also in existence today many private study and
meditation groups, and other groups concerned with self-healing and self-defense, that may
or may not be part of what Geertz refers to as "internal conversion." Leo Howe has recently
described these groups and their uneasy relationship with the government-backed *agama
Hindu*.[94] In addition to these groups, in the past few years various devotional movements
introduced from India, including Sai Baba and Hare Krishna, have become popular.[95]

A recent study by Barth, however, stresses that the decentered and locally based char-
acter of Balinese religious life continues despite the many pressures for change.[96] My own
experience supports the view that village people go about their lives, continuing to fulfill
their elaborate ritual requirements, with little concern for the debates of reformist intellec-
tuals and elites. Howe too observes that customary ritual practice continues—if anything
with renewed enthusiasm—as new wealth has brought greater resources to be channeled into
ritual and notes that to withdraw from such activities is impossible since to do so would be
to cut oneself off from community life as a whole.[97] The complexity of the present situation
of competing ideas and interests—which involve issues of status, caste, and identity inex-
tricably interwoven with religion—is clearly delineated in Howe's recent study. He notes:

> While the creation of *agama Hindu* is an attempt to add theological sub-
> stance to and provide philosophical justification for traditional Balinese
> ritual practices by giving them a rational foundation, these additions
> also form a reasonably coherent system of doctrine, which, to some
> extent, stands apart from the ritual practices of village Balinese. Thus, in
> aligning Balinese religion with the ethical and theological tenets of Indian
> Hinduism, officials of the Parisada and other leading intellectuals created
> a new form of Balinese religion, with its own distinctive mode of knowl-
> edge and doctrine. This *agama* has similarities to and differences from
> customary *adat* religion, but, while *adat* is more an orthopraxy, *agama
> Hindu* is more an orthodoxy.[98]

In this situation, the danger arises of assuming (which Howe does not) that all philosophi-
cal and mystical elements to be discerned in current Balinese religious thought necessarily

owe their origins to the efforts of the Parisada or other reformists. In recognizing the complex effects of religious change, I think we must guard against any simple equating of *adat* (customary practice) with "tradition" and attributing all other elements to recent innovation. In the confusing ferment of current thought about religion, we need to acknowledge a continuing stream of Balinese philosophical and mystical thought that is not owed to, and predates, twentieth-century reformist efforts to realign Balinese religion with Indian Hinduism or to introduce Hindu devotional religion.

In the following chapters we will find that the themes reflected in the paintings of Budiana and Mirdiana are not recent exoticisms or rationalizations arising out of the modern ethical and theological viewpoints of *agama Hindu*. Indeed they are ancient ideas deeply embedded in the culture. They are revealed in the *lontar* texts of mythic narratives and in abstract mystical texts, all of which certainly predate modern reformist movements. Even more significantly, as we will see in Chapter 5, they are discernible in Balinese ritual practices—the very ritual practices that Clifford Geertz and many others have come to see as constituting the essence of Balinese religion.

If we focus on the level of local cultural expression—the wide variations to be found across Bali—the differences are of course going to be exaggerated. If, however, we look at other levels of understanding, such as those suggested in the artworks about to be discussed, we can discern themes, ideas, rituals, and myths that have many parallels with Shivaitic Tantrism. This is not really surprising in view of the fact that several scholars have suggested that such represents the teachings originally brought to Bali from India.[99] My argument is not that Balinese Hinduism is simply identical with Indian Shivaitic Tantrism; I contend the similarities go much deeper than has previously been acknowledged. Furthermore, these themes are not mere superficialities overlaying earlier beliefs but are woven through current ritual practice and belief to form a recognizable pattern.

Hildred Geertz wisely cautions against making sweeping generalizations about Balinese religion:

> Many Balinese today stress that their religion is at base monotheistic, that the greatly varied gods and demons are, in fact, all manifestations of the one God, who sends out avatars as numerous as the rays of the sun. However, no present-day Balinese religious leader has succeeded in establishing doctrinal uniformity on this or other matters. Not only is every locality different from every other in the modes of worship and ways of speaking about it, but different social groups, too, cannot agree. There is, no doubt, a central core of principles to which all Balinese adhere, but no one, Balinese or Westerner, has been able to explicate these adequately.[100]

In the following discussion I make no pretense of identifying a central core of religious principles to which all Balinese might adhere. Nor do I set out to provide a comprehensive picture of Balinese religion as a whole.

In defining it as an "orthopraxy," Clifford Geertz declared that traditional Balinese religion failed to develop a system of either "ethical or mystical theology."[101] Thus he explicitly

denies the existence of a Balinese mysticism. Yet there are important elements of Balinese religious life that can be shown to fit his own definition of a "mystical theology" involving, as he puts it, "direct, individual experiential contact with the divine via mysticism, insight, aesthetic intuition, etc., often with the assistance of various sorts of highly organized spiritual and intellectual disciplines, such as yoga."[102] It is the aim of the following chapters to describe a stream of traditional Balinese mystical thought that fits this definition.

Fire, Destruction, and the Power of the Mother

The Paintings of I Ketut Budiana

I KETUT BUDIANA is a well-known figure in contemporary Balinese art. His paintings hang in all of Bali's museums, they are illustrated in many books, sought after by collectors from Indonesia, Europe, America, Japan, Australia, and elsewhere, and they have been shown in many international exhibitions.[1] He is not, however, a rich man. Like most Balinese, Budiana shares what income his works bring him with his extended family and his community. He lives modestly and is little interested in the commercial aspects of his profession. In fact, he devotes a great deal of his time to producing works for ritual and religious purposes, and not only does he refuse payment for them but often these creations are made simply to be destroyed a short time later.

Budiana is a living example of the Balinese ideal of *ngayah* referred to in the previous chapter. He sculpts statues and carvings for temples, masks for sacred dances, and animal-shaped coffins for cremation rituals, as well as designing, building, and repairing temple structures. One wonders how he finds a moment to devote to his paintings, such as those illustrated here, which take weeks and even months to

complete. He teaches traditional Balinese painting at the Batubulan Senior High School of the Arts and has private students as well. His output is prodigious, yet Budiana rarely looks tired and never hurried. He does not give the impression of a man driven by passion, but rather one who derives a continuous, calm joy from what he does. Balinese are well known for their ability to mask negative emotions, always presenting an unruffled exterior to the world. Budiana, however, goes beyond this, managing to create a sense of calm space around himself.

The sharp contrast between Western and Balinese understandings of art and the role of the artist was deeply impressed upon me the first time Budiana invited me to watch his *banjar* (neighborhood) members preparing for a communal cremation ceremony. When I arrived at the *bale banjar* (the neighborhood meetinghouse), I found dozens of men and youths busily engaged in carving and putting together ten or more bull-shaped coffins. As this was to be a communal cremation, several coffins were required and, as is customary, the whole *banjar* was there to help. Finally I located Budiana in the crowd: he was wielding a large knife and hacking out the wooden leg of one of the bulls while other men were putting together the rattan body to which it would later be attached. Far from playing a supervisory role, Budiana was just one amid many workers offering their labor. A team was working on each bull. In the end, no doubt, the animal Budiana was carving would be more elegant in form and make a more powerful impression than the others, yet this was not really significant. What mattered was that each man contributed as best he could. If other people sought his advice, Budiana would give it, but essentially he participated in the work as an equal member of the team. I stood amazed at the sight of this distinguished artist laboring like an ordinary carpenter in the dust and heat, freely donating his time and creative energy to produce something that would soon be consigned to the cremation fire. This was art, but not of a kind I could easily comprehend. It was essential that the final object be ritually correct and perfect. Yet the perfection so carefully striven for was to last but a moment. And Budiana would receive no reward for his efforts beyond the satisfaction of giving.

I have also observed him, along with other artists, spend hours every day for several weeks helping his community repair and refurbish the old Barong Landung figures possessed by a local temple. On another occasion I went to the neighboring island of Lombok to observe Budiana, and members of his group, repair a Barong mask they had made for a Balinese Hindu community. Many times I have watched him perform as a dancer at temple ceremonies, usually dancing the part of Barong. Whenever there is an important religious ceremony held by his community, or surrounding communities, Budiana can be found there pouring his energy and vast talents into it. This free labor given out of devotion, which Balinese refer to as *ngayah,* is of the greatest importance to him and he clearly derives great personal satisfaction from it.

Budiana learned his professional skills from his grandfather, who was a traditional architect. Budiana took me to see the Pura Dalem of Padang Tegal, where his grandfather had worked on many of the impressive structures and carvings and he himself had learned the carver's art at his grandfather's side. Intriguing little statues of strange goblinlike creatures along the front wall of the temple were carved by Budiana many years later. Befitting his status as a master carver *(sangging)* and architect *(undagi),* Budiana is a student of the *lontar* texts and all his artistic productions reflect this.[2] Thus to explore the imagery of his paintings

is be drawn into the deeper reaches of Balinese mystical thought. He employs traditional imagery, but not that which is to be found in conventional representations of deities and mythology. Familiar with mystical concepts outlined in esoteric texts, he also creates imagery inspired by the *lontar* manuals of talismanic drawings *(rarajahan)*.[3] Because such esoteric works are accessible only to scholars who are able to read Kawi,[4] these traditional sources of Budiana's inspiration are recognized only by those Balinese who possess a similar familiarity with the *lontar* texts. To Western eyes, the imagery of his paintings has an almost surreal quality so that it somehow resonates at deep unconscious levels and seems to communicate beyond cultural boundaries.

The aim of this chapter is to show how Budiana's work as a whole can be understood as reflections on a number of related themes that come together in a cluster that he calls "the power of the Mother" *(kekuatan Ibu)*. It must be understood that this Mother is not the human mother but the abstract creative cosmic principle responsible for bringing into being every entity that exists in the material world. This creative principle is represented in the Dewi, the Goddess, who in Bali is refracted into various aspects: Dewi Sri, the rice goddess, Dewi Saraswati, the goddess of knowledge, Dewi Danau, the goddess of the lake, Dewi Uma, the consort of Siwa, the high god, and so on. Ibu Pretiwi, Mother Earth, is another of her aspects and as such represents the earth and all its life forms. It is easy, but incorrect, to think of the Goddess as equivalent to Mother Nature. The Goddess (the Mother) incorporates every material object and creation, cultural as well as natural, so that not only the natural world about us but all manufactured objects and material possessions are equally emanations of her power. All worldly material things *(duniawi)* originate from the Goddess, whom Budiana always refers to simply as "Ibu" (Mother).

The symbols, ideas, and stories that he draws upon are provided by his culture, and many, indeed most, of the elements that comprise his paintings constitute well-known aspects of Balinese thought. It is rather the way in which he combines and juxtaposes this cultural imagery that is unique artistically and novel in terms of Western understanding. I will put aside for the moment the question of how representative his interpretations are. Here I want to explore Budiana's work—as exemplified in the twelve paintings illustrated in this book—to show how a consistent view of the cosmos, and the powers that comprise it, is revealed. I focus on the imagery of the paintings so that readers may judge for themselves whether the meanings I identify emerge from the painting as visual expressions once the cultural background is understood. I also draw on the artist's responses to my detailed questions about each painting in order to establish for myself, and for the reader, that what I have read in the imagery is what the artist intended or at least is consistent with the artist's intent. Yet a work of art, like any text, is never exhausted by a single reading. Indeed this richness of resonance and multiplicity of meaning are an important aspect of what constitutes art. In offering a consistent view of the philosophy expressed by Budiana, I do not pretend to exhaust all possibilities of interpretation or to resolve all questions; my intent is to high-light certain important themes.

Budiana's paintings are not depictions of meditation or images visualized in meditation; rather the painting itself should be understood as a process of meditation. That is to say, the act of producing the work of art is a meditative experience. Budiana explains that he begins a painting often with no idea of what will emerge from within him and appear on the canvas:

it is as if some other hand guides the brush as he watches. The painting constitutes an unfolding of imagery evoked by or linked to a particular feeling or idea. If we follow the imagery of the painting, like the unfolding imagery of a dream, we can discern the themes that occupy the artist's meditations.

The readings I give here are not, however, based primarily on my personal response and emotional reactions (although these of course are involved in any process of interpretation). The readings are based on the artist's own explanations.[5] In attempting to unravel the multiple layers of meaning held in a single painting, it helps to pay attention first to the title Budiana gives to the painting, second to the colors he uses, and third to the specific images and combination of images he employs. These considerations guided our discussions.

Fire and Destruction

I begin with the painting titled *Gunung* (Mountain; Plate 1). This small work on paper depicts a majestic figure, draped in what appears to be a blue cloak, with a strangely formed head emerging out of what looks like some kind of armored corselet. The colors are striking: bright, blood red; deep, aqueous blue; and cloudy white. Budiana's paintings on the whole use a minimum of color, relying primarily on black, white, and shades of gray, and all the colors he employs have a specific significance within traditional Balinese cosmological concepts.

Budiana explained that the earth is female and said that this painting represents the power of the earth, of Ibu Pretiwi, the goddess of the earth.[6] Evidently it is terrible and destructive power Budiana had in mind since the natural form he chose to represent it is an exploding volcano. When asked the title of the painting, he replied: "*Gunung* [mountain]— *gunung meletus* [exploding mountain]." The shape of the volcano, merging into a woman's body composed of various natural elements, animals, trees, and plants, reiterates the idea of *female* power. Many Balinese, as Budiana pointed out, have been the victims of volcanic eruptions and know well the devastating force of such events. Another symbol of female power is placed at the bottom of the painting between the feet of the volcano woman. This small white naked female figure assumes a dancing pose, which suggested to me the high god Acintya (who is conventionally represented naked but with male, not female, genitals). There is a play on visual associations here. The small naked female figure at once brings to mind the high god Acintya, who is so pure and beyond human understanding that his name means "The Inconceivable." Yet at the same time it resembles the figures of female witches with fire coming from their genitals to be found in traditional Balinese paintings.[7]

Budiana agreed that this paradoxical figure has connections to these two opposites: "Yes, like Acintya. That is because the movement of the figure is the movement of life. That is because if a person or thing does not move, it is not alive, it is dead. This is a symbol of movement, so that everything can move, and also the mountain that explodes—that is movement, a symbol of movement." The dancing position of the figure, like the posture of Acintya, represents movement, which constitutes life. The color is white, symbol of purity and spiritual power, usually associated with the male creative principle. Red, the color of heat and blood, is the color of the female element. But we see that from the womb of the white naked figure gushes blood or fire.[8] Budiana commented that the figure is exuding *sakti* (mystical power),

or heat *(panas),* like the volcano: "It is a symbol of power *(kekuatan)*. Ibu Pretiwi (Mother Earth) has very great power. For example, in 1963 Mount Agung erupted and there were many victims, many people died."

Now we can link the volcano woman erupting fire and lava with the witch issuing fire from her genitals and with the human mother shedding blood in birth and menstruation. Budiana links volcanic fire and heat to the blood of birth, equating both with the power of the *leyak:* the power of *sakti* or the fire that issues from the witch's vulva. *Sakti* is a Balinese concept that Western writers have long struggled to understand.[9] It is usually translated as "magical" or "mystical power," but this explains little about its actual nature. For Budiana *sakti* is evidently a power with both creative and destructive aspects that emanates from the Goddess/Mother.

The small figure at the base of the volcano woman is white in color to stress, as Budiana explains, that her role and function, though apparently frightening, with her menacing expression, disheveled hair, and snakelike tongue, are in fact positive and benign. To underline her positive function, she holds in her left hand (always associated with the female) a vial of holy water. The meaning of the holy water is, Budiana explained, "to bring to life, to revive. This holy water is guarded by these powers. Powers that are positive, a white power guards it. Although the shape is like a *leyak* [witch]—the tongue long, the face frightening—the purpose of this figure is to return what is not good back to good." We can now see that the small naked female figure begins to reverberate with the majestic volcano woman, who is draped in a mantle of blue plants and rain. Both bodies are white in color; both are issuing forth red fire and heat; both are bearing water. The volcano woman brings about terrible destruction with her erupting fire and molten rock, but like the mother/witch bearing the vial of holy water her function is positive: to purify through destruction and thus return matter to its original pure state. Like the mother giving birth, both give rise to new life. But the creation of new life requires the meeting of opposites: female and male, fire and water. The vial of holy water, together with the blue mantle covering the volcano woman, point to a meeting of fire and water from which issues—like vapor above the volcano—a third element. Budiana agreed: "Yes, the meeting of fire and water creates cloud and later this becomes *tirta* (holy water)—life!" This "thrilling mystery of the marriage of fire and water," as C. Hooykaas calls it,[10] is a central mystery of Balinese Hinduism and a key theme of Budiana's paintings. We will return to it many times in this discussion.

Budiana's imagery in this painting might well seem to draw on symbolic universals that speak with the language of dreams, conveying the same deep unconscious meanings for all human beings. Or perhaps the artist employs the language of his own personal unconscious. Undoubtedly the images seem to evoke a response in us: we feel, once we have been told what the images mean, that we knew them all along. However this may be, Budiana's symbols and the meanings he expresses are not exclusively the products of his private fantasy. They are expressions of basic concepts in Balinese religious thought.

The association between woman, earth, fire, witchcraft, and destruction is a common theme in Balinese culture. Red stands for female reproductive power on a human and a cosmic scale. White is associated with spirit as opposed to matter, with sky and heaven as opposed to earth, and with male creative power—semen. Human conception is believed to take place as the result of the meeting of red female reproductive substance *(kama bang)* with

white male reproductive substance *(kama petak)*.[11] In terms of natural elements, the female creative principle is symbolized by fire and the male principle by water and rain. White is also associated with holiness, purity, and goodness; red is linked to physical matter, such as flesh and blood, and to destruction and danger. These symbolic equivalents are so widely known to Balinese that I need quote no further authority.

With these simple symbolic elements and contrasts, Budiana conveys his message in imagery by transposing some of these oppositions. Thus the female earth/volcano/witch is colored white to emphasize, paradoxically, that although she spews out fire and is possessed of great destructive power, this power is directed to a good and necessary end: returning all back to its original, pure state. What appears to be destruction and disaster is, from a wider perspective, part of the necessary cycle of life, destruction, and death. In a similar way, the artist transposes the movement of the high god Acintya onto the figure of a naked woman. Both figures derive from traditional motifs, but Budiana's combination of them is unique. Although the animal shapes and monstrous faces that emerge from the shoulders, elbows, and knees of the volcano woman have their counterparts in the *lontar* manuals of talismanic drawings, the way they are used as part of a larger figure is Budiana's innovation. The volcano woman and her tiny counterpart, half witch, half dancing Acintya, are unique products of Budiana's creative imagination. But the symbolic elements he combines and the themes he expresses are drawn from Balinese esoteric teachings expounded in the *lontar* texts and from the manuals of talismanic drawings.

Fire, as a symbolic element, plays an important role in Budiana's works because this is a key symbol of the feminine creative principle. Budiana explores the dual nature of fire: it destroys but also purifies; it is both terrifying and beautiful. *Kebakaran* (Conflagration; Plate 2) is an eloquent visual statement of this dual aspect of fire. The large canvas is filled with sizzling heat and roaring flames blown to a fury by Hanuman, the White Monkey, in his aspect as god of the wind. Nothing is left in the midst of this natural furnace, only fire itself, which has consumed all. Yet the light and heat and powerful energy that the painting radiates are striking. We stand back from the flame but are caught enthralled by its ferocity. This is the destructive power of the natural world unleashed, a raging monster, a ravishing spectacle. Such is the Terrible Mother, the creative principle that gives birth to all forms of life and in turn destroys them. Budiana wants us to feel her rage—and see her beauty.

Gunung Meletus (Exploding Mountain; Plate 3) is another representation of the volcanic powers of the earth. But in this case the colors are much more subdued and the association with fire and the Terrible Mother is less obvious. Indeed were it not for the title, it might be difficult to guess that the two huge heads with gaping mouths at the bottom of the painting represent volcanoes. The heads possess monstrous teeth and tusks, white mustaches and beards; one belches forth smoke, the other spews out lava. The dark browns, blacks, and grays employed in this work are in fact more characteristic of Budiana's paintings than the bright reds encountered in *Gunung* and *Kebakaran*. One has to look closely to see that the smoke and clouds issuing forth are tinged with red; thus the colors do not offer an immediate clue to the theme. To my eye, the monstrous heads, which appear to be masculine rather than feminine, might be interpreted in other ways, but the artist himself identifies them as volcanoes. Furthermore, since they represent the forces of the earth, they stand for the power of the Mother in Budiana's view, whether they take masculine or feminine form.

The small grotesque figures in the right field of the painting (hideous female shapes as well as indeterminate ones), as well as the various menacing faces that peer out from the gloom, represent destructive and negative forces: the *bhuta kala*. This is a term usually translated into English as "demons," and Budiana's *bhuta kala* seem every bit as devilish as the demons represented in medieval Christian paintings of hell.[12] Yet we will find that the *bhuta kala* are quite different from Western concepts of demons. They are forces present in physical matter rather than supernatural entities; indeed, they are inherent in the very nature of material substance. They might be said to constitute the energy contained in matter—a force that Budiana shows to be neither inherently evil nor destructive.

From the midst of all these dark, chthonic shapes emerges at the top left of the painting the figure of a goddess, of beauteous form and face, holding a golden vial that radiates a halo of white light over the surrounding gloom. This graceful figure with her golden vase stands in total contrast to the ugly, misshapen forms beneath. Yet both are but different aspects of the same cosmic force: the power of the Mother. The golden vase, the artist explained, contains *tirta,* holy water, which symbolizes new life. Thus this beautiful female form at the top of the painting brings us back to the grotesque female form to be found at the feet of the volcano woman in *Gunung* (Plate 1). Both figures are represented as carrying vases of holy water, which, as the artist explained, symbolize giving or returning to life.

The destructive forces of Mother Earth—the fire that explodes from her orifices and rages in the furnace of her womb—bring death and destruction. (Note the scenes to the center right of the painting, reminiscent of scenes of the netherworld where human souls are tortured by demons.) But out of this destruction emerges new life. The theme is the same: the Terrible Mother destroys in order to purify and give rise to new life.[13]

Demons and Dark Forces

The identity of the Mother with the witch has already been touched upon. This theme is further developed in *Melihat Bhumi* (Behold the World; Plate 4). The central figure is extraordinary: it is both grotesque and repellent, yet at the same time somehow evoking compassion. The figure is both infantile and senile, its white flabby flesh and bald head suggesting old age, yet the rounded form and head and the proportions of the body are those of a child. The pendulous breasts and the prominent vulva leave no doubt as to the sex of the figure, and the blood or fire that streams from the genitals attests to its reproductive powers, seemingly incongruous with advanced age or infancy. The face is turned down, revealing to our view a bald pate surrounded by a few wisps of white hair. Despite its ugliness, the white flesh and bald head seem vulnerable and in need of protection. The figure as a whole arouses a powerful ambivalence in the viewer—disgust, fear, even loathing—and yet also pity and perhaps guilt.

Budiana identifies the figure as the Mother, the world, *bhumi*. The title of the painting— *Melihat Bhumi* (Behold the World)—commands us to face the source of our being. This is certainly not the smiling, beautiful Goddess but a grotesque female ogress, with hairy limbs and great claws on hands and feet, who assumes the stance of a witch dancing on one leg on human skulls from which rise flames. (Witches are thus depicted in the Balinese manuals of

talismanic drawings.)[14] From her head spiral flames swirling with diabolical leering faces, their sharp fangs protruding from bloodred lips. Everything about her, including the fire streaming from her womb, suggests the *leyak* dancing in the graveyard rather than Mother Earth. Only her color, white, indicates otherwise. When I asked Budiana why she was colored white, he said she is pure *(suci)* and holy. Nevertheless, the identification of the Mother with the witch is very clear. What does this mean? Is Mother Earth a witch, or does the witch have characteristics of the pure and holy Mother? I think that both witch and Mother Earth participate in, or are expressions of, the same natural force and power.

The heads spiraling out of the flames issuing from the Mother's head are, Budiana explained, powers existing in the natural world; he refers to them as *"banas"* (a term I will return to later in the discussion). To our eyes they look demonic, but in fact they are neither good nor evil. Like the volcano woman of *Gunung* (Plate 1), they are simply natural forces without ethical content. The physical world is, in Budiana's vision, a seething cauldron of natural forces. It is composed of the five elements: the *panca maha bhuta*—earth, fire, metal, water, and air. These are referred to as the five gross elements perceptible to the senses. *Bhumi,* the world, is composed of these five elements, or *bhuta.* Our bodies likewise are combinations of these five elements, and on death, and the dissolution of the body, the body returns to these basic elements. The forces present in the natural world have, from a human perspective, both creative and destructive aspects. Both aspects are inherent in and essential to the material world and both are aspects of the power of the Mother. The Mother is the origin of *bhuta* substance and the source of *bhumi,* the earth. All the powers and forces of the material universe issue from her, as do the *bhuta kala,* the disruptive and dangerous aspects of these forces.

The term *"bhuta kala"* has conventionally been translated into English as "demons," a circumstance that, in my view, has given rise to much misunderstanding concerning the Balinese worldview.[15] Many Balinese do speak as if the *bhuta kala* were entities analogous to Western notions of demons—dangerous supernatural entities to be placated and banished. The need for a more nuanced understanding of the *bhuta kala,* however, has been indicated by several Western scholars.[16] Stephen Lansing reminds us:

> Balinese religion is a sophisticated blend of Hinduism, Buddhism, and indigenous beliefs, and the ceremonies of Buta Yadnya are not simple-minded offerings of appeasement to slavering devils. All Balinese "demons" may take form either in the outer world *(buana agung)* or the world of the self, the microcosmos *(buana alit)*. Demons *(buta)* may be viewed from many perspectives. A strong Buddhist element in Balinese religion suggests that demons are essentially psychological projections, but differs from western psychology in insisting that "demonic" forces are part of the intrinsic constitution of inner and outer reality. The demons, according to this interpretation, are simply the raw elements from which the higher realities of consciousness and the world are created. *Buta,* which is usually glossed as "demon," actually means "element."[17]

Mark Hobart has explored Balinese understandings of the term *"bhuta kala,"* noting that a primary sense of *"bhuta"* in Bali is "blind"; it also refers to "elements," he says, "as in

pañcamahabuta, earth, water, fire, air, ether."[18] The Balinese term *"kala,"* he notes, is more complex, but among its many homonyms are "time" and "raw energy." Hobart further observes that *"buta"* in ritual "is often spoken of as returning complex entities to their constituents." And perhaps closest to the interpretation given here, he says: *"Kala* are often treated as the negative aspects of high deities, or the inevitable entropy of all visible forms."[19] Similar meanings are given by Leo Howe, who likewise emphasizes the Balinese linking of the concept of *kala* with time.[20]

The Old Javanese and Sanskrit roots from which the terms derive also point to these more abstract, philosophical meanings. As the first meaning of *"bhūta,"* P. J. Zoetmulder gives: "that which exists, any living being; (material) element"; the second meaning given is a "class of demons, demon (in general)."[21] Several meanings are given for the term *"kāla,"*[22] but the one that is most relevant lists as the first meaning "time"; the second is "time as inescapable fate"; and the third is "Kāla as the god of death and annihilation."[23] Thus the term *"bhuta kala"* might suggest material entities subject to the destructive force of time— a definition that comes very close to what I think Budiana is trying to communicate. Philologists may dispute the accuracy of the etymology here, but from my perspective the important point is the links of association that Balinese make between these ideas, not the actual origins of the terms.

As physical bodies, inhabiting a material world, human beings are composed of *bhuta* substance and subject to the ravages of time, *kala.* The *bhuta kala* do not merely surround us: they are within us and part of us; they constitute the basic instinctual natural energy we possess as embodied beings. If properly understood and treated correctly, this instinctual level of our human nature becomes a powerful force to be used for higher ends. If misunderstood, ignored, or given free rein, it becomes destructive. Greed—and desire— originate here, as do energy and aggression. This is the realm of the Mother par excellence. But the Mother cannot be destroyed or killed; we cannot destroy our physical world; rather her power in us must be respected and controlled. The monstrous yet pure figure that Budiana depicts in *Behold the World* reveals this origin, this matrix, of our physical embodied nature.

The Four Mystical Siblings

In the Balinese view, human beings are born into the world possessing a threefold potential. There is a *bhuta* level, a human level, and the *dewa,* or god potential, in all of us.[24] Which level we aim to develop is our choice. Each person is believed to be born with four mystical siblings referred to as the *kanda empat.* These siblings—identified with the placenta, the amniotic fluid, blood, and other birth substances—become the invisible helpers and protectors of their human sibling throughout life, and the person who aims for spiritual development must enlist their aid. The *kanda empat* change their forms and names over the course of life, depending on the person's relationship with them. The first form they take is that of the *bhuta* level with the names Angapati, Mrajapati, Banaspati, and Banaspati Raja.[25] Although the concept is elaborated in the mystical texts described by C. Hooykaas and others, the Catur Sanak—or more commonly, in my experience, the *nyama* (siblings)—are also part of the understanding of ordinary Balinese.[26]

The mysterious *Bayi di Kandung* (Baby in the Womb; Plate 5) unveils a vision of the *kanda empat*. Although only one is pictured, the fourfold nature of the siblings is suggested in the four leaves of the tree or stem to which the fetus is attached in a kind of transparent bubble. A complex of interrelated ideas is involved here. The tree is evidently the human mother's body, which contains the child in her womb, the large swelling on the lower part of the trunk. And the four siblings, the four leaves, are likewise emanations of the mother's body. In Balinese belief, certain large trees are believed to be animated by unseen forces termed *"banas."*[27] As we find in the three paintings *Gunung, Gunung Meletus,* and *Melihat Bhumi,* Budiana often represents monstrous faces peering out from trees, rocks, and clouds, all of which he says represent *banas*. A particular tree, the *pule* tree, produces rounded swellings on its trunk that Balinese liken to a pregnancy. These swellings are cut out of the trunk and used to make the sacred Barong and Rangda masks. The wood is said to contain *banas*. Budiana reverses this symbolism: instead of the *pule* tree being represented as a pregnant mother, the human mother is represented as a *pule* tree. What is the significance of this identification? First of all, the close relationship between the human being and the natural world that surrounds us is emphasized—we are part of this material world, not something different. We also participate in its powers, and our four spiritual siblings possess *banas* as does the *pule* tree. Here they are pictured as four leaves or branches or sections of the *pule*. *"Kanda,"* according to Zoetmulder,[28] has the meaning of "a single joint of the stalk or stem of a plant, such as bamboo, or reed or cane, any part or portion." Since *empat* means four, *"kanda empat"* literally means four segments of the same stalk or trunk.[29] Budiana's representation is thus an ideograph of the term.

The number four is also represented in the circle bisected by a cross held in the arms of the central figure and occupying the very center of the painting. This is a Balinese symbol of the five directions. East is represented by the color white, south is red, west is yellow, and north is black; in the center is a mixture of all colors termed *"brumbun."* Each of these directions and colors also stands for a god: Iswara to the east, Brahma to the south, Mahadewa to the west, Wisnu to the north, and in the center Siwa. This is the *bhuwana agung,* the world at large. In the *bhuwana alit*—the human body—the center and four directions are identified with the person and his or her four spiritual siblings. Thus the *kanda empat* are identified with a specific direction, color, and god, while the human person is identified with no less than Siwa himself.[30] This points to the god potential of every human being.

As noted earlier, the *kanda empat* take different forms and provide the means whereby we as human beings can realize our different potentials: the *bhuta* level, the human level, and the god level. *Bayi di Kandung* focuses on the *bhuta* level. The central figure is human in shape but has strange clawed hands and feet like a frog. The body conveys no hint as to gender, but the red color identifies it with fire, the female element. The leopard or panther to the left of the figure, with its flamelike tongue, sharp fangs, and feet in a conventionalized three-pronged form representing fire, is the king of the forest—standing for the animal power and ferocity possessed by the *bhuta* forms of the *kanda empat*. The emphasis on teeth and tongue and fire reiterates the themes of devouring greed and destructiveness.

It is the *bhuta* level of the *kanda empat,* according to Budiana, that must be developed if a person desires to obtain the powers of witchcraft.[31] The witch, the *leyak,* employs rituals to change shape—first taking the form of a monkey (a transformation more than hinted at

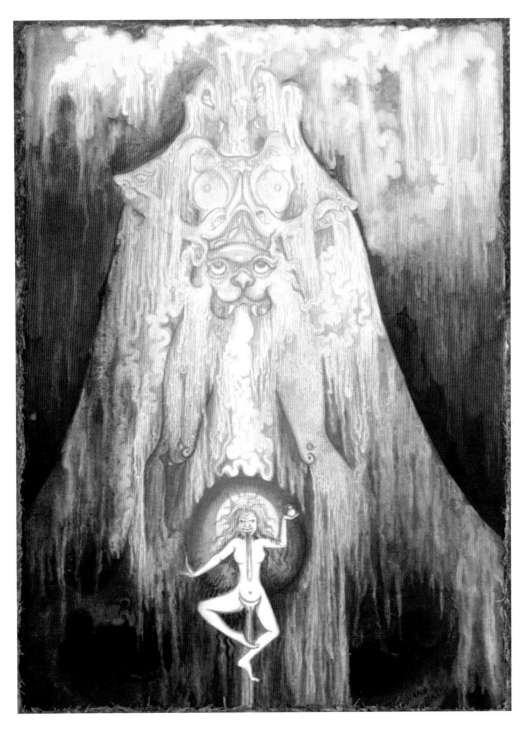

Plate 1. Gunung *(Mountain), 2000, acrylic on paper, 49 × 35 cm, by I Ketut Budiana.*

Plate 2. Kebakaran
(Conflagration), 1998,
acrylic on canvas,
103 × 232 cm, by
I Ketut Budiana.

Plate 3. Gunung Meletus
(Exploding Mountain),
1998, acrylic on canvas,
90 × 131 cm, by I Ketut
Budiana.

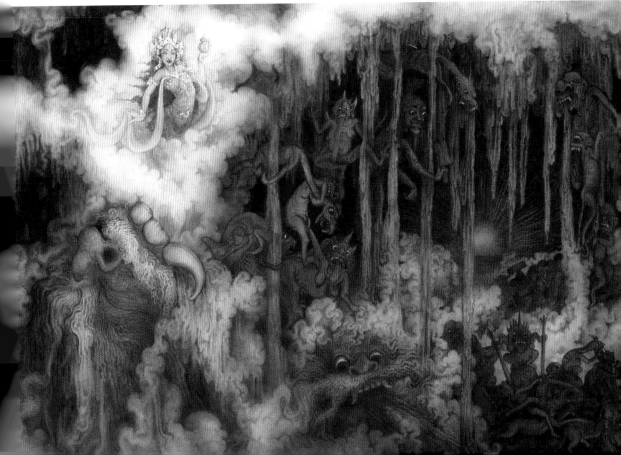

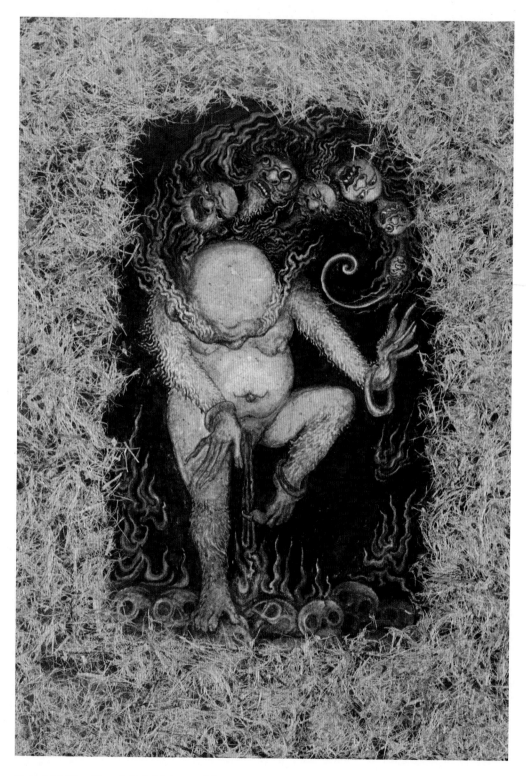

Plate 4. Melihat Bhumi *(Behold the World), 2000, acrylic on paper, 79 × 60 cm, by I Ketut Budiana.*

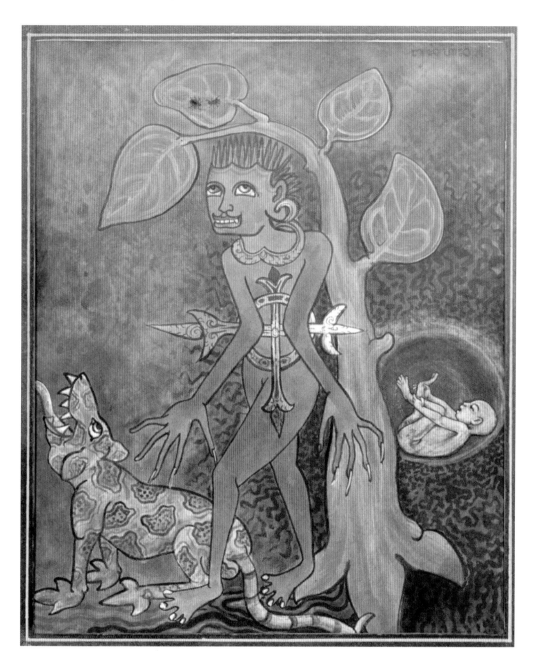

Plate 5. Bayi di
Kandung *(Baby in the
Womb)*, *1996, acrylic
on paper, 46 × 36 cm,
by I Ketut Budiana.*

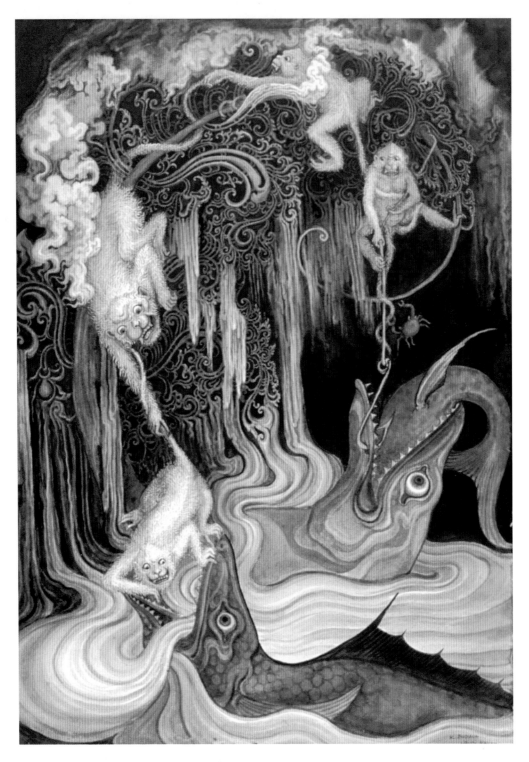

Plate 6. Memancing *(Fishing), 2000, acrylic on paper, 49 × 35 cm, by I Ketut Budiana.*

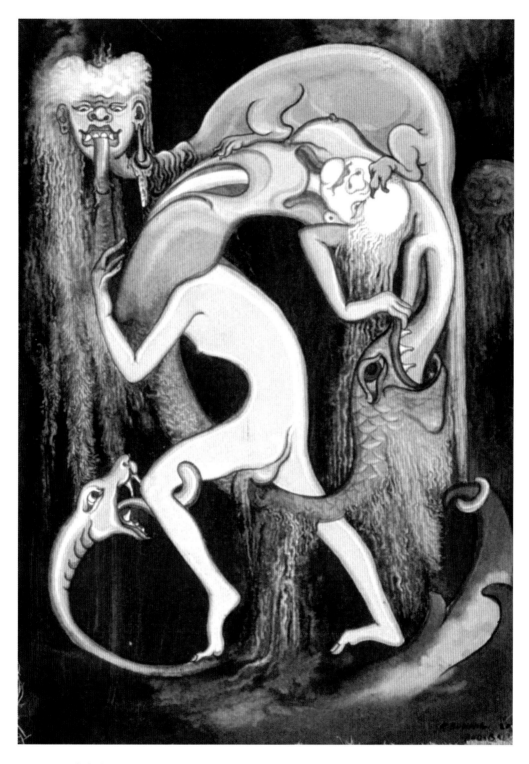

Plate 7. Kembali *(Return), 2000, acrylic on paper, 33 × 24 cm, by I Ketut Budiana.*

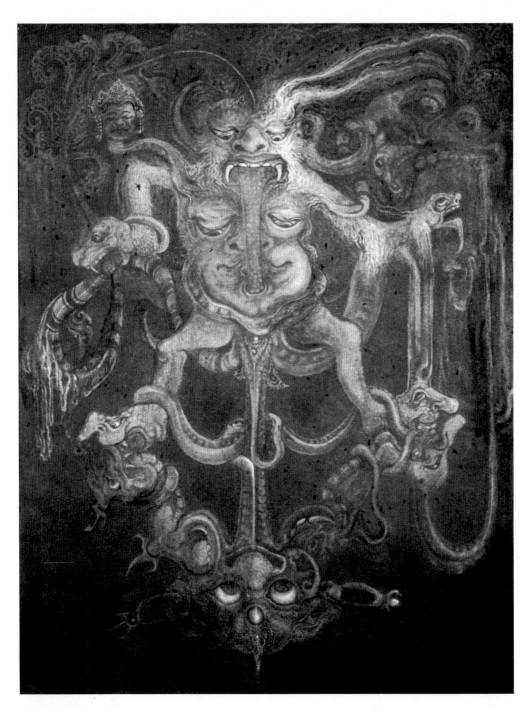

Plate 8. Merah Putih
(Red and White),
1998, acrylic on
canvas, 109 × 85 cm,
by I Ketut Budiana.

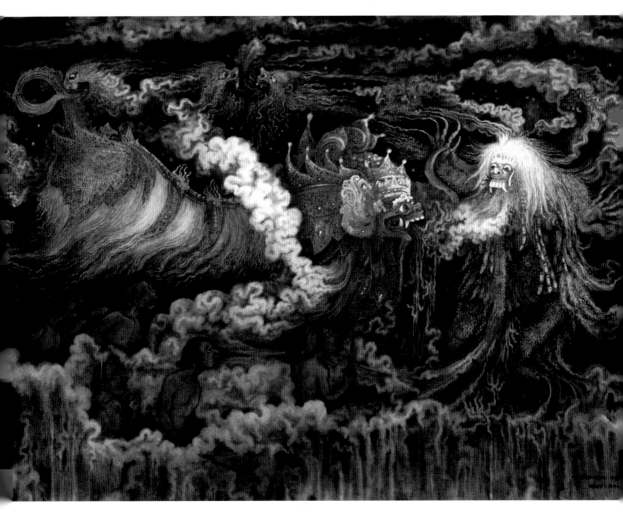

Plate 9. Barong dan
Rangda *(Barong
and Rangda), 1998,
acrylic on canvas,
100 × 139 cm, by
I Ketut Budiana.*

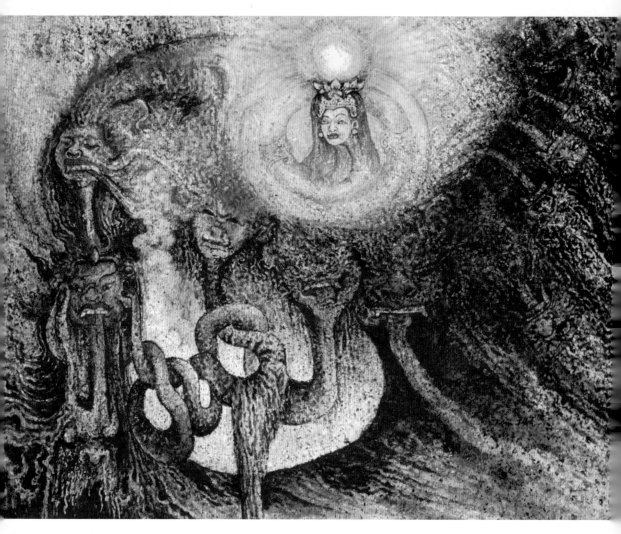

Plate 10. Mahkota
(Crown), 2000, acrylic
on paper, 60 × 80 cm,
by I Ketut Budiana.

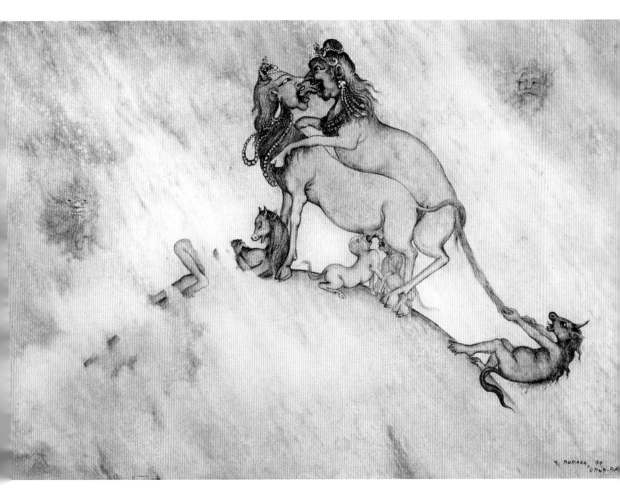

Plate 11. Kasih Sayang
(Love and Affection),
1999, acrylic on canvas,
95 × 140 cm, by I Ketut
Budiana.

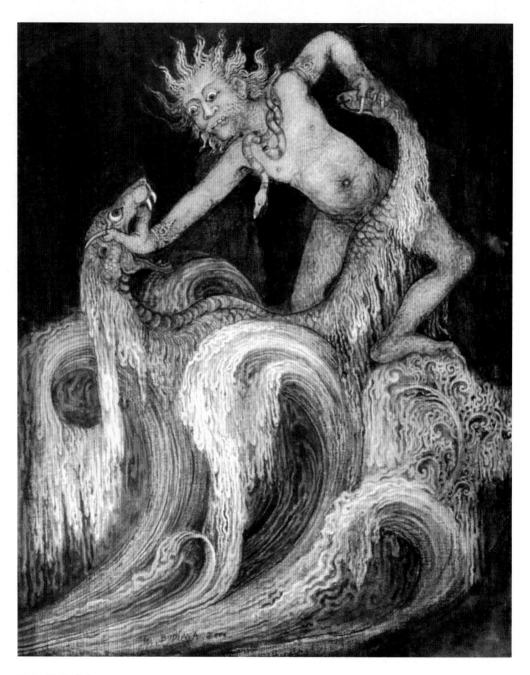

Plate 12. Ombak
(Waves), 1999, acrylic
on canvas, 51 × 41 cm,
by I Ketut Budiana.

in the hairy simian form of the central figure of *Melihat Bhumi,* Plate 4) and ultimately that of the terrible goddess Durga herself, the ultimate origin of disease, plagues, and human witchcraft.[32] According to Balinese belief, human witches desire to harm and kill their neighbors and family members out of jealousy, spite, greed, or ambition. If they invoke the goddess Durga and seek the aid of their *kanda empat,* they can obtain their desires. This course of action is to identify with the most destructive and terrible aspect of the Mother. It is to give full rein to the basest instincts of aggression and cruelty and sink to the murkiest depths of our animal nature.

The Web of Cruelty and the Devouring Witch

Budiana's reflections on human cruelty sometimes invoke humor as the means of throwing a shaft of light into the deep. *Memancing* (Fishing; Plate 6) shows monstrous creatures—part shark, part crocodile or dinosaur—emerging from a seething ocean while a group of playful, chattering monkeys attempts to snare them.[33] One of the monstrous fish is on the point of swallowing whole one of its own kind, but at this very moment is hooked in the lower jaw of its open, devouring mouth by a monkey hanging from the tree above. The tree from which the monkey hangs is in fact a *kakayonan*—a figure from the *wayang kulit* (shadow puppet theater) that represents trees or a forest and is always used to mark the beginning and end of a performance.[34] This suggests the idea, often quoted by Balinese, that life is like a shadow puppet play with humans the puppets. Evidently the monkeys are to be interpreted allegorically as a reflection on the human condition.

Budiana confirmed this interpretation, observing that monkeys do not in fact use each other as bait, but human beings do. He pointed out that the large monkey to the left of the painting was dangling a smaller one by the tail and lowering it into the very jaws of the sharklike monster. The smaller monkey seems blissfully unaware he is merely bait and about to be gobbled up. The ruthless greed of human beings, who blithely sacrifice their fellows to satisfy their own desires, is revealed as a relentless cycle. All four monkeys are bound together clinging to each other's tails. The one holding the fishing line that has just hooked a shark monster seems more likely to end up becoming the shark's dinner than vice versa. In any case, at the other end of the chain of monkeys one is about to disappear into the maw of another monster, inevitably pulling all his companions after him: a truly vicious circle of greed, ruthlessness, and cruelty. And yet it seems the monkeys only want to eat.

Budiana points to the ruthlessness that mere existence in the material world engenders. Just to survive we devour each other and in turn are devoured. But I do not think we should draw a simple moral conclusion from this. Rather Budiana is pointing to what Philip Rawson cites as a key theme in Hindu and Buddhist Tantric thought: "the web of cruelty which binds life to life" that the seeker after truth must learn to recognize as "essential to creation, essential to bliss," and an integral part of "the purpose of the Great Whole."[35]

Another horrific cycle of devouring mouths and swallowed bodies is the subject of *Kembali* (Return; Plate 7). The return in this case is the reversion, on death, of the material constituents of the physical body, the *panca maha bhuta,* to their origin. The central white figure represents the corpse beginning the process of dissolution, depicted here as being devoured

by greedy mouths with sharp fangs and great lolling, licking tongues. The corpse is being sucked up through an eviscerated female torso, the neck and head of which are in the process of being swallowed by a fishlike monster. Finally, the scaly body of the fish monster curls around to become the woman's torso that it is in the process of consuming. The fish monster is the grave that dissolves the dead body and, at the same time, the mother from whose womb we are born.[36] The fish form Budiana employs here recalls the fish-shaped coffin *(sudang)* used by ordinary Balinese for cremation *(ngaben)*.[37]

Participating in and linked to the chain of dissolution are ugly, menacing forms: below is a great snake with human tongue; above and crouching over the body like a tiger is a diabolical creature with an animal body and a human face at the end of a snakelike neck. Its lolling tongue of fire wraps around and becomes one with the corpse and the mother's body as its reptilian tail snakes down to grasp the fin or tail of the fish monster. A face, part-woman, part-tiger, leers from the darkness to one side and then merges with the tail of the sphinxlike beast. These grotesque creatures Budiana identified as *leyak*—the human witches who transform themselves into horrifying shapes and in this form feed on corpses in the graveyard. Here are conjured for us the horrors of the grave, the sickly, slimy colors of decay, the nauseating rending of flesh and dissolving of form that constitute the witches' feast. Yet these repulsive depths are necessary to the natural processes undergone by physical matter. It is only through decay and dissolution that the dead body can be returned to its original elements and thus be reconstituted as new life forms. The witch, in Budiana's view, is part of this natural process. The human witch participates in the power of the Terrible Mother and, regardless of human morality, this destructive power is inherent in the nature of creation.

The source of the Mother's power—the heat, the fire, *sakti*—is pure: it burns away dirt, corruption, and all that is bad. Fire is both destructive and beautiful, as we see in *Kebakaran* (Plate 2). The corruption of the graveyard is indeed terrifying; but since the *leyak* consume the flesh of corpses, they too are part of the process of purification of matter and substance, returning them back to original condition. The mystery is the transformation of decay into earth, the basis for new life. The seeker after spiritual truth must encounter the Mother in her most terrible aspect to experience fully the nature of her power. Budiana's paintings are spiritual exercises to this end. The aim, as I understand it, is to see through the horror to the beauty—of fire and dissolution.

This is not to be understood as an injunction to human beings to become witches. Budiana reveals that the witch, in seeking to develop this potential, becomes part of the cosmic processes of destruction and thus remains fixed within this horror of devouring and decay. The seeker after spiritual truth, by contrast, encounters the Terrible Mother in order to realize her power within the self and use it to burn away all dirt, filth, and corruption and thus reach a higher level of spiritual awareness.

Erotic Meetings

Physical bodies are created out of matter in the fiery womb of the Mother. But in order for new life to begin, first matter must be touched and met by spirit. The play of cosmic forces

from which our universe emerges is pictured by Budiana as the meeting of male and female creative principles: the union of god and goddess, sky and earth, father and mother, spirit and matter.[38] Every new entity is, according to the artist, the result of a meeting and fusion of two opposing forces, thus giving rise to a third and different entity. Human coupling and reproduction provide the visual and emotional template for the artist to represent these meetings. But this does not imply that human sexuality presents a model of divine creativity; rather it is but a tiny part of the dance of cosmic forces from which emerges our universe.[39] Budiana focuses on the forces of attraction that draw entities together and, as well, those that tear entities apart.

Merah Putih (Red and White; Plate 8) depicts a monstrous form astride an equally monstrous supine form. The dark, gloomy colors and the menacing shapes twisting together in some strange kind of union leave us in little doubt that this meeting is a dangerous one. The dominant figure, with its swelling belly, apelike face, the wispy white hair/fur of arms and face, the demonic faces that swirl up from the head, resembles the Mother/Witch of *Melihat Bhumi* (Plate 4). A closer look reveals that the red tongue, which always represents fire in Budiana's works, lolls out between white fangs to enter a second mouth in a second face that comprises the torso and belly of the monster. The stream of fire then issues out again from between the legs to merge with coiling snakelike forms below. As the hair of the monster flies out to become other grotesque forms, so too do its limbs, hands, and feet reach out to become independent creatures with fanged reptilian heads that are in the process of seizing and devouring other forms. This monster is a nightmare octopus, or giant amoeba, ever oozing its substance out in grasping tentacles, intent upon overcoming and engulfing all within its reach.

Beneath, submerged in the gloom, barely able to hold off the monster that stands astride it, is another grotesque form, its head inverted and arms reaching up to grasp the feet of its adversary. Yet if the posture of the two figures suggests battle, as hands and feet transform into faces that meet with open mouths and entwining tongues, the battle becomes an erotic encounter.[40] In the lower center of the painting, the phallic tongue of the lower figure rises to meet the tongue of flame issuing from the ogress, and there they coil around each other like amorous snakes. This is indeed a vision of horror. The artist, however, combines these disturbing forms in such a manner that they create a dynamic pattern which captivates the eye. Swirling shapes and limbs squirm before our eyes, transforming into tendrils of vines and the knotted branches of great trees. Step back a little from the painting, and the monstrous forms resolve themselves into an abstract pattern that pleases the eye. Move closer, and one is drawn again into a growing realization of its horror.

What horrific meeting is depicted here, and what is its significance? The title, *Merah Putih* (Red and White), indicates a meeting between the cosmic feminine principle and the cosmic male principle.[41] Red, fire, and the feminine principle are clearly dominant over white, water, and the male creative principle. The monstrous feminine figure strides or dances upon the supine body of the male and appears on the point of smothering and annihilating him. One is reminded here of Kali astride the dead body of her spouse Shiva in the graveyard.[42] The natural movement of the element fire, Budiana pointed out, is up; the natural movement of the element water is down. Here the positions are inverted: fire roars down and covers the water that is barely able to rise to meet it. Thus water is unable to neutralize

fire and control it, its natural function. The destructive feminine power rages unchecked, and the instinctual power of the Mother, of physical bodies and matter, dominates over spirit.[43]

Merah Putih points to our situation in the present age of Kali Yuga. In Balinese Hindu belief, the world has experienced four ages—and we are now in the fourth, which will end with the destruction of the world. During this time of Kali Yuga the proper world order is inverted. Budiana reveals the consequences of this inversion, as the insatiable greed of materiality spirals out of control. The significance of the face superimposed on the breasts and belly of the Terrible Mother is, I think, evident—in this time of Kali Yuga, instead of mind and spirit (located in the head), sensual desires and the lower instincts rule.

Barong dan Rangda (Barong and Rangda; Plate 9) depicts another meeting of cosmic dimensions. Here, however, the two protagonists are on a more equal footing. When I first asked the artist the title of this painting, he replied: "The Power of the Mother" *(Kekuatan Ibu)*. At the time I was puzzled by his response as the painting seems to be a fairly conventional representation of the famous Barong and Rangda dance/drama. To one side stands Barong, his huge body occupying two-thirds of the space, and confronting him is Rangda, great claws splayed out as if to attack. Both mouths of both monsters are open wide, and from these fanged orifices issue tongues meeting in a seething cloud of vapor. Almost hidden by the clouds of smoke that surround the two main figures are frightened childlike human figures crouching in the shadow of Barong and clutching daggers (kris). The Barong illustrated in Budiana's painting is the form known as Barong Ketket. There are other types of Barong, including tiger *(macan/mong)* Barong and pig *(bangkal)* Barong and the two giant figures, male and female, referred to as Barong Landung, but it is only Barong Ketket that is paired with Rangda in ritual performance. Throughout my discussion "Barong," unless otherwise specified, refers to Barong Ketket.[44]

The drama performance in which Barong encounters Rangda is usually explained by Western writers as a battle between good and evil in which no side really wins.[45] Barong represents the "good spirit" who saves the community from the "wicked witch" Rangda. During the confrontation, young men bearing kris storm out to try to stab Rangda but she turns their power back upon them and they go into trance, falling on their own daggers and trying to kill themselves. Ultimately the kris dancers are carried off, still in trance, and both Barong and Rangda are returned to the inner part of the temple. No evident resolution or victory has been reached. The priests bring the dancers out of trance and everyone goes home for the night.

Budiana's painting is a more or less realistic depiction of the performance in which the masked figures meet. But the seething clouds and fire that surround the figures, and the monstrous faces that loom out of the dark, suggest the otherworldly nature of the encounter. The meaning this confrontation holds for Budiana is very different from the conventional battle of good versus evil. Having now examined at length the symbolic elements Budiana employs in his works, it is not too difficult to identify the figure of Rangda as the Terrible Mother—a figure we can trace back to the ogress in *Merah Putih,* to the Mother/Witch of *Melihat Bhumi,* and so on. The animal faces, the shaggy bodies, the huge claws, the great fanged mouths, the tongues of flame, are the same in all. When compared with the ogress of *Merah Putih,* the significance of Rangda's huge, lolling tongue, which reaches below her knees and

hangs between her legs, becomes obvious. The tongue represents the fire and blood from the vulva and womb—a statement made quite explicitly in the imagery of *Merah Putih,* where the tongue actually enters a second mouth and then streams out of the vulva. This huge red tongue has inescapable phallic significance, as well, although as a symbol of fire it is feminine. The Terrible Mother becomes the Phallic Mother, thus containing both male and female power.[46]

Just as a careful observation of the imagery of *Merah Putih* reveals not a battle but a union—a sexual coupling—we find in *Barong dan Rangda* that the two monsters merge at the point where the fire issuing from the mouth of Rangda meets the tongue/saliva of Barong, giving rise to a cloud of white vapor between them. This is another depiction of the mysterious marriage of fire and water. Barong, whose gilt and mica costume represents rain, descends from his element, sky, to meet on earth the fire of the Mother. The two figures are represented facing each other, Rangda's face a little above Barong, the tops of their heads level. Barong, however, is much larger than Rangda, and his huge body occupies twice as much space in the painting. Barong's aim is not to kill Rangda but to meet her power and bring it under control. As Budiana explained: when water meets fire, the two neutralize each other, so that the fire and water are transformed into vapor. This third entity, produced by the union of the two, symbolizes, according to Budiana, the creation of a new entity: the soul, or *atma.*

Budiana's painting reveals that the dance performance where Barong meets Rangda not only holds a much more complex meaning, but performs a much more significant ritual function, than an inconclusive struggle between the forces of good and evil. In Budiana's view, Barong is the cosmic male principle come to contain the Mother, whose destructive powers are out of control and destroying the world. By unifying with her, he neutralizes her fire and transforms it into creative energy. Thus when disease or misfortune plagues a community and human witches *(leyak),* the students of Rangda, are rife, a Balinese community stages a performance in which Barong is called upon to confront the Terrible Mother and thus return her to her positive aspect.

And the kris dancers, what is their significance? Budiana's representation of them as frightened children crouching to the side of their fighting/coupling parents is psychologically very compelling. The meeting of Barong and Rangda suggests what Freudians would call the "primal scene," and for small children this scene is often interpreted as large animals fighting.[47] From such a perspective, the young men who rush in with their daggers and attempt to stab the Witch/Mother act out forbidden oedipal desires for the mother—they always aim at the abdomen of Rangda, and the phallic significance of the kris is quite explicit in Balinese cultural understanding.[48] But this forbidden libido is turned back upon the self and transformed into self-destruction. For Budiana, the kris dancers are ourselves: the human offspring of the great parents. The kris dancers' thwarted attack on the Mother's body reveals the impossibility of denying or rejecting the power of the Mother because it is the origin of ourselves. Budiana shows us that to attack the Mother is to attack the self. Finally Barong intervenes, snapping his jaws over the entranced dancers and bringing them back to consciousness. Thus the masculine principle of spirit brings awareness. Whereas the realm of the Mother is pure instinctual power, that of the Father is mind and spirit. Both are essential to human life. If uncontrolled by the masculine principle, the feminine deteriorates

into pure destruction and death. If spirit fails to meet matter, it likewise is dead. Life is engendered when the two meet.[49]

From the perspective of mythology, Barong and Rangda can be understood as transformations of the high god Siwa and his wife, or Sakti, Uma, who in her terrible form becomes Durga.[50] In Barong's confrontation of Rangda, the Terrible Mother, Durga, is brought under control by Siwa, who assumes the form of Barong. Budiana, however, is not so concerned with the narrative plots of the myths as with conjuring images of the cosmic forces allegorized by these narratives. He explained that from his perspective Siwa, Uma, and Durga are but names to represent cosmic processes of creation and destruction. For the Western observer, however, the mythic narratives can help to clarify meanings encapsulated in the imagery, and we will return to them in more detail in the following chapter.

Another mystical marriage on the point of consummation is revealed in *Mahkota* (Crown; Plate 10). *"Mahkota"* refers to the diadem borne on the head of a woman with the body of a snake, the figure in the upper center of the painting. Evidently a goddess, with her gold crown and earrings and her long black hair, the woman has a face that is regal and stern, though beautiful. Her coiled serpent body is white in color and adorned with gold bangles or belts. Below her seethes an excremental mass of grotesque, leering faces, necks, bodies, and tongues twisting together to form (and forming themselves out of) a knot of slimy entrails at the bottom left of the painting. To the right are more demonic faces, mouths open, shaggy hair streaming behind them, pulled from the murky depths of blood and excrement up toward the goddess. The whole painting churns with a ferocious power spiraling inward and upward. The white power of the goddess explodes from below—coiling around to suck into its force field all the surrounding murky elements and drawing them upward as the goddess herself emerges on high, serene and radiating pure light.

The serpent goddess represents Kundalini. In Budiana's view, Kundalini is the power of the Mother in the human body.[51] Her dwelling place is between the organs of excretion and reproduction. If she can be awakened and made to rise up the channels of the body until she reaches the head, her power can be used to burn away all dirt, impurity, and sin. At this point, the mysterious marriage of fire and water can be consummated within the body of the seeker after spiritual truth as the feminine principle meets and unifies with the masculine principle of spirit. From this meeting is created, not a new physical person, but spiritual awareness and liberation as the soul *(atma)* is now purified and freed from all material attachment and defilement. The crown *(mahkota)* worn by Kundalini, which radiates pure light, represents this union and its fruit: liberation *(moksa)*.

Mahkota reveals that the seeker after spiritual truth must encounter within the self the lowest and most frightful aspects of the Mother in order to realize her power to draw together all the force and instinctual energy of the body and direct it toward spiritual ends. In this painting we see the hideous shapes of those instinctual desires—greed, lust, aggression—that are conjured by *leyak* and those who employ the power of the Mother to destructive ends. But by awakening Kundalini in the self, and controlling her ascent, these destructive forces can be transformed into a purifying process leading to spiritual realization and perfection. In Budiana's view, without Kundalini, without the instinctual energy of the physical body, without the power of the Mother, this aim of unification and the liberation of the soul cannot be achieved.

The Inherent Destructiveness of Love

Why the emphasis on the Terrible Mother rather than on the creative aspects of the feminine principle? We might well ponder this point as we view Budiana's works. And how does the beautiful Goddess become the hideous Ogress/Witch who devours us all? The paradoxical answer is: excessive love and attachment. The term in Balinese for love or attachment is *"tresna."* According to Budiana this implies a love or attachment that is unreasonably or abnormally strong.[52] In Indonesian, Budiana translates this as *"kasih sayang,"* which is the title of one of his paintings. At first glance, *Kasih Sayang* (Love and Affection; Plate 11) seems mischievous and humorous; yet at a closer look it becomes somehow disturbing, even repellent. It leads us to the important insight that excessive concern for material creations brings monstrous results.

The background color in this painting is unusual for Budiana: a shade of pale lavender blue that appears gay and lively at first and then takes on a sickly hue. The central figures, two equine or bovine creatures with human heads and their four offspring, are not known mythological creatures but purely the products of Budiana's imagination, though the whole scene somehow reminds us of the meeting depicted in *Barong dan Rangda* (Plate 9). Here also is the primal scene: two monstrous parents whose coupling is more suggestive of animal aggression than human eroticism. Budiana softens the ugliness of the scene with humor, an indication that here he is dealing with human beings. This picture depicts the human family—the model Balinese family of parents and four children, Wayan, Made, Nyoman, and Ketut. Here is the human mother, part-workhorse, part-milch cow, her body the site of sexual meeting and conception, while simultaneously giving suck from her cowlike udder to new offspring. The two older children, their swelling bellies proof of indulgent nurture, cling around the mother, one jealously pulling on the father's tail to separate him from the mother, presumably intent on replacing him. The faces of the coupling parents are turned toward each other, the noses touch, the mouths open, the tongues curl around one another as in *Merah Putih* (Plate 8) and *Barong dan Rangda* (Plate 9). Though the faces are still recognizably human, the expressions are fierce and bestial; the parents seem to be on the point of devouring each other. Their faces are filled with not love or affection but sheer lust. What kind of a family is this? Why is the painting titled "Love and Affection"? Might it not be better called "Lust and Greed"?

Also puzzling are the golden crowns, earrings, and necklaces worn by the mother and father. The bodies are a strange composite: animal, human, and something more suggested by these royal ornaments. In the Balinese view, human beings have a threefold nature—as we saw with regard to the beliefs concerning the *kanda empat,* the four spiritual siblings. These three potentials are expressed here.[53] Evidently these ugly parents have developed their animal potential to the detriment of their human and divine nature. Thus their bodies have become totally animal, their faces are distorted by lust, and even their golden crowns, representing their divine potential, are beginning to sprout small animal horns.[54] Their strange offspring have human bodies and animal heads. Human minds give way to animal bodies with the result that the children have human bodies controlled by animal minds. The transformations, at first glance humorous, begin to take on an ominous cast. But this painting is not simply about lust and greed; there is a deeper significance.

Erotic meetings in Budiana's paintings take place at many different levels and with different results. The union of god and goddess gives rise to the universe; the union of god and goddess in monstrous form gives rise to dangerous and destructive forces, the *bhuta kala*.[55] Human unions are in the middle, giving rise to beings who possess a threefold potential. Excessive attachment to the physical and sensual aspects of procreation and nurture draws human beings down into their animal natures so that human consciousness and intelligence are overwhelmed by animal instinct. Caught up in the relentless cycle of procreation, the human mother can degenerate into a kind of monstrous animal and give birth to monsters with horses' heads that lack all capacity for human thought, speech, and discrimination. Such is the human danger involved in excessive attachment—and in the mother's passionate concern to give birth to and care for many children. The more children she has, the more food she needs, and more and more material possessions; she becomes greedy for money to meet these ever-growing needs. She is jealous of what others possess and increasingly ambitious for her offspring; she will stoop to anything to get them what they need; she becomes fierce and aggressive in defense of them. She lusts for power, her greed takes control of her, she is becoming the witch; and in her raging desire for material power she will eventually devour her own offspring. Although the masculine principle, representing spirit, must be present to generate new life, this too can be sucked down into the vortex of materiality, reduced to sheer lust, serving only to engender low and bestial forms.

Even so, the golden diadems and royal jewels adorning the parental figures in *Kasih Sayang* remind us of their god potential and suggest that the erotic force of attraction drawing man and woman together is part of the divine cosmic play of the universe. The human-headed beasts are also mother and father, goddess and god. The grotesque faces peering out from surrounding clouds represent *banas,* the unseen forces of the natural world. The rounded shape that supports the family suggests once again the maternal belly swollen with new pregnancies, the ever fecund Mother Earth.

The witch, as we have seen, possesses power called *sakti,* which Budiana images as fire issuing from the witch's womb. *Sakti,* in his view, is inherently female. Yet men are more often referred to as *anak sakti*—persons possessing *sakti*—than are women.[56] When I asked Budiana about the relationship between *sakti* in this sense of magical power and Sakti as the feminine active aspect of god, he replied emphatically that they are one and the same. All power to act upon the material world originates from the Mother, who is inherently *sakti.* That men are able by ritual means to appropriate this power does not vitiate its source in the Goddess/Mother.

The human potential to obtain or use *sakti,* according to Budiana, lies in the *bhuta* level of *kanda empat,* the four mystical siblings. This is the basest level of desire: greed, lust, and aggression. Those who seek *sakti* must encounter the most terrible level of the Mother. Once obtained, the power can be used for purely selfish ends to inflict revenge or gain worldly power. The human witch, in using this power to attack neighbors and rivals by devouring them from inside, becomes the epitome of the most extreme cruelty and destructiveness of the Terrible Mother.

Budiana's paintings also reveal that the cruelty of the Terrible Mother is a necessary part of the cycle of life and death, of returning dead matter to its original source. The witch's cruelty is not inevitable, however, but results from a human choice to identify with our most

frightful potential. We have the capacity to realize the power of the Terrible Mother since this is inherent in our physical nature and bodies. But as human beings we also possess the awareness necessary to channel this fierce energy to higher ends.

A final paradox is exposed in Budiana's depiction of *Kasih Sayang*. Love and affection can be clinging and destructive—and not only human love, for it is nothing other than too great an attachment to material creations that causes the gentle Goddess to rage on earth as the Terrible Mother who devours her own creations. As love finds material form, so it eventually degenerates into terrifying forms.

The Heroic Struggle, Balance, and Dynamic Tension

The Balinese cosmos as revealed in Budiana's works is anything but a balanced ordering of supernatural beings. His paintings depict vortexes of creative and destructive energies ever meeting, merging, transforming, exploding, rending, engulfing, consuming, ever giving rise to new forms and new life, ever destroying them. Caught in the cosmic play of attraction and repulsion, human beings are but specks tossed on a great ocean. Yet still they possesses a heroic potential. In the last painting, *Ombak* (Waves; Plate 12), we confront a naked human figure wrestling with great serpents that rise out of a boiling sea. The white foam on the raging waves seethes into the form of the *kakayonan*—the figure from the shadow puppet theater *(wayang kulit)* that conventionally represents trees and forests and marks the beginning and end of the performance. As we saw with *Memancing* (Fishing; Plate 6), Budiana's use of this motif indicates that the scene is allegorical. Angela Hobart observes that the dancing movement of the *kakayonan* on stage signifies the "*panca-maha-buta,* the five great elements, air, wind, fire, water and earth, which are responsible for creation and form the essence of both the macrocosm and microcosm."[57] The ocean in *Ombak* is the phenomenal world that surrounds us and threatens to engulf and drown us. The waves, *ombak,* are the waves of desire that crash upon us, dragging us under.

Fearsome serpents emerge from the depths to seize the struggling central figure, who fights bravely despite his evident vulnerability. He is alone and naked. The lower part of his body is covered with hair, and his feet and hands have claws like an animal. He is using these claws, his animal strength, to defend himself against the serpents. The upper part of his body is human. His face is bearded and resolute, not bestial. He wears a snake necklace—the ornament of heroes like the famous Bima of the great epic, the *Mahabharata*. His hair fans out around his face like the rays of the sun, giving him a noble, godlike quality. He stands up out of the waves, dominant, and holding back the ravenous serpents, though ever in peril of losing his advantage and being dragged under by the terrifying powers that surround him.

This vulnerable but courageous figure is the human being confronted in life by waves of desire that will overpower, consume, and destroy him if he gives in. To survive he must constantly battle the negative aspect of desire. Yet his aim is not to kill or defeat or disperse the enemy but rather to gain control and use it—transforming animal desires into positive energy to achieve higher levels of spiritual development. His precarious balance is not stasis but a dynamic tension achieved through constant struggle—a dynamic that is powerfully depicted in this painting of pounding waves and roaring winds. For Budiana, human life is

a heroic endeavor: a battle to realize the higher spiritual potential of the self. The hero, of course, is the artist himself.

The Power of the Mother

Budiana's works reveal that the Goddess, in her many refractions, can take forms both beautiful and terrifying. She is the tender loving mother who gives birth to and nurtures all beings; she is the hideous ogress who devours and destroys all in her path. This dual aspect of the Goddess/Mother is central to knowing and understanding the nature of her power. Indeed in Budiana's works, as in Balinese religious art in general, monstrous figures of the divine mother predominate over the gentle and benign. The Mother is not only the origin of life; she is also the origin of death, and womb and tomb are often equated. In the womb, material elements are brought together to form a body that is the vehicle for a new life; in the tomb, the material body is decomposed to its original elements so that they may be used again to create new material entities. Life and death are part of a continuous cycle of transformations of physical substance into different forms.[58] This is the process referred to as "lebur" (in Indonesian, Balinese, and Old Javanese), meaning "destroyed, melted, dissolved." The essence of the word is the idea of returning something to its original, undifferentiated state.

Many of Budiana's works depict creative meetings from which life originates. Yet it would be wrong to see these works as simply erotic. Rather the force of erotic attraction between human beings is but part of the play of cosmic principles out of which all existence springs and, ultimately, is dissolved back. Budiana also explores the mystery of the correspondence between the body of the individual person and the structure of the material universe—between what the *lontar* texts call the *bhuwana alit* (the small world) and *bhuwana agung* (the great world). He shows that the transformations taking place in the universe also take place in the human body. The aim of spiritual practices is to guide these transformations toward ultimate unity of the individual soul *(atma)* with its divine source.

This spiritual aim is to be achieved, in Budiana's view, through approaching the Goddess, the origin and source of our material being. Offering worship to the Mother, participating in her power, realizing her inner nature and finding it within the self, encountering both her benign and horrific forms, constitute the path that ultimately leads to enlightenment. It is this mystery and journey that form the substance of Budiana's artistic oeuvre.

Budiana's vision has its own philosophical and artistic integrity. I have tried to do justice to this vision while at the same time indicating some of the many well-known elements of Balinese thought on which he draws. It is, I think, his emphasis on cosmic transformation and ambivalence—especially his emphasis on the power of the Mother—that may seem unusual to those familiar with Balinese culture. In the next chapter we will see how another Balinese artist, working in a very different style, explores the same thematic ground, though in a very different way.

Mythic Transformations of Desire

The Paintings of I Gusti Nyoman Mirdiana

I GUSTI NYOMAN MIRDIANA grew up in a household of famous artists where he constantly saw about him paintings dealing with mythological themes. His grandfather, Kompiang, the eldest of the family, was not an artist but worked in the fields to support the studies of his two younger brothers, Kobot and Barat, both to become famous artists. They specialized in the *wayang* style—a traditional mode of representation influenced by the puppets used for the shadow puppet theater, the *wayang kulit,* and devoted to mythological subjects.[1] Mirdiana's happiest memories of childhood are of being taken by his grandfather to watch *wayang kulit* performances. The thrilling myths and stories of heroes and gods and goddesses enchanted the child, who loved to be told the tales as bedtime stories. His grandfather, Mirdiana recalls, knew all the stories and songs and never tired of telling them, and he would walk miles, carrying his small grandson on his back, to attend performances in other villages. Mirdiana did not paint mythological subjects, however, until he came to work for me. At high school he studied art, but not the traditional styles. To help pay for his school fees, he also painted in the "flora fauna" style made popular in

his community of Pengosekan by the well-known artist Dewa Nyoman Batuan, a maternal nephew of Kobot and Barat. At the suggestion of Batuan, his senior kinsman, Mirdiana came to work as my research assistant in October 1996. In July the following year, during convalescence from a motorbike accident, he began for the first time to paint mythological subjects, beginning with a dancing Gana (Ganesha).

As my research assistant, Mirdiana was exposed to many different view points concerning Balinese mythology and religion. Together we interviewed many different people, and we sought out, translated, and studied textual material as well. In the process we came across much information that is esoteric in nature and not available generally.[2] Although our quest was primarily shaped by my needs as a foreign researcher, Mirdiana was learning too—indeed far more than I was. His understanding easily outstripped mine since he possessed a matrix of cultural knowledge in which to place all the new information he was discovering, whereas I was struggling to acquire the basics. What he distilled from these encounters with texts and learned Balinese scholars he put into his paintings, and he was able to draw upon all that he had learned as a child simply by being around traditional artists, observing their techniques, and listening to their stories.

Over the next several months Mirdiana continued painting mythological subjects. Impressed by his work, I arranged for some of his paintings to be shown along with those of his uncle, Dewa Nyoman Batuan, at an exhibition of Balinese art held at La Trobe University in March 1999.[3] When he returned to Bali, Mirdiana began a new series of paintings, further refining his style, that constitutes the twelve works discussed here. They were produced between April 1999 and September 2001. These paintings were not commissioned by me, nor were they directly influenced by my requests or instructions, but the subject matter did arise out of the work the artist was doing for me at the time.

Through our research, the artist was learning a deeper significance to stories he had known since childhood. He was also hearing for the first time more esoteric myths. It should be stressed that Mirdiana's interpretations of the myths are in no sense to be regarded as the authoritative account. His is but one of numerous possible interpretations. Nor can the literary sources I quote later be regarded as the authorized versions. Scholars of Balinese culture—and of course Balinese themselves—know many variants. Balinese stressed to me that every version carries its own veracity.[4] This is not simply Balinese politeness that avoids confrontation and disputation, I think, but a deep recognition of the many different levels of understanding that may be drawn upon in any myth or symbolic form. Each person responds according to their age, education, character, experience in life, intelligence, and, most important for Balinese, their level of spiritual development. In the following discussion I am not concerned with "correct" versions but with the varied richness of meaning to be discovered in mythic narratives.

Mythic Heroes and the Material World

Western artists trawl the depths of their individuality to draw up imagery with deep emotional significance. Balinese artists—and others like them who belong to cultures possessing rich mythological resources—find in them enduring themes and images reflecting

personal meaning. The anthropologist Ganath Obeyesekere has referred to this inner process as the "subjectification" of cultural symbols.[5] Balinese Hinduism certainly provides an extraordinarily rich mythology in which to discover even the most secret murmurs of the soul. As a young man, only just putting adolescence behind him, Mirdiana is not surprisingly attracted to hero myths and to painting mythic narratives in heroic mode. Scholars influenced by Jungian depth psychology have argued that such myths reflect the inner psychological development of every youth as he struggles to free himself from infantile attachments.[6] Undoubtedly personal and unconscious conflicts and motivations influence the artist's themes. Mirdiana confesses: "All these paintings are influenced by myself. I pick some idea to fit myself. My experience influences me to choose from the myths what is suitable for me personally."[7] It is not, however, the task of this book to deal with the individual psychology of the artist beyond pointing to the rich resonance of myth with the self.

The story of Sutasoma is well known in Bali and provides a conventional subject for Balinese artists.[8] Describing the adventures of the Buddha on earth, it is based on a Mahayana Buddhist epic poem composed in Central Java in the fourteenth century.[9] Mirdiana's familiarity with these stories, like that of most Balinese artists, derives from oral sources, not textual ones; he was unaware of the complete story, or the mystical teachings concerning Siwa and the Buddha, contained in the literary version.[10] He has painted the two Sutasoma episodes known to him. The first, *Sutasoma and the Tiger* (Plate 13), depicts an encounter in the forest with a starving tigress so desperate for food that she is about to devour her own cub. Moved by her desperate plight, Sutasoma offers his own body as a substitute.

For Mirdiana, this apparently simple tale holds a complex significance. The tigress, the artist explained, represents *bhuta* forces or elements. Conventionally *"bhuta"* is translated in English as "demon" or "evil spirit" but, as we have seen with respect to Budiana's work, such a rendition is misleading. Mirdiana commented: "The tiger represents a kind of *bhuta*. *Bhuta* characteristics are controlling the tiger; that is why she wants to eat her baby. The tiger is not wrong, but because she has nothing at all to eat, just her baby, she must eat it to live." The tigress, compelled by her powerful urge for survival, cannot help acting as she does. If she is to survive she must eat, and as an animal she is driven by her animal nature. In this context, it is clear that *"bhuta"* refers to those instinctual energies and patterns that determine animal behavior and thus shape the natural world.

Humans too are shaped by these instinctual forces, of course, but unlike animals we possess higher potentials. Mirdiana explained: "In every person there is a *bhuta* character that is like an animal, and also a god character, or somewhere between human and god. That is Sutasoma." Human beings can control their instinctual desires and passions—their *bhuta* character—in order to realize a higher potential and act in accord with the law of *dharma* (moral order). The tigress devouring her own offspring offends against the moral order, but not against nature. Sutasoma represents *dharma* and throws himself down as a sacrifice to remove the dreadful necessity faced by the tigress. Mirdiana continued:

> If the tiger can be controlled by Sutasoma, then the tiger becomes a
> protector. And inside yourself, this [your *bhuta* characteristics] becomes
> protection to support you. Then it becomes a positive not a negative
> thing. Yes, the tiger represents a part of the self; it can be a danger to the

self or protect it. It is the same as the *panca maha bhuta* [the five physi-
cal elements that constitute all physical matter] in ourselves. This is the
source of greed and desire. But it is important to use the god aspect to con-
trol the self.

The notion of sacrifice is important. But the sacrifice Mirdiana has in mind is not so much
a sacrifice of the self, out of compassion for all sentient beings, as a Buddhist view would
suggest. Rather he emphasizes the need to control, via sacrifice, dangerous forces within the
self and in the natural world we inhabit:

> The deep meaning of my painting is that if there are *bhuta* forces and we
> give sacrifice with love, then those forces will take care of us, like the tiger
> will take care of the baby once her hunger is satisfied. Because of this,
> *bhuta* can be controlled through *dharma* [moral order]. But if that *bhuta*
> energy is not controlled, then maybe it will devour everybody.

Here Mirdiana expresses the idea that offerings or sacrifices made to the dangerous forces
in the world (and in the self) are not intended to drive out these forces but to transform them.
The tigress is a perfect symbol: she is fierce and destructive to the point of devouring her
own young; yet if she is given her due, she will guard and protect them. Thus compassion
in the form of giving (offering sacrifices) to others—including all the dangerous forces in the
natural world—transforms these potentially destructive forces into beneficent ones. Western
scholars writing about Balinese religion have conventionally interpreted sacrifices to the
bhuta kala either as exorcisms or as bribes to placate them and send them on their way.[11] Mir-
diana's comments indicate the role of sacrifice in bringing about transformations of unseen
powers from negative to positive.

Unlike some Balinese artists, Mirdiana does not present Sutasoma as a passive victim.
This Sutasoma is a hero; his stance suggests admonition and an active role in subduing the
tiger. As we know from Budiana's works, the tiger represents the most powerful and fero-
cious of all animals and hence is a symbol of the earth and the monstrous Devouring Mother.
The teeth and claws of the tigress about to rend her own cub remind us of the terrible god-
dess Durga and the *leyak* who seek to acquire her powers. Human witches kill and devour
their own offspring; but unlike the tigress, they are not compelled to act in this way. The
tigress is starving; her animal instinct to survive is stronger than even her maternal feelings.
She simply obeys a cruel necessity imposed on her. This is what Mirdiana calls her "*bhuta*
character."

Sutasoma is juxtaposed against the fierce beast. His foot just touches the earth; his
head, shoulder, and hands point to the heavens from whence he has come; his angelic face,
soft white body, and floating garments convey sweetness and purity. The painting's move-
ment rises from below: from the crouching energy of the tigress and the toiling roots under
the earth that surround her, moving up to the tree and flowers that emerge from the dark
earth, to the butterflies floating in the pure air. The painting evokes the beauty of Sutasoma's
selfless compassion. Nature's potential for ever-increasing bestiality and destructiveness has
been halted and reoriented by his action. The energy is now directed upward. Animal cruelty

is transformed by compassion. Even the tigress becomes softened so that her hold upon her cub begins to look more playful than savage. The Balinese audience, however, knows the story and recognizes that the tigress is on the point of killing her own baby. Mirdiana's painting emphasizes the transformation of that bestial horror through an act of sacrifice.

Another well-known episode of the Sutasoma story often represented by Balinese artists is Sutasoma's encounter with a huge serpent *(naga)* that tries to devour him but is eventually transformed into his protector. Balinese often refer to Sutasoma as the God of Truth, and the encounter with the *naga* is interpreted as truth overcoming falsehood and evil. Like most Balinese, Mirdiana's familiarity with this story is once again based on oral tradition, not written texts. The symbolism of the great snake wrapped around the body of Sutasoma seems self-evident to a Western observer. Mirdiana's comments on *Sutasoma and the Naga* (Plate 14), however, are not what we might expect.

The serpent is not a symbol of evil in Mirdiana's view. Quite the contrary, it represents for him the source of all material things, the riches of the earth, the world around us:

> This *naga*, we believe in Bali, is the symbol of wealth. It is called Anantabhoga—wealth—all kinds of material things.[12] Riches. . . . The *naga* represents material things, and it wants to eat Sutasoma. But Sutasoma doesn't want to see material things controlling the world, so he offers himself as a sacrifice to the *naga*. The *naga* wanted to eat Sutasoma, but it couldn't digest him. When the *naga* tried to spit him out, he got stuck in its throat. The *naga* was really suffering. At last it became so weak that it begged forgiveness of Sutasoma. Then [as in the story of the tiger] Sutasoma brought the *naga* under control, and it became his protector and guardian.

I asked Mirdiana why there are bats at the top of the painting, above Sutasoma's head, and what is streaming from the mouth of the *naga*. He replied:

> The bats show that the *naga* is in a cave and this is at night. Because people driven by material desires are like blind people, they can't see anything. In the dark we need Sutasoma to bring light. Here Sutasoma represents honesty *(jujuran)* and patience *(kesabaran)*. Coming out of the *naga's* mouth is fire—very, very hot flames—and not only hot but this is poison *(racun)* too. . . . If people are touched by greed for material things, I think it will change those people. It is like poison and each person finds this poison enter their blood. It is a contagion. . . . That is the *naga's* poison!

The significance of the snake as a male phallic symbol is so prominent in Western thinking that it is easy to overlook the fact that this huge *naga*—in Mirdiana's view—is female. (I should have written "she" rather than "it," but this would read oddly in English.) Is the *naga* also the Mother that Budiana talks about? Mirdiana replied: "Yes! She is the Mother—this is Anantabhoga. Female! The one who gives food, who gives, creates every material thing that exists in the world."

We can now understand that this *naga* is in no sense simply "evil" or entirely negative, although she spits out dangerous poison. She is the source of our basic sustenance, the nurturing Mother, the source of all food, wealth, and riches.[13] It is evident now why she is garlanded with rich jewels and gold. We cannot live on this earth without food and material things, but the danger the Mother holds is that of too great an attachment to this materiality. Mirdiana sees her wrapping around us in a loving embrace, but as she does so she gradually transforms into a great serpent crushing her prey:

> At the time I painted this I felt that a lot of material things were controlling the world. Wrapping around people. . . . People don't actually set out with the aim of acquiring material riches, but they get caught by them. The situation is like that. They do not directly seek these material things, but before they know it they are already controlled by them. Yet we must have material things to exist.

When asked why the *naga* was green in color, Mirdiana replied: "I think I picked this green because green is a reflection of the natural world." I persisted: "Haven't you told me that the most poisonous and dangerous snakes in Bali are the green ones?" "Yes," he agreed, "they are the most poisonous." Thus the very coloring of the serpent reflects her duality.

As a whole, Mirdiana's painting is rich, sumptuous, and heavy. In the center Sutasoma dances lightly in the monster's gaping maw: his smooth, pale gold skin, light blue garments, and simple, graceful form contrast against the decadent luxury of background detail and color and the jeweled, scaly coils that slide around him. Sutasoma is clearly the victor in this battle with the Devouring Mother, who once tamed will become his protector. The monster is not slain but is transformed by sacrifice into a positive force, which, after all, is her original nature: Anantabhoga consists of two words, "endless, abundant" and "sensual/material pleasures."[14] All these conflicting and paradoxical elements are brought together in the painting to form a visual image of arresting beauty.

The imagery selected by Mirdiana and Budiana to express their insights could hardly be more different. Yet the theme of excessive attachment, and the poison contained in the Mother's gifts, is the same. Budiana employs esoteric symbols drawn from traditional manuals of talismanic drawings—and his unique imaginative variations on them—compelling our attention with their strangeness. Mirdiana, drawing upon myth, uses more conventional symbols. The danger here is of reading his imagery in a stereotypical manner; if we pay careful attention to its nuances, however, Mirdiana's work yields new insights into the complexity of conventional forms.

The heroic theme is continued in *Gana and Detya* (Plate 15), which depicts the elephant-headed god Gana (Ganesa) in the act of killing the powerful demon Detya. Initially perhaps the most striking thing about this painting is the difficulty in distinguishing between the two opponents. Their heavy bodies and limbs swirl as a centripetal force draws them together as one. The god, Gana, and the demon, Detya, form almost a mirror image of each other. They seem to be twins: brawny arms and legs, hefty bellies, and grotesque heads. Both wear loincloths of *poleng* (checked black and white) fabric, usually worn by fierce or demonic deities, and both bear royal ornaments and crowns. Their weight keeps them balanced in a fierce

dynamic tension. Closer examination reveals that the elephant-headed Gana, with his four flailing arms, is in the ascendant; he is bearing down on the two-armed demon, driving his own broken tusk into his victim's belly.

Gana is the son of the high god Siwa and his consort Uma. He has the head of an elephant, the body of a human being, but is the offspring of gods. Mirdiana explained that symbolically Gana combines in his person the three worlds of Balinese cosmology: animal *(bhur)*, human *(buwah)*, and divine *(swah)*. He possesses special abilities such as being able to see into the past and foretell the future. His role as protector and demon queller is celebrated in this painting. According to Mirdiana, whose version of the story is once again based on oral tradition, not literary sources, Detya was a giant so clever and so filled with *sakti* that he overcame all in his path. He soon conquered the animal and human worlds and aimed to overthrow the gods themselves. It was known to the gods that nothing could defeat the giant except a being that combined the strength, energy, and intelligence of the three worlds, animal, human, and divine. The task of dispatching the demon thus fell to Gana, but Siwa advised his son that before he could vanquish Detya he would have to kill himself. Gana broke off his own right tusk and, brandishing it like a spear, fell upon the demon and dealt him a fatal blow. Thus heaven itself was saved from destruction by Gana.[15]

Mirdiana observed that the myth of Gana and Detya was a reflection of the dangers threatening our world in this dark age of Kali Yuga. If some clever, greedy, and ruthless creature succeeded in taking over the animal and human realms and then defeated the gods, all would be destroyed. If our universe is to function, it must be controlled by god-power. Gana, who participates in all three worlds, reveals the connection and interdependence between the three. What is really at issue here, according to the artist, is gaining control over the animal part of the self:

> How can Detya be controlled? This is like controlling yourself. This is like Gana breaking his tusk. He wants to kill Detya, but Siwa says to him, "First you must kill yourself." What is meant by this? This means he must first control the power in himself. So he just broke his own tusk to use as a weapon to kill Detya. . . . Breaking the tusk represents killing the demon.
>
> In Bali we have *masangih* (tooth filing). This also is to control the animal part of the self. So if I cut your tooth or tusk, this refers to your greedy, energetic, and aggressive part. We can control that aspect of the self. After tooth filing we are not so greedy or aggressive. So how to control the world? If you can't control yourself, how can you control the world? This is the deep meaning of why Gana must break his tusk to destroy Detya.[16]

Gana is actually defeating the inferior aspect of himself. If we look again at the two figures, we can now understand why they are depicted as twins or as two swirling halves of a central unity. We can also appreciate their subtle differences. Detya's body is covered with thick hair; his hands and feet bear animal talons; his teeth are fangs and his face coarsely bestial. Gana's body, by contrast, is smooth and hairless; his feet and hands are human; although he

has the head of an elephant, his face is intelligent and refined; his four arms suggest his greater capacity and ability.

A very different mythological figure, the mighty warrior Bima, second of the five Pandawa brothers and famous hero of the great epic tale *The Mahabharata*, is another source of inspiration for Mirdiana, as for many Balinese artists. Perhaps the best-known story of Bima is how he braves hell itself in order to rescue the souls of his parents and install them in heaven. Another well-known tale tells of Bima being sent by his teacher, Drona, to find the water of immortality. Mirdiana has selected the latter account. So that we can appreciate the way in which the artist draws his own meaning from the story, I will begin with a summary from an independent source. Often referred to as *Nawaruci* or *Bima Suci*, it is a popular plot for *wayang kulit* performances.[17] The following account originates from a *dalang*, or puppeteer, quoted by Angela Hobart in her study of the Balinese shadow puppet theater.[18] It represents the kind of story Mirdiana learned as a child watching *wayang kulit* performances. Ordered by his teacher, the Brahmana priest Drona, to find the elixir of immortality, Bima encounters many adventures before learning that the treasure he seeks is to be found in the middle of the sea:

> When Bima arrived at the shore of the ocean where the holy water was to be found, large snakes approached him intending to eat him, but he cut off their heads. As he continued into the waters he met his death. The heavens became dark and swayed in sorrow for the brave prince. The supreme god, Tunggal, had compassion on Bima, whom he dearly loved because of his honesty and brought him back to life. He then told Bima that if he wished to obtain the holy water he would have to enter his (the god's) body as it was kept there. Bima was amazed as in front of him he saw a tiny figure who was a replica of himself.
>
> The prince first asked the god several questions. Why did man have to die? Why did man dream? What was the purest thing in the world? The god Tunggal replied as follows. Death takes place at a certain stage in man's life when the gods have left the body. When man dreams his soul leaves the body and wanders around. Nothing on earth is perfect. Apart from the god of love, Semara, all the gods are still impure. Even the flowers used for worshipping are not completely pure.
>
> Having answered Bima's questions, Tunggal spread apart his legs and told the prince to enter his body through the phallus. When Bima entered he found himself in heaven and the holy water was stored there in a gold casket in a five-tiered shrine. He took the casket and returned home.[19]

Mirdiana's painting *Bima* (Plate 16) shows the hero struggling with the two serpents *(naga)* as he is entering the ocean. Above Bima, to the left of his head, is the high god Tunggal, or Acintya, in a form conventionally represented in Balinese art. Bima himself is burly and bearded, wearing the headdress, the *poleng* (black and white checked) loincloth, and the snake necklace that are his conventional symbols.[20] Evidently the imagery of the painting follows the story of the *wayang kulit* performance just quoted. Yet Mirdiana emphasizes

somewhat different elements and draws a deep significance that is not disclosed in the pre-ceding account. The artist emphasizes three things about Bima: his honesty, his devotion, and his stupidity:

> Bima is very strong but he has a simple mind. If some clever person asks him to do something he just follows what they ask without thinking first! Some people are like that. Very strong but not really clever. Honest, yes honest, but they do not think before they act. Bima is not aware what he is doing, whether it is good or not, true or not. His teacher, Drona, asked him to get *tirta amerta* [the elixir of immortality]. But Drona him-self doesn't know where to find *tirta amerta*. But because Bima is honest and wants to help and do what the teacher asks, he is a good student. Later he finds *tirta amerta*. The meaning is that if you really really want to learn something, even if your teacher doesn't know it, you may find it. Maybe you can achieve even more than your teacher . . . that comes from hard work and *bakti* (devotion).

Bima is a prince and a mighty warrior, yet Mirdiana presents him as a burly peasant with a broad honest face, snub nose, and vacant smile. His expression is not fierce, it is amiable and kind, even as he is in the act of dispatching the two *naga*. Undoubtedly the artist draws a message for himself from Bima's exploits, but this is no self-portrait. Physically Mirdiana is no more this coarse yokel than he is the angelic Sutasoma of girlish cheeks and soft white skin. Yet both might be understood as aspects of the artist's inner self. Given his youth, it is only natural that Mirdiana sometimes feels himself to be stupid and unsophisticated, and it is not surprising that Bima's stupidity might appeal to him as much as his strength and honesty.

Although we might easily assume that the artist is concerned with life's struggles in gen-eral, he is thinking here of spiritual aims and interprets Bima's discovery of *tirta amerta* as symbolizing the attainment of spiritual awareness:

> Where did Bima find *tirta amerta*? Inside himself. It was inside himself. If you know yourself you find life. When he fell unconscious in the ocean, in a kind of dream, he entered the ear of Acintya. And there he found *tirta amerta*. Life *(kehidupan)*. If you work hard and continue to try, you will find what you want inside you. *Tirta amerta* is not a kind of *tirta* (holy water). What is the meaning of *tirta amerta*? *"Tirta"* means water; *"a"* means not; *"merta"* means to die. So this means that water which is the cause of us not dying. This you will find inside yourself. Because inside yourself you have fire and water—everything, all the elements.[21]

At this point in the discussion it became clear that Mirdiana was pointing not simply to self-knowledge and self-awareness in general but to esoteric knowledge—to the mystic union of fire and water depicted by Budiana. Mirdiana agreed: "If we study this [the myth] deeply, it is about lessons concerning *kemoksaan* [liberation from the cycle of births and

deaths]." Mirdiana's version of the story and the version summarized by Hobart both empha-
size the obtaining of spiritual or esoteric knowledge. Why does man have to die? What is the
nature of dreaming? What is the purest thing in the world? The three questions that Bima poses
to Tunggal (Acintya) in Hobart's version clearly touch on some of the highest mysteries of
the human soul. Although Mirdiana made no mention of these questions, they might be un-
derstood generally to refer to esoteric knowledge concerning the self and its spiritual goals.[22]

The bare story of *Nawaruci* leaves the uninformed with the impression that *tirta amerta*
is simply a magical potion to confer immortality. Yet the deeper interpretation given by
Mirdiana is consistent with Angela Hobart's narrative and indeed makes sense of otherwise
puzzling elements of it. For the peasant and the child watching the *wayang* puppet theater,
Nawaruci is an enthralling tale of heroic adventures in a magical realm. For more educated
members of the audience, it holds a moral lesson that might be emphasized, for example, in
the ethical views promoted by the Parisada Hindu Dharma: believe in yourself and strive
with a brave heart and firm mind to achieve your goals. For the seeker after spiritual under-
standing, yet other treasures of mystical knowledge lie hidden there. In this instance, Mir-
diana is interpreting the stories he heard in his childhood in the light of new knowledge he
was acquiring—both through our discussions with Brahmana priests and other literati and
through our reading of texts.

If we return to Budiana's *Ombak* (Plate 12), we find that the central figure wrestling with
the two *naga* is evidently Bima. Not only does he wear the distinctive necklace of a coiled
snake, but the hand grasping the *naga* is in *danu-mudra* (the fingers clenched and the long
nail of the thumb used as a stabbing weapon)—two features symbolic of Bima.[23] But there
is no Tunggal or Acintya in Budiana's painting, just waves and snakes. And although the
stance is the same as in Mirdiana's painting, this Bima is very different. He is naked, with a
hairy lower body, while the face is refined and the tendrils of hair suggest the rays of the
sun. This figure represents the self cast in heroic mode, rather than the story of Bima. For
Budiana, the heroic journey is a riding of the waves of desire created by life. Mirdiana, at a
different stage in life, is more concerned with obtaining knowledge and succeeding on one's
own. Yet both artists are concerned with inner heroic journeys. The material world repre-
sents the Mother; the hero's task is to use the power derived from her, transforming it in the
process. Thus we can see both artists pointing to deeper levels of mystical meaning contained
in conventional tales and myths.

Exploring the Myths of Siwa and Uma

Mirdiana's interest in esoteric teachings and his growing knowledge of such matters are indi-
cated in his treatment of familiar Balinese topics such as the stories of Sutasoma, Gana, and
Bima. These tales of heroic exploits he learned and loved as a child. As he grew up, he saw
the same stories illustrated in the paintings of the many artists who came to work and study
with his grandfather's younger brothers, Kobot and Barat. He heard the stories they told and
listened to their interpretations of the myths. By the time he came to work for me, therefore,
he had gained an extensive knowledge of these oral traditions, which he had absorbed sim-
ply as part of growing up in a household of artists. During our work together he was exposed

to other influences—verbal explanations from Brahmana priests and other knowledgeable persons, as well as textual versions of myths. This material expanded his understanding of the stories he knew and introduced him to others that he had not heard before. The paintings discussed in the previous section were based on the knowledge he had derived from oral tradition and performance. We now turn to works based on myths that he encountered during his work as my research assistant.

I first came across these myths concerning the high god Siwa and his consort, Uma, through conversations with Brahmana scholars and priests *(pedanda).*[24] Although these myths seemed important, I could find only brief references to them in the anthropological literature, so I began to look for their literary sources. I discovered some key leads in C. Hooykaas' work—especially in the text of what he calls the *Litany of the Resi Bhujangga,* which tells how the world was created by Siwa and Uma. But I could get no clear sense of how widely known this myth was or what place it might have in present Balinese thinking. When I turned to my Brahmana informants, they suggested various *lontar* texts. At the Gedong Kirtya *lontar* library, I found these were mostly unpublished *lontar* texts of a mystical and philosophical nature—a type of text usually categorized as *tutur.* With the help of a translator, an expert in Kawi from Udayana University who rendered the material into Indonesian for me, I thought I would see what I could make of them. Throughout the process, Mirdiana assisted me by interpreting during interviews and helping with the written Indonesian translations.[25]

I soon discovered that this textual material provided a useful basis on which to ask new questions of my *pedanda* informants. Perhaps pleased by my efforts to read the texts (however clumsy in the eyes of the professional philologist), *pedanda* and others began to respond to my new questions with more precise and fuller answers. Furthermore, I began to reread the published texts, in particular Hooykaas' extensive opus, with new eyes. Elsewhere I have referred to my method as an "anthropological reading of the texts."[26] This is not a means of producing authoritative translations of texts: it is a means to deepen the exchange between ethnographer and respondent in a situation where the respondent's knowledge is based on written sources.

Although Mirdiana was unfamiliar with most of the myths of Siwa and Uma we found in the *tutur* texts, he soon began to realize that they were expressed in rituals and sacred performances he had witnessed all his life. As we follow the unraveling of these tales, we will find that they express, though in a very different way, the same mystical themes explored by Budiana. For a long time I assumed that knowledge of these myths was confined largely to Brahmana scholars and other literati. Eventually, however, I discovered that many stories relating to Uma and Siwa, including several previously unknown to me, are discussed by Leo Howe, whose research was based on ethnographic fieldwork among ordinary village people.[27]

The Balinese myths of Siwa and Uma, and their offspring Kala, Kumara, and Gana, emphasize cosmic transformations from the divine to the terrible and back again.[28] The stories Mirdiana elects to paint highlight certain important episodes in the cycle. All involve as their central theme the role of desire as a cosmic force bringing the world into being and, at the same time, leading to its destruction. These myths reveal that all dangerous and destructive forces in the cosmos originate from a single source: the divine pair, Siwa and Sakti. Moreover, all terrible forces and entities can be returned to their divine source by

means of human ritual, thus averting the destruction of the world.[29] Mirdiana's paintings in this series vividly depict the terrifying transformations and monstrous creations brought about in the amorous play of Siwa and Sakti.

KALA: THE DEMONIC SON OF SIWA AND UMA

The god of all terrible and destructive forces in the world, Sang Hyang Kala, begotten in anger and born without contact with his mother's body, is nevertheless the son of Siwa and Uma.[30] The mythic account of his birth is the subject of Mirdiana's painting *Siwa and Uma Riding Nandini* (Plate 17).There is nothing in the painting to suggest the ominous consequences of this occasion. Indeed the mood is lyrical: the handsome young god and his beautiful consort soar through space, their robes and hair flying gracefully in the wind. Siwa's face is suffused with tender passion as he gently places his arms around Uma's waist. As if to reject his embrace, she turns away, her diaphanous robes just baring a glimpse of dainty thigh. Here we find the divine pair in god form, gentle, and beautiful. When I commented to Mirdiana that this was the first of his paintings to depict only beautiful images, he replied: "Yes, but this is the origin of a very horrible thing!" He was referring to the birth of the god Kala.

We were first told the story of the birth of the monstrous Kala by the late Ida Bagus Sutarja, a learned Brahmana scholar, priest, and maker of exquisite masks. Later we found in the Gedong Kirtya library, at Singaraja, a transcription of the *lontar* text *Kalatattwa* that recounts the birth and exploits of the monstrous god.[31] Sutarja's oral version, which inspired this painting, begins with the high god Siwa and his wife Uma flying through space on their mount, the bull Nandini. As they descended toward the earth, its material influence caused Siwa to be overcome by erotic desire. When the wind caught Uma's robes, exposing her thigh, Siwa attempted to embrace her. Uma protested that his behavior was unworthy of the gods and struggled against him, whereupon his sperm fell into the ocean. Siwa and Uma then departed the scene quarreling, but below, in the sea, a monstrous egg formed. From it emerged a terrifying ogre: the god Kala.

Mirdiana's painting focuses on the gentle and beautiful nature of the divine pair, their godlike, or *dewa*, characteristics, as if to emphasize the extreme poles of cosmic forces represented by Siwa and Uma. This benign form is referred to in the *lontar* texts as *somyarupa*.[32] From this pinnacle of divine beauty, Siwa and Uma can transform into monstrous creatures of mind-numbing horror, as we find in subsequent paintings. It is as if Mirdiana wants nothing to detract from this vision of the beautiful pair just before they begin to quarrel. The connection with the birth of Kala is left implicit. When I asked why the painting does not suggest the link to Kala's birth, Mirdiana explained that he had already painted Kala together with his brother Kumara. (We will turn to this painting next.)

The *lontar* text *Kalatattwa*, which describes Kala's origin from Siwa's sperm, goes on to tell how the giant emerged from his egg in the middle of the ocean to find himself all alone and abandoned. The newborn looked in vain for his parents:

> He wanted to know his father and mother. He watched the ocean but it
> was completely deserted; he looked to the east, deserted; to the south,

deserted; to the west deserted; to the north deserted; below deserted; and
above also deserted. Suddenly the giant screamed, he roared very loudly,
the earth shook, and every corner of heaven swayed.[33]

Frightened by the terrible sound, the gods looked down from heaven and saw the giant. They rained arrows upon him, hoping to kill him. Instead of retaliating, the giant spoke politely to them: "Oh, I am very pleased to meet you. Don't attack me, I only want the truth."[34]

The gods are not reassured by this and attack him again, but the giant continues to advance on heaven. Finally Siwa himself confronts him, but even Siwa's thunderbolt *(bajra)* could not wound Kala. When Siwa demands to know why the fearsome ogre is attacking heaven, Kala again explains: "I don't want to attack anyone, I only want to ask something. Forgive me, my lord, but I do not know who my father and mother are."[35] Siwa instructs the giant to break his right tusk and he will learn who his parents are. Siwa reveals that he himself is Kala's father and Uma is his mother. Both parents give special rights and duties to their son, including the right to devour all sinners and, with his deputies the *bhuta kala,* the right to punish those on earth who neglect their duties. He was, however, admonished to spare those who performed the appropriate rituals. If humans perform the correct sacrifices *(jadnya)*—which are prescribed in detail by Siwa in the text—the hideous Kala and his demonic minions will be totally transformed as a result. Siwa explains to Kala:

> You can change from terrifying form to gentle form *(somyarupa),* together with your followers, and stop all your cruelty and punishments. You all will enjoy purification *(lukatan)* from Siwa and Buddha priests that can remove the dirt inside yourself and outside yourself. Certainly you will become gods and goddesses, and you, Kala, will become one again with your father and mother and enjoy life in heaven.[36]

Kala himself represents the extreme of godlike power become destructive. The hideous product of anger between his divine parents, his role is to wreak havoc in the world. But just as he originates from the god and goddess, he possesses the potential to return and become one with them again in heaven. If Kala is "the Evil One," as C. Hooykaas calls him,[37] his destructive role represents not a continuous state but a phase in an ever-repeating cycle of transformations from destructive to benign. For human beings, the imperative is to provide sufficient offerings to keep the cycle moving toward the positive pole.

Kala and Kumara (Plate 18) depicts the terrible Lord Kala as a huge, heavy-bellied ogre with popping eyes, the flesh-tearing teeth of a ghoul, and a great bald pate. His hands reach out like the talons of some gigantic bird of prey to pounce on the small, soft creature below him. In a fury of blood lust he leaps and dances, his robes and royal ornaments whipped about by the storm of dangerous energy roaring around him. The innocent babe he is about to crush with his right foot is the divine Kumara, who is also the son of Siwa and Uma and thus Kala's own brother. To the left of Kala, taking up a large part of the left field of the painting, is an intricately drawn *kakayonan,* the cosmic tree of the *wayang kulit* puppet theater.

The story of Kala and his brother Kumara provides the mythic basis of a ritual that must be performed for all Balinese born on a particular date. The Javo-Balinese calendar year,

consisting of 210 days, is divided into thirty *wuku,* each with its own name.[38] Kala, according to the myth, was born in Wuku Wayang and asked his father Siwa for permission to devour everyone born on that date. Subsequently his brother, the beautiful infant Kumara, was born in Wuku Wayang, whereupon Kala insisted on his right to eat him. How Kumara was saved from his terrible brother is told in a *lontar* titled *Kala Purana.*[39] Siwa tried to save Kumara by cursing him to remain forever a child and then instructing Kala to wait until his brother grew up before he could eat him. But Kala was not so easily discouraged. Finally Siwa sent Kumara to earth to seek refuge with a powerful king. Kala pursued him, however, and even the king's soldiers could not drive him away.

After various narrow escapes, Kumara came across a puppeteer about to give a *wayang kulit* performance and wept and begged for help. The clever *dalang* quickly hid the child in the bamboo sounding tube of his *gender,* a musical instrument used for the *wayang kulit.* Shortly afterward Kala arrived howling with rage and hunger and demanding to know where Kumara was. Sighting the offerings to the gods that the *dalang* had set out before his performance, Kala fell upon and devoured them. Bravely confronting the monster, the *dalang* courteously pointed out that because Kala had consumed all the offerings, he was now indebted to him. In payment of this debt, the *dalang* said, Kala should spare Kumara and give his promise, to be recorded in the *lontar,* that he would never disturb Kumara again. Kala conceded to the *dalang*'s request—whereupon an amazing change came over him: "The heart [literally, liver] of Bhatara Kala became gentle: he rejoiced and no longer wanted to devour Kumara."[40] In this way the *dalang* became the protector of everyone born in Wuku Wayang.[41] The large *kakayonan*—the cosmic tree that marks the beginning and end of the *wayang kulit* performances that we see in the painting—refers to this story of the wise puppeteer who saves Kumara.[42]

From a philosophical perspective, Kala is time and death, which inevitably devour all human beings and all material things.[43] Kumara, cursed by his father never to grow up, represents immortality—that which cannot be devoured by time. The pair might also, therefore, be said to symbolize the material and spiritual aspects of existence.[44] The bestial Kala, with his raging anger and hunger, represents material existence, while the sweet-faced baby, immune from age and death, represents the immortal beauty of the spirit. Mirdiana's painting, however, suggests that these two opposites are in a sense one. Kala, though huge and threatening, mirrors the shape of the baby below him, with the same plump body, the same bald head, the same golden ornaments. Kala is but a large, distorted version of the beautiful child Kumara. This image takes us back to the description of the birth of Kala in the *lontar* text *Kalatattwa.* Here the newborn surveys the world about him and cries in fear and loneliness for his parents. Although his appearance is monstrous, Kala is but an abandoned child wailing for the mother who has left him and returned with Siwa to heaven.

Mirdiana has chosen to paint the lord of all terrible and destructive forces in cool shades of blue, gray, and green, with details of gold and smaller touches of red, the whole infused with a bright, clear luminosity. The delicate floral designs, the intricate patterns of jewelry and drapery, the feathery *kakayonan*—all lend a graceful elegance so that the grotesque, heavy figure of Kala himself takes on a strange beauty. Mirdiana expresses the mythic truth that even the most horrible entity in existence ultimately derives from a divine source and, if properly treated and cared for, will return to its original pure state. Kala sprang from *kama*

salah, wrong desire, between his divine parents. Mirdiana pointed out to me that Siwa, the high god himself, was overcome by erotic desire because he had come too close to the earth and thus was influenced by physical desire. He could not control himself and was filled with anger when his wife rejected his embrace. Uncontrollable desire and anger bring monstrous consequences. Yet even the hideous and destructive Kala can be returned to gentle form *(somyarupa)* if given the prescribed offerings. The Lord Kala is demon, hungry infant, and also the divine Siwa himself.

The cycle of transformations from divine to demonic is strikingly depicted in *Dewi Rohini* (Plate 19). Monstrous and exquisite forms of the divine pair spin together in a four-sided tangle of shapes—now godlike, now hideous. At the top left of the painting is Siwa, calm and handsome, seated in silent meditation. Below him is his consort, Uma, who has taken the hideous shape of Durga, flames issuing from her mouth as she leaps about in an angry dance. Above her, to her right, prances the demonic Kala, greedy mouth open in a leer, claws about to seize her. Below him, in the right bottom corner of the painting, is a gentle girl, Dewi Rohini, kneeling in an attitude of prayer.

This painting represents another story told to us by the late Ida Bagus Sutarja. Dewi Rohini was a beautiful Brahmana girl who aspired to nothing less than marriage with the high god Siwa. To this end she performed endless austerities in the graveyard until the power generated by her intense spiritual concentration succeeded in attracting the attention of the god. When the lovely Rohini revealed her determination to marry no one but him, Siwa replied that he would have to call upon his wife Durga and his son Kala in order to grant her wish. Siwa hoped to resolve the unfortunate situation that had arisen following the birth of the monstrous Kala. After being cursed by Siwa for rejecting his embrace and causing his sperm to be shed in the ocean, Uma in anger descended to earth as Durga. Her son, born without entering his mother's body, now desperately sought to possess her. But since she was his mother, albeit having assumed the guise of Durga, this was forbidden. Siwa, for his part, was missing his consort and wanted Durga to resume her beautiful form of Uma. Thus he proposed to transfer the spirit of his wife, Durga, to the body of the beautiful Brahmana girl, Rohini, so that she would become Uma and return to Siwa in heaven. To enable this, the spirit of Rohini must first be transferred to the body of Durga—and this in turn would also allow Kala to possess Rohini in the material form of Durga, as she was not his mother. Thus the desires of all four could be met.[45]

The entangled shapes of the painting reflect the ambiguities of identity, one merging into the other. Siwa is Kala, since Kala is his son. Kala is also Durga, since Uma is his mother. Durga is Uma and ultimately Uma is Siwa, since all originate from Siwa and all return to him. Although Rohini adds a fourth presence required for the plot of the story, essentially she represents the gentle form of the beautiful goddess Uma. Kala's role in this myth as the son who desires to possess the mother, an element stressed by Sutarja, suggests various interpretations. Stephen Headley, in a discussion of Kala myths connected to Javanese *ruwatan* (exorcisms), draws attention to the theme of incest, pointing out that this is also a prominent element in Indian myths of Shiva.[46] From a Freudian perspective, the focus on Kala's desire for the mother might be seen as a reflection of everyman—of the inherently incestuous desires that underlie all erotic attraction and the need to displace them onto a woman who is not the mother. It might equally be seen as reflecting the bestial nature of all erotic desire

in contrast to the purity of spiritual love. In mythic terms, Kala is the male principle untouched by the mother, born without the shelter and nurturing of a maternal womb. This was the element in the story that Mirdiana emphasized; he suggested that Kala's destructiveness must be modified by contact with the maternal element. Yet this should not constitute an incestuous meeting—another form of *kama salah,* wrong desire. If one instance of *kama salah* between Siwa and Uma in their divine form gave rise to the monster Kala, what frightful entity might emerge from an incestuous union between the terrible Durga and Kala?

The seething energy and the dark, almost murky colors dominating the painting suggest the threat of destruction on a cosmic scale. The small, calm figure of Siwa is the point of origin and, at the same time, the means of averting the danger. Yet even Siwa is part of the cycle, drawn toward the other figures by centripetal force—indeed the figures seem to spin, so that as we watch them they begin to merge.

SIWA KALA AND DURGA: THE MONSTROUS FORMS OF SIWA AND UMA

When touched by earthly desire and anger, Siwa and Uma in their divine form conceived a monstrous son. But the creator pair take on terrifying shapes themselves, and Mirdiana provides startling images of their metamorphoses. In *Kama and Ratih* (The God and Goddess of Love; Plate 20) we find that the handsome young Siwa depicted in previous paintings has here become a grotesque ogre burning to ashes with his yogic fire the god and goddess of love. Mirdiana shows Siwa in destructive form as even more horrific and awe inspiring than his monstrous son. Whereas Kala, as imaged by Mirdiana, seems always to have a touch of the infantile or vulnerable about him, Siwa Kala is a nightmare shape of sheer power with his great hairy body, his one huge staring eye, fire streaming from his gaping jaws and igniting from his bulging arms and shaggy head. The fire that issues from Siwa Kala is anger.

The painting was inspired by a mask of Siwa Kala made by Ida Bagus Sutraja and what he told us of this demonic form of Siwa. Mirdiana already knew the story of Kama and Ratih, but his understanding was now greatly enhanced by our discussions with Sutarja and others. The literary source of this myth is an Old Javanese *kekawin* (poem), the *Smaradahana,* a copy of which was obtained for me and translated by I Nyoman Suarka after he saw Mirdiana's painting in progress.[47] According to Mirdiana's version of the story, Siwa had retired from heaven and the world to meditate in a mountain forest. He was gone so long, however, that the gods in heaven became worried; they sought ways to rouse him from his deep contemplation and persuade him to return, but to no avail. Finally they sent the god and goddess of erotic love, Kama and Ratih, to distract Siwa from his austerities. Provoked by the amorous dalliance of the beautiful couple, Siwa's concentration was broken, and in rage he advanced upon them, assuming the frightful shape of Siwa Kala. From the great eye of the monster flame burst forth and the heat was so intense that Kama and Ratih were burned to ashes. Nothing was left but the finest of ashes that fell upon the earth and all living creatures. Love thus became invisible, without physical form, but the fine particles of ash filled the world, so that all living creatures are influenced by erotic desire.[48]

The artist has chosen to show fire streaming from Siwa Kala's mouth—not his eye as the myth relates. Fire is symbolically a feminine element for Mirdiana, as for Budiana. According to Mirdiana's interpretation, Siwa's concentration was broken because he had spent a

long time on the earth meditating and thus had been influenced by the *panca maha bhuta*, the physical elements that constitute the earth. These give rise to the five senses *(panca indriya),* which in turn give rise to the six vices *(sad ripu):* lust *(kama),* greed *(lobha),* anger *(krodha),* drunkenness *(mada),* confusion *(moha),* and jealousy *(matsarya).*[49] In other words: physical embodiment is the inevitable source of material desires. All beings touched by the material world become subject to these desires, even the high god Siwa.

Overcome by rage, Siwa is filled with the demonic energy and destructiveness inherent in the physical world. Seething with lust, greed, and hatred, he lays waste to all in his path. The fire that spews from his gaping maw is the element of the Terrible Mother, as we have consistently found in Budiana's works. Mirdiana has chosen to emphasize the link to the destructive feminine principle—a connection that is further revealed in the treatment of the mouth and teeth, which closely resemble the fangs and tongues of fire of the goddess Durga to be seen later in the painting *Panca Durga* (Plate 21). It is said, in English, that love or indeed any strong emotion is blind, but the metaphor tends to lose the obsessive fixation of desire upon a single object or intent. Lust, hunger, and anger allow no quiet assessing of a situation; they impel immediate action to achieve satisfaction. Siwa Kala's one staring eye conveys this mindless drive. Although sight, and thus the eyes, usually suggest the power of the mind and reason, this single great orb sees nothing but the object of its passion.

The myth, and this painting, focus on two kinds of emotion: Siwa's anger and his erotic desire. Is this another instance of the *kama salah* (wrong desire) that gave rise to the dreadful Lord Kala? Kama and Ratih are the god and goddess of love. Their union in itself cannot be wrong. Yet by disturbing Siwa's meditations, their act of love results in the benign high god, Siwa, taking terrible form and destroying them. Is this simply the antithesis between spiritual concentration and the physical desires that drive the body? According to the myth, erotic desire is not in fact destroyed, only its physical form ceases to exist, but as an unseen force it spreads over the earth and all living creatures. Is erotic love thus to be understood as something divine in origin? The myth seems to play with these ambiguities. Is *kama* simply a sin—one of the *sad ripu*? But we have seen that there is *kama* and there is *kama salah*—desire and wrong desire. Even the gods can be guilty of *kama salah,* as we found in the myth of Kala's origin, an event that also was a result of too strong an influence from the material world.

Kama is the force that draws separate entities together to unite and to produce new entities. In this sense it is a cosmic force of divine origin and, in turn, the origin of all entities. Perhaps Siwa meditating alone wished to remain a single unity; perhaps he did not want to concern himself with the world or the gods. The force of *kama,* however, draws him to seek out another entity with which to unite. Thus when drawn out of his self-containment, he turns destructive as he becomes aware of his incompleteness. But this destructiveness can be turned to creativity in achieving a new union. The myth suggests that it is desire as a cosmic force which creates the dynamic behind the cycle of cosmic transformations.

As Mirdiana pointed out to me, the story offers tantalizing hints of matters developed elsewhere. Other myths reveal that Kama and Ratih are the son and daughter of Uma and Siwa—again raising incestuous, oedipal themes, at least in a Western interpreter's mind. Mirdiana suggested that the myth should be understood metaphorically to mean that Kama and Ratih are actually part of Siwa himself: his own feelings *(rasa)* concerning love *(cinta)* and

affection *(kasih sayang)*. Thus Siwa, disturbed from his self-absorbed contemplation by his own feelings and memories of love and attachment for other entities, wants to burn away these distractions and return to a higher state of awareness.

While it dwells on the awe-inspiring figure of Siwa Kala, Mirdiana's painting is nevertheless composed of elegant forms, exquisite decorative motifs, and crisp graceful lines. The coloring is rich but subdued, the red flames cooled by the black and gray rocks and clouds. Floral elements—the wildflowers growing around Siwa's mountain retreat—are interwoven with the jewellike flames that engulf the beautiful lovers. The composition has a fierce energy to it, yet it is contained within the fine, precise lines that define each form, even Siwa Kala's distorted face and bulging body. Again we see Mirdiana's unique ability to render the grotesque, and terrifying, beautiful.

Durga is well known to Balinese as the consort of Siwa and the goddess resident in the Pura Dalem of every Balinese village. In Balinese Hinduism, Durga is the demonic form assumed by Uma, the beautiful and gentle wife of Siwa, but one hears much less of Uma than of Durga from ordinary Balinese.[50] The five terrifying ogresses exuding the stench of blood and graveyard decay that confront us in *Panca Durga* (The Five Durgas; Plate 21) are but the other side of the exquisite goddess pictured in Plate 17. They are the counterparts of Siwa Kala—the terrible aspect of Siwa. The similarities between Siwa Kala and Durga as depicted by Mirdiana are evident when we compare *Panca Durga* (Plate 21) with *Kama and Ratih* (Plate 20). The heavy shape of the bodies, the shaggy hair, the protruding eyes, the coarse nose, the large ears, and especially the gaping jaws, fierce tusks, and tongues of flame, are of a piece. In Durga, Siwa Kala finds a fitting mate.

We first heard the story of the Five Durgas from two Brahmana priests, and both later gave me handwritten texts of the story in Balinese and Indonesian.[51] Subsequently we obtained a copy of the *lontar* text *Siwagama*,[52] which gives a fuller though very similar account. It tells how the beautiful goddess was cursed by her husband Siwa and in anger descended to the earth as Durga. Reaching the crossroads, she divided into five—creating a Durga for each of the four directions and the center. Together the five fiends plotted to destroy the world. Meanwhile Siwa in heaven was beginning to regret cursing Uma and driving her away, and so he resolved to win her back. Cursing himself, he became the monstrous Kala Rudra and went to earth in search of her. (Siwa in terrible form is given different names by different texts: Siwa Kala and Kala Rudra seem to be interchangeable.)[53] At the crossroads Kala Rudra met the Five Durgas. Each requested his touch and from their meeting was spawned a host of terrible creatures in all five directions. This was the origin of the *bhuta kala*—all the dangerous and destructive forces that plague the world.[54]

This centrally important myth explains the origin of *caru* offerings. All Balinese rituals begin by making *caru* offerings—usually placed on the ground, unlike offerings for the gods *(dewa)*, which are placed on stands of varying heights. The contrast has been interpreted by many Western scholars as indicating the lowly status of the *bhuta kala*. Yet, as we learned from Budiana's work, the *bhuta kala* represent the energies and forces of the earth. *Caru* offerings are placed on the ground, or close to the ground, because they are directed to the chthonic powers. The aim of the *caru* rituals is not to exorcise these powers but to convert them from negative into positive energies. The theme of sacrifice as a means of persuading dangerous entities to become protectors has already been touched on in the discussion of Mirdiana's treatment of the stories of Sutasoma and the god Kala.

The nature and intent of *caru* rituals are clearly revealed in the myth. After the meeting of the Panca Durga with Kala Rudra and the creation of the *bhuta kala,* destruction was unleashed on humankind. Meanwhile in heaven the Tri Semaya—Brahma, Wisnu, and Iswara—had become worried about the doings of Siwa as Kala Rudra on earth. Among themselves they discussed how they could persuade him to return to heaven in his gentle form *(somyarupa).*[55] They decided to go in search of him and found him on earth, with Durga, sitting on the Bale Agung (a ceremonial structure located in the village temple, the Pura Desa). Kala Rudra had now taken the name and form of Sang Jutisarana and Durga had taken that of Sang Kalikamaya. Both names include a word meaning "deception" or "disguise" *(juti* and *maya).*[56] Despite their disguised form, they were recognized by the Tri Semaya, who then approached the king of the country of Galuh, King Batatipati, and instructed him to make appropriate offerings, including blood and raw meat, to satisfy the cannibalistic hunger of the demonic deities. When all was prepared, the offerings were laid out in front of the Bale Agung. The ceremony, called *caru pancasia,* was led by the Tri Semaya who took the form of Brahmana priests *(pedanda)*. The Tri Semaya then constructed a stage, and the god Iswara became a *dalang* (puppeteer). With Brahma and Wisnu on either side of him, he performed a shadow puppet play depicting the journey of Kala Rudra and the Panca Durga on earth.

After watching the performance, an extraordinary change came over Kala Rudra and Durga. They became aware, and then ashamed, of their murderous actions on earth—whereupon they were transformed back to their benign divine forms of Siwa and Uma. Their demonic minions, the *bhuta kala,* were also transformed after they consumed the offerings set out for them—resuming their original forms as the nymphs *(bidedara, bidedari)* of heaven. Thus by means of the rituals taught to humankind by the Tri Semaya, the terrible potential of Kala Rudra, Durga, and their followers was defused. This myth not only explains the origin and intent of *caru* rituals. It also explains the role of temple entertainment *(imen-imen),* such as the *wayang kulit,* in bringing Kala Rudra and Durga to awareness of their destructive deeds.[57] Furthermore it asserts that the Brahmana priests *(pedanda)* in their role as ritual leaders are no less than manifestations on earth of the gods Brahma, Wisnu, and Iswara. The role of the king, guided by his priestly advisers, is also emphasized.

Mirdiana's comments on the painting (Plate 21) reveal an understanding of Durga that is very similar to Budiana's. When I asked him about the circle above the head of the central figure, he replied: "That is the moon—the moon is the symbol of the Mother." The moon is usually associated with the goddess in beautiful form, either as Ratih, the goddess of love, or as Uma, Siwa's consort. Balinese also liken beautiful women to the moon. The moon thus reminds us that Durga is the other face of the beautiful mother goddess. I asked why the five fiends were draped in snakes or worms like so many Medusas. The worms, Mirdiana explained, are the worms of the graveyard, indicated by the human skulls on which the central Durga dances. Worms perform the function of breaking down the corpses in the earth. Although this is horrible, Mirdiana continued, it is a necessary part of life: bringing matter back to its source so that it can be used again to create new life forms. This is the same theme that Budiana has explored at length—the role of Durga as *pelebur* who smelts down matter to its original constituents. The long fiery tongues of the Five Durgas, Mirdiana added, represent desire.

This indeed is demonic desire at its most grotesque: the five fiends ready to devour the world and inciting Kala Rudra to join in their orgy of destruction. One fiend clutches a baby

to her breast, but it is not clear whether she is about to give it suck or if it is a corpse she is about to devour. Although the painting has to be observed closely to identify what is being held in the monster's claws, the ambivalence provoked by the Mother could hardly have been shown more directly. The colors are dark and heavy, redolent of blood, decay, and the frightening shadows of the graveyard, yet the painting is filled with the wild energy of the witches' dance. For Balinese the graveyard is a place of great power, magical and spiritual. Those who desire *sakti,* mystical power to influence material things, must meditate in the graveyard and pray to Durga to achieve their desires. Mirdiana observed that Durga's great tusks, two from below and two above, symbolize the union of powers from below, the earth, with powers from above. This meeting of energies from above and below generates intense power that can be harnessed—for good or for evil—by human beings. Again the emphasis is on the dual potential of these powers. Durga's power is terrible, but its consequences depend on how humans attempt to deal with it.

Mirdiana shows us a nightmare scene. Yet the prancing forms possess a strange grace, and the elegant lines and flowing composition draw us to a realization of an underlying beauty. Like the fire of Budiana's *Kebakaran* (Plate 2), Mirdiana's *Panca Durga* is both terrifying and beautiful.

RWA BHINEDA: THE MEETING OF FIRE AND WATER

Another important myth concerning Siwa and his consort Uma is the subject of *Rare Angon* (The Cowherd; Plate 22). The story has often been represented by Balinese artists,[58] although not always with a deep understanding of its meaning. The literary source of Mirdiana's painting is the *lontar* text *Siwagama.*[59] According to this version—there is always more than one version, even in the written texts, and different sources weave together the elements in varying ways—Siwa decided to test the faithfulness of his wife, Uma.[60] He instructed her to go to earth and find him the milk of a black *lembu* (ox). He then changed himself in a cowherd, descended to earth, and waited for Uma. After searching high and low for a black female *lembu,* Uma finally came upon the cowherd Rare Angon. Seeing that he possessed the milk she needed, she asked to buy it from him. When he demanded to know what she would pay, she replied she would give him jewels and gold, as much as he desired. But he refused, saying gold and jewels were of little use to him: he would only give her the milk if she agreed to make love with him. At first Uma refused, but as she was unable to persuade him to part with the milk in any other way, she finally agreed. According to this version of the myth, she carefully placed his loincloth between her thighs so he would be deceived into thinking he had penetrated her hymen. Another version relates that she submitted to the cowherd's request, but only on the condition that he touched her legs, not her genitals; thus his sperm was shed between her thighs and fell down into a cut on her foot. Both constitute *kama salah* (incorrect unions).

When Uma returned to heaven, Siwa asked their son, the elephant-headed Gana, to divine how his mother had managed to obtain the milk. Gana possessed a special *lontar* book, given to him by Siwa, enabling him to see into the past and the future. When he opened the book he saw there the meeting of Uma with the young cowherd. Uma was furious that her actions were disclosed by Gana. In her anger she became Durga, burned the *lontar* with the

fire of her rage, and threatened to kill Gana.[61] Siwa then intervened and asked whether Gana had spoken the truth. When Uma finally confessed to her adulterous meeting with the cowherd, Siwa cursed her and sent her to earth.

The story continues with Durga arriving in the cemetery of Gandhamayu and meeting there her daughter Kalika, who had also been cursed by Siwa for sexual misdemeanors and sent to earth in demonic form. Kalika obtains from Durga secret teachings of sorcery and black magic to spread sickness and plagues in the world and instructs her disciples, human women, in these black arts. In payment for their lessons, the women had to provide the flesh of their own husbands, children, and other relatives for Durga's minions, the *bhuta kala,* to eat. This, the *lontar* explains, was the origin of witchcraft and sorcery in the world.[62]

In Mirdiana's painting, the elephant-headed Gana is shown on high, reading his *lontar,* wherein is revealed the scene, spread out below him, of Uma meeting with the cowherd on earth. To either side of Gana are his mother, Uma, and his father, Siwa. Although the myth specifies the milk of a black cow or ox, Mirdiana has placed two large buff-colored cows in the center of his composition. Here aesthetic considerations have outweighed the need to be faithful to every detail of the narrative. Uma is shown as a beautiful girl, richly dressed, but modest in demeanor with downcast eyes. In her hands she holds a dainty vessel in which to collect the milk. Rare Angon, the cowherd, is a handsome youth with broad shoulders, a bold expression, and simply a loincloth, yet he still looks more like a god in disguise, which he is, than a peasant. He leans back casually, resting his arm on a large calabash of milk. Some artists have depicted the cowherd as an old man, bald and ugly, possibly to emphasize that he offered no temptation to the goddess. The name of the cowherd, however, suggests a young man or a boy. *"Rare"* in Old Javanese means a small child or "a young man or woman in service."[63] Furthermore it is usually boys or youths who tend cattle. According to a text used by the *pemangku* (temple priest), quoted by Hooykaas, Rare Angon is explicitly linked to the body of the *pemangku* and said to be incorporated in it: "The Cowherd Boy functions as a temple priest in your body. . . . The entire contents of the Microcosm are in your body, located in the place where the liver is hanging—that is called The Cowherd Boy."[64] I was also told by a Brahmana priest that the reflection one sees in the pupil of the eye is Rare Angon. Given that the *pedanda* identifies with Siwa in his rituals, it seems that the more humble *pemangku* is identified with Rare Angon, a disguised human form taken by Siwa.

Mirdiana creates a sense of erotic tension between the two figures, the handsome boy and the graceful girl. There is nothing to suggest the disastrous consequences of this meeting. The overall impression of the painting is gentle and soft; the pastel colors on a pale bluish gray background, the rounded forms and kindly bovine faces of the animals, the elegant human figures, the tendrils of flowering vines, all provide an idyllic pastoral scene. Yet like the equally idyllic rendering of Siwa and Uma on their bull flying through space, this encounter also presages divine anger and danger for the world. Yet again Uma's anger, roused by Siwa, results in the beautiful goddess becoming the terrifying Durga and bringing death to the world—this time in the form of the disease-inflicting sorcery she teaches to human women.

How is humankind to be saved from the depredations of Durga and her disciples, the human witches? Since it is Siwa who tricked his wife and then cursed her to go to earth as Durga, only he can stop her devastation of the earth. In another *lontar* text, *Andabhuwana,*[65]

Siwa himself instructs Durga to inflict sickness on humankind, specifying what diseases should be spread during which months of the year. Finally Durga asks Siwa when she will meet him again, and he replies that later he will come to earth in the terrible form of Durgakala to meet her.[66]

It is this extraordinary meeting of terrible powers, exploding with dynamic energy and force, that is revealed in Mirdiana's *Barong and Rangda* (Plate 23). This painting is hardly the conventional depiction of Barong and Rangda that, like Budiana's painting of the same title (Plate 9), usually presents views of masked actors playing out the battle between the witch Rangda and the shaggy beast Barong. Mirdiana focuses not on the temple performance but on the mythic meaning that underlies it. The two figures in fierce embrace are not costumed actors but the cosmic powers symbolized by the actors and masks. Mirdiana's Rangda is Durga, and Barong is Siwa in monstrous form come to meet his banished consort. *"Rangda,"* as is well known, also means widow or a woman estranged from her spouse.[67] Since Durga is Uma when driven away by her husband, she is in truth a Rangda.

Durga/Rangda, like the Five Durgas of *Panca Durga* (Plate 21), is a half-naked ogress draped in entrails. Her staring eyes, great tusks, and long red tongue of fire are those of the Rangda mask; her whirling mass of knotted hair is Rangda's wig; and in her right hand she brandishes the *kreb,* the white cloth Rangda shakes at her attackers. Barong leaps upon her, grasping her in his talons, as his beard entwines with her tongue. His body is covered with a curly white pelt and ends in a long tail that wraps around Rangda/Durga's right leg. His crown and golden ornament sparkle with jewels representing rain.

The monstrous bodies move together in a wild dance, but the huge, hairy animal bulk of Barong dominates and encompasses Rangda. Flames burst from them as the energy generated by their meeting reaches a crescendo. Yet the terrible power raging in the center is contained, encapsulated within the spinning movement of the figures, so that surrounding them is a quiet ground of empty space. In this union the destructive power of Durga is met and contained by the male principle represented by Barong. Here the male principle is ascendant—in contrast with the meeting between the Five Durgas and Kala Rudra, where female power predominated five to one. When Kala Rudra touched the Five Durgas, they gave birth to the *bhuta kala,* filling the world with destruction. In this new meeting, the masculine principle prevails with the result that the fire of Rangda's anger is met by the water, semen, of Barong. The two elements neutralize each other, becoming vapor that rises upward, representing the transformation of destructive power back to its divine source. In the language of mythology, Siwa takes monstrous form to bring under control his angry consort, thus returning Durga to heaven as the gentle Uma. These myths reveal that Siwa is both the source from which the anger and destructive power originate as well as the source to which they return.

The dreadful shapes assumed by Uma and Siwa when they come to earth as Durga and Kala Rudra are described in detail in the *lontar* text *Bhumi Kamulan.* Here I quote Hooykaas' translation of the relevant passages:

> The Goddess then looked on Her Self
> And full of wrath She then became.
> Her urge was then to eat mankind;
> She screamed, and like a lion roared.

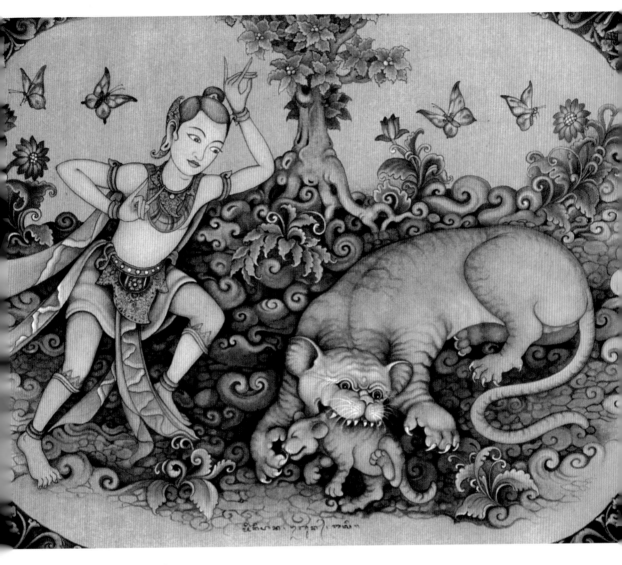

Plate 13. Sutasoma and
the Tiger, *2000, acrylic
on canvas, 51 × 68 cm,
by I Gusti Nyoman
Mirdiana.*

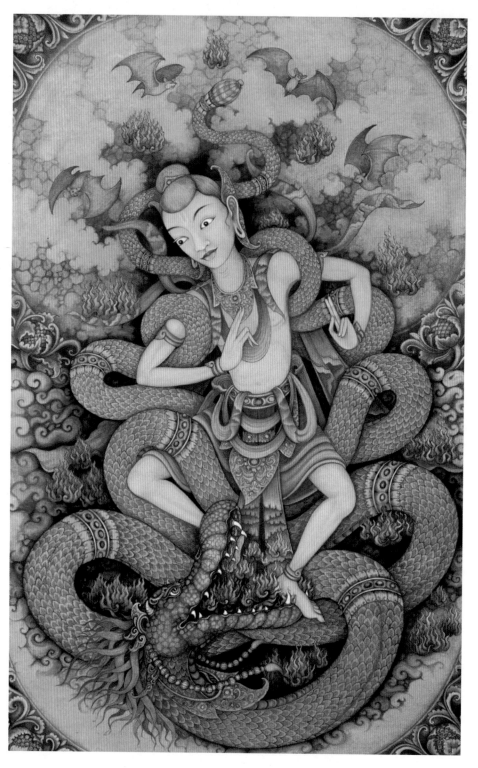

Plate 14. Sutasoma and the Naga, *2000, acrylic on canvas, 95 × 80 cm, by I Gusti Nyoman Mirdiana.*

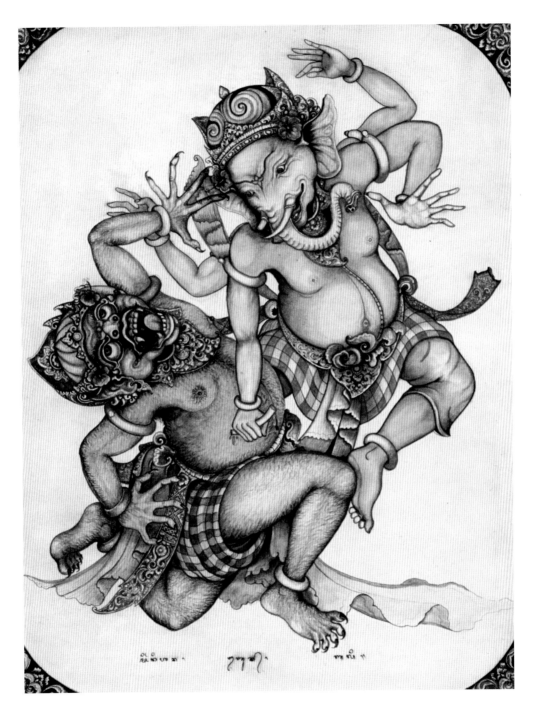

Plate 15. Gana and Detya,
1999, acrylic on canvas,
65 × 50 cm, by I Gusti
Nyoman Mirdiana.

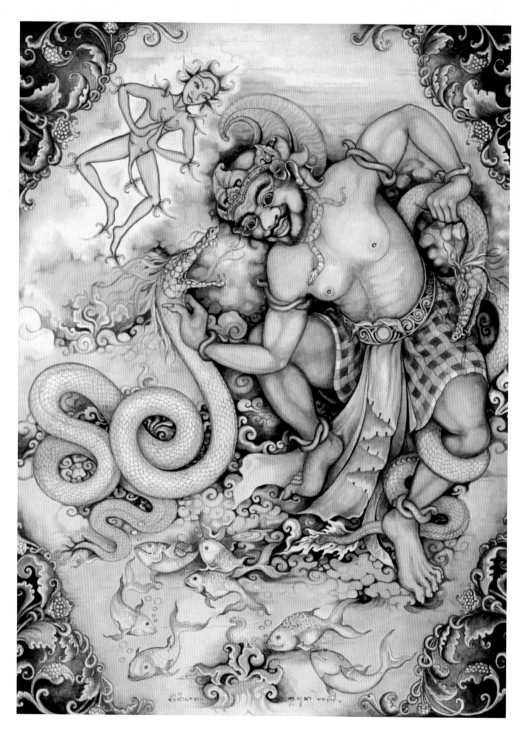

Plate 16. Bima, *2000,*
acrylic on canvas,
80 × 60 cm, by I Gusti
Nyoman Mirdiana.

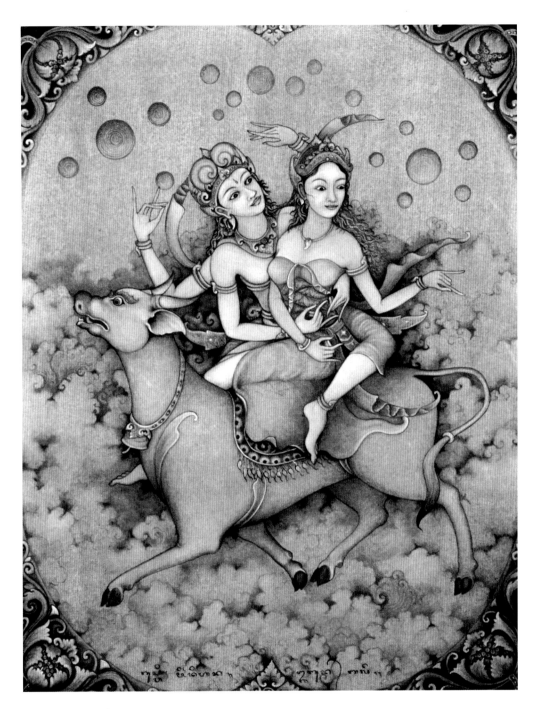

Plate 17. Siwa and
Uma Riding Nandini,
*2000, acrylic on
canvas, 68 × 52 cm,
by I Gusti Nyoman
Mirdiana.*

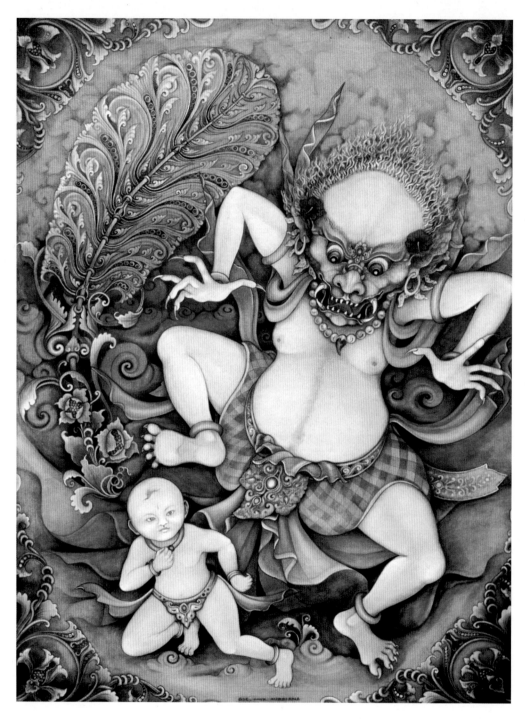

Plate 18. Kala and
Kumara, *1999, acrylic
on canvas, 80 × 60 cm,
by I Gusti Nyoman
Mirdiana.*

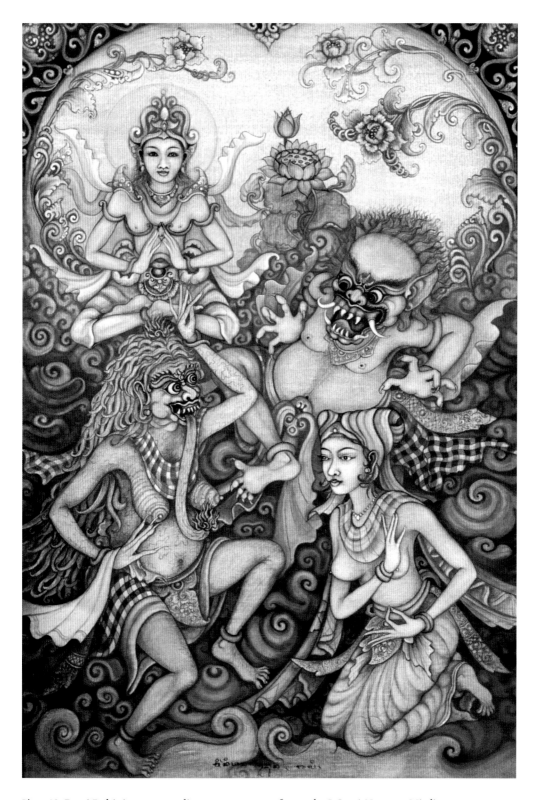

Plate 19. Dewi Rohini, *1999, acrylic on canvas, 90 × 60 cm, by I Gusti Nyoman Mirdiana.*

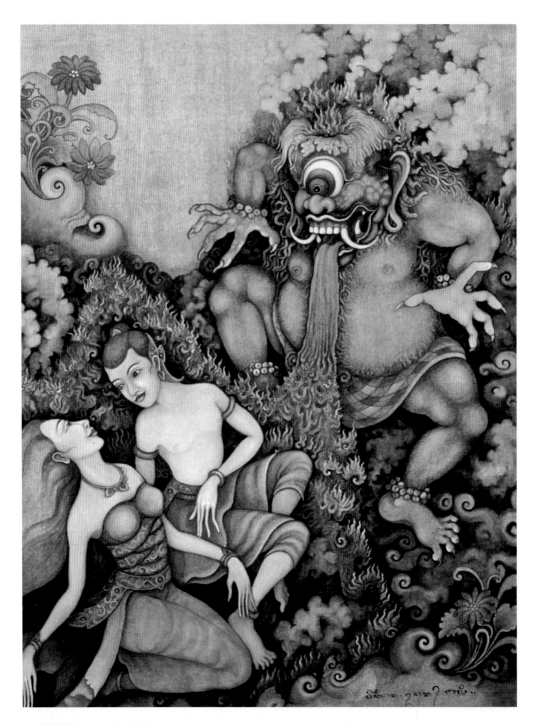

Plate 20. Kama and Ratih
*(The God and Goddess of
Love), 2000, acrylic on
canvas, 68 × 52 cm, by
I Gusti Nyoman Mirdiana.*

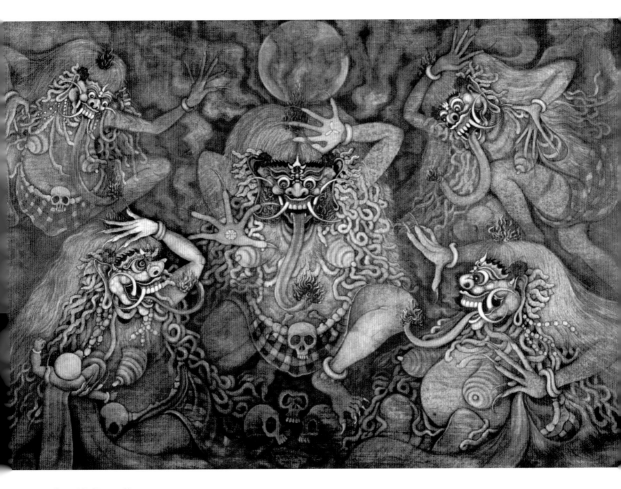

Plate 21. Panca Durga
(The Five Durgas),
1999, acrylic on
canvas, 97 × 118 cm,
by I Gusti Nyoman
Mirdiana.

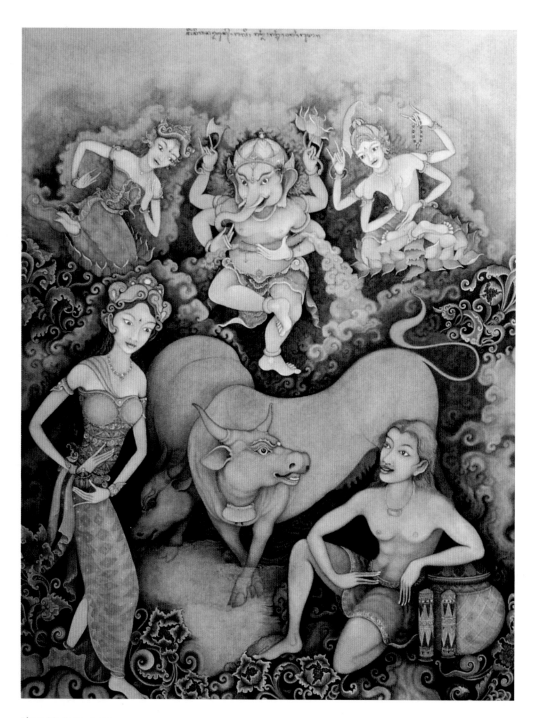

Plate 22. Rare Angon
(The Cowherd), 2001,
acrylic on canvas,
90 × 70 cm, by I Gusti
Nyoman Mirdiana.

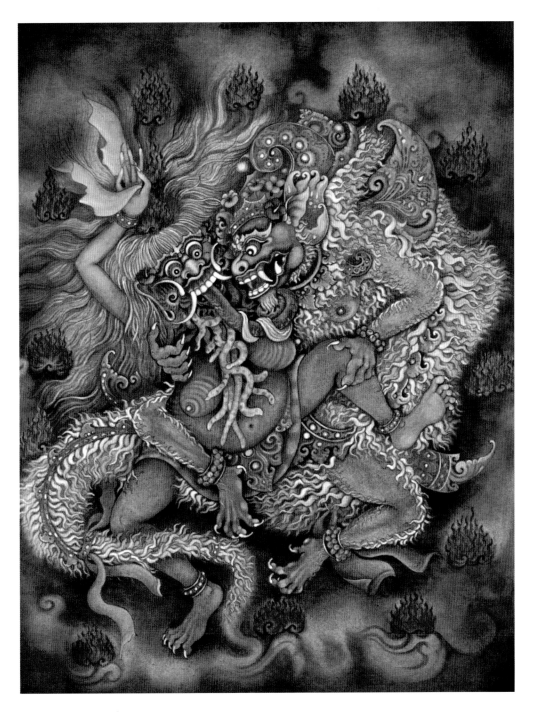

Plate 23. Barong and
Rangda, *2000, acrylic
on canvas, 68 × 52 cm,
by I Gusti Nyoman
Mirdiana.*

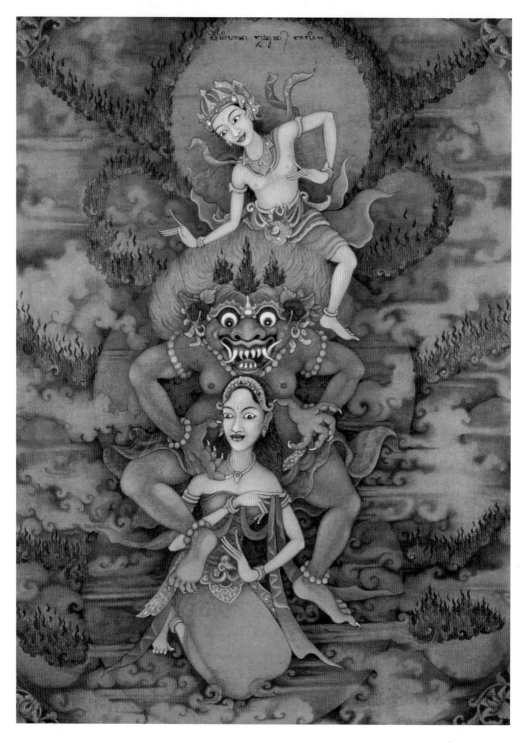

Plate 24. Kerinduan *(Longing), 2000, acrylic on canvas, 80 × 60 cm, by I Gusti Nyoman Mirdiana.*

Her teeth were long and sharp, like tusks,
Her mouth an abyss in between,
Her eyes shone, they were like twin suns.
Her nostrils, deep and cavernous.

Her ears stood like two thighs, straight up,
Matted and twisted was Her hair;
Her body was misshapen, huge,
There was nothing that broke its height.[68]

Observing Uma's metamorphosis, Siwa assumes a similar monstrous shape:

He screamed, and like a lion roared,
His teeth were long and sharp, like tusks,
His mouth an abyss ,
His eyes shone, they were like twin suns.

His nostrils, deep and cavernous,
His ears
Matted and twisted was His hair,
His body was misshapen, huge.[69]

These descriptions given in the *lontar* texts are entirely consistent with Mirdiana's representations of Durga and Kala Rudra, just as they are with the conventional forms of Barong and Rangda created by the masks and costumes used in present-day temple performances.[70]

Clearly for Mirdiana, as for Budiana, the dance/drama in which Barong meets Rangda is much more than an inconclusive morality play. At a deep level it is about the meeting and redirection of cosmic powers so that the destructive potential of the cosmic feminine element may be reversed and returned to its pure source. Although Mirdiana focuses more explicitly on mythic narratives in his work, the meanings he expresses are essentially the same as those that Budiana explores in different ways. Like Budiana, Mirdiana also points to the meeting of these powers within the self. Here the narrative language of mythology is replaced by abstract mystical symbols. The union of fire and water is brought about in the self through yogic practices and meditation—either with the aim of purifying the self of sickness and sin or achieving the spiritual goal of *moksa* (liberation). These esoteric yogic practices are described in various *lontar* texts that are discussed more fully in later chapters. One text, *Siwa Linga Suksma,*[71] which Mirdiana helped me to translate, describes how the water from a golden vessel, visualized as located in the brain, must be poured down to meet fire in the navel, washing away the ashes of the dirt consumed by the fire and thus cleansing and purifying the self of all disease and sin. This is the meeting of fire *(ANG)* and water *(AH)* constituting the union of opposites: *rwa bhineda*. Out of this meeting of fire and water in the self arises vapor symbolizing the *atma* or soul. Thus the two—*rwa bhineda*—give rise to One: Tunggal. This One is both the *atma* and the one god, Tunggal, since one is but a part of the other. From this perspective, the temple dance of Barong and Rangda can be understood as

a public ritual means of achieving in the external world *(bhuwana agung)* the same purification from disease and sin and the same return to divine unity as achieved in the self via yogic visualization. We shall take up this point again in Chapter 5.

In Mirdiana's final painting, *Kerinduan* (Longing; Plate 24), Siwa and Uma have resumed their beautiful, heavenly forms, yet between them still looms their monstrous son Kala. This painting is not in fact based on a mythic narrative; it represents the artist's mythic reflections on an actual natural event he observed: a planetary eclipse during which sun, moon, and earth were aligned. Siwa, at the top of the painting, is the sun, Siwa Raditya. In the center is the earth, the material realm characterized by the monster Kala. Below is the moon, the feminine element in its heavenly aspect, the goddess Uma. Mirdiana explained that such a rare planetary alignment generates great power since the energies of all three worlds come together at this time. If one knows how to attract and draw this energy to the self, one can gain great spiritual power—indicated in the painting by the flames bursting from the points of intersection between the three heavenly bodies. When I pointed out that he had reversed their comparative size and that the earth seemed on the point of devouring the moon, the artist replied that Kala, the earth, was between his two parents and thus controlled by them. Although Siwa is the smallest figure, he is at the top and his stance is the most dynamic; he dominates Kala. Kala, the earth, appears to be about to attack his mother, Uma, the moon, because the earth's shadow is about to cross the moon but does not extinguish it. According to Mirdiana, Kala contained between his two parents indicates that the great natural energy of the earth is aligned with the spiritual power of the heavens. No longer in conflict, the three powers are focused in one line.

When the partial eclipse took place, Mirdiana observed it alone from his house temple *(pemrajan)*. He recalls feeling a deep peace within himself: "I was praying, and at that time I felt very close to the planets, as if I were pulled by the moon. I felt this was a perfect situation. Very complete. Because at that time in the family, in myself, in my spiritual connecting, all were in one line like that. I felt very happy, very peaceful, and powerful." Here the artist expresses his satisfying spiritual experience of a correspondence between the inner world of the self *(bhuwana alit)* and the outer world *(bhuwana agung)*. For him this is a rare experience, like the eclipse itself. The "Longing" of the title refers both to his own longing for such contentment and to the longing that draws separate entities together on a cosmic scale.

Although Kala's destructive potential is controlled for the moment, it remains—and as the celestial bodies move away from each other again, it will be unleashed once more. The movement of the three figures, the fire, wind, and clouds surrounding them, and especially the sense that Kala is about to leap out at us, all convey this potential. We feel that any moment Uma may revert to Durga and that Siwa will take angry form as Siwa Kala or Kala Rudra. Following the myths of Siwa and Uma, Mirdiana's painting reveals the Balinese cosmos as an endless cycle of transformations: dynamic forces ever moving from divine to destructive and back to their source. The painting brings about a resolution and harmony, but the perfection achieved is just for a moment.

The Influence of Tantric Thought

WHAT PATTERNS can be discerned in the previous two chapters? And to what extent might they represent Balinese philosophy and religious understanding? In attempting to answer these questions, I want to explore certain broad similarities between the Balinese mystic themes identified in the work of Budiana and Mirdiana and the doctrines of Shivaitic Tantrism as redefined in recent studies by Indologists. These explorations will lay the basis for the new interpretations of Balinese ritual presented in Chapter 5.

Budiana offers us a cosmic view that is clear and consistent. This, of course, may be an idiosyncratic view based on his own spiritual insights, the esoteric teachings of a particular group or guru, or a combination of all of these. Here I have examined only twelve of his paintings, but I have selected them to be representative of his work as a whole. The same themes are revisited again and again, though each time presented in a fresh and creative way, in Budiana's extensive oeuvre. His paintings are in no sense didactic; he is not trying to preach any simple moral message. The paintings are almost like snapshots—obtained who knows how—of the inner workings of the spirit: glimpses into the fires and cauldrons of the human heart.

There is no doubt he is painting directly from his own inner vision. Yet these visions are informed by a culturally constructed reality, that is, Balinese ritual and religion. My aim in this book is to elucidate these connections and, in doing so, show how the artist's unique vision can vivify for us, and cast in a new light, the cultural sources of his inspiration. Thus I am really searching, not for what is unique, but for what is shared in the artist's vision— an approach that perhaps typifies an important difference between the art critic and the anthropologist. For myself, writing as an anthropologist, the sparkling individuality of the artist speaks for itself and the aesthetic appeal of the works is for me a mystery that I do not seek to unravel. Rather the enchantment inherent in the aesthetic becomes a means of approaching the cultural forms that inform the artist's creations.

I begin my discussion with Budiana not only because he is the more famous and more established artist but because his works present a cohesive view of certain key themes that lie at the heart of Balinese understanding of the cosmos, the powers that constitute it, and the place of human beings within it. His view is very far from the stereotypical descriptions that have become entrenched in much of the Western scholarly literature—stereotypes that some Balinese themselves, including many artists, have come to internalize at one level as received wisdom and readily repeat when questioned by foreigners about their beliefs.

Budiana's cosmos is a clashing symphony of powers, now terrible, now divine, ever exploding into chaos, drawn by frightful passions, united in cataclysmic meetings, resolved and rising upward into exquisite forms and light, to descend again into terror and the inferno in never-ending cycles. Human beings, swallowed up by the maelstrom or tossed about like flotsam and jetsam on the surging waves of existence, are but momentary expressions of soul unified with matter—for a cosmic second—to disintegrate again, on and on, endlessly. Yet in this chaos the human spirit can find a way to realize its potential to achieve liberation *(moksa)*. It is via ritual and meditative practice to train the spirit that this potential can ultimately be realized.

Evidently this is Budiana's view as expressed in his paintings. But are we to accept it as an accurate reflection of the understanding of other Balinese? In the first place, Budiana himself firmly believes that what he expresses in his work reflects shared Balinese thinking and teachings. In his own view, his most important works are the temple sculptures he has made for many communities around the Ubud area and the sculptures, paintings, and other equipment that he produces for cremation ceremonies—all without accepting payment. No reclusive mystic obsessed by a private vision, Budiana follows most faithfully the living tradition of the Balinese artist sharing his skills to the benefit of all in enhancing the ritual life of his community. The paintings bought by Western collectors, such as the works discussed in this book, are not set apart from his life and work as a whole; they are simply another expression, in another medium, of the same ideas and mystical insights.

Like many Balinese known personally to me, Budiana belongs to a study group centered on a spiritual teacher (guru). Many different groups, focused on different spiritual leaders, who are often healers as well, flourish in Bali today, but their existence tends to be known only to their adherents. It is difficult to describe these groups as they are informal, usually known about only by word of mouth, and requiring some form of initiation in order to gain access to them. People seeking healing of an ailment, or perhaps spiritual guidance, may be drawn to such a group or advised to join by friends. A person might consult a traditional healer *(balian)* to obtain treatment and then become a follower of the healer, whose spiritual

advice has attracted a like group of followers. Healers who do not employ traditional methods of treatment are known to Balinese as "paranormals" rather than *balian*. The spiritual practices advocated by such a healer may be based on a mixture of personal revelations and methods derived from foreign sources. Other groups form around priests, usually *pedanda* (Brahman priests), who may offer both healing and spiritual advice (which in Balinese belief are not easily separated). Then there are the *kebatinan* groups, which tend to emphasize a combination of martial arts and spiritual practices, often deriving from Java. I have also heard many rumors about various teachers of magic specializing in techniques to control and use the *kanda empat* (the four spiritual siblings possessed by every person).

It is difficult, in the absence of methodical studies,[1] to know whether these groups represent new developments in Balinese religious life or simply represent continuations of informal study groups and followings that gathered around particular healers, teachers, and priests in the past. Certainly my impression is that they are nothing new and constitute something rather different from the reform movements studied by Frederik Bakker,[2] Michel Picard,[3] and Leo Howe.[4] The reform movements appear to constitute a more formal level of self-conscious reassessment of religious practice. It is this intellectual and Western-influenced level of discourse that Clifford Geertz referred to as constituting a process of "internal conversion."[5] It is no easy matter to separate popular and intellectual levels of discourse in changing worlds, however, and clarification of these matters must await future research. My point here is that although it might appear that the themes expressed in Budiana's works derive from recent, imported teachings, they are based on mystical understanding deeply embedded in Balinese culture. Yet it is certainly true that Budiana's opinions—and equally Mirdiana's—reflect to some degree the influence of the modern, reformed version of Hinduism in Bali that places emphasis on *moksa, karma pala,* and other ethical concepts that had much less salience in the past.[6] Given the wide currency of such ideas in contemporary Balinese discourse, it could hardly be otherwise; but this is not to assert that older understandings have necessarily been supplanted.

A further dimension is added when we consider Mirdiana's paintings, which explicitly draw on Balinese mythology. I have discussed the literary sources at some length to show that the themes developed by Budiana are not only expressed in Mirdiana's paintings but constitute the crux of several key Balinese myths. The *lontar* texts on which Mirdiana draws are classified under the category of *"tutur"*: works dealing with philosophical and religious matters. In effect, they are the texts likely to be studied primarily by Brahmana priests and scholars. It was through my conversations and interviews with such persons, during which Mirdiana usually acted as my Balinese interpreter, that he came to know of the myths of Siwa and Uma and we both began to realize their significance. Mirdiana's own interpretation of this material is important; he grasped things quickly and, given his cultural background, ideas immediately made sense to him that remained puzzling to me. Thus he helped me to make connections that I would never have seen for myself.

An Emerging Pattern of Mystical Themes

Based on the material presented in the previous two chapters, I think we can see an emerging pattern of mystical themes. The cosmic cycles of terrifying and turbulent powers

depicted by Budiana are also explicitly described in the myths. As we have seen, the divine pair, Siwa and Uma, move constantly between extremes—raging upon the earth as Durga and Kala Rudra, then resuming their gentle forms and returning to Siwa's heaven. The myths further reveal that the feminine cosmic principle—what Budiana simply refers to as "the Mother"—is the active principle, the power that gives rise to all material forms, and in doing so eventually becomes destructive. It is Uma's anger that leads to the birth of Kala, to the creation of the *bhuta kala,* and to the origin of disease and witchcraft on earth. Drawn by desire to reunite with the feminine, the male principle, constituting spirit, is pulled by materiality and thus also degenerates into lower forms. Siwa, missing his wife, takes terrible form and follows her to earth where he finds the Five Durgas in all of the five directions. Budiana's painting *Merah Putih* (Plate 8), where a hideous female form stands astride and merges with a male monster, is another representation in a different form of the fateful meeting described in the myth of the Panca Durga, where the destructive feminine principle is dominant.

Cosmic meetings are represented in the myths as sexual unions between the god and goddess in their multiple forms. The results of these unions are likewise divine and demonic. At times Siwa descends to earth in monstrous form to contain the dangerous power of Durga. In the shape of Barong, a demonic force possessing a positive potential, Siwa brings the destructive potential of the Mother under control. Water, the element symbolized by Barong, meets fire, symbolized by Rangda. Their meeting neutralizes both elements and gives rise to a nonmaterial entity, the soul, represented by vapor. In the self, also, this "marriage of fire and water" can be brought about by inner yogic visualization. Fire, the female element, is also Kundalini, representing the goddess in the self. Union with the divine is achieved when Kundalini is made to rise up and meet her spouse Siwa.

Such myths reveal that it is through ritual action—and appropriate sacrifices made to the destructive forces inherent in the material world—that these powers can be directed back to their original divine source. This is not a matter of exorcising, dispelling, or placating demons. The nature of cosmic powers is to follow a cycle beginning with a divine unity, which has no concern with the world, to ever-multiplying and degenerating forces that begin to feed on what they have created. Human ritual is constantly needed to redirect these forces toward the positive pole. Yet these forces are not different entities or powers; it is simply a matter of encountering them in different states—now controlled, now out of control. They cannot be destroyed or banished since they are the very origin of our existence.

If the perfect unity of the one god (Tunggal, Acintya, Paramasiwa) had never been broken, no material world would exist.[7] Once that unity is broken, and material beings and entities are brought into existence, the forces giving rise to them take lower and lower forms. Thus every act of creation eventually leads to destruction. Human beings, however, have been given the means to preserve themselves and their world. Through performance of the appropriate rituals, destructive forces can be reoriented and persuaded to return to their pure source. Human beings, composed of both material and spiritual aspects, aim to return both aspects to their sources. Thus the material constituents of the body are smelted down to become matter from which new bodies are created, while the soul *(atma)* returns to its divine source. Such, I suggest, is the hope and aim of the complex Balinese mortuary rituals.[8] Yet the soul is not so easily freed from its attachment to physicality, and it keeps being pulled back again and again to seek new incarnations in the material realm.

Spirit and matter are endlessly drawn together by the invisible force of desire to unite and thus produce living beings. Once divided, the original unity is separated into forces and entities ever desiring to achieve that perfect unity again. Desire to merge, to unite, becomes a dynamic that moves the cosmos. The union of the god and his Sakti is the highest expression of desire, leading to a return to the blissful state of original unity—but not forever. Sakti is that aspect of the godhead that cares about the world. Without her no world would have been created. But in the process of creating and caring about the material world, she grows too attached to her creations and finally becomes dangerous and destructive. This change is clearly described in a Balinese myth of the origin of the world translated by C. Hooykaas. Having brought forth the world, the creatrix then turned upon her creations in anger:

> The Goddess Umā glanced around
> And everywhere Her feet had touched
> There was whiteness, there was redness,
> There was yellowness, and blackness.
>
> The Goddess then looked on Her Self
> And full of wrath She then became.
> Her urge was then to eat mankind;[9]
> She screamed, and like a lion roared.

Fred B. Eiseman quotes an authoritative Balinese interpretation of this myth specifically referring to Siwa and Uma's excessive attachment to their creations:

> After creation, the earth could not yet produce anything. Dewi Uma created the matter or material of all living things. And Siwa gave them all life or spirit. But Siwa and Uma became extremely attached, too attached *(terikat)* to their creations. This attachment was not good and built up too much energy in Siwa and Uma and they changed into strange and frightening forms. Uma changed herself into Durga in the shape of Rangda; Siwa changed into the form of Rudra.[10]

The same theme, I believe, is expressed in the myth of Rare Angon where Uma is sent to earth to find the milk of a black *lembu*. Although she acts out of concern to help her husband, when confronted with the choice between failing to get the material/medicine he needs or committing an unfaithful act, her love and concern for Siwa outweigh her need to be considered a faithful wife. This decision leads to her exposure by Gana and her descent to earth as Durga. This narrative reiterates the theme that the Mother's care and love lead to over-attachment to materiality and thus ultimately lead into terror and destruction.

This dual aspect of Sakti, her creative and destructive power, is, I believe, the key to understanding the mystical/magical power referred to by Balinese as *sakti*—a concept that has created much difficulty for Western interpreters, as Hildred Geertz's work in particular has shown.[11] In Budiana's view, those persons whom Balinese refer to as *anak sakti* (people who possess *sakti*) seek through ritual practices to acquire power from the Mother: her power

and herself are one and the same. (Though he does not advertise the fact, he himself might well be considered to be such a person.) *Sakti* is the invisible, mystical power to create, influence, and destroy material entities. Human beings who develop these powers in themselves may use them to constructive or destructive ends.[12] The *balian* uses his or her *sakti* to help others; the *leyak* uses the power to inflict sickness and harm. It is, however, the same power—and this duality, as we have seen, inheres in its very nature. Belief in witches and the power of human sorcery is not peripheral to Balinese religion, as Hildred Geertz points out although on somewhat different grounds,[13] but is integral to underlying concepts of the very nature of the cosmos and the forces that bring it into being and sustain it.

How Representative Are These Ideas?

My understanding of these themes did not emerge from working with Budiana and Mirdiana alone. The ideas the two artists expressed in their works were explained to me by many other Balinese and elaborated in the texts to which they referred. Perhaps my most important informant—in the sense that my discussions with him, coming early in my fieldwork, challenged what I thought I knew about Bali and introduced me to ideas I am still today unraveling—was the Brahmana mask maker and scholar, Ida Bagus Sutarja of Mas. I first met Sutarja when I went to view his amazing collection of masks. Later I returned to ask him about the masks of Rangda and Barong. What he had to say so impressed me that I soon returned to ask further questions. This grew into a regular dialogue, and for many months I conversed with him for several hours each week. Gradually my questions and his answers were leading to a comprehensive picture of a Balinese religion that seemed very different from what I had read about in the general anthropological literature. Sutarja's knowledge, I learned, was based on textual sources and so I began to seek them out. I also sought out as many other informants as I could, as I became aware of the many different levels of understanding that prevailed. The question of who knows what—and what kinds of knowledge people were disclosing to me—became uppermost in my mind.

Over a period of three years, in addition to observing daily life and ritual, I consulted many Balinese, including ordinary villagers, men and women, gentry and commoners, university-educated elite, temple priests *(pemangku)*, puppeteer priests *(dalang)*, local leaders *(bendesa adat, klian banjar)*, healers *(balian)* of various kinds, spirit mediums *(balian kataksson)*, Brahmana priests *(pedanda)*, Brahmana scholars, artists, traditional architects, woodcarvers, mask makers, performers, and others. Undoubtedly the best informed, those with the most comprehensive view, were Brahmana priests and scholars, although I also encountered *pedanda* who were not so learned. I found that village priests were rarely able to articulate the themes explored here. *Balian usada,* by contrast, were evidently familiar with these ideas; but I always found healers to be more interested in selling cures or talismans than in offering information, and most were reluctant to part with professional secrets. The problem arises, of course, that the kind of knowledge I was seeking was essentially esoteric knowledge and access to it requires an ongoing relationship of trust with the person concerned—a relationship that cannot be built with a large number of people or even several. Thus it is really impossible to know precisely what another person knows—only what they

will disclose to you in certain circumstances. It was for this reason also that I sought out textual knowledge so that I would not be entirely dependent on what particular individuals were prepared to tell me.

Sutarja, the Brahmana mask maker, once commented that my researches were leading me to the "deep meaning" of Balinese culture. At the time I felt embarrassed and laughed, thinking he was seeking to flatter me. He explained there are three basic levels on which rituals are conducted and three different levels of understanding them. He called them the *nistha, madhya,* and *uttama,* the ordinary, middle, and highest levels.[14] I had heard other people use these terms to describe a ceremony's level of complexity and elaborateness: ordinary people might conduct a ceremony at the *nistha* level, those of greater status or wealth might aim at the *madhya,* while only kings and princes could afford the *uttama* level. According to Sutarja, all religious and ritual matters can be understood on the basis of these three levels. The ordinary person knows enough to prepare the offerings and carry out the physical work necessary to perform a ceremony. At the middle level are the community leaders—the *pemangku* (village priests), the *bendesa adat* (local leaders), and other local officials—who know what is needed to guide and organize the people's labors. Then there is the level of the scholars and priests who study the *lontar* texts and understand the underlying significance of the rituals. In the past, and even today, Sutarja insisted, it is not appropriate for people to know more than their status and role require. Each knows what is necessary to their functioning within the whole scheme.

From this perspective, it might be expected that each level of society possesses a rather different view of what is going on and that many Balinese might know nothing of the esoteric themes and metaphysical understandings under discussion. Certainly in Sutarja's view, those who are privy to the "deep meaning" are Brahmana scholars and priests like himself. Yet I was to find that many other Balinese possessed similar understandings. Essentially my observations concerning the different levels of knowledge parallel studies by philologists, referred to in Chapter 1, concerning the distribution of traditional literacy in Bali. Those who have the most extensive knowledge are the *pedanda* and Brahmana scholars—the apex of the literacy pyramid. But many others, according to vocational needs, personal ability, and preference, are deeply versed in the mystical understandings I have described. The ideas expressed by Budiana and Mirdiana are not common knowledge in the sense that every Balinese can articulate them, but neither are they confined to a specific elite. Like traditional literacy, to which it is evidently closely linked, this knowledge is much more broadly distributed throughout the populace.

Clifford Geertz's influential observation that Balinese religion is more about praxis than ideology may be true for some or even many Balinese, but not for all. The textual scholar C. Hooykaas made the same point many years ago—challenging Geertz's assertion that all Balinese were uninterested in philosophy and metaphysical speculation and drawing attention to the proliferation of translations into Indonesian of Balinese mystical texts, a trend that continues to the present.[15] Furthermore, these ideas are propagated indirectly in other ways. Mirdiana, brought up in a household of distinguished artists, knows most of the myths he paints from listening to his elders tell stories and especially from watching *wayang kulit* performances as a child. His experience is typical of many. Stephen Lansing has drawn attention to the way in which Hindu ideas were propagated in Bali (and all over Indonesia)

through performance in the form of the shadow puppet theater and the many dances, dramas, and textual readings that accompany rituals of all kinds.[16] My informants often commented that the mystical understanding they described was in fact expressed in public ritual; it was not secret or hidden from those who cared to listen. Indeed when I was alerted to the meaning of textual readings at temple festivals and started to pay attention to *wayang lemah*—the daytime puppet theater "performed for the gods"—I discovered in them the stories of Siwa and Uma taking demonic form as well as the origins of *caru* rituals held for the *bhuta kala*. If one listens to the words of the Pandung (the king's minister) at performances of Calong Arang, the mystic marriage of fire and water is mentioned, as is the *rwa bhineda* (the two different ones; the union of opposites). Most members of the audience, it is true, seem little aware of these details, but they are there for those who are interested.

Although many Balinese cannot articulate them in so many words, I am convinced that the ideas revealed in the works of Budiana and Mirdiana are in fact widely known. Indeed the reason I have chosen these two artists as the focus of my discussion is that their works express in concrete form understandings described to me by many other Balinese. I find further compelling evidence in Howe's ethnographic study of Balinese culture where, on the basis largely of explanations given by ordinary villagers and observations of a wide range of ritual activities, very similar ideas and understandings are described.[17] I have noted many parallels in the previous two chapters. In particular, I am struck by Howe's emphasis on the demonic forms of the high gods, the nature of the *bhuta kala,* the intent of *caru* rituals as returning demonic entities to benign form, the importance of mother goddesses such as Ibu Pretiwi, Uma, and Sri, the association of the earth with wealth and riches and materiality, the meetings and separation of Mother Earth and Father Sky, the cycles of transformation through birth, marriage, and death rituals, and the cosmological notions where high, center, and masculine prevail over low, periphery, and female. Furthermore, I am impressed by the degree of conceptual coherence that Howe reveals in the vast diversity of the ethnographic evidence he presents. Starting from an entirely different perspective, drawing on different informants and sources of information, Howe presents an analysis of the cultural concepts and idioms shaping the Balinese worldview that is entirely consistent—although not identical—with the mystical themes expressed by my priestly and literati informants.

Sutarja's explanation of the three levels of understanding clearly implies that the different levels are not unrelated and, moreover, that the ritual actions of the ordinary person are guided by others who know more. This points to an underlying pattern of significance shaping the ritual action. We have glimpsed something of this in the connections between the symbolism of the Barong and Rangda temple performance and the marriage of fire and water as described in *lontar* texts.[18] Nor are the vast quantities of offerings required for various ritual occasions simply left to the discretion of village experts. They are minutely detailed in the *lontar* texts—further indicating that the link between the texts and ritual performance might be an intimate one. I am not suggesting the existence of a precisely formulated doctrine. Rather I wish to suggest that certain shared ideas and understandings, such as those I have cited in the previous two chapters, constitute a core of organizing themes around which ritual is structured. I will return to these arguments in Chapter 5.

Parallels with Tantric Thought

Although the themes of transformation, ambivalence of divine forces, and power of the Mother that I have identified may seem unfamiliar in the context of Balinese religion, they are by no means foreign to Hindu thought in general, especially Shivaism. As Shakti Gupta observes: "In Hindu mythology and symbolism, Vishnu, Shiva and Shakti, the Mother Goddess, are visualised as both terrible and benign, creative and destructive, ugly and handsome."[19] Mirdiana's handsome and horrific representations of Siwa and the mother goddess Uma clearly belong to the same conceptual world; in Budiana's work the emphasis on sexual symbolism, the power of Sakti, Kundalini, and the union with god within the self evokes classic Tantric themes.

A central theme of Tantrism is an emphasis on "the divine energy and creative power (Shakti) that is represented by the feminine aspect of any of various gods . . . above all as the wife of Shiva."[20] Budiana's fascination with the Mother, especially in her terrible forms, suggests even the more extreme forms of Indian Sakta teachings.[21] If we are inclined to dismiss this fascination as merely his eccentricity or the result of modern influences, we need only remind ourselves of the predominance of terrifying images of Durga in Balinese temple sculpture and the hideous Rangda in temple performance (see Plates 25–28). It was through my investigations into the meaning of Rangda and the mythical beast Barong that I first began to learn of the "power of the Mother."[22] I was astonished to hear Brahmana scholars, such as the mask maker Ida Bagus Sutarja, speak so eloquently of Rangda (I had thought she was merely the evil witch) as the "Mother," the source of all physical being and existence. Sutarja once remarked to me that when he was a child his father once pointed to the masks of Barong and Rangda and told him: "These are our great parents." Sutarja scoffed at the idea Rangda was killed in the temple performances. This was impossible—to kill her would be to destroy the very source of our own being. The Mother possesses enormous power, and this constitutes a great danger if it gets out of control. The role of Barong, who is also Siwa, is to bring this dangerous, terrible, but creative power under control.

The relation between Siwa and his Sakti was explained to me in the following terms by a Brahmana priest. Siwa is the *pelebur,* the destroyer, the divine principle whereby the physical universe is returned to its original state. It is usually, however, Siwa's Sakti or female energy, the Dewi, in her fierce form of Durga, who performs this role. God is not concerned with the material world; it is only his Sakti that is drawn to the material and is responsible for creating and caring for it. "It is like this," the *pedanda* observed jokingly: "If people bring presents and food here to the *griya* [Brahmana household], the *pedanda* does not think about them, but his wife *(pedanda istri)* will care and will take and use those material gifts." Thus the Sakti is that aspect of divine power which concerns itself with the physical world of material substance and bodies. The "power of the Mother" (Dewi/Sakti), which plays such a central role in Budiana's oeuvre, is, I believe, a highly important aspect of Balinese mystical thinking that has been overlooked by many European scholars, though certainly not all.

It has long been thought that the form of Hinduism brought to Bali was Shivaism strongly influenced by Tantrism. More than forty years ago, Jacoba Hooykaas noted several important Tantric elements in Balinese ritual:

> The religion which found its way from India to Java was a Siwaistic
> Tantrism. . . . In this religion the sexual union of the Upper God Siwa and
> His spouse plays a prominent part. It is believed that a *yogin* who is able
> to effect in his body the intercourse of these two gods achieves liberation.
> In Java several images of the divine figure have been found in which is
> expressed this complete blending of male and female. They are called
> *Ardhanareswari* and have one male and one female breast. In Bali nowa-
> days, when the Brahmin priest, to prepare the holy water, achieves this
> mystic union in his body, he mentions the divine couple *(dampati)* in his
> chant; his manuals recommend him to concentrate his thoughts on *Ardha-
> nareswari.*[23]

The Sanskrit scholar Sylvain Lévi had even earlier drawn attention to the pervasive
influence of Tantrism in Bali.[24] The clearly Tantric nature of many texts found in Bali has
been noted by several textual scholars.[25] Archaeological studies have revealed Tantric ele-
ments in old Balinese sculpture, structures, and inscriptions.[26] The anthropologist James
Boon has identified Tantric elements in Balinese ritual and religion while at the same time
observing that these have been underplayed by most scholars.[27] A reluctance to engage with
the obvious Tantric elements in Balinese thought has been further noted by Barbara Lovric;[28]
her detailed investigation of Balinese traditional medical texts *(usada),* unfortunately unpub-
lished, provides extensive and important data to demonstrate the pervasiveness of Tantric
influences in Bali. Hildred Geertz too refers to Tantric aspects of Balinese ritual, especially
in relation to witchcraft and sorcery.[29]

Tantrism remains a topic surrounded by much misunderstanding and popular sensa-
tionalizing and has only recently become the subject of serious scholarly study among
Indologists themselves.[30] Indeed just to mention the word "Tantrism" immediately conjures
in some minds visions of sexual orgies and revolting rituals thinly disguised as spiritual prac-
tices.[31] Naive enthusiasm in the West for Eastern religions, along with New Age spiritual-
ism, have added to the problems of sensationalizing, debasing, and exoticizing. Any attempt
to place Balinese mysticism in the context of Tantric thought must struggle against these
strong opposing currents.

But a coming of age of Tantric studies among Indologists is beginning to offer a fresh
basis for understanding Tantrism,[32] recognizing it as an important and pervasive stream in
Indian thought, not a decadent backwater. Teun Goudriaan explains that a simple definition
of Tantrism is impossible: "The extremely varied and complicated nature of Tantrism, one
of the main currents in the Indian religious tradition of the last fifteen hundred years,
renders the manipulation of a single definition almost impossible."[33] Recent studies by
Indologists are revealing the philosophical and spiritual insights that inform Tantric ritual
practices, as well as the metaphysical concepts underlying the use of mudra, mantra, and
yantra, all of which had previously appeared to many Western scholars to be so much
mumbo-jumbo. Tantrism in India is no longer dismissed by serious scholars as a bizarre con-
catenation of sexual and graveyard imagery. It is now recognized as a "practical individual
road to salvation" that provides for many an alternative to the Vedic *sadhana* (an alternative
to orthodox vedic practices).[34]

These new understandings are contributing to a renewed scholarly interest in Tantrism in Bali and pre-Islamic Java.[35] A recent study by Raechelle Rubinstein has drawn attention to the strong Tantric elements in the Balinese *kekawin* literature, identifying the very aim of the *kekawin* genre of poetry to be nothing less than a form of "literary yoga."[36] Rubinstein develops Zoetmulder's insights concerning the mystical function of Old Javanese *kekawin* poetry as providing a concrete vehicle—yantra—in which the presence of the deity could be invoked in order to bring about a mystical union of the soul of the poet with the divine.[37] Rubinstein shows, however, that the Balinese works have their own character and emphasis, drawing much more extensively on sexual imagery to depict the beauty of the natural world celebrated by the poet. She observes:

> An interesting shift would appear to have taken place in the conceptual-
> ization of nature's beauty, from the female body in Java to the sexual
> union of a man and woman in Bali. However, these images are not irrecon-
> cilable but can be seen to complement each other. Whereas the beauty of
> nature depicted as sexual union that Nirartha observed symbolizes the
> union of the self and the cosmic soul by way of the ritual copulation of
> the divine couple, the beauty of nature expressed as female beauty in Java
> symbolizes and celebrates the goddess alone. Worship of the divine
> female consort, the *Śakti,* is a prominent element in Indian Tantrism. In
> Tantrism, the *Śakti* is the Mother Goddess known by a number of names
> such as Devī, Durgā, Umā and Kālī. . . . The beauty of the natural world
> is represented as Woman, for she represents unevolved nature, the seed
> of the material universe. The poet contemplates and immerses himself in
> nature-Woman as a mystical rite, as ritual copulation. His goal is yogic—
> to become one with the goddess, to mystically unite with the cosmic
> source.[38]

Underlying the Balinese poet's Tantric goals, Rubinstein further shows, is a complex philosophy and practice wherein written letters and syllables take on a mystical significance developed in yogic meditation.[39] The resemblance of this "alphabet mysticism" to similar ideas in Indian Tantrism, she observes, has been noted by several Balinese scholars including Goris, Weck, and Soebadio.[40]

Rubinstein's bold departure from previous reticence by textual scholars to deal with the erotic in Balinese literary and philosophical works is reinforced by new research by Helen Creese and Laura Bellows on Balinese sexuality in nineteenth-century textual sources.[41] They describe how earlier scholars avoided erotic texts and note the tendency to dismiss any text with overt erotic content as pornography and thus not worthy of serious scholarly attention. Their discussion ranges over Balinese *kekawin* texts describing courtly love and a number of *tutur* texts dealing explicitly with sexual matters and what the authors term "sexual yoga," drawing attention to similarities with various Indian erotic texts. These arguments open up a new perspective on the erotic in Balinese mysticism.

In view of this renewed interest in Tantrism in Balinese culture, as well as the emerging maturity of Indian Tantric studies in recent decades, a broad reassessment is due. As a step

in this direction, I wish to undertake an extended comparison of the basic premises of Tantric thought, as outlined in a groundbreaking study by the Indologists Gupta, Hoens, and Goudriaan,[42] with Balinese mysticism. Although I do not advocate an approach that sees Balinese religion as merely a reflection of Indian models, I think such a comparison can help us advance beyond old stereotypes and begin to appreciate the breadth of Tantric thought as a philosophical system. Goudriaan, of course, worked extensively with Hooykaas on Balinese materials.[43] A problem for textual scholars is to discover the relation between the texts they examine and the place of those texts in contemporary ritual practice. Soebadio, for example, in translating the *Jñānasiddhânta,* a recognized Tantric text from Bali, observed that the manuscript hardly seemed to have been used or even opened, suggesting it played little part in contemporary Balinese understanding.[44] Such, I think, is often the assumption of the philologist, who in any case is not primarily concerned with how a text might be used in contemporary religious life. This, however, is precisely the concern of the anthropologist. Rubinstein's work is especially valuable here since she approaches the *kekawin* genre not as a static body of texts, as one might expect a philologist to do, but from the perspective of *kekawin* composition as a ritual act or process.

Before I begin my comparison, I would like to draw attention to the fact, rarely remarked upon by Western scholars,[45] that the word for "religion" in Balinese, in Old Javanese, and in modern Indonesian is *"agama."* This word in Sanskrit, from which it derives, is the term usually applied to Tantric scriptures. Literally meaning "the source of teachings,"[46] the word *"agama"* in Indian Hinduism specifically refers to the teachings Shiva gives to his Shakti. Such texts are usually structured as dialogues between Shiva and Uma whereas texts in which the goddess is the proclaimer are termed *"nigama."*[47] Hooykaas notes that a "well-beloved form of literary composition," both in the Indian Tantra and in Old Javanese/Balinese *tutur* texts, consists of Uma/Parvati being instructed by her spouse Lord Śiva.[48] With this in mind, it is not difficult to see why the Balinese myths concerning the divine couple might prove to be so important. The origin of the term *"agama"* suggests that in Java and Bali the very essence of mystical and spiritual teaching was that deriving from the agamic dialogues of Siwa and Sakti.[49]

Key Features of Tantric Thought

In seeking to trace parallels between Balinese thought and Indian Tantrism, I should stress that my aim is not to establish historical antecedents. As Indologists refine their understanding, it is evident that what previous scholars may have identified as Tantric themes may no longer apply or must be broadened to encompass new ideas. My aim here is to demonstrate certain fairly obvious parallels between the ideas reflected in the artworks I have discussed and the central premises of Tantrism as emerging from recent research by Indologists. This is not to assert that the Balinese themes I cite are directly linked historically to India but simply to place them in the same generic group of ideas constituting the multiplex traditions that have come to be known as Tantrism. I am not attempting to explain how these ideas developed in Bali or detail their antecedents—a huge task that would involve careful historical investigation of what is known of Tantrism more generally in Indonesia, especially

pre-Islamic Java. I am simply trying to establish that many elements of Balinese mysticism can, in Teun Goudriaan's terms, be clearly identified within the Tantric tradition.

Goudriaan observes that in Indonesia there are "various traces of Hindu Tantrism" and that in Bali "various Tantric elements are well known. . . . Among them are the six *cakras* and the Kundalini as well as micro-macrocosmic symbolism."[50] I think his observations can be taken considerably further than this: much more than "traces" of Hindu Tantrism can be found in Bali. In seeking to outline the nature of Tantrism as a system of thought in India, Goudriaan cites eighteen key distinguishing features.[51] I want to discuss each feature in turn to reveal the important parallels that can be drawn with Balinese religious thought and ritual. Most of what I describe are in fact well-known aspects of Balinese thought, but they have not always been recognized as Tantric.

1. Tantrism offers "an alternative and practical individual road to salvation, characterized as a *Sādhanā*, beside the Vedic one which is often considered to be antiquated."[52] Here Goudriaan asserts that Tantrism in India is a system complete in itself—a position we are not yet ready to argue in the case of Bali, where Tantrism has so far been identified in "fragments" or "traces."[53] Yet it is clear that Balinese Hinduism constitutes a complete system. C. Hooykaas offers a short comparison of the Indian *panca-yajña* and the Balinese *panca-yajña* (five sacrifices), pointing to the differences between them, although revealing overall a basic similarity in nature and intent.[54] Although Balinese often use the term *"veda,"* the Indian Vedas have not been found in Bali, suggesting that these texts are unlikely to provide the basis of Balinese religious thought and practice.

2. Tantrism expounds "mundane aims beside spiritual emancipation. . . . Tantric methods are considered applicable for various sorts of practical attainments including astrology, medicine and magic. . . . Many written sources of Tantrism are pre-occupied with the description of supernatural abilities. . . . There remains, however, always a connecting thread between . . . the magical and the spiritual."[55] The intense interest in magic and sorcery in Bali has been understood by many Western scholars as separate or tangential to religion, the legacy of a primitive past of animistic belief.[56] Yet it is widely recognized that astrology, medicine, and magic are the subject of a great many Balinese *lontar* texts. Hooykaas has discussed and translated several magical texts.[57] The predominance of Balinese texts dealing with medicine is such that a special category of these works exists, the *usada,*[58] and the manuals of magic are referred to as *kawisesan.*[59] In his study of Tantric magic,[60] Goudriaan discusses some magical texts from Bali; Lovric, in her extensive investigation of Balinese *usada* texts and healing rituals, has emphasized a "strong Tantric orientation" in Balinese magic.[61] Yet in general, Western writers have overlooked these Tantric elements in Balinese magic. For many, especially the early Christian missionaries and Dutch colonial officials, a division between religion and magic was assumed, a point also emphasized by Hildred Geertz.[62] This notion, I suggest, from the outset led to assumptions that such apparently primitive practices as sorcery had nothing to do with the higher teachings of Hinduism. Similar assumptions have pervaded the approach of Indologists to Tantrism in general, as Max Nihom points out.[63] Certainly not all scholars of Bali have treated magic as marginal to Balinese religion, especially anthropologists,[64] but few have categorized these practices as Tantric.

Goudriaan suggests that the spread of Tantric doctrines in India and Southeast Asia must be understood, at least in part, as motivated by the appeal of such teachings, promising mundane achievements, to local rulers.[65] Kings desiring to increase their own secular powers would have good reason to give patronage to sages who presented themselves as superior magicians and sorcerers. Margaret Wiener's recent study of the importance of magical/supernatural powers in the history of Balinese dynastic struggles against colonialism provides ample evidence to support this view.[66]

Balinese magic must be approached, not as an outworn relic of decadent "left-hand" Tantric practices or primitive animistic beliefs, but as an integral part of a complex, highly developed Tantric philosophy and worldview. That simple village people understand magic in simple terms is, of course, no reason to assume theirs is the sole level of understanding. We are dealing here with what is essentially esoteric knowledge. In the Tantric view, the acquiring of magical powers, the *siddhi*, is a natural consequence of the development of spiritual powers—but a potentially dangerous one since it can pose serious obstacles to further spiritual development.[67] Balinese have often told me that some students of the *lontar* texts, including *pedanda,* become so fond of exercising these powers that their development to higher levels is blocked and they become powerful magicians rather than spiritual adepts.

3. Tantrism "teaches the practice of a special variety of yoga destined to transform the animal instincts and functions by creating an upward movement in the body along yogic nerve centres (cakra). The process is most commonly expressed as "rousing . . . the Kuṇḍalinī."[68] We have seen Budiana's understanding of kundalini clearly revealed in works like *Mahkota* (Plate 10), where the upward movement of the snakelike Goddess from "the animal instincts and functions" is vividly depicted in the twisting forms of the painting. Goudriaan states that kundalini is "well known at present in Hindu Bali."[69] Kundalini, who in Tantric teachings is revealed as the goddess Uma in the body, is mentioned in Soebadio's published translation of a Kawi text, the *Jñānasiddhânta,* found in Bali.[70] Soebadio also notes R. Goris' discussion of *"Kuṇḍalinī* and *amṛta-Kuṇḍalinī"* in Balinese philosophy.[71] In her examination of the *usada* texts, Lovric points to the knowledge of kundalini yoga in Bali and refers to *lontar* texts providing instruction in its practice.[72]

The technical terms used in kundalini yoga, such as *prana, pingala, susumna, nadi, bindu (windu),* and *nada,*[73] are also found in unpublished Balinese *tutur* texts that make no mention of kundalini or refer only briefly to it.[74] Some of these texts, such as *Siwa Linga Suksuma,* describe the mystic marriage of fire and water in the self achieved through yogic visualization, as I discussed earlier in relation to both Budiana's and Mirdiana's works. This union of opposites in the self, if not identical to, is very similar to the kundalini practices, where Kundalini/Sakti is united with Siwa in the body of the adept. There is a further similarity with the union of opposites described in the texts of the Brahmana priest's daily ritual, where at the climactic moment the priest concentrates on Ardhanareswari: Siwa and Sakti united.[75]

Although the precise relationship between these different esoteric teachings has yet to be established, what seems very clear is the prominence of yogic practices aimed at achieving a union of cosmic energies within the self. (I will discuss Rubinstein's work on literary yoga in section 5 and Creese and Bellow's description of sexual yoga in section 11.) Furthermore it is evident from the works of our two artists that living traditions are involved, not

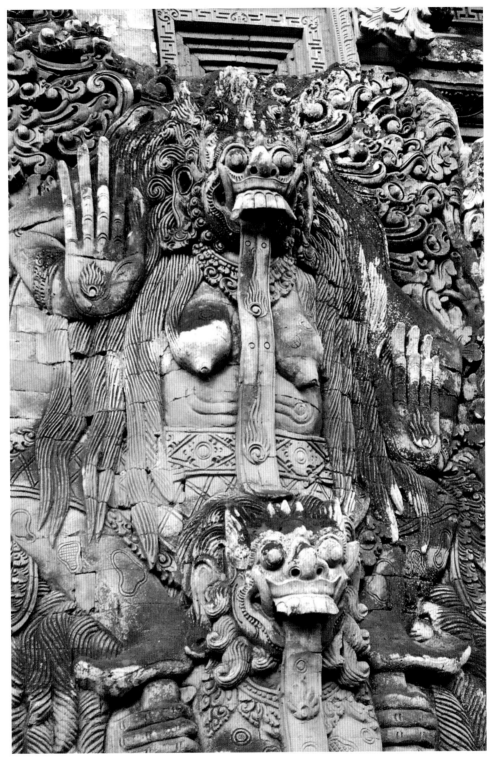

Plate 25. *Temple relief of Durga on the left side of the Kori Agung (enclosed entrance to the inner court), Pura Dalem, Sidan. (Photo: Michele Stephen)*

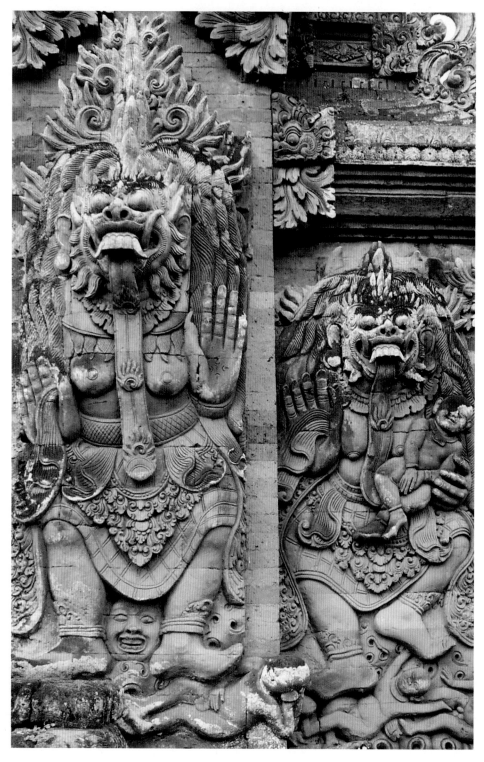

Plate 26. *Temple reliefs of Durga's followers dancing on the corpses of babies. Detail of the Candi Bentar (split gate), Pura Dalem, Sidan. (Photo: Michele Stephen)*

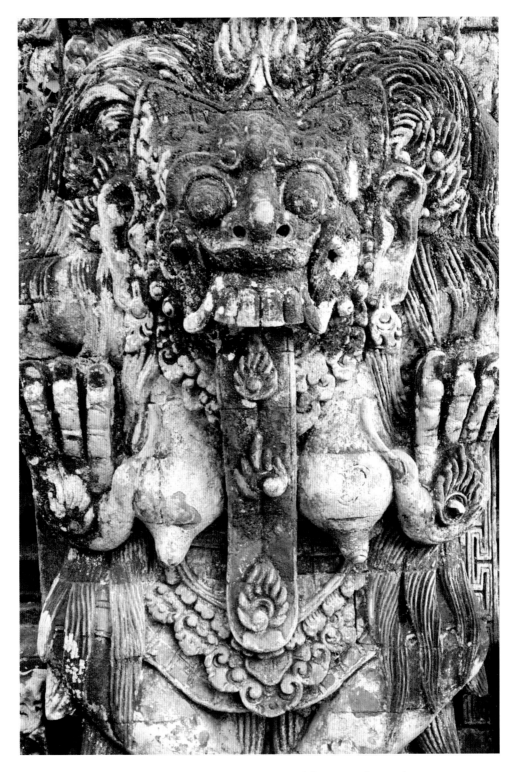

Plate 27. *Stone statue of Durga in the inner court* (jeroan) *of the Pura Dalem, Sidan.*
(Photo: Michele Stephen)

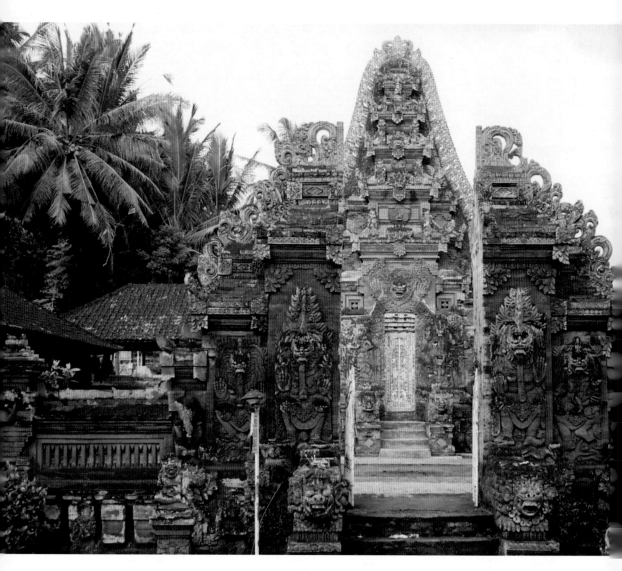

Plate 28. *The Pura Dalem, Sidan, facing the Candi Bentar (split gate) and looking through to the Kori Agung (enclosed entrance to the inner court). On both sides of the split gate can be seen reliefs depicting Durga's followers and disciples. (Photo: Michele Stephen)*

merely textual survivals. Lovric notes that several of her informants were familiar with the practice of kundalini yoga.[76] Likewise I have been told by Balinese well known to me of their personal experiences of raising the kundalini in healing rituals. Thus there is extensive evidence to indicate that kundalini yoga has long been known to Balinese—the *Jñānasiddhânta,* for example, is dated by Soebadio to the Majapahit period—and that it continues to play an important role in Balinese mystical thought.[77]

4. **"Connected with this yoga is the elaboration of a mystic physiology in which the 'microcosm' of the body is identified or homologized with the 'macrocosm' of the universe and the world of the gods. Insight into and meditation on the various aspects of this identification, concomitant with the worship of internal divinities, is necessary."**[78] The correspondence between the *bhuwana agung* (macrocosmos) and the *bhuwana alit* (microcosmos) is one of the best-known characteristics of Balinese religious thought and ritual,[79] yet it has rarely been acknowledged as an aspect of Tantric thought. Goudriaan and Rubinstein, however, have both drawn attention to the important similarities of this Balinese concept with Tantric ideas.[80] The numerous *lontar* texts dealing with the four spiritual siblings *(kanda empat)* describe, though often in different ways, the correspondences between the human body and the natural world: the grass is hair, the mouth a cave, and so on.[81] The skin, flesh, bones, and organs of the body are identified as the dwelling places of the various gods and are assigned mystical sounds, letters, and mantras. Meditation and visualizations of these internal deities are clearly evident in the unpublished *lontar* texts referred to earlier, as well as the texts translated by Hooykaas and Lovric.

5. **"Important are speculations on the mystic nature of speech and its constituents (the articulated sounds; in practice: the Sanskrit alphabet); the existence is assumed of a phonic creation parallel to the material phenomena."**[82] The constant references in Balinese *tutur* texts to the *dasaksara* (the ten sacred letters) and their numerous transformations—and the importance of meditation on the *ongkara, windu, ardhacandra,* and *nada,*[83] all of which are written symbols related to mystic sounds—can leave no doubt as to the significance of such matters in Balinese mysticism. Hooykaas and Zurbuchen have described the *dasaksara* and the ritual manipulations of them.[84] More recently, Rubinstein has drawn attention to the Tantric nature of what she describes as Balinese "alphabet mysticism."[85] Many Balinese have emphasized to me that the very shape of the sacred letters, as well as their sound, exerts a mystical influence on the user; thus to encounter the texts in transliterated or translated form is to lose much of their power. In other words: the conceptual level of understanding is but a small part of the meaning invested in these symbols.

Once the Tantric nature of this "alphabet mysticism" is recognized, it becomes clear that a great many Balinese mystical texts are essentially Tantric. The Brahmana priest's *Surya-Sevana* is evidently one, as are the unpublished *tutur* texts referred to earlier, as well as Soebadio's *Jñānasiddhânta.* Rubinstein's work goes even further to establish in detail that the whole genre of *kekawin* poetry in Bali has a Tantric cast. The primary aim of composing *kekawin* poetry, Rubinstein argues, is to achieve a union between the poet and the divine—a process she describes as "literary yoga," the poem serving as a yantra into which the divine or Siwa soul is ritually invested. If Rubinstein is correct—and she supports her arguments

with careful and extensive philological evidence—then her study has a far-reaching implication: a large amount of what Western scholars have understood as merely literary works must now be reassessed in terms of their mystical, essentially Tantric, import. And there are yet further ramifications in that the shadow puppet theater *(wayang kulit)*, and other types of drama, dance, and performance on ritual occasions, all to some extent draw on the *kekawin* literature. These genres too must now be reassessed in the light of Rubinstein's work.

6. "This has been developed concretely in the very frequent use of generally short, often wholly or partly unintelligible formulas *(mantras* and *bijas)* invested with supernatural power by means of definite ritual procedures and made the object of cosmic symbolism."[86] The important role of mantras and *bijas*—the same terms are used in Balinese texts—is obvious in Hooykaas' many translations, although he himself does not remark on the Tantric nature of such elements. Lovric emphasizes the importance of mantras in Bali mystical thinking, describing the "power of utterance *(sabda)*" in Balinese texts.[87] The pervasive use of mantras is evident merely by watching priests and even laypersons performing rituals, and Balinese will commonly refer to any formula recited in a ritual context as "mantra."

7. "General use of concrete devices like intricate formulas, geometrical designs *(maṇḍala, yantra, cakra)*, gestures *(mudrā)* for the expression of metaphysical or other abstract principles . . . such concrete resources are apt to be burdened with one or more symbolic meanings, by preference three, often distinguished by the terms *sthūla-* 'coarse' or 'material'; *sūkṣma-* 'subtle,' which may refer to the phonic plane; and *para-* 'supreme' or 'metaphysical'."[88] The importance of the mudra is well documented in the works of Hooykaas and others and easily observed in the ritual performances of Brahmana and commoner priests.[89] The use of geometrical designs is most evident in the *nawasanga*, which represents the nine directions and is often drawn as a *padma* (lotus) in a circular geometric form.[90] Such a diagram usually includes the gods of each direction with their female energies (Sakti), each with its specific color and emblems, and may include sacred letters such as the *ongkara*, or *bija* mantra, written on each petal of the lotus.[91] The *cakras* of kundalini yoga have been noted by Goudriaan.[92] The *cakras* and the *nawasanga* can be regarded as types of mandalas. Diagrams drawn on the ground are used today in the *caru* ritual known as Resi Gana. Hooykaas' compendium of Balinese "magic drawings" *(rarajahan)* provides many other examples,[93] as does Lovric.[94] Rubinstein and Zoetmulder have identified literary works as "yantra."[95] The different levels of symbolic meaning carried by these concrete devices, referred to as *sthula, suksma,* and *para*, are distinctions also commonly made in the Balinese texts between different levels of phenomena.

8. "Realization of the supernatural world by specific methods of meditation *(dhyāna)*, involving in the first place the creation of mental images or pictures of gods and goddesses who may be worshipped internally. The deity thus created may be invoked for social, especially medical, aims."[96] The role of visualization in Balinese ritual is clearly indicated in texts such as *Siwa Linga Suksma,* where the adept is instructed to imagine a golden vase pouring nectar *(amerta)* over him, or in the *kanda empat* texts, which provide vivid correspondences between the adept's body, the natural world, and the heavens, so that his physical body becomes a reflection of the universe.[97] Hooykaas' translations provide many examples, such as *Surya-Sevana,* the

text of the Brahmana priest's daily ritual.[98] The text is replete with instructions to visualize each step of the rite, as the priest's soul is removed from his heart to just above his head, so that the burning and washing away of all impurities in his body can be performed, until the climactic moment when the priest must focus his attention on Siwa as Ardhanareswari (Siwa and his Sakti united in one body). At many points in the text the precise form in which the deities are to be invoked—their shapes, colors, decorations—is described in detail. There can be no doubt, reading the text, that the aim of the ritual is to induce a vivid mental picture through meditative concentration. Watching the performance, one observes that the priest appears to be in trance.

9. **"Ambivalence of divine—and human—existence: the divine and the demoniac, as also the erotic and the destructive, are considered to be complementary aspects of the same awesome invisible reality."**[99] Western scholars of Bali are by no means unaware of the demonic forms taken by Siwa, Uma, and other high gods, but less attention has been paid to the processes of cosmic transformation these forms imply.[100] Hildred Geertz is one of the few Western scholars who has pointed to ambivalence and transformations of deities and spirit beings as constituting a pervasive and important theme in Balinese religion.[101] Lovric, whose view is based primarily on medical *lontar* texts *(usada),* likewise draws attention to these themes:

> Things are fluid. Nothing is unalterably fixed. Spirits, deities and demons, the prime causal agents in the fluctuations of existence, defy definition and determination. They have an existence of "becoming," of illusions and of transforming rather than being. They are mobile, not confined. They mutate and merge. *Bhuta-kala,* when decontaminated by *caru,* can become *widydara-widydari* and *gandharwa-gandharwi.* The non-linear or cyclical mode of thought inherent in constructions of beings and things becoming something else or assuming new embodiments is unlike the analytical linear thinking which emphasizes the polarity and the fixity of opposites.[102]

Yet for many scholars the idea that the Balinese cosmos constitutes an unchanging hierarchical ordering, reflecting the social order, seems to have prevailed against evidence to the contrary.

Exploring transformations of the divine and the demonic has been one of the central concerns of this book. I have traced these transformations, not only in the works of Budiana and Mirdiana, but more importantly as they are revealed in Balinese mythology—especially in the myths concerning Siwa, Uma, and their offspring Kala and Kumara. These mythic narratives point to abstract and philosophical understandings of the cosmos and the forces that shape it—understandings that clearly reflect Tantric concepts. In my view, the dynamic nature of the Balinese cosmos is a key to understanding Balinese religious thought.

10. **"The importance of female manifestations called Śaktis."**[103] The importance in Balinese mystical thought of the "power of the Mother," or the Sakti, has been one of the major themes of my discussion so far. Yet while the literature in general recognizes the importance

in Bali of female deities, such as Dewi Saraswati, Dewi Sri, and Durga, on the whole these have been described as "goddesses" with little attention to their more esoteric significance as Sakti, or female energies of gods. Those who have noted the Tantric elements in Balinese religion, however, such as Boon[104] and Lovric,[105] refer to Sakti and stress the importance of feminine deities. It is well known that the gods of the four (or nine) directions possess female counterparts, and textual materials provide endless references to Siwa and Sakti. Few textual scholars, however, have made the Tantric implications of this parallel as clear as Rubinstein in her discussion of images of the feminine in Balinese *kekawin* literature.[106]

The negative aspect of the Sakti as Durga in Bali deserves particular attention.[107] Durga is associated with the death temple, not because she is simply destructive, but because of her important role as *pelebur,* the one who returns dead life forms to their source. What this means is that Durga, as Siwa's Sakti, takes on his role as *pelebur,* the Sakti being the active principle. This function has, I think, been misconstrued by many Western scholars as the remnants of some kind of demonic cult centering on black magic and graveyards, with Durga as the queen of the witches.

Hariani Santiko, for example, observes in the iconography of Durga statuary in Java during the tenth to the fifteenth centuries a change from a beneficent form of the goddess, represented as the slayer of the demon Mahisa, to later portrayals of her as a demonic figure. In Santiko's view, this change came about because of popular misunderstandings of Tantric rituals in which the goddess was worshipped, which "caused her image to be tarnished, turning her into an evil *rākṣasī,* not a goddess, but a fanged queen of the dead who lives in graveyards."[108] What Santiko does not explain is how this "popular" misconception was then fed back into the court circles responsible for commissioning the literature and statuary portraying demonic forms.[109] In Bali today, the beautiful form of Durga as the slayer of the demon Mahisa is still known, though far less common than the demonic form. Balinese refer to Dewi Durga, as well as Durga, indicating a less terrible, more beneficent, form. Some would say that it is Dewi Durga who is found in the Pura Dalem and Durga or Rangda who is found in the cemetery. The point is that we are dealing here with transformations along an axis from divine to demonic and back again. Uma becomes Durga/Rangda on earth; is returned via ritual to the Pura Dalem as Dewi Durga; and ultimately returns to Siwa's heaven as Uma. These transformations are not aberrations but inherent in the cosmic powers that the myths portray.

Budiana's work gives us a more subtle understanding of the demonic aspect of Durga. He shows that Durga is horrific in the graveyard, yet her function is positive: to return what is damaged and degraded to its original perfect condition. So long as Durga and her minions, the *leyak,* are confined to the graveyard, they serve an important end. Only when they get out of control and start to attack the living are they dangerous. Thus the figure of Durga is not a figure of evil but represents the necessity of death and dissolution for all living entities. In the mother's womb, material elements are combined to create a new physical body; in the grave, Durga dissolves these elements so they can return to their source and be recombined in new forms. Though death and dissolution are horrible to behold, they must be embraced as an aspect of the awesome reality of life. This, I think, is the very quintessence of Tantric thought. It is of course easy to love the beautiful nurturing mother as represented by Saraswati or Sri; but to love her in her demonic aspect requires true spiritual insight. This

is what Budiana reveals to us—and is evident in the role Durga plays in Balinese religion as a whole.

11. **"The practice of realizing the double-sided nature of existence by an intentional, regulated contact—often performed only mentally—with socially disapproved persons or entities such as meat, wine, low-caste women or bodily excretions."**[110] It is of course this aspect of Tantrism that has earned for it such notoriety in the West. Literal-minded Western commentators have often confounded meditation and ritual with actual acting out of the forbidden and horrifying. Meditating in the graveyard on the dissolution of the body is not the same as devouring corpses; nor is meditating upon the god and goddess in sexual union to be understood as fornication performed by the priest. That some cults may have interpreted such acts literally does not vitiate the argument that in general they are carried out on a higher level than physical reality.

By way of comparison, it is interesting to note that Tibetan Tantric practices have usually been understood as involving symbolic actions visualized in meditative states of consciousness. Why Western writers should have assumed a literal meaning in the case of the Hindu texts is not clear to me, although it evidently satisfies a desire for sensationalism. The difference may be that Tibetan scholars have made much more extensive efforts to explain their rituals to a Western audience. Budiana's erotic visions and nightmare glimpse of the corpse's decay are clearly not to be taken as depictions of actual events in waking reality: they are insights into secrets revealed in states of higher consciousness. Of course, at the time of the experience they are totally real to the practitioner.[111] Likewise the grotesque Balinese temple reliefs depicting all kinds of graveyard horrors are not primarily depictions of black magic but images of Durga's role as *pelebur*. This is not to deny, however, that Balinese believe that human beings who wish to acquire mystical power to inflict illness and harm on others can acquire them from Durga, since she is mistress of the pathological processes of death and decay.

Important new work on erotic themes and symbolism in nineteenth-century Balinese literature by Creese and Bellows has drawn attention to a body of *tutur* texts dealing with sexual techniques in which the sexual act is raised to a mystical identification with the divine. Noting the parallels with Indian erotic texts, as well as their Tantric nature, the authors identify these practices as "sexual yoga." Since such texts were deliberately avoided by earlier scholars, this work, along with Rubinstein's, offers a fresh perspective on the pervasive eroticism in Balinese mystical symbolism. The relationship of this "sexual yoga" with what Rubinstein calls "alphabet mysticism" and "literary yoga" is not entirely clear, however. The *tutur* texts quoted by Creese and Bellows do not appear to use the symbolism of either the *cakras* of kundalini yoga or the symbolism of the sacred letters *(dasaksara)*. Perhaps they simply represent a different tradition of teaching—comparable to the "five m's" of Tantric practice in which sexual intercourse *(maithuna)* serves a ritual means of "realizing the double-sided nature of existence."[112]

Yet the Balinese *tutur* texts described by Creese and Bellows are explicitly concerned with sexual intercourse as a procreative act: the aim is conception. In Tantric ritual, by contrast, sexual encounters are directed to semen retention and the absorption of the female partner's sexual fluids.[113] Furthermore, the Balinese rituals involving kundalini yoga or

manipulation of the sacred letters *(dasaksara)*, such as that described in the *Surya-Sevana* or the *Jñānasiddhânta,* involve a union of Siwa and Sakti in the self. No human partner is involved or required. The "sexual yoga" Creese and Bellows describe would seem, therefore, to be of a rather different nature. They themselves observe that, in contrast to the *tutur* texts they examine, the *kekawin* literature places virtually no emphasis on the reproductive aspect of sexuality. Although I never tried to obtain such texts, I often heard Balinese refer to *lontar* describing how to conceive a "good son" *(suputra)*—that is, a male child perfect in all respects, physically, mentally, morally, and spiritually, the perfect son all Balinese parents desire. It is possible that the texts Creese and Bellows describe represent rituals directed to achieving this end, rather than mystical union with the Siwa soul. This, however, in no way vitiates the authors' arguments concerning the sacred nature of sexual union as a participation in the divine loveplay *(lalita)* that gives rise to the material world. My point is only that the intent of these sexual treatises may not be to achieve spiritual enlightenment or liberation but rather to create a child in which the highest human potential can be realized.[114] In any case, the Tantric nature of the ideas underlying these practices is unquestionable.

12. "Emphasis upon the absolute necessity of initiation *(dīkṣā)* by a qualified spiritual guide or teacher (guru)—who is commonly identified with the chief deity."[115] This is clearly evidenced in the requirements surrounding the Balinese Brahmana priest who must undertake initiation, where the same term *"diksa"* is used. The rituals have been described in detail by V. E. Korn. The identification of the teacher (guru) with the "chief deity" is also present, and in Bali it is common for Siwa to be called Bhatara Guru. Korn notes that Balinese Brahmana priests commonly referred to their teacher or mentor as their "Siwa."[116] Recently Rubinstein has drawn attention to the Balinese parallels with Tantric practices of initiation.[117]

13. "The development of a complete set of ritual practices besides the traditional, Veda-oriented one. This created a 'double framework' for the practice of Hinduism."[118] To determine whether this statement might also apply to Bali, we would need a comprehensive comparison of Bali rituals with Vedic rituals, which does not yet exist, so I will put it aside.[119] It is evident, however, that Balinese religion has developed its own "complete set of ritual practices."

14. "A far-fetched categorization of reality, especially in the symbolism of numbers and of speech."[120] This is another prominent characteristic of the Balinese *tutur* texts. Hooykaas in his discussion of the five Resi has drawn attention to the Balinese propensity for elaborate categorizations of multiple entities:

> Anthropologists are familiar with the "classificatory" thinking of the Javanese, but might be surprised by the tour de force of the Balinese who manage to equate the *panca-vara,* the five-day week, with the *pancasânak,* the five brothers, i.e. the four elder brothers and the younger one, and the Panca Kosika, being the Gods of the four directions plus Upper God. This unity of macrocosm and microcosm is a basic and beloved piece of Balinese philosophy.[121]

Lovric describes the same kind of extensive categorization using the nine directions.[122] The archaeologist A. J. Bernet Kempers also notes the importance of number symbolism.[123]

Speculations on the ten sacred letters *(dasaksara),* the five *(pancaksara),* the three *(tryaksara),* the two in one *(rwa bhineda),*[124] and the various sacred syllables are an ever-present feature of the *tutur* literature and can be found in all the unpublished *lontar* texts referred to earlier.[125] Indeed this extensive symbolism of numbers and speech is one of the most noticeable characteristics of the *tutur* literature I have examined, and this impression is reinforced by the work of Zurbuchen and Rubinstein.[126]

15. "Further elaboration of speculations common in (or produced by) Brahmanism . . . ten manifestations of Brahman as against the usual number of five."[127] I have no evidence concerning this characteristic, as the texts have yet to be examined from this point of view.

16. "A connection of the yoga mentioned under 3 with the very old alchemical practices of the Siddhas."[128] Again I lack the data to make this detailed comparison.

17. "The existence of a special religious geography by the cultivation (also in symbolic form) of places of pilgrimage of its own."[129] Pilgrimages to special temples or sequences of temples are very popular in Bali today. Indeed Budiana recommended I visit each of the main temples of Bali to seek permission to write this study. Hooykaas notes the correspondence between the six *cakras* of the body and the six principal temples *(sad kayangan)* of Bali.[130] Thus the pilgrimage could also be effected through inner meditation. Rubinstein further emphasizes the symbolic importance of journeys in Balinese *kekawin* poetry and their Tantric significance.[131]

18. "The use of a special set of terminology or even of 'code language,' both of them requiring particular methods of exegesis which were originally meant to be handed over only orally by the guru."[132] Balinese *lontar,* especially the *tutur* and *usada* texts, are notoriously difficult to understand and are often said to require oral instruction in order to reveal their deep meaning. Soebadio, for example, observes that the *tuturs* in general are intended, not as manuals of instruction, but for the use of students and teachers already well informed on the topic.[133] She further notes that in the case of aspirants to the status of *pedanda,* the student is required to live with a mentor and study with him.[134] Thus it can be inferred that "many lessons are given orally and that the texts need not, therefore, be too elaborate, for the pupil is not expected to study them alone."[135] Many Balinese have stressed this very point to me. The role of the guru and the importance of secrecy with regard to the *tutur* literature is further emphasized by Rubinstein, who explicitly compares contemporary Balinese practice with Tantric textual practices.[136]

Further Parallels

Having examined Goudriaan's key features of Tantrism, I wish to add two further possible parallels with Bali. The first relates to ideas about the hero, the *vira;* the second is the wor-

ship and symbolic import in Bali of the lingam (Shiva as the generative force in the universe). Although Goudriaan does not list these as defining characteristics of Tantrism, they constitute, I think, significant similarities in Balinese and Indian thought.

THE HERO: THE *VIRA*

In the same volume as Goudriaan, Dirk Hoens outlines the important role of the hero *(vira)* in Indian Tantrism.[137] His description has much resonance with those heroes depicted by Budiana and Mirdiana—and in Balinese mythology generally. The *vira* is one whose state of spiritual development is above that of the ordinary person, but not yet that of the enlightened sage. In him is an urge to reach beyond the *sthula:* the coarse, material realm. He is engaged in a heroic battle with the six enemies (the passions) but has them already well under control. Budiana's painting *Ombak* (Plate 12) shows such a hero—the man who dares the waves of passion. Mirdiana's concern with mythic heroes partly reflects a youth's fascination with heroic deeds, yet it is clear from what he says about the hero, Bima, that Mirdiana is also concerned with deeds of spiritual heroism. For Mirdiana, Bima is not just a mighty warrior on the battlefield: he is the spiritual warrior, and, like the struggle between Gana and Detya, Bima's battle takes place in himself.

LINGAM WORSHIP IN BALI

The lingam, usually a stone pillar in the form of a phallus symbolizing the god Shiva and in which form he is worshipped,[138] is a predominant symbol in Indian Hinduism, especially Shivaism. Hooykaas has drawn attention not only to the archaeological evidence for ancient lingam worship in Bali but also to the continuing importance of lingam symbolism in Balinese religion.[139] The myth of the Linggodbhawa, originating from the Indian *Isana-Purana*,[140] is well known in Bali and a popular subject for Balinese artists.[141] (Indeed during the period he painted the other works illustrated in this book, Mirdiana began, but did not finish, a powerful ink drawing of the Linggodbhawa.) The myth tells of a dispute over who was the most powerful deity. When Siwa became a lingam of immense height and challenged Brahma and Wisnu to determine its limits, Brahma flew upward to find its peak and Wisnu downward to find the base, but both were unsuccessful and finally had to acknowledge Siwa's supremacy. Balinese interpretations given to me of this well-known myth reiterate the obvious: Siwa is the most powerful of the gods. More learned persons might add that the other gods are but emanations of Siwa.

In addition to several lingam statues at Besakih and other important Balinese temples, Hooykaas shows that a structure to be found in every Balinese temple—the *padmasana*—is also in essence a lingam representing Siwa.[142] This "lotus seat," as is well known in Bali, represents Siwa in his form of Surya, god of the sun. This structure is also to be found in house temples, where it is invariably the highest structure, placed in the most auspicious position, the northeastern corner. For those who contend that the Hindu high gods have little place in the lives of ordinary people, the prominence of the *padmasana* should be kept in mind. Hooykaas also argues on textual grounds that the *padmasana* has an even more esoteric, Tantric significance as the lotus throne where Siwa as Ardhanareswari (Siwa and Sakti

united in one body) is manifested. He also refers to the term *"padmasana"* as referring to "a kind of coitus" and concludes jocularly: "A Balinese drawing of Ardhanarêśvarī in Padmâsana might be revealing; I do not expect to find depicted Śiva and Umā sporting in a pond!"[143]

The sprinkler known as the *lis,* used by Balinese priests in dispensing holy water, an object of everyday use in Bali, is also identified by Hooykaas on textual grounds as symbolizing the Siwa-lingam.[144] The mantras recited when using the *lis* clearly establish this identification and further underline the importance of the lingam as a symbol of Siwa in Balinese ritual practice. For example:

OṄ AṄ HOMAGE TO THE UNION OF NATURE AND SPIRIT,

TO THE GOD OF THE DROPLET, THE ENJOYER, THE LORD OF THE WORLD;

HOMAGE TO THE PARAMOUNT UNION OF GOD (ŚIVA) AND GODDESS (UMĀ),

HOMAGE BE TO PARAMA ŚIVA, HAIL![145]

Hooykaas also discusses the observances of Shiva-Ratri in India and Bali and considers their associated lingam worship. He notes too that Siwaratri in Bali was rarely observed and was considered to be the special prerogative of princes.[146] Today, however, it has become a popular observance in Bali—even parties of schoolchildren, led by teachers, undertake all-night vigils in temples. This change has presumably come about as a result of reforms implemented by the Parisada Hindu Dharma intended to bring Balinese ritual observances closer to Hindu models. In any case, the Balinese texts Hooykaas quotes describing the Siwaratri ritual clearly reveal the mystical union achieved by causing the Siwa soul to descend to the lingam, where it is united with the supplicant's soul. This, as Hooykaas points out, contrasts with the Surya-Sevana ritual, where the yogic union takes place in the body (or just above the head) of the priest. If recent changes have caused the observances to became more widespread in Bali than in the past, it is evident that the basis for them, and practices of lingam worship, were part of a preexisting Balinese tradition.

Hooykaas' evidence is extensive and can leave little doubt, I think, of the presence and pervasiveness of lingam symbolism and worship in Bali that have close parallels with Indian practices. Not only does archaeological and textual evidence indicate that these practices have a long tradition in Bali, but the continued importance of ritual structures and objects like the *padmasana* and the *lis* make it evident that lingam symbolism remains part of living culture in Bali. I am not suggesting that these elements were imported directly from India. Undoubtedly the symbolism has important precedents in Java; my point is that the Balinese forms remain very close to the Indian roots from which they originally drew inspiration and, moreover, can be seen to embody classic themes of Shivaitic Tantrism.

A Balinese Tantrism?

It should now be evident that much of Balinese esoteric religious thought is clearly identifiable as Tantric. Here I have been able to draw close Balinese parallels with fifteen of the eighteen key features of Tantric thought outlined by Goudriaan. In addition, I have

suggested two further parallels: the role of the *vira* (hero) and lingam worship. Nor do I claim to have exhausted all possible similarities; I have touched only on those that seem to me the most obvious. Although these elements are on the whole well-known characteristics of Balinese thought, only occasionally have they been acknowledged as Tantric. Clearly the nuanced and sophisticated understanding of Tantric philosophy being developed by scholars like Hoens and Goudriaan allows us to go beyond those earlier writers who recognized Tantric influence only in overtly bizarre forms such as graveyard imagery and "sexuo-cosmology."[147] In my view, the evidence summarized here clearly indicates that Balinese religion and ritual are essentially Tantric in nature, although not necessarily following any single tradition or sect.

As noted earlier, Lovric has suggested that scholars of Balinese religion deliberately avoid the topic of Tantrism.[148] Their reluctance to deal with any material of an apparently erotic nature has been revealed by Rubinstein, as well, and by Creese and Bellows.[149] This avoidance is not surprising given the negative and sensationalizing view of Tantrism that has long prevailed, even in India. In a nation where Balinese Hindus are vastly outnumbered by adherents of Islam, there is still a strong political need to present Balinese religion in a light acceptable to Islamic (and to Christian) sensibilities in order to elicit national and international support for their cause. Yet paradoxically, this position has led to a situation where much of Balinese belief is in danger of being oversimplified or trivialized as mere ritualism in popular view. A broad appreciation of the metaphysical depths and complexity of Balinese religion is needed to redress the balance, but this involves coming to terms with the obviously Tantric nature of Balinese ritual and belief. Curiously, Tibetan Tantrism seems not to have been devalued in the same way as Hindu Tantrism. Nihom has pointed out, for example, that while Tibetan Tantric texts have received serious consideration from Western scholars of Indian Tantrism, Tantric Buddhist texts of Indonesian origin have been regarded as essentially indigenous and independent products—a position strongly challenged by his research.[150]

The question that faces us now is not whether Balinese mysticism is Tantric in nature but, rather, what kind of Tantrism do we encounter in Bali? Indologists have identified many schools of Tantric thought.[151] Furthermore, we need to keep in mind that whatever the nature of the teachings introduced directly from India, and later via Java, they had centuries in which to develop unique and divergent forms. Although our present state of knowledge does not allow any specific identification of the kind of Tantrism closest to Balinese practice, certain features of Balinese mysticism stand out and may lead us to the source of the teachings:

- The importance of holy water (*tirta*—another word of Sanskrit origin,[152] of which there are many kinds including those referred to as *amerta* and *amerta kundalini*)
- The prominence of kundalini yoga
- The meditations described in numerous *lontar* texts on *ongkara, windu,* and *nada,* all key terms and concepts to be found in the Indian Tantric traditions[153]
- The importance of Ardhanareswara/Ardhanareswari (Siwa and Sakti combined in one body)[154]

Two outstanding features of Balinese mysticism seem absent in current studies of Indian Tantrism—the concepts of *rwa bhineda* and *kanda empat*—although both are expressed in words of Sanskrit origin.

Hooykaas refers to evidence that the sect of Shivaism introduced to Java was the Pasupata.[155] The leader of the sect, Lakulisa, had four disciples: Kusika, Garga, Mitra, and Kaurusya. These four figures, Hooykaas shows, form the basis of the Catur Lokapala (guardians of the four cardinal directions) and the *kanda empat* in Bali, and many *lontar* texts support the connection he establishes. This would indicate that the *kanda empat* have a Tantric origin, even if the concept as developed in Bali (or Java) has no clear Indian parallel. Recent research by the philologist Max Nihom also points to Pasupata influences in Indonesian texts.[156] Although further historical and textual research is needed to confirm whether the Pasupata sect is indeed the most likely source of Balinese mysticism, it seems to offer an intriguing lead.

In arguing for close parallels between Balinese mysticism and Hindu Tantrism, as revealed in the works of Indologists such as Goudriaan and others, it is not my aim to establish that Balinese practices are an exact or even rough copy of Indian prototypes. My intent is to emphasize that Balinese thought represents a unique variant on classic Tantric themes. Given the diffusion of ideas over long periods of time and the lack of any central religious authority or overarching structures, this is only to be expected. As in other examples of the "Indianization" of Southeast Asia,[157] Indian philosophy, mysticism, and art inspired new expressions in different contexts. Bali adapted these Indic influences and reshaped them through its own creative genius. The result, however, is not a mishmash or quaint mixture as many Western scholars would seem to assume. As we shall begin to see more clearly in the next chapter, the result was a new vision, expressed in local forms, of central themes in Shivaitic Tantrism.

[CHAPTER 5]

Balinese Ritual in a Dynamic Universe

IN BROAD TERMS the cycles of transformation from divine to demonic, which play such an important part in Balinese mystical thought as revealed in the previous chapters, have striking similarities with esoteric themes in the Indian mythology of Shiva as described by Wendy O'Flaherty[1] and in a more recent study by Richard Davis[2] of ritual practice in medieval Indian Saiva-Siddhanta. Neither study describes precisely the same cosmological view that we find in Bali, yet the resonances between the three are great, I think, and can lead us to important new understanding.

O'Flaherty analyzes the vast corpus of Indian myths surrounding Shiva and finds a basic paradox in his asceticism and eroticism that is resolved in the cyclical movement of the cosmos between states of quiescence and states of energy.[3] Shiva poses, as it were, a dual threat to the world. His wild energy can annihilate the world; yet when he withdraws into the quiet contemplation of the ascetic, his absence removes the creative principle from the cosmos. To save the universe, Shiva must be kept moving between these two extremes. O'Flaherty, quoting Sir Charles Eliot, observes that cycles of activity and quiescence play a key role in Tantric teachings, which regard the universe as

an eternal rhythm playing and pulsing outwards from spirit to matter (pravritti) and then backwards and inwards from matter to spirit (nirvritti). . . . The Tantras recognize and consecrate both movements, the outward throbbing stream of energy and enjoyment (bhukti) and the calm returning flow of liberation and peace. Both are happiness, but the wise understand that the active outward movement is right and happy only up to a certain point and under certain restrictions.[4]

Both the Tantric adept and Shiva himself follow these two paths, according to O'Flaherty, the outgoing surge of energy and material creation and then the return to quiescence to regain power.

Cycles of Emanation and Reabsorption

The cycle we find in Balinese myths of Siwa and Uma, moving from the benign downward to become destructive and then returning to benign origin on high, mirrors this Indian Tantric worldview and is illuminated by it. We can now better understand the Balinese paradox that as Sakti/Uma creates more and more entities, so she eventually reaches the point where she assumes terrible form and turns upon her offspring and devours them. This is a mythological statement of the Tantric view just quoted: the movement outward toward materiality is good and right only up to a point. The Balinese myths of Siwa and Uma reveal that without the rituals taught to human beings by the Tri Semaya (Brahma, Wisnu, Iswara) to reverse the process, the world would be destroyed. The cosmic cycle must be reoriented by ritual means from materiality and directed inward and upward toward spirituality again.

The danger that Siwa will be tempted to lose himself in austerities and take no further concern with the world finds expression in the Balinese version of the story of Siwa burning Kama, which closely parallels the Indian myths recounted by O'Flaherty.[5] In the Balinese version, as we have seen, Siwa's austerities are interrupted by the god and goddess of erotic love, Kama and Ratih.[6] They had been sent by the gods who were afraid because Siwa had so long absented himself from the world. Furious at the interruption, Siwa takes terrible form and burns Kama with the fire from his third eye (from his mouth in Mirdiana's painting). When I asked the artist about his depiction, Mirdiana explained that he felt Siwa was so angry because seeing Kama and Ratih together reminded Siwa of his own experiences of love and sadness and thus drew his thoughts back to the material realm when he simply wanted to be free and alone and at peace in his yogic meditation. Mirdiana explained that he painted the fire coming out of Siwa's mouth because, by giving in to his anger, Siwa had already been pulled down in the direction of materiality, the realm of greed, the domain of the Mother. Thus the artist explicitly recognizes a similar, if not identical, meaning to the one O'Flaherty gives to the Indian version.[7]

According to O'Flaherty, Kama is not destroyed by Shiva but only transformed. As in the Balinese version, Shiva's fire reduces Kama to fine particles of ash that then fall upon earth influencing all living creatures; thus although Kama is now invisible, all things are drawn by the power of erotic attraction. O'Flaherty points out that Kama in fact becomes more

powerful as a result of Shiva's action: his "magic is made stronger by the advantages of in-visibility, no longer concentrated in one anthropomorphic form but diffused into the world, like the demons released from Pandora's box."[8] Indeed Shiva is about to be conquered by Kama since he now finally gives in to the request of the gods to marry. Although Shiva tries to present his marriage as a sacrifice to the interests of others (the gods want Shiva to marry so he will produce a son capable of defeating the terrible demon Taraka), he is over-come with passion *(kama)* for Parvati/Uma. Shiva in a sense is himself Kama, O'Flaherty argues, and in his actions is constantly being swayed by desire and thus drawn back to the world of materiality.[9]

The Indian myths discussed by O'Flaherty reveal that *kama,* the force of erotic attrac-tion, provides the dynamic that leads to the movement outward toward materiality. With-out Kama, Shiva would remain forever in his state of quiescence, lost in his pure state of meditative consciousness. It is Shiva's desire for his Sakti that sets the outward process in action. This reflects the Balinese priest's explanation, quoted in the previous chapter, that the god has no interest in the material world; it is only via the medium of his Sakti that he engages with it. This is an ancient and central theme in classic Hinduism, expounded as early as the *Rig-Veda,* where desire is represented as "the first movement of the Absolute towards manifestation."[10]

The erotic meetings depicted in the works of Budiana, together with the mythic mar-riages painted by Mirdiana, conjure before our eyes the dynamic, transformative power of cosmic desire. Desire inevitably leads to terrible and demonic forms as material forms multiply and become more and more differentiated; yet without it no material world would exist. The imperative is to keep the opposing tendencies in the universe in balance. Yet as O'Flaherty shows, such a balance is not a matter of stasis:

> In many myths Śiva is merely erotic or merely ascetic, as a momentary view of one phase or another. But in the great myths . . . he participates in cycles of cosmic dimensions which melt into a single image as they become ever more frequent . . . creating an infinitely complex mosaic. The conflict is resolved not into a static icon but rather into the constant motion of the pendulum, whose animating force is the eternal paradox of the myths.[11]

O'Flaherty's analysis of the classical Indian myths of Shiva invites closer comparison with the Balinese myths.[12] Not only are the central themes the same, but some key myths such as that of Siwa burning Kama and the myth of the Linggodbhawa are virtually identical, the Balinese deriving directly from Indian models.[13] Yet most of the Balinese myths of Siwa and Uma have a distinct and unique character of their own. The stories concerning Kala are a clear example. In Indian mythology Shiva is known to take the form of Mahakala, destroyer of the world, and in this respect the Balinese Kala's identity with Siwa is entirely appropriate. But the actual stories of the birth of Kala from the *kama salah* between Siwa and Uma, his birth from the egg hatched in the sea, his advance on heaven and confrontation with Siwa, and his attempts to devour his brother, Kumara, correspond with no well-known Indian

myth.[14] There are certain similarities with the tale of the *asura*, Andhaka, the son of Shiva and Parvati/Uma, who confronts Shiva and is defeated.[15] Yet his mode of birth—he is conceived when Parvati playfully places her hands over Shiva's eyes—is quite different from that of the Balinese Kala. Andhaka also has incestuous desires toward his mother, Parvati, as does Kala. In the Balinese myth painted by Mirdiana, however, Kala wants to possess Durga. The young Brahmana woman who practices austerities in the graveyard to attract Siwa's attention brings to mind Parvati/Uma herself, since in the Indian myths it is only via her austerities that Parvati succeeds in marrying Shiva. Furthermore, the name of this girl, Rohini, suggests Mohini, the beguiling female form Vishnu takes to seduce Shiva in the Indian myths.[16] It seems as if the Balinese myths are combining elements derived from the Indian myths, expressing similar themes and concerns, but in new narrative form.[17]

Likewise the plot of the Balinese myth of Uma going to earth to find milk for Siwa pivots on an event—the tricking of a spouse into adultery by disguise as someone else—that O'Flaherty identifies as a highly popular motif in Indian folklore.[18] Yet the story as a whole has, to my knowledge, no exact Indian parallel. Shiva and Parvati, like their Balinese counterparts, are ever quarreling, separating, and reuniting. This in O'Flaherty's view represents Shiva's constant movement between erotic and ascetic extremes. In the Balinese versions, anger between Siwa and Uma, usually created by Siwa, causes Uma to take terrible form as Durga and wreak destruction on the material world. Here the emphasis is placed on the destructiveness of the Sakti when separated from the male principle of spirit. As Uma moves away from Siwa, she becomes the terrible Durga; the movement out toward materiality finally reaches danger point and must be returned "backwards and inwards from matter to spirit (nirvritti)."[19] Mirdiana's painting *Panca Durga* (Plate 21) shows the destructive forces as they move out in all directions and Siwa himself is about to be drawn down to the material world by desire to meet them and thus engender yet more horrible entities. The Balinese myth of the creation of the *bhuta kala,* recounted in Chapter 3, reveals Siwa himself out of control, drawn down to meet his terrible Sakti, and ritual must intervene to avert impending disaster.

With regard to the Indian cosmos, O'Flaherty observes that Shiva himself is the source of the movement between the extremes of "action and quiescence, passion and peace,"[20] implying that no ritual action by mortals is relevant to these fluctuations. A somewhat different view is offered in a recent study by Richard Davis of ritual practice in medieval Indian Saiva-Siddhanta texts. Davis clearly demonstrates the close connections between Indian ritual performance and what he calls an "oscillating universe":

> The universe oscillates. It comes and goes, emerges and disappears. This is
> a basic cosmological tenet for many schools of Hindu thought: the universe
> as we know it undergoes an endless cycle of creations and destructions.
> Within each cycle, the cosmos begins as an undifferentiated "something"
> from which evolves, in orderly sequence, the multiplicity of creation that
> we see all around us. In time the cosmos exhausts itself, and all this multiplicity merges once again into its undifferentiated source. A period of
> cessation or sleep follows, and then the cosmos begins its evolution again

in the next cycle. In this way, our universe oscillates between moments of creation and destruction, evolution and involution, activity and quietude, expansion and contraction.

For Śaivas, this pulsation does not confine itself to cosmogonic motion. Rather, it is a ubiquitous principle of a dynamic universe, governing all creation.[21]

This idea of an oscillating universe is evidently very similar to O'Flaherty's cosmic movement between quiescence and energy, but it goes somewhat further. Davis argues that the two fundamental processes—one of emission and one of reabsorption—give order to these cosmological pulsations.[22] Emission, or creation, moves downward and outward from unity, integration, subtle, pure, superior, high, and center.[23] Reabsorption moves upward and inward from differentiation, disintegration, gross, impure, inferior, low, and periphery. The oscillations between these opposite poles are "under the direction of Śiva, the ultimate instrumental cause of all transformation."[24] Davis explains:

> For Śaiva cosmology, *māyā* is the material cause of our world. It is real and substantive . . . not illusory, and it is ontologically separate from Śiva. . . . At the outset of each creation, *māyā* is undifferentiated and pervasive. Śiva then agitates *māyā* with his appointed powers and causes it to emit, in orderly sequence, the differentiated thirty-one *tattvas* of the impure cosmos. . . . While *māyā* is subtle, its derivative *tattvas* become increasingly tangible until we reach the five material elements *(bhūta)*, among which Earth is the most highly differentiated and gross of all *tattvas*. These differentiated *tattvas* enter into multiple combinations with one another, together constituting what we recognize as our ever-fluctuating world of *samsāra*. At the time of reabsorption *(pralaya)*, each *tattva* remerges into its source, until all are reintegrated into *māyā*. Quiescent, unitary *māyā* then awaits another emission.[25]

In this way, the whole cosmos emerges from nothing by a process of differentiation into increasingly more manifest and coarse elements. It is also returned back along the same route, so that the gross, impure entities of the material world are reabsorbed back into their pure and subtle constituents. Shiva's function of *pralaya* is not "destruction" in the sense usually conveyed by the English word but a truly divine function whereby every gross, hideous, and dreadful material entity or force can be transformed back into the pure source from which it originally emanated. Davis clarifies a central idea that seems extremely difficult for Westerners to grasp: in Hindu thought, destruction or dissolution does not mean a final end; rather, what is created is later reabsorbed back into the original unity. This idea helps to resolve the problems we may have in understanding how the most frightful horrors created by the Balinese Durga and Kala Rudra can be "returned to original form." The terrifying Durga/Rangda is not killed or destroyed; she is dissolved back, reabsorbed, into her pure original form of Uma (or, in Davis' terms, Maya).

Saiva-Siddhanta and Balinese Daily Ritual

Saiva-Siddhanta, developed in South India, is considered by many scholars to be the form of Shivaism brought to Java and Bali.[26] Pointing out that it was mainly from the south that Indian culture was spread to Southeast Asia, Hooykaas has made a detailed comparison of Saiva-Siddhanta ritual in South India and Bali, based on his translation of the *Surya-Sevana* text, the daily rites of the Balinese Brahmana priest.[27] Since Davis is concentrating on medieval Saiva-Siddhanta texts, rather than modern practice, his interpretations are based on material that may be even closer to the practices originally introduced to Bali. But as Soebadio observes, it is not yet certain what schools of Shivaism were originally brought to Bali, and we should be wary of assuming any exact correspondence.[28]

The rites Davis describes are similar in many respects, although not identical, to the Balinese Brahmana priest's daily ritual, Surya-Sevana, recorded by Hooykaas.[29] Both involve purification of the priest's body by ritual means, the removal of the priest's soul from the body, then the burning of bodily impurities, washing away the remains, and imposing mantras on the hands and body of the priest—thus creating a new "body of power." Shiva/Siwa is then invoked to enter this carefully prepared vessel. At this point the actions diverge. The South Indian rituals require the priest to use his Shiva powers to cause Shiva to enter a lingam statue, where he is offered elaborate worship, and the rituals are conducted in a temple for the benefit of others. The Balinese rituals, by contrast, are performed by the Brahmana priest in his home and directed to producing holy water. The priest achieves a union in his own body of his soul with Siwa, visualizing the union of Siwa and Sakti as Ardhanareswari (half lord/lady) and the *amerta* (water of immortality) issuing from the divine couple.[30] In this way the water in his container becomes mystically infused with the subtle essence of *amerta*.

Although the aim and climax of the rituals are different, the preparations up to the point of Shiva/Siwa entering the priest's purified body are very similar. Not only is the ritual action similar in form, but similar mantras and mudras are used and both employ similar formulas of *utpatti* (appearance), *sthiti* (maintenance), and *pralina* (reabsorption).[31] All are directed to the same intent: first to reabsorb the impurities of the priest's material body, raising it to a higher, more subtle level, and then to transform it into a subtle body of mantra so that it now has reached a level where it may be entered by Shiva/Siwa. Davis explains that the problem for any worshipper of Shiva is that in order to worship the god, he must first become a Shiva himself. That is to say: the unmanifest, undifferentiated purity of the ultimate unity of Paramashiva must become manifest in the differentiated form of Sadashiva; only then can Shiva be comprehended and approached by human worshippers. This involves a process of emission that begins at the most subtle *(suksma)* phonic level of mantra. According to Davis, Shiva constructs for himself a mantra body through which he is able to act and from which less pure and more manifest entities emerge. The movement is from *para* (ultimate) to *suksma* (subtle) to *sthula* (coarse or material)—distinctions commonly made in the Balinese texts as well. Mantras themselves begin at a level above sound and then are manifest as speech *(sabda)*. As Shiva moves downward toward more differentiated form (the process of emanation), the human priest follows the path of reabsorption, purifying the coarse elements of

his body and then creating a subtle mantra body. In this manner, the paths of emission and absorption meet, whereupon the priest's soul *(atma)* can be unified with Shiva.

The same logic is evident in the Balinese Surya-Sevana rituals. These rites involve a re-absorption—as the impure elements of the priest's body are collapsed back into the refined elements from which they originated—and an activation of the process of emission whereby the pure and high moves downward in differentiated form until it meets the earthly officiant. This meeting (in which the priest acts as female earth, *pradana,* to the descending male spirit, *purusha*) reactivates a new process of emission. In the language of mythology, Siwa is drawn down to unite with Sakti.

Davis' arguments that cosmic processes of emission and reabsorption constitute the basic organizing principle of Shivaite ritual in general can, I believe, put Balinese ritual in a new perspective, so that what on the surface appears to be meaningless rote action takes on a clear logic of operation.[32] Next I want to examine certain Balinese mystical texts describing inner meditative practices and then turn to the public rituals of the temple festival *(odalan),* the dance/drama in which Barong meets Rangda, the important calendrical rites of Nyepi, Galungan, and Kuningan, and the grand observances of Eka Dasa Rudra to show how each can be understood to embody the ritual logic outlined by Davis. I hope also to shed new light on the role of holy water and the complementary roles of the *pedanda Siwa* and the *pedanda Buddha.* To conclude the discussion, I offer a reinterpretation of the so-called Balinese cosmic map, the *nawasanga,* showing how it too mirrors the cosmic processes of emanation and reabsorption.

Balinese Yoga Texts

There are numerous unpublished Balinese *tutur* texts, cited in previous chapters, that out-line various yogic practices to purify the self and achieve union between the soul of the prac-titioner and the Siwa soul. The texts I consulted included *Siwa Linga Suksma, Aji Mayasandi, Tattwa Kala, Kanda Empat Rare, Tutur Dalem Turaga, Tutur Dalem Gading, Kanda Empat Dewa,* and *Pancamahabhuta.*[33] These represent only a sample, and they have as yet to be translated into English. In my view, they constitute an important source of information about Balinese mysticism that is still largely untapped. Such texts are notoriously difficult to understand—intentionally so, since they were intended as guides to esoteric mystical prac-tices that required oral instruction from a guru. As a result, most Western scholars have been discouraged from exploring them in depth, preferring instead to concentrate on literary and historical works.[34]

In drawing attention to this material, I do not pretend to have succeeded where others, much better informed, have failed. My concern is that since the majority of scholars apart from Hooykaas have until recently steered away from these mystical texts, anthropologists and others have not really been aware of their nature and extent. It is therefore easy to assume that Balinese lack mystical teachings and knowledge of yogic practices—or else to attribute such things to recent reformist efforts to remodel Balinese religion along Indian lines. My efforts to engage with this material, as discussed in Chapter 3, represent an anthropological

reading that draws on present-day Balinese understanding. The Balinese translator of these texts is, for my purpose, a key informant and his interpretation of this material has its own value as a source of ethnographic information.[35] Furthermore, the texts I obtained follow a discernible pattern that is recognizable in its basic outlines in published texts such as *Surya-Sevana*[36] and the *Jñānasiddhânta;*[37] this pattern is further reflected in the work of the philologists Zurbuchen and Rubinstein on Balinese mystical notions concerning the written word.[38] Rubinstein also refers briefly to the role of the ten sacred letters, the *dasaksara,* in yogic practice,[39] while practices surrounding "sexual yoga" as outlined in the *tutur* texts have been identified recently by Creese and Bellows.[40] In view of this previous work, I am persuaded that my interpretations are credible, although I look forward to correction from textual scholars.

The texts to which I refer are similar to the Surya-Sevana rituals employed by the Brahmana priest as discussed in the previous section. The key difference is that in Surya-Sevana the priest brings about an inner union with the Siwa soul in order to obtain holy water that can be used by, and on behalf of, other people, whereas the yogic texts I refer to describe a purely inner procedure that benefits only the practitioner. The fact that the yogic texts refer to practices that benefit only the practitioner seems to indicate a lesser, or perhaps more limited, level of spiritual practice. The works I obtained make no mention of kundalini or the six *cakras;*[41] they express the union of Siwa and Sakti in the abstract symbolism of the meeting of fire and water, a theme we have encountered several times with reference to Budiana's and Mirdiana's paintings. Hooykaas explains the link between the symbolism of fire and water and the ten sacred letters in this way:

> Well known is the formula *sa-ba-ta-a-i,* the so-called *pañca-brahma,* five-fold fire, consisting of the initial syllables of the five of the best known of Śiva's one hundred names: Sadyojāta-Bāmadeva-Tatpuruṣa-Aghora-Īśāna. The *pañca-brahma* is often followed by the *pañca-tīrtha,* five-fold holy water, being *na-ma-śi-vā-ya,* this time no abbreviations but two words plainly meaning: homage be to Śiva. . . . Whether one examines the Śaiva priest's ritual at home or in public, in temple or in graveyard, directed mainly in adoration of the godly powers or mainly in averting the evil powers—fire and water, water and fire are the dominating forces. *Pañca-brahma* and *pañca-tīrtha* together are called *daśākṣara—daśa akṣara—*the ten syllables.[42]

In the yogic concentration described in *Siwa Linga Suksma,* fire is visualized as rising from the navel to meet water poured down from a golden vessel *(cucupu mas)* located in the brain.[43] This text gave me an important insight into a small ink drawing by Budiana that depicts the artist's head emerging out of a base of flames. (See Figure 1.) From the eyes fall torrents of tears to meet the flames; to the side of the drawing, rising out of the flames as they mix with tears, is a tiny, naked figure of the artist with hands in a gesture of prayer—the *sembah,* which also symbolizes unity. This figure, I realized, represents the soul *(atma)* emerging from the meeting of fire and water, a realization which first alerted me to that fact

Figure 1. Melihat Diri *(Behold Yourself), ink on paper, by I Ketut Budiana.*

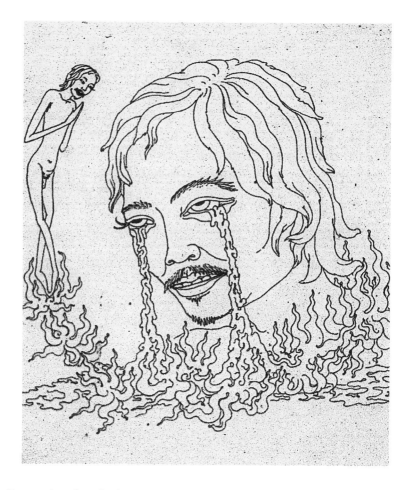

that Budiana was well acquainted with the concepts described in the text. When directly asked, the artist confirmed this and further explained that, in his opinion, there is no difference between this meeting of fire and water and the union of Kundalini and Siwa in the highest *cakra*. It is the role of one's teacher or spiritual guide to elucidate these matters, he noted, as the texts provide only part of the information required. This, as we saw in the previous chapter, is characteristic of Tantric teachings in general.

The duality of fire and water, represented by the sacred syllables *ANG* and *AH,* is referred to as *rwa bhineda* (literally "two different"). Often misunderstood to be a binary opposition along the lines suggested by French structuralism, the *tutur* texts reveal that the *rwa bhineda,* when associated with the *ANG AH* formula, symbolizes in essence the union of Siwa and Sakti, *purusha* and *pradana*.[44] The key point here, I suggest, is not the opposition but the uniting of the two into one. When fire and water meet, they neutralize *(dumalada)* or dissolve each other to become one in the form of vapor. Thus two material entities or elements—fire and water—are transformed into a single, more pure, less coarse entity—vapor—that symbolizes the soul *(atma)* or more generally the spiritual, nonmaterial realm.[45] Here we can see that the path of reabsorption described by Davis is being followed. To explain this more fully, I need to go back to trace how the adept is able to realize *rwa bhineda*

in the self. Basically this is achieved through meditations upon the ten sacred letters *(dasaksara)* and their contractions. Hooykaas,[46] Soebadio,[47] Zurbuchen,[48] and more recently Rubinstein[49] have examined such practices in some detail, and the similarities with the texts I describe are evident.

In essence, these Balinese yogic texts focus on the central mystery of how the material world originates from a nonmaterial, pure, undifferentiated source and how it can, by ritual effort, be returned to this source. As Zurbuchen observes: "In accordance with the main philosophical thrust of Balinese Hinduism (which was heavily influenced in ancient times by the Śaiva-Siddhānta school of South Indian thought), Siwa is the supreme principle from which all creation emanates and the void into which, eventually, all will dissolve."[50] The Balinese texts emphasize the essential unity of microcosm and macrocosm, so that what pertains to the external world also pertains to the individual self, and what is contained in the external world is also contained in the self. This doctrine is constantly reiterated in the numerous *tutur* texts dealing with the *kanda empat,* the four mystical siblings.[51] Indeed Rubinstein argues that this mystical correspondence provides the very basis of the perceived efficacy of the sacred letters, "thereby associating the Divine and the human body through the agency of *aksara.*"[52] Zurbuchen likewise emphasizes that "language, according to Balinese traditions of metalinguistic commentary, is a representation of the congruence between the structure of the inner self and external reality (micro- and macrocosms)."[53]

Siwa and Sakti exist in the self, just as they exist in the macrocosmos, and can be unified in the self. The first step in this process requires that the multiple diversity of the material world be gathered together, as it were, and reabsorbed back into the duality from which it all originated. The differentiated diversity of the phenomenal world is represented by the ten (sometimes twenty) sacred letters or syllables *(dasaksara).* Zurbuchen notes that in reciting the *dasaksara* "one in effect recreates the dimensions of the universe with all its ordered variation, at the same time naming the higher-order principle that subsumes it all."[54]

The Balinese yogic texts instruct the adept to focus on these letters—and on their sounds, since the level of sound, as we have seen, is a subtle level of the process of creation. The texts further provide various mantic formulas to compress or reabsorb each letter or syllable into a higher level. *"Sa ba ta a i na ma si wa ya,"* the ten letters, are collapsed into five, the *pancabrahma;* then they are compressed into three, the *tryaksara;* then into two, *rwa bhineda;* and finally into one: Tunggal or Eka.[55] The *tutur* text *Siwa Linga Suksma* outlines the method whereby the adept can unify all the differentiated parts and essences of the self to become one:

> You need to understand how to compress Sang IIyang Dasaksara to become *pancabrahma;* then to be compressed to become *tryaksara (ANG, UNG, MANG);* the *tryaksara* then becomes Sang Hyang Rwa Bhineda *(ANG, AH).* The *rwa bhineda* then becomes Sang Hyang Ekasara—one.[56]

At this point the phenomenal world, in this case the physical body of the adept, has been reabsorbed back, and up, to its pure origin. This, however, does not mean it has been returned to the ultimate point of origin, since, as Davis shows, the process of emission from

the original void progresses downward through several steps of increasing differentiation from Paramasiwa to Sadasiwa to Siwa, who unites with Sakti to create the phenomenal realm. Thus to reabsorb the material realm back to its pure origin is to return it to Maya or Sakti, while beyond and above her lie many increasingly higher levels of purity and unity.[57]

In texts such as *Siwa Linga Suksma,* the *rwa bhineda* is unified to become One: Eka or Tunggal. This level of unity is represented by the sacred letter and sound *OM,* or *ONG,* but it too can be dissolved back into yet higher and more purified levels represented by the symbols *ardhacandra* (in the shape of a crescent moon), *windu* (a circle with a dot in the center), and *nada* (a pear-shaped dot) until finally the original void, *sunya,* is reached. Manipulations and explanations of these mystic terms fill the pages of the unpublished texts I collected. *Nada,* according to Indian Tantric teachings, stands for the primordial sound caused by the union of Shiva and Sakti and thus is the origin of, and the point of return, for all creation.[58] *Windu* can be given various meanings: it can refer to Shiva, but it can also symbolize zero, empty, the ultimate void. Soebadio,[59] Zurbuchen,[60] and Rubinstein[61] have discussed in some detail these various components of the *ongkara,* the written symbol that represents the sacred sound *OM.*

My Balinese informants gave a similar range of meanings. Budiana explained that the *ongkara,* which includes the letter *ONG* surmounted by the *ardhacandra, windu,* and *nada,* is a model of ourselves (see Figure 2).[62] The lower *ONG* letter signifies the physical body; the symbols above it represent the spiritual aspect, the soul or *atma.* The crescent, circle, and pear-shaped drop can also represent Brahma, Wisnu, and Siwa,[63] in ascending order, or Siwa, Sadasiwa, and Paramasiwa. They also represent fire, water, and ether,[64] as well as moon, sun, and stars. Thus the *ongkara,* as Budiana explained, is also a model of the universe: the lower part is the material world, the impure realm; the upper part is the pure realm and its different levels from Siwa up to Paramasiwa. Budiana located the meeting with Sakti that brings about the differentiated world as taking place between Sadasiwa and Sakti (as Davis does). My point in quoting Budiana here is not to suggest that his is the most reliable interpretation but to indicate that the concepts revealed in the *tutur* texts are part of contemporary Balinese understanding and are not confined to purely priestly or Brahmana elites.

Davis' oscillating universe is further revealed in the symbolism of the sacred syllable *ONG (OM)* in this quotation from the *Jñānasiddhânta:*

Figure 2. Ongkara Symbol, *ink on paper, by I Gusti Nyoman Mirdiana.*

> Out of the Unmanifest the resonance is born, and out of the resonance
>> the dot appears;
> Out of the dot the (half)moon is born, and out of the (half)moon *Viśva*
>> (the sound OṂ) appears time and again.
> . . .
> *Viśva* vanishes into the (half)moon, and the (half)moon vanishes into
>> the dot;
> The dot vanishes into the resonance. That is the course of Reality.
> . . .
> The resonance dissolves into the Void, the Void again is born;
> Or what is more Void than Void, extremely Void.[65]

The details of the Balinese yogic texts vary, but all reflect the same cosmic movement downward from a single, pure undifferentiated immaterial source and upward from impure, differentiated material forms to more subtle forms. Different teaching and different practices probably aim at achieving different levels of reabsorption, but most that I have encountered employ the marriage of fire and water as the central symbol of unification and progression toward a higher state.[66] This does not, however, involve *moksa* or final liberation. The soul is raised to a purer level where it can unite briefly with the Siwa soul, but it is clear that what is aimed at is a temporary union; following this brief bliss, the adept returns to the mundane realm and to life. The texts reveal that the union of fire and water gives rise to new life. Thus when death approaches, the adept in his meditations must reverse the formula *ANG AH,* so that fire is above and water is below and the two cannot meet. The adept who can achieve this, the texts tell us, will achieve permanent release from the material world and will not be reborn as a person.[67]

The bliss experienced by the adept during his temporary union with the divine is symbolized by *amerta,* the water of life—visualized in his meditations by the Brahmana priest as flowing down from Ardhanareswari, Siwa united with Sakti—a union that also symbolizes Siwa's mystic meeting with the soul of the priest.[68] The yogic marriage of fire and water aims at a temporary union between the material realm and the spiritual realm. To achieve this, the material realm or the physical body must be purified and raised to a point where it meets with the pure realm. This encounter constitutes the union of *purusha* and *pradana,* Siwa and Sakti. In terms of the oscillations of emission and reabsorption, the aim is to bring about a meeting between the two movements in the self. In this manner, all the sins, sickness,[69] and impurities of the material body are reabsorbed back into their pure origins, raising the body to a level of sufficient purity to meet with the pure realm of spirit. From this union issues a new phase of life symbolized by *amerta.* (The Indian Tantric significance of *amerta (amrita)* as representing the combined sexual fluids of Shiva and Sakti is described by Feuerstein.)[70]

The Balinese Temple Festival Reconsidered

A similar meeting of the dual processes of emission and reabsorption can be discerned in the Balinese public ritual of the *odalan,* the temple festival, and the *caru* sacrifices that proceed

it, both of which were briefly described in Chapter 1. The usual account of the temple festival explains that it is a time when the Balinese gods are invited to descend to their temple and receive worship from human beings in the form of offerings and entertainment.[71] For days they are regaled by their human hosts and then duly sent back to heaven. Accordingly the *caru* rituals that precede the *odalan* are conventionally explained as necessary to clean the area before the gods are invited down. Many European scholars have assumed that this cleansing involves placating demonic entities with offerings of meat and blood so that they will depart the scene and not disturb the proceedings; thus it is thought to constitute a lesser part of the proceedings. Jacoba Hooykaas, reflecting this view, refers to the *caru* rituals as "a casting out of the demons before the really holy (and more Hindu) part of the ceremony is enacted."[72] The *caru* rituals are thus interpreted as a survival of primitive practices rather than an integral part of what is going on.

I suggest that the *caru* can be more accurately understood as a ritual process of reabsorption whereby the disruptive forces in the material world, the *bhuta kala,* are drawn together from the four corners to the center, given their offerings, and thus reabsorbed into positive forms. This is why a *caru* ritual is performed in the crossroads, as well as in the temple, so that the *bhuta kala* are drawn from all four directions to the center, following the movement from periphery to center cited by Davis. Once the *pemangku* has called the *bhuta kala* and asked them to partake of their feast, he leads the people in a dance around the offerings, moving in an anticlockwise direction *(prasawya),* and amid shouting and yelling the offerings are broken and tossed around—representing the *bhuta kala* devouring their feast. The *prasawya* circumambulation of the offerings in the center symbolizes a movement upward. (We shall see that when the gods descend, they do so in the opposite direction, *pradaksina.*) This signifies that the *bhuta kala* have moved up to a less dangerous and purer form. Even ordinary people will say that the *bhuta kala* have now become *"kala hyang,"* that is, purer entities. *"Hyang"* is the title usually given to gods *(dewa).* In other words: the disruptive chthonic forces have been dissolved into higher, more positive forms. Leo Howe offers a virtually identical account of a *caru* performed to cleanse a temple, noting that offerings are laid out in the four directions; then the *bhuta kala,* considered to be "demonic forms of the guardian gods," are summoned to eat their fill so that they "will calm down and so change back to their divine forms."[73] It is evident that the ritual movement of the *caru* is inward from periphery to center, and then upward from impure to pure (or relatively pure), following the logic outlined by Davis. In mythic terms, as we saw in the story of the creation of the *bhuta kala,* the terrible Durga and Siwa Kala have been returned to heaven as Uma and Siwa—that is to say, ritually reabsorbed back into their original divine forms.

Once the *caru* rituals have been completed, the *odalan* can begin. Now the ritual movement is from high to low as the gods are invited to descend and officiants circumambulate offerings in a clockwise direction *(pradaksina).* Now pure entities—gods and goddesses, *dewa* and *dewi*—are being invited to descend to the less pure earth. A process of emission is ritually activated to match or meet the process of absorption begun in the *caru* rituals. The first step was to reabsorb dangerous entities into more benign ones, beginning the movement upward; now a counterbalancing movement downward is brought about. Why should this be? If the process of reabsorption was carried to its logical conclusion, the world would ultimately disappear into the void from which it originated. The first ritual aim is to arrest the process of

emission before it reaches the point where it becomes dangerous and destructive; but if the material world is to continue to exist, a new process of creation must be initiated. In other words: as one purifies and dissolves degenerate forms, so one must begin to replace them with new ones—otherwise life will cease altogether. In the language of mythology, Siwa must not be allowed to lose himself in austerities; he must be enticed back to the world and persuaded to unite once again with his Sakti.

The esoteric meaning of the *odalan,* according to my most knowledgeable Balinese informants, is that it involves a marriage and a birth. The marriage is between sky and earth, *purusha* and *pradana,* god and goddess, Siwa and Uma. What is born from this union is *tirta amerta* (holy water). The significance of the term *"odalan"* has often been linked to *"medal,"* meaning to "go out, to be born," leading some European scholars to the erroneous conclusion that the *odalan* represents the birthday, or anniversary, of the temple.[74]

A close examination of the rituals of the *odalan* reveals that a marriage and birth are doubly enacted. First they are enacted in the ritual performance of *pemangku* and the congregation. Then they are realized in the ritual performance of the *pedanda* as he produces his holy water. We have already seen how this is carried out in the *pedanda's* daily ritual practice, Surya-Sevana. The priest, through his yogic meditation, invokes Siwa to descend into his own body while he focuses his concentration on Siwa as Ardhanareswari: Siwa unified with his Sakti.[75] From this divine union is produced *tirta amerta*. At the temple festival, the *pedanda* goes through the same ritual to produce holy water—with the difference that he performs his rituals in the temple in front of the congregation. What is taking place is not evident to the audience, of course, since the divine marriage and the resulting birth of holy water are brought about in the yogic visualizations of the *pedanda's* inner concentration.

This inner vision, however, is also being acted out on the public stage through the actions of the *pemangku* and their helpers (though most do not seem to be aware of it). Preparations for the *odalan* begin by taking down with much ceremony—from the place in which they are usually stored in the most holy part of the temple—the tiny images, the *pratima,* that symbolize the gods.[76] The *pratima* are always a pair, male and female, and usually a temple possesses only one pair. This process of taking out the *pratima* is referred to as *"nedunan"* (coming down). They are always stored in a high place *(gedong nimypanan pratima)* and must be brought down by the *pemangku* and then directly given offerings, which are circumambulated in a clockwise direction *(pradaksina)* by a member of the congregation bearing the *pratima* on his or her head. The *pratima* are then cleaned and decorated to make them fitting receptacles *(tapakan)* for the divine powers that will enter them. Later, at dusk, they will be carried in procession to a nearby spring or stream to wash. When it is dark the *odalan* begins with the *pratima* (along with other sacred masks and paraphernalia) being carried out in procession from the inner part of the temple *(jeroan)* to a temporary structure, the *pangubengan,* erected in the middle courtyard *(jaba tengah)*. Here the *pratima* are placed on the *pangubengan* after being carried three times around it in a clockwise direction. The congregation gathers around and prays. The gods have now descended.

On the *pangubengan,* the place of meeting, has been placed along with many other offerings a large *babangkit* offering that symbolizes Ardhanareswari, the lord who is half lady, or the god in union with his Sakti.[77] The *pemangku* then makes a *segehan agung* offering on the ground in front of the *pangubengan*. This offering involves mixing the blood of a decapitated

chicken with coconut milk and spices. According to knowledgeable Balinese, this symbolizes conception—the red reproductive fluids *(kama bang)* of the female mixing with the white reproductive fluids of the male *(kama petak)* to form an embryo. Following this, the *pratima* and other sacra are taken from the *pangubengan* and carried into the inner part of the temple via the Kori Agung (inner enclosed gateway). In the inner courtyard, the *pratima* are placed on the *pesamuan,* a central shrine or place for the gods to stay. The reproductive symbolism is continued in these movements, since, according to my informants, the three parts of the temple are correlated with the lower part of the female body: the *jeroan* is the womb, the *jaba tengah* the thighs, and the *jaba* the feet.[78] The temple thus symbolizes the earth, *pradana,* lying supine to receive the god-power descending from above. The place of meeting/union is the temporary shrine, the *pangubengan,* in the *jaba tengah*—between the goddess' thighs. Conception, the mixing of reproductive fluids, is symbolized in the *segehan agung* offering, following which the embryo is carried, via the Kori Agung (symbolizing the vagina), into the *jeroan* (the womb) to develop.[79]

At this point the *pedanda,* seated in the inner temple *(jeroan),* begins his work. The congregation sits around in the *jeroan* and outside in the *jaba tengah* as the *pedanda* goes through the lengthy procedure of making the holy water. This is the "child" about to be born. When after forty minutes or so the *pedanda* has completed his ritual, he gives a signal whereupon the *angklung* orchestra begins to play in the *jeroan,* the *kulkul* (wooden slitgong) begins to sound, and in the outer court *(jaba tengah)* the gamelan orchestra starts up and the masked dances begin. At the same time, the *pemangku* assisted by his helpers takes holy water and proceeds to sprinkle it *(malis)* throughout the three parts of the temple. Then the *pedanda* officially presents *(mangatur)* the assembled offerings to the gods. Finally the congregation prays and each worshipper receives holy water. The entertainment in the outer courtyard continues as new worshippers arrive bringing their offerings and receiving holy water. The climax is now over; the "baby" has been born. Or rather *tirta amerta*—which symbolizes new life and presages the beginning of a new phase of emission—has been born *(medal).*

Eventually this new phase will degenerate into lower forms, but for the time being sky and earth are brought together. The upward movement toward reabsorption is balanced by the downward movement of emission. For the moment, a time of maximum harmony is achieved on earth as the dangerous forces have been reabsorbed into purer forms and the new emission is still close to its pure, spiritual source. The product of this cosmic meeting, where the forces of reabsorption and emanation are momentarily in perfect balance, is *tirta amerta.*

At the close of the *odalan,* the gods are duly sent back to heaven along with all the formerly negative forces in the area, the *bhuta kala,* who are now returned or reabsorbed back into their original pure form. As one Balinese text tells us, demons and ogres return as the angels and nymphs of heaven.[80] But human beings need have no fear that the material world will vanish along with them, since the process of emission has already started. Two hundred and ten days later, the cycle will be judged to have reached danger point again and the rituals must begin once more. Everything must be cleansed again, the cosmic forces brought into alignment, for a moment of perfect harmony, a union, and then a birth that starts it all anew. Human ritual is essential in this worldview since to allow either cosmic process—that of emission or that of absorption—to proceed unchecked would lead to the

destruction of the universe. Either it will descend into ever more terrible and differentiated forms—exploding into something like the maelstrom of fire that Budiana reveals to us—or it will gradually be absorbed back into ever more pure and simple forms until it collapses into the void: into the emptiness *(sunya)* from which it originated at the dawn of time. The *caru* and *odalan* rituals together strive to achieve a balance between these two opposing tendencies, but such a balance in fact involves constant movement, not stasis, and is achieved but for a brief time.

Every temple in Bali holds its own *odalan,* preceded by the *caru* sacrifices, every 210 days, and there are great variations from region to region. Even in the same temple there are different levels of observances: some *odalan* last only a day and are conducted by the *pemangku* alone; others extend over many days and involve the participation of several priests of different type and rank. It might appear that in attempting to identify a single pattern in these multifarious observances I am blatantly ignoring the evident diversity of ritual practice. Furthermore, since other gods and goddesses are given worship in these temples, how can I suggest that all are celebrating the mystical marriage of the high god Siwa and his consort? In the first place, we must keep in mind that Siwa and Uma are but mythological names to symbolize cosmic forces; Siwa and Uma represent more generally *purusha* and *pradana*—male and female cosmic principles. The *odalan,* of whatever form, aims to bring about a meeting of the two. Some Balinese might express it as a meeting of heaven and earth.[81]

The cosmic oscillations or pulsations that Davis describes do not simply constitute a regular cycle of creation and destruction involving the cosmos as a whole. Rather, different oscillations are taking place simultaneously within the world, so that within each individual, or within each community, or locality, varying pulsations are taking place. The world is thus composed of a seething mass of opposed energies. The yogin might succeed in achieving a perfect balance of forces within himself while around him others are subject to disease and suffering. Likewise one community, via the correct rituals, might achieve peace and harmony while another experiences disaster. Fluctuations or oscillations in cosmic powers are felt to occur in localized pockets, as it were, each community or temple congregation striving to regulate the flows of emission and reabsorption within its small area. Ultimately all these energies derive from the same source—described as Siwa and Uma—but since these energies have local manifestations, they can also be understood as deities specific to that locality or temple. The *bhatara* and *bhatari* of a particular temple are perhaps known to their congregation as named entities and individualized personages. The *pratima*—the sacred images of the gods held by each temple, always a pair (sometimes more than one pair), one male and one female—represent these localized deities and the union celebrated at the *odalan* is their marriage. Yet at the same time this is also the mystic union of Siwa and Uma, since all other powers are but refractions of the divine pair.

The Kayangan Tiga, the three temples that exist in each Balinese community, are conventionally said to be devoted to Brahma, Wisnu, and Siwa. This, however, should not be understood as involving personal worship of these three gods. At a higher level, the three symbolize the three functions of god-power: creation *(utpatti),* sustenance *(sthiti),* and destruction *(pralina).* All derive from Siwa. Some Balinese will explain that the Pura Dalem is the place where Durga resides, not Siwa, although Siwa is of course her spouse. This

emphasizes that Siwa as the destroyer or *pelebur* is but one aspect of his power. In all these temples, the *odalan* brings about a union between *purusha* and *pradana*—aspects of, local manifestations of, cosmic forces ultimately deriving from Siwa and Sakti.

Some Western scholars have observed that the ideas concerning the union of Siwa and Sakti so important in Shivaitic Tantrism found fertile ground in Indonesia because of indigenous notions concerning sacred unions between Mother Earth and Father Sky.[82] One can only speculate how indigenous forms in Bali were accommodated to Hindu mystical notions. Hindu temples built in Java can be seen to have followed Indian models closely, but the Balinese temple retained its open structures reminiscent of the Polynesian *mare*.[83] Nevertheless the present plan of the Balinese temple, as we have seen, lends itself to a mystical interpretation well suited to the idea of the temple as *pradana* made ritually ready to receive her spouse, who descends from above. Possibly before the arrival of Hinduism, the Balinese temple already served as the place of a ritually celebrated union between sky and earth and thus was easily accommodated to the new understandings. Possibly also the Kayangan Tiga system of village temples was based on indigenous worship of originating ancestors, the ancestors of the living community and the spirits of the recently dead, which were then easily incorporated into Hindu concepts of the three functions of god-power: creation, sustenance, and destruction. In any case, one can see the extent to which ritual practice in Balinese temples has been shaped to express Tantric mystical concepts.[84]

The Meeting of Barong and Rangda

In mythic terms, it is by means of the *caru* sacrifices that Durga and Kala Rudra are together reabsorbed back into their divine forms of Uma and Siwa, whereupon the *odalan* celebrates their marriage in order to initiate a new phase of life. At certain times, however, Durga alone rages upon the earth, inflicting on humankind pestilence and death. In these circumstances different ritual measures are needed to contain her destructive power. Several Balinese myths, as we saw in Chapter 3, tell of occasions when Uma, cursed by her husband Siwa, takes terrible form as Durga and descends in fury upon the earth. The problem then is how to restore her back to her gentle form of Uma before she, along with her followers, succeed in their desire to destroy humankind.[85] Since the cause of her anger is a quarrel with her spouse, she must be reconciled with him before she can resume her benign form. This is Barong's role. Siwa takes the form of a monstrous beast to meet with Durga on earth. When Barong confronts Rangda he brings under control her raging, destructive energy.[86] Fire (Rangda) is met by water (Barong), a calm, purifying agent, and the two neutralize each other. From this meeting is born vapor, symbolizing the soul, or purified spiritual aspect.

The meeting of Barong and Rangda and the meeting of *rwa bhineda* in the self follow the same pattern—only one is an interior yogic visualization while the other is a public performance. In fact some of the verbal commentaries given by actors during the dance performance explicitly state the connection with the textual sources. At a Calong Arang performance held at Pura Puncak Padung Dawa in Tabanan on 30 May 2002, for example, the Pandung, just before attempting to stab Rangda, spoke to the audience, referring to *rwa bhineda*, Siwa and Uma, *purusha* and *pradana, ANG* and *AH*.[87] The mystic significance of the confrontation

with Rangda is clearly alluded to for those who are already familiar with the texts; but of course the majority of the audience does not possess this esoteric knowledge and thus is oblivious to the meaning of the words the actors recite.[88]

Following the ritual logic outlined by Davis, we can understand that both meetings are directed to the same end: bringing the impure world or the physical self back to a pure level. In this way all dirt, disease, and sin in the self (microcosmos), and in the external world (macrocosmos), can be reabsorbed back into their source. The fearsome Durga is transformed back into a pure and less dangerous form. In Davis' terms, I think that what is achieved in the mystical marriage of fire and water—whether in the self or in the ritual dance of Barong and Rangda—is the reabsorption of the impure realm back into *maya*, which is the cause of the impure material realm yet itself part of the pure realm. At the same time, the union of *rwa bhineda* also presages the creation of new life since the vapor arising out of the meeting of fire and water will later become water, *tirta amerta*, the water of life.

The first step in the process of returning Durga to her gentle form of Uma is to encounter the most dangerous form of Durga: Berawi (Bhairava) Durga,[89] who is at large in the grave-yard with her minions, the *leyak*, inflicting plagues of disease on human beings. Barong meets and contains this most degenerate level, so that the terrible Mother resumes the less danger-ous form of Dewi (Goddess) Durga, who resides in the Pura Dalem. From this higher, purer level, she can be absorbed back into her original divine form of Uma. When contained in the Pura Dalem, Durga's destructive power is a necessary part of the process of *lebur*, whereby dead matter is returned to its pure origins. By providing appropriate offerings and sacrifice, humankind seeks to ensure that she and her followers are satisfied to remain there. Once they leave the Pura Dalem, however, and enter the graveyard, their dangerous powers and energy increase to the point that they threaten the lives of the whole community. This is why Barong meets Rangda in the graveyard but at the end of the performance Rangda is returned to the temple. Berawi (Bhairava) Durga has been met and transformed into Dewi Durga, a higher and less dangerous force that can be contained in the temple. Durga herself has several forms, as we saw in the myth of the Panca Durga, where Durga divides into five—four emanating from the center. Accordingly, following the process of reabsorption, the four on the periphery are drawn back to the center and become one, Dewi Durga, who is returned to the temple. The multiple nature of Durga herself is also indicated in the fact that often a temple possesses not one but two Rangda masks, one white, one red. The red mask repre-sents the more dangerous form, Berawi Durga; the white mask signifies the goddess Durga.

Dance/dramas in which Barong confronts Rangda are performed at times of danger when disease is rife and *leyak* are believed to be attacking the community.[90] For this reason the per-formances have been considered to be exorcistic rites against evil and especially witchcraft. Certainly the aim is to deal with destructive powers—not to banish or defeat evil but to reab-sorb dangerous, impure entities back to pure and thus less dangerous levels. This is achieved by collapsing the diversity of the material realm back into *rwa bhineda*, which unites to become one.[91] Or to use a different symbolism, one contained in the concept of *rwa bhineda*, a meeting of fire and water is brought about, giving rise to a purer single entity: vapor. What the individual *(bhuwana alit)* achieves through inner yogic visualization—purification of the body of all sin and physical disease—can be achieved for the community *(bhuwana agung)* via public ritual performance in which fire, Rangda, is met by water, Barong.[92]

Nyepi: The Day of Silence

Important Balinese calendrical rituals such as Galungan, Kuningan, and Nyepi can also be understood as ritual efforts to control the cosmic processes of emanation and reabsorption. The rites we have considered up to this point are confined to particular individuals, temples, or communities, but some rituals aim to coordinate the cosmic fluctuations of emission and reabsorption on an islandwide basis.

Nyepi, the day of silence, offers a particularly clear example. This observance, based on the Hindu Saka year of twelve lunar months, is observed by the whole island at the same time. During the day of silence no activity of any kind is permitted. People must stay quietly in their houses; no fire or lamp may be lit; no work can be performed. The roads are empty and the whole island appears deserted. What is the significance of this empty day? Hooykaas offers the following explanation:

> Once a year, at *nyĕpi*, i.e. practicing silence and desertion, the Balinese people try to keep quiet as much as possible and to forgo lighting lamp or fire, avoiding light and smoke, the best visible signs of life. This suggests to the ever invading forces of evil, *bhūta,* that the island has been deserted. The exorcist priests, *sĕṅguhu,* try actively to expel the *bhūta* and to that purpose recite a litany which should exist of at least three hundred octo-syllabic lines.[93]

How this litany, which turns out to be an account of the origin of the world, disperses the demonic forces, Hooykaas does not attempt to explain. And the idea that people hide in their houses to avoid the *bhuta* seems just a little too simplistic, even if some Balinese may have expressed such a notion to Hooykaas.

The day of silence must be understood in the context of the rituals that precede it and are part of it. Two or three days before the day of silence, every community performs a large *caru* ritual: Taur Kasanga (Repayment of the Ninth Month). According to my informants, this repayment is to Durga. Put another way, this means that the rite is intended to transform the destructive entities created by Durga into more positive, higher forms. Taur Kasanga begins with *melasti,* when all the sacra, including the *pratima* and the Barong and Rangda masks, from each village temple are carried in procession to the sea. There on the beach, facing the ocean, the sacra are given offerings, Brahmana priests recite their mantras, and the village congregations pray. The aim is to begin the process of purification—that is, to reabsorb all negative and dangerous influences back to higher, purer forms. After this cleansing in the sea, the sacra are carried back to the village and placed on the Bale Agung in the Pura Desa.

At midday the *caru* offerings are presented in the crossroads, where according to the myth Siwa Kala met the Panca Durga to create in all directions the *bhuta kala*. Accompanied by exciting gamelan music to attract the *bhuta kala,* the offerings are given by the *pemangku*. Meanwhile, on the Bale Agung, a pavilion in the Pura Desa, the Barong and Rangda masks are placed side by side, like Durga and Siwa Kala in the myth, to receive their offerings.[94] Later in the day the *pratima* and other sacra are returned to their temples. People also make smaller *caru* offerings in their homes. At twilight *(sandykala)* people make as much noise as

possible *(ngrupuk),* circling their houses banging pots and pans to chase away, it is often said, any remaining *bhuta kala.* In fact the loud noises are intended to attract any remaining *bhuta kala,* like the loud exciting gamelan music played when the *caru* offerings are made earlier in the day, the aim being to bring any remaining disruptive forces to the center to be reabsorbed into higher entities. In the evening people perform *mabiakaon* rites intended to purify themselves—that is, transform all negative *bhuta* influences in themselves into positive influences. Now every effort has been made to reabsorb into purer forms all disruptive forces in the self, in the household, in the temples, and in the community as a whole. The next day is the day of silence. The world has been emptied and returned to the original quiet before creation began. As the *tutur* texts put it, all has been collapsed back into the one from which all originated.

Nyepi thus represents the logical end achieved by *caru* rituals: to return all to its undifferentiated source, ultimately the void, *sunya.* Symbolically the world has been reabsorbed back into the void. Now a new process of creation must be awaited. Accordingly this is enacted by the *senguhu* priests as they recite the *tutur* text that Hooykaas refers to as the *Litany of the Resi Bhujangga.*[95] I have referred to Hooykaas' translation of this text to illustrate several points in the discussion so far. Now we are in a position to appreciate its significance as a whole. The litany begins with the void, Sang Hyang Sunya.[96] Since the world, symbolically, has been purified back into the void, this is the logical starting point for the recitation. The text relates that Sunya, the void, becomes desirous of companions and creates six children. The firstborn is a woman, the lovely goddess Uma. Then five sons are created, one of which is Siwa, who together with Uma creates the material world.

The litany goes on to relate how, once the process of creation is completed, a strange and terrifying change comes over the goddess Uma. Turning back to observe her creations, she suddenly is overtaken by a wild anger. Transforming into Durga, she descends to earth to devour the human beings she has just created. Siwa follows her, also taking terrible form as Siwa Kala, and together with their followers they lay waste to the earth. Finally the high god takes pity on humankind and sends the Tri Semaya (Brahma, Wisnu, and Iswara) to teach human beings how to control the wild energy of creation. Thus Iswara becomes a *resi* (sage, holy person), Brahma a Brahmana priest, and Wisnu a *bhujangga* (exorcist priest),[97] and they show human beings how to perform the sacrifices and worship necessary to avert annihilation by Siwa Kala and Durga.[98] The offerings are made, and after consuming their feast the demonic hosts are transformed back into their divine forms of Uma, Siwa, and the *bidedaradedari* (nymphs) and all return to heaven in perfect form. The litany thus establishes that human ritual can persuade the gods to resume their original gentle forms *(somyarupa).* In abstract terminology, the flow of cosmic energy has been redirected back and up toward its original pure source. The recitation of the *bhujangga* priests does not enact a return to the void *(sunya),* however, but to the more differentiated, yet still pure, level of Siwa's heaven. Thus humankind can be assured that the process of emission will soon begin anew. Indeed on the following day the world returns to its usual active state.

This myth of creation chanted by the *bhujangga* priests at Nyepi clearly depicts the cosmic movements of emission and reabsorption—beginning with creation from the void, the movement downward as the creative process degenerates into the wild energy of Durga and Siwa Kala, and the counterbalancing function of human ritual that serves to return, or reabsorb,

the dangerous energy back to its pure origins. The cosmic flow of transformations is explicitly stated in the text. Evidently much more is involved than the simple warding off of evil that Hooykaas suggests. Furthermore, if one places Nyepi in the context of the ritual actions of Taur Kasanga and *melasti* that immediately precede it, we see that the disruptive forces of the *bhuta kala* have already been purified, reabsorbed, the day before and that Nyepi symbolically brings into being the pure silence and emptiness of creation returned to its source: the void *(sunya)*.

Galungan and Kuningan from a Different Perspective

Galungan and Kuningan, as noted in Chapter 1, represent a time of family celebration and feasting accompanied by ritual activities in homes and temples throughout the island. The period begins with the three days of Galungan (Penampahan, Galungan, and Manis Galungan) and then, ten days later, the three days of Kuningan (Penampahan, Kuningan, and Manis Kuningan). These observances are timed by the 210-day Javo-Balinese calendar and thus take place roughly every six months. Galungan and Kuningan are observed by the whole of Bali at the same time, although observances in southern Bali tend to be more elaborate than in the north.

For most Balinese today, Galungan and Kuningan represent a kind of festive season when everyone buys new clothes, visits friends, and consumes lots of rich food—much like Christmas and New Year in Western countries. The religious significance, like that of Christmas, is understood only in general terms by most people. Large quantities of elaborate offerings are made and placed in the houses and temples. On Penampahan Galungan many chickens, ducks, and pigs are slaughtered to provide the meat offerings required, and human beings too get plenty to eat. This is repeated on Penampahan Kuningan. These meat offerings are not for the gods *(dewa)* but for the chthonic forces, the *bhuta kala*.

Lovric observes that Galungan is a *bhuta yadnya,* or sacrifice to the demonic forces,[99] as does Howe,[100] although the usual Western accounts of the observances give little indication of this.[101] The need for so many offerings containing blood and meat indicates that the disruptive forces in the world have reached a peak and must be brought under control. Lovric also notes that Galungan once coincided with the change in seasons in Bali, "a dangerous time in terms of illnesses."[102] As we have seen, offerings and sacrifice are meant not simply to persuade the *bhuta kala* to depart but to transform them into positive entities. That is to say, the negative energy they represent is reabsorbed back into higher and purer forms.

During the period between Galungan and Kuningan many Barongs are abroad. Accompanied by youthful musicians, Barongs can be seen parading the village streets, stopping in front of each house to receive offerings or small payments of money. This practice is referred to as *nglawang,* and the Barong is said to bring the *bhuta kala* under control by this means; sometimes it is even said that the *bhuta kala* are persuaded to enter the Barong and are thereby removed.[103] Barong, with his gold and mica ornaments, his bells and peacock feathers, is evidently an auspicious monster and part of the general air of celebration.[104] People are happy to welcome him as he prances past their homes.

Various stories and myths are attached to Galungan. The following account was related to me by Dewa Nyoman Batuan, a renowned artist and *bendesa adat* for his community:

Siwa was quarreling with his wife Uma, so that she became angry and went to earth as Durga and was killing the populace. Finally Siwa sent his son, Ganesha, to find his mother and ask her to stop destroying the world. When Ganesha found his mother she explained that the people had forgotten about her, they no longer made offerings to her in the temple, they thought only of themselves. Ganesha told the people that they must remember to hold ceremonies and make offerings, so that Durga would not be angry with them, and that he would check on them every 210 days. Siwa then sent Barong to *nglawang* past every gate to see that people had not forgotten Durga. This is the origin of Galungan.

The *lontar* titled *Usana Bali* attributes the origin of Galungan to a king of Bali, Jayakasunu, who prayed in the graveyard to Durga that he might be spared the fate of several of his predecessors who had died shortly after taking office and whose people had likewise been decimated by plagues.[105] Durga appeared to the king, explaining that for a long time the ancestral temples and shrines had been deserted and the proper sacrifices to the *bhuta kala,* and herself, had not been made. She told the king that in order to avert the plagues of sickness he needed "to make offerings in the week *(wuku)* of *dungulan* in order to entice the demon trinity (Sang Kala Tiga) to enter the *Barong* (Sang Kala Gede)."[106] In this account, the demonic forces causing death and disaster to the populace must be contained by making sacrifices to persuade them to enter—to be reabsorbed—into the auspicious Barong.

According to one of my most knowledgeable sources, Ida Bagus Sutarja, Galungan is an extremely dangerous time of the year when three very powerful demons, Bhuta Galungan, Bhuta Dungulan, and Bhuta Kuning, attack the world. These are the offspring of the goddess Durga, and their arrival presages a time when the dangerous energy inherent in the material world is at a height. For this reason, large quantities of offerings must be presented to the demonic forces to assuage their hunger. Lovric quotes from a *lontar* text, the *Sunar Agama,* that closely parallels Sutarja's opinion:

> On the day named *panyekeban,* Sanghyang Kala Tiga Wisesa commence their descent to become Bhuta Galungan and to receive offerings prepared for them by mankind. . . . It is a dangerous time when human welfare is in jeopardy. The following day, *panyajaan,* is a time when people should meditate and free themselves of passion because on this day Sang Kala Tiga appear. The next day, named *panampahan,* is a time when offerings and animal sacrifices should be made at the crossroads and in houseyards, for Sanghyang Kala has now become Sang Bhuta Galungan. They have the potential to harm the population or they can protect it. On this day danger culminates. *Abaya-kala* offerings, aimed to secure the well-being of individuals, should be made so that people have a long life and are undisturbed by illnesses.[107]

What these different accounts have in common is the understanding that Galungan represents an attempt to avert the danger for humankind that arises when the terrible Durga and her demonic followers rage uncontrolled on earth.

We have seen that the Balinese myths of Siwa and Uma describe many occasions on which Uma is cursed by Siwa to descend to earth as the terrible Durga. In order to return Durga to her gentle form, she must be reunited with Siwa. The myth of Rare Angon, recounted in Chapter 3, is a clear example, and I believe this story is the mythic counterpart of Galungan. Uma's encounter with the cowherd (Siwa in disguise) is revealed by their son, Gana (Ganesha), and in consequence Siwa curses Uma to go to earth as Durga and inflict disease and plagues on humankind. When Uma asks when she will meet with her husband again, Siwa replies that she must ask people to build the *mrajapti* as a place for them to meet on earth. He promises to descend in the form of Durgakala accompanied by all his heavenly followers in demonic form.

We have seen, too, that in some myths Siwa assumes terrible form and meets with Durga to generate yet greater destructive energy—as in Hooykaas' *Litany of the Resi Bhujangga,* which we have just considered in relation to Nyepi, and in the myth of the origin of the *bhuta kala* discussed in Chapter 3. When Siwa assumes the form of Barong Ketket to meet Durga, however, he does so to bring Durga's dangerous energy under control. Galungan is the season of Barongs since this is the time that Siwa comes to earth as an auspicious beast to meet with Durga and tame her wild desires. His presence is welcomed by the people, seen as a protector and even savior, since only he can satisfy Durga. In Barong form, he parades through the villages and attracts to him from every gateway the disruptive *bhuta kala* forces within each household. These *bhuta kala* are in fact his own creations, engendered in the meeting of the Panca Durga with Siwa Kala. Now he reabsorbs them back into himself, upward to their purer form and origin. Durga and her minions are thus doubly satisfied: by their huge offerings of meat and by being united again with Siwa/Barong.

At Kuningan more offerings of meat are given, and people say that the ancestors descend to every household. Special decorations called *tamiang* are hung around the house to represent, it is said, victory. *Dharma* has won over *adharma*—order over disorder. In mythic terms, Siwa as Barong has succeeded in controlling the negative energy of Durga, who can now be returned to her divine form of Uma. In mystical terms, *pradana* (a purified earth) is now ready to meet with *purusha* (sky/heaven), as divine power descends to bring about a new marriage between Siwa and Sakti and thus the generation of new life. The processes that we traced in the *odalan* festival are also enacted in the observances of Galungan and Kuningan—but with the difference that here the whole island participates at the same time in the reabsorption of dangerous energies and the initiation of a new, pure phase of emission.

The view of some earlier scholars that Galungan and Kuningan were originally based on agricultural observances is not incompatible with this interpretation. We need only remind ourselves of how Christian rituals in Europe were accommodated to pagan calendrical feasts. The rice harvest, when people have a lot of time and resources to put into rituals, is naturally a time of rejoicing and celebration—a time of plenty. The present-day Parisada Hindu Dharma view that Galungan and Kuningan symbolize the victory of *dharma* (order) over *adharma* (disorder) simply puts an ethical emphasis on the complex metaphysical themes of dangerous energy and the ritual reabsorption to purer forms. Galungan and Kuningan represent a ritually created period when the downward cosmic process is reversed by drawing the dangerous energies in toward the center, then reabsorbing them into their purer origins, so that the world as a whole (that is, the island of Bali) is brought back to a state of purity.

Once this has been achieved through extensive sacrifices to the chthonic forces, the purified earth can connect with the pure realm of spirit. For a few days, the world enjoys a state of peace, harmony, and goodwill as it is infused with the positive power of the divine realm. For the ordinary person, the presence of gods and ancestors and their benign influence are felt all around. At another level, this ritually created time of harmony is a realization of the mystical marriage of Siwa and Sakti—intimation, at least, of the divine bliss of the soul's union with the Siwa soul. And from this mystical union flows a fresh stream of life.

The Eka Dasa Rudra Ritual

The Eka Dasa Rudra ritual is a grand ceremony to purify the whole island of Bali. Ideally it should be performed approximately once every hundred years, but in recent times it has been held twice, in 1963 and 1979.[108] Although a very special occasion involving enormous expenditure of time and resources, in essence it is an extended and elaborated version of the Taur Kasanga rituals held to mark the last day of the Balinese lunar year, preceding Nyepi, the day of silence, and thus it constitutes a *bhuta yadnya,* or sacrifice to the demonic forces. It is not, however, celebrated separately in each community like Nyepi, Galungan, and Kuningan but is held at Besakih Temple, the most important temple in Bali, on behalf of the whole island. David Stuart-Fox , who observed the 1979 Eka Dasa Rudra, points out that the notion of "demons" needs to be understood in a more subtle sense than simply evil forces:

> *Bhuta yadnya* ceremonies are directed to potentially disruptive nether
> world forces, the demons. *Bhuta* means element; and *kala,* another word
> for demon, means time or energy. Demons are personifications of forces
> derived from the five elements *(panca mahabhuta)* at such times as these
> forces exceed their normal intensity and bring misfortune to man.[109]

Yet he nonetheless explains that the intention of the ritual is to "placate the demons."

Other scholars, such as Leo Howe,[110] have observed that the aim of the Eka Dasa Rudra is in fact to transform the demonic forces into benign ones. Hildred Geertz has suggested that the aim is to reorient the destructive forces at large in the universe.[111] Stephen Lansing points out that this aim was symbolically expressed in two drawings placed in the temple during the rituals: "The first showed the god Siwa springing out of the demon Kala, the second showed the goddess Uma springing out of the demoness Durga."[112] He also observes that this "process of dissolution and realignment of elements" should occur both in the external world and in the inner world of each individual.[113] Although Lansing clearly describes a process of transformation, he goes on to compare it with cycles of growth and decay,[114] making the ritual's intent somewhat more comprehensible to a Western audience. Lansing thus stops short of revealing the interplay of the processes of absorption and emanation I have cited. In a later publication, however, he explicitly states: "Various sacred texts describe Rudra as an ancient Sanskrit destroyer god, the fierce demonic incarnation of the supreme god Siwa. The culmination of the Eka Dasa Rudra ceremony is an attempt to transform Rudra from an agent of chaos into his godlike form as Siwa."[115]

Texts relating to the Eka Dasa Rudra performed in 1963, compiled by C. Hooykaas, constantly reiterate that the aim is to restore all things to original or perfect form. Hooykaas himself refers to the "conquering" of evil and the "exorcising" of demons,[116] since in his view what is evil can only be banished or defeated. But his text reveals a different picture:

> May banished be the evil shape, may the natural form return,
> Ogresses become like Umā, ogres then become like Guru,
> Youths become like heaven's fairies, maids become as female fairies.[117]

Such passages, of which there are numerous examples in the text, clearly reflect the themes of returning dangerous and impure entities back to pure form. Demons are to be transformed into gods. The text declaims:

> In the past thou hast been *bhūta, yakṣa, yakṣī;* return to thy godlike shape.[118]

The following passage, which invokes the many forms of Kala, the god of evil according to Hooykaas,[119] would be incomprehensible if the ritual's intent to convert Kala to benevolent form were not understood:

> Oṃ Lord Kāla . . .
> this is the food offered to thee, enjoy its essence, do not be
> fastidious and particular; enjoy it, be good and eat of it as thou canst.
> If in any respect there is something to blame, great may be thy
> forgiveness. When thou hast enjoyed the essence, I hope thou wilt
> bestow a favour upon me: Protect X and accompany him where ever
> he may go and do not trouble him; accompany him on the right path,
> [make him] turn [from evil ways] and enjoy the Eternal Law of
> Absolution.[120]

Here the dreaded demon Kala is being requested to be not only the supplicant's protector but indeed his moral guide.

One of the key passages of the text is titled "Praise of Bhūta-Kāla, Called Five Great Bhuta." It presents a kind of summary of the Five Great Bhuta, who are identified with the five directions, five weapons and emblems, five days of the week, and five holy letters constituting their mantra. It also lists the five different levels of forms these entities take, the top two levels being *rĕsi* (sages) and gods. The text declares:

> As *rĕsis* thou art called / Kurṣika / Garga / Maitri / Kuruṣya / Patañjala / :
> as Gods thou art called / Īṣvara / Brahmā / Mahādeva / Viṣṇu / Śiva /[121]

The demons, or *bhuta,* are but aspects of transformations of the high gods. Each level, from *bhuta* to god form, is a transformation of the other.

If the Eka Dasa Rudra is, as Lansing points out, a *bhuta yadnya* "simply made more complete and comprehensive than ever before,"[122] a point also stressed by Howe,[123] it is to be expected that its aim is essentially the same as ordinary *caru* sacrifices. We have already seen that *caru* are said to have originated when Durga and Kala/Rudra brought into being the *bhuta kala* in the five directions. *Caru* are intended to persuade Durga, Kala/Rudra, and their followers to return to god form. The drawings of Uma springing from Durga, and Siwa from Kala, mentioned by Lansing confirm this as the goal of the Eka Dasa Rudra observances. Hooykaas includes in his text two drawings that he describes as Durga eating Uma and Kala eating Siwa.[124] In fact the drawing can be interpreted in both ways, since Uma descends in anger to become Durga and Siwa descends to become Kala/Rudra. This is the state of affairs at the beginning of the ritual. But following its completion the process is reversed; then Uma arises out of Durga to return to divine form, and likewise Siwa arises out of Kala/Rudra.[125]

Possibly because the Eka Dasa Rudra rituals have been the object of recent observation and study by Western scholars—and also because the scale of the event tends to bring into clear relief its main elements—the transformatory intent of this sacrifice has been better understood than that of the ordinary *caru* sacrifices. Yet evidently they follow the same pattern. The Eka Dasa Rudra ceremony, I suggest, can be understood as the pinnacle of ritual efforts to achieve the reabsorption of all the dangerous and impure elements in the world that have reached a critical point of extreme danger. In the language of mythology, the eleven Rudra of the eleven directions have been drawn together and upward to their pure source, Siwa.

The fact that the Eka Dasa Rudra is performed in one place, Besakih Temple, on behalf of the whole island (symbolically the whole world) perhaps also results in an explicit emphasis on Siwa and Uma since they are the ultimate manifestations of the cosmic principles to which this grandest of all Balinese rituals is directed.

Holy Water *(Tirta)* and the Role of the *Pedanda Buddha*

Two further aspects of Balinese ritual can be illuminated, I think, by placing them in the context of absorption and emanation: the various types of holy water made by priests and the different functions of so-called Siwaistic and Buddhistic Brahmana priests. The proliferation of different kinds of holy water used in Balinese ritual might well be considered just another instance of the Balinese love of elaboration and replication in artistic and ritual expression.[126] Yet I suggest that this seemingly random diversity can be understood as variations on the same ritual pattern I have emphasized throughout this chapter. Although there are many different kinds of holy water and methods of preparation, two basic forms have been identified by Hooykaas.[127] Hildred Geertz too identifies two basic types—one seen as "cleansing and providing protection against evil-minded spirits" and the second also for cleansing "but providing the positive blessings of health and fertility."[128] The former is usually referred to as *tirta panglukatan* and the latter as *tirta amerta kamandalu*.[129] Since *"lukat"* is conventionally translated as "exorcism," *tirta panglukatan* would be holy water to exorcise evil. But such a rendition fails to recognize that evil is not exorcised but, rather, negative

influences are transformed into positive ones. When, for example, in the *lontar* text *Siwagama* Durga is instructed by Siwa that she must receive *"lukat"* from the hands of Sahadewa in order to become Uma again and return to heaven, this does not mean that Durga is exorcised but that she is transformed back to her pure state as Uma.[130] *Tirta panglukatan* purifies not by extirpating evil but by reabsorbing it back to its pure origins. It is an agent of reabsorption—that is its function and constitutes its value. *Tirta amerta kamandalu,* by contrast, which confers blessing and fertility, is the holy water that is "born" following the marriage of *purusha* and *pradana* at the *odalan* (temple festival). It is the divine substance that the *pedanda* visualizes as issuing from the limbs of Ardhanareswari (Siwa and Sakti united in one body). *"Amerta,"* as we have seen, means literally "no death." It is the elixir of immortality, representing new life, and the cosmic process of emanation. Therefore it brings material blessings such as fertility, but it also cleanses because it represents a new process of emanation still close to its pure source.

Balinese often told me that preparing *tirta panglukatan* was the special province of the *pedanda Buddha* and that, furthermore, *pedanda Buddha* were especially knowledgeable in carrying out *caru* and *taur* rituals. Some observed that the syllable BU *(bhu)* is root of the words *bhumi* (earth), *bhuta* (demon or element), and Buddha.[131] Many said that the *pedanda Buddha*'s role was to deal with the demonic forces and observed that ideally all important *yadnya* required the presence of both *pedanda Buddha* and *pedanda Siwa.*[132] The special role of the *pedanda Buddha* with respect to *bhuta yadnya* is also described by Hooykaas,[133] whose texts pertaining to the Eka Dasa Rudra ceremonies were in fact derived from *pedanda Buddha.* Nevertheless he assumed that because of their falling numbers, *pedanda Buddha* no longer play a prominent role in Bali. According to my informants, however, the decline in numbers relates to family lines dying out and subsequent difficulties in finding appropriate candidates to become *pedanda.* The services of *pedanda Buddha* continue to be essential, and those remaining officiants find themselves in great demand today.

Some Western scholars have written as if the *pedanda Buddha* represented a different sect or denomination. Even Hooykaas tends to give the impression that the *pedanda Buddha*'s position is a historical relic of a time when Buddhism was in competition with Hinduism.[134] Yet it is clear from Balinese statements—and from the fact that *pedanda Buddha* and *pedanda Siwa* continue to the present day to perform their rituals side by side at important ceremonies—that they operate within the same system and certainly not as competitors.[135] Their complementary role can, I suggest, be understood as related to the complementary processes of absorption and emanation. The *pedanda Buddha* with his *tirta panglukatan* and his special knowledge of *caru* and *taur* deals with the ritual directing of the process of reabsorption—that is, returning all the dangerous and destructive forces out of control in the world to their original pure source. But his actions must be balanced by the *pedanda Siwa,* who through his rituals brings Siwa and Sakti to unite and thus begin a new process of emanation—the symbol and instrument of which is *tirta amerta.*

Numerous scholars of Old Javanese have written on the Siwa-Buddha cult of Java, usually stressing the fusion of the two figures.[136] Marijke Klokke, for example, draws attention to the oneness of Siwa and Buddha in Old Javanese texts and quotes several texts illustrating the concept that Siwa and Buddha are "different manifestations of the same highest principle."[137]

I would suggest that in Bali, Siwa and Buddha represent not a unity but rather the two different that become one, or *rwa bhineda*. Rubinstein notes that in Balinese texts the *rwa bhineda* is composed of two syllables, *ANG* and *AH,* and that *ANG* is associated with Buddha and *AH* with Siwa.[138] The two syllables are also associated with inhaling and exhaling,[139] *ANG* representing the inward movement and *AH* the outward movement.[140] This clearly represents, in my view, the cosmic processes of absorption and emanation as expressed in the movement of breath in the human body, the control of which, of course, is such an important part of yogic practices. From this perspective, Buddha can be understood as the "calm returning flow of liberation and peace" and Siwa as "the outward throbbing stream of energy and enjoyment": the eternal opposing rhythms of *nirvritti* (from matter back to spirit) and *pravritti* (from spirit outward to matter) that give rise to our universe and thus are one.[141]

Budiana often mentioned how Buddha and Siwa represent two opposite flows of energy. In his view, Buddha symbolizes the quiet return to the inner self, to silence and emptiness, whereas Siwa represents the outward flow of life, ever differentiating into richer and more diverse forms. Art, according to Budiana, follows these two directions. There is art that flows outward from the inner spirit, creating objects of beauty in the material world that can inspire admiration and wonder in the populace, so that even ordinary people feel compelled to praise and worship the divine powers depicted by the artist. And then there is art that through its purity and simplicity directs our attention back inward toward the source of all creation: the pure and empty void. Classic Balinese art, with its endless multiplication of rich and elaborate forms surging upon themselves, represents the flood of creation outward. The contemplative forms of Buddhist art and the classic statuary of Hindu deities of the medieval kingdoms of Java, by contrast, represent the sage's vision of the soul's return to its pure source. Art serves these two ends: it can instill in the common person respect, awe, and love for the majesty, beauty, and power of the divine forces that control and give life to the world, while a different kind of artistic vision speaks to spiritually more developed persons, heightening and refining their awareness of the spiritual potential within the self. Modern artists, Budiana believes, are able to draw on either or both of these potentials.

Although the Balinese rituals I have discussed here are clothed in specifically Balinese details of expression, their underlying themes are demonstrably the same that Davis has identified as the basic pattern for all Shivaitic ritual. From this perspective it becomes evident that many of the apparently random and quaint rituals of Bali can be understood at a deeper level as clear symbolic expressions of classic Hindu cosmological and mystical understandings. The Balinese cosmos is not simply a matter of periodic cosmic cycles of creation and destruction; rather it is a matter of constant pulsations of cosmic forces—operating in individuals, in specific locations, and generally within the material world as a whole. For this reason ritual action in some form is constantly being required, leading to the impression of an endless proliferation of ritual. The *otonan* performed for each individual, the *odalan* performed in each temple, the Galungan and Kuningan ceremonies performed by the whole island every six months, Nyepi every twelve months, and the Eka Dasa Rudra once a century—all reflect these constant pulsations and fluctuations of cosmic forces and the imperative need to bring and keep them under ritual control.

Models of a Dynamic Cosmos

Like Richard Davis, I have worked from the assumption that we need to understand the "matrix of propositions that constitute the world" within which a ritual system operates.[142] Balinese ritual is so multiform and variable that the surface differences make it almost impossible to discern similarities. If, however, we approach this complexity from the perspective of the two cosmological processes outlined by Davis and Wendy O'Flaherty, an underlying pattern or core of organizing beliefs emerges—one that can be seen to generate the differences we encounter as variations on this underlying pattern.

Finally, let us consider the *nawasanga* (nine directions)—the cosmological grid that so many scholars have identified as the fundamental model of the Balinese universe. (See Figure 3.) A lot of ink has already been spilled on this topic.[143] Ironically this key symbol has usually been seen as confirmation of the hierarchical and static nature of the Balinese cosmos, each cardinal direction given its appropriate god, color, and emblems, with Siwa in the center

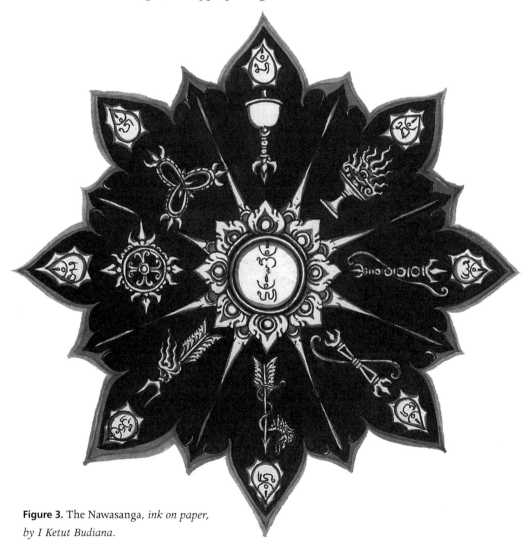

Figure 3. The Nawasanga, *ink on paper,*
by I Ketut Budiana.

represented by the five colors *(panca warna* or *brumbun)*. This directional model of space, it has been assumed, provides the basic pattern of orientation for the human household, the village settlement, and the world as a whole, modeling all upon a divinely appointed order. Furthermore, the cosmos is layered into different worlds—*swah* (the world of the gods), *bwah* (the world of human beings), and *bhur* (the netherworld) plus seven or more layers of heavens and hells—reflecting the hierarchical positioning of gods, humans, demons, and animals.[144]

What this conventional view fails to consider is that the *nawasanga* is not a static grid.[145] It represents a spinning helix or cone.[146] In addition to the eight cardinal points and the center, there are two more points—up and down—making a total of eleven, or *ekadasa* (as scholars writing about the Eka Dasa Rudra rituals have observed). In terms of the number symbolism discussed earlier, the number eleven has the mystical significance that ten becomes one—that is, when ten is reached, the numbers return to one. This symbolizes the cosmic origin from, and return to, a single source. The cosmos is represented as spinning outward and downward from a single point in a clockwise direction—and this clockwise movement, *pradaksina,* we have observed in the temple festival as representing the descent of the gods to earth. At the same time, there is a counterbalancing movement, anticlockwise, *prasawya,* that is followed when the gods are returned to heaven and when the *caru* offerings are given to transform the *bhuta kala* into purer entities.[147] The Brahmana scholar Ida Bagus Sutarja drew my attention to this fact early on, remarking that I must not think the *nawasanga* is still: it is in fact spinning like a top. It has taken me a long time to grasp his meaning. He also spoke of how as one force field spins down in a clockwise direction, another is moving up toward it in the opposite direction until they meet and lock together as in a sexual union. The temple festival, he explained, aims to bring the two together so that the powers of the earth and heaven meet—and for a moment a perfect balance of cosmic forces is achieved. The cosmic movement is symbolized here as downward and outward from a center; from the periphery, below, it moves upward toward the originating point. Thus the *nawasanga* symbol itself expresses the processes of emanation and reabsorption outlined by Davis.

If we examine the *nawasanga* in Figure 4, we can see that the increasingly differentiated material world is depicted in the widening segments of a cosmic circle. Each segment, representing one of the eight directions, comprises a god standing on the head and shoulders of a larger demon. This represents the idea that as the divine forms move away from their origin (Siwa in the center of the circle), so they become dangerous and destructive forces ever expanding outward. The potential for expansion is infinite—until the whole explodes into a maelstrom of degenerate forms. To avert this catastrophe, ritual means must constantly be employed to return the flow of dangerous energy to its source. Likewise in the microcosmos, the self, the yogin seeks to encounter the cosmic energy and then redirect it back to its quiescent source. This is the vision of the Tantric hero, the *vira,* that Budiana presents to us. What the *vira* achieves within himself, the Brahmana priest achieves with his mystical union with Siwa as a way to purify others—via the *tirta amerta* that results from his mystic union with the divine.

The many levels of Balinese heavens and hells do not, from this perspective, represent a hierarchically ordered cosmos. Rather they express symbolically the many different levels of creation—beginning with the void *(sunya)* and Paramasiwa; moving downward to

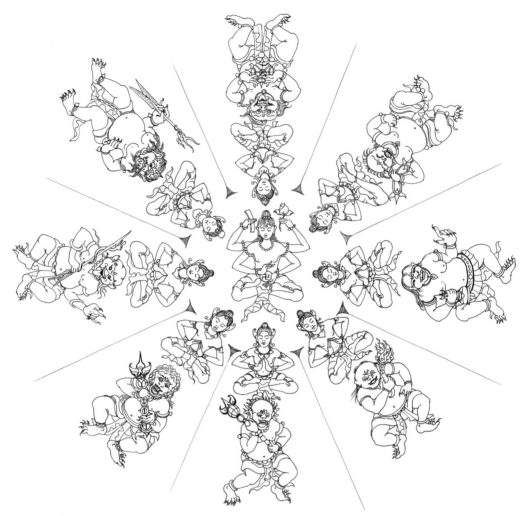

Figure 4. The Nawasanga, *ink on paper, by I Gusti Nyoman Mirdiana* (above) *following a painting by Dewa Nyoman Batuan in the author's collection* (opposite).

increasing differentiation as Sadasiwa, Siwa; and then to the numerous gods and goddesses as multiple manifestations of the original divine source that gave rise to other entities until ultimately the material world emerges. Once the material world appears, the creative process degenerates into increasingly negative energies until finally Siwa descends into Siwa Kala, the demonic level.

Some versions of the *nawasanga* depict it as an eight-petaled lotus with one of the ten sacred letters *(dasaksara)* written on each petal and the final two in the center (Figure 5). As we have seen, the *dasaksara* represent the differentiated world that in the process of ritual reabsorption is compressed into five, then three, then the two that become one. In this way, the cosmic movement from periphery to center, and upward, is also indicated in the diagram of the *nawasanga*. Following its lotus shape, this version is referred to also as a *padma* (lotus) and sometimes as a mandala. The mandala is also the *cakra,* or wheel. This form evidently suggests movement. Although to a Western observer the *nawasanga* may appear static, to

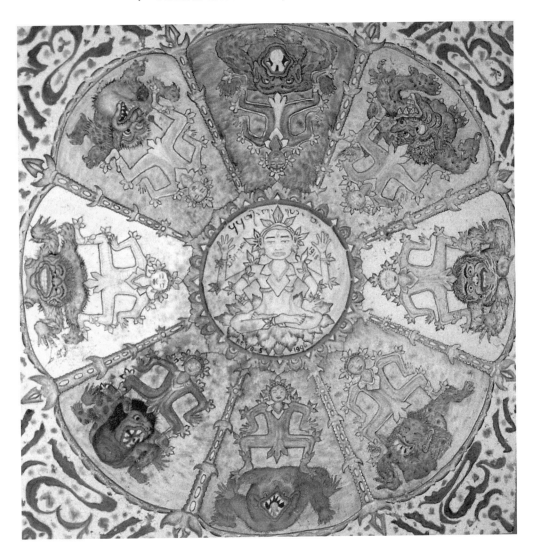

an informed Balinese eye it is essentially dynamic, spinning like a wheel, since all that has life moves. As Budiana observed in relation to the dancing stance of his figures, the movement of the dance represents life. Stillness is death. The world mandala, lotus, wheel, is inherently dynamic.[148]

Furthermore, the world is not simply spinning in one spot: the forces that constitute it are moving up and down, in and out, on a vertical axis as well. This vertical axis is, in mythological and mystical terms, the Siwa lingam. The Balinese myth of the Linggodbhawa recounts how Siwa demonstrated his power to Brahma and Wisnu by confronting them with the lingam that reached down into the earth so far that neither could find its origin and so high into the heavens they could not find where it ended. This infinite power of Siwa constitutes the central axis of the Balinese universe. At the highest level is Paramasiwa; at the lowest is Siwa Kala. The vertical axis is divided horizontally into the pure and impure realms. The earth is part of the impure realm. The earth and its contents originate from the meeting of Siwa and Sakti in pure form, but they exist in the impure realm. As the process of emission

descends into the impure realm, it begins to degenerate into lower and wilder forms. In the language of mythology, *dewa* (gods) become *kala* (demons); Siwa becomes Siwa Kala—but, as we know, the process can be reversed and reoriented through ritual.

The *nawasanga* or *padma* also provides a model for the self and the force fields operating within it. Once again, the processes of emission and reabsorption are evident. In the center is the self, *lega prana;* in the four directions are the four spiritual siblings, the *kanda empat.*[149] The siblings can be called into the center, to unite with the body, and sent out in the different directions to guard the self or carry out its commands. Thus there is a pulsating movement out from the center. There is also movement up and

Figure 5. The Nawasanga *in the form of a lotus inscribed with the* dasaksara, *ink on paper, by I Gusti Nyoman Mirdiana.*

down, since the *kanda empat* and the self have many levels. Basically these are divided into three: the demonic *(bhuta)* level, the human *(manusa),* and the divine *(dewa).* At the *bhuta* level, the *kanda empat* are Angapati, Mrajapati, Banaspati, and Banaspati Raja. At a higher level they represent the Catur Lokapala, or four heavenly guardians, with Siwa in the center (that is, the self). The many different levels and names are given in the numerous *lontar* texts concerning the *kanda empat.*[150] One level can be transformed into the other—obviously by ritual means. Every 210 days, every Balinese adult observes an *otonan* when offerings are given to the *kanda empat.* The intent, I believe, is to align mystical forces within the self to ensure that the movement downward toward the *bhuta* potential is checked before it becomes dangerous, yet ensuring that life continues. In other words: this ritual brings about a meeting of the paths of reabsorption and emission within the self. Here the meeting in the self is achieved via an external ritual process, the *otonan* observances, rather than an inner state of visualization as in the yogic practices of the adept discussed earlier. Further research is necessary to confirm my arguments. But given the correspondences between the *bhuwana agung* and the *bhuwana alit* in Balinese mystical philosophy, I have little doubt that, as my most knowledgeable Balinese informants assure me, the same general principles apply.

Another pictorial representation of this cosmic dynamic is found in Balinese paintings of *Pemutaran Mandara Giri,* which depicts the churning of the oceans to obtain *tirta amerta,* the water of life.[151] A line drawing based on Kamasan-style painting of the story is shown in Figure 6. The mountain, which is also the Siwa lingam, is being turned in the ocean by the combined efforts of the gods and demons. The *naga* Basuki is being used as a rope tied around the mountain/lingam that is being pulled in one direction by the gods *(pradaksina)* and in the opposite direction by the demons *(prasawya).* Both forces are necessary to keep the mountain turning. As the mountain turns, so eventually emerges the water of life, *tirta amerta.* The sexual symbolism is also evident: the lingam moving in the yoni, Siwa and Sakti united, the beginning of new phase of emission. In this context, the gods and the demons

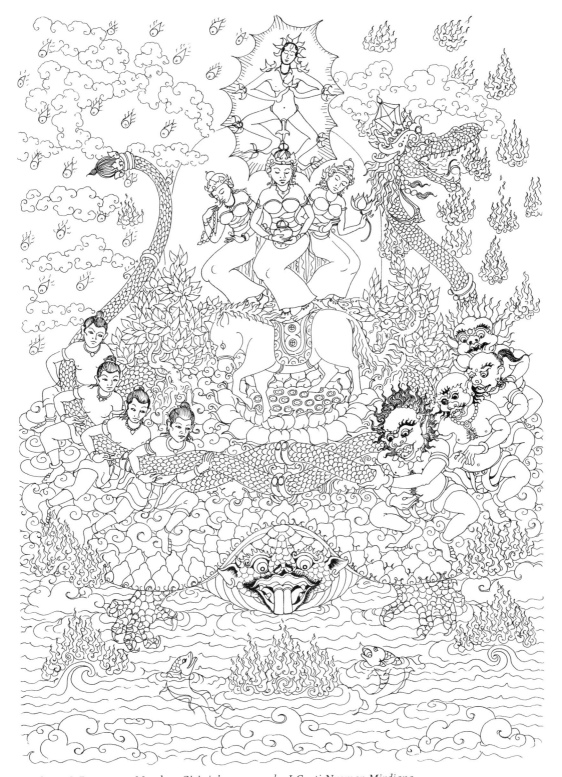

Figure 6. Pemutaran Mandara Giri, *ink on paper, by I Gusti Nyoman Mirdiana.*

need to be understood—not as forces of good and evil, which a Christian perspective would lead us to expect—but as the pure and impure realms, or spirit and matter. Both are necessary to create life in the world. Indeed life comes about only when matter is infused with spirit. Since this is in essence the theme of the temple festival, Budiana explained that paintings of *Pemutaran Mandara Giri* are often displayed in the temple during this time. For the same reason, the story of *Pemutaran Mandara Giri* is also a popular subject for *wayang kulit* performances held during temple festivals.

At this point we are beginning to appreciate the redundancy of ritual symbols. As Freud observed of dream symbols, there are an infinite number of different symbols, but all point to a few underlying themes.[152] Balinese religious symbolism is so profuse and so rich in detail that the observer is easily mesmerized into thinking that each represents something different—rather than realizing that the symbolic repertoire consists of countless variations and embellishment on basic themes. Many Western attempts to understand Balinese religion and ritual have, I believe, foundered on attempts to analyze the surface detail combined with the assumption that all this burgeoning richness must be the result of a haphazard mixing of cultures and traditions. From this perspective, there is no point in looking for some underlying pattern of organizing ideas.

In contrast to this view, I have argued that Balinese mystical symbolism repeats, in endless variations, certain basic themes. The whole cosmos is moving and pulsating—up and down, in and out—transforming from divine to demonic through meetings and marriages. The aim of ritual is to bring about a balance between these dynamic forces and energies. Thus it is not surprising that Balinese try to explain to Westerners that they seek to achieve harmony in the cosmos. Yet this is not a reflection of a divine harmony—quite the contrary. Ritual seeks to bring dynamic forces into balance, a goal that can only be achieved through constant efforts to bring counterbalancing powers to meet, to fuse, and to give rise to new life. To stop the movement of the universe would mean death and a return to the void. Ritual aims to keep the movements of the material world within certain limits by reabsorbing dangerous energies, before they spiral down out of control, and bringing them back closer to their pure origins. When the two meet, a momentary balance is achieved: the two opposites, spirit and matter, fuse and give rise to new life. The movement downward then begins again.

The Balinese universe, like the classic Hindu view described by O'Flaherty and Davis, is one of pulsing oscillations, of swings between wild energy and quiescence. This movement is not simply cyclical; it represents the incessant dynamic flow of cosmic forces. The universe is a divine play of opposing forces, drawn together by desire, united into one, exploding forth into new forces and entities, in endless succession. The universe is brought forth by the erotic play of Siwa and Sakti, ever drawn together, ever drawn apart, now creative, now destructive, now demonic, now divine.

Balance and harmony are not inherent in the Balinese cosmos; they are what human ritual strives to achieve: a balance between the processes of emission and reabsorption in an ever-fluctuating and dynamic universe.

[CHAPTER 6]

Visualizing Pure Realms

FOR TOO LONG Western scholarship has helped to perpetuate views of Balinese religion that fail to do justice to its mystical insights and spiritual practices, to its degree of conceptual organization, and to its closeness to the central concepts of classic Hinduism. New and very different views are now beginning to emerge from the work of numerous scholars, including philologists, anthropologists, and historians. This book has argued the view that rather than fixed hierarchies, harmony, and balance, Balinese cosmology can be better understood in terms of transformations, ambivalences, and dynamic cycles of desire and destruction—that far from being primarily an "orthopraxy," Balinese religion encompasses important streams of mystical thought including the inner, spiritual discipline of various yogic practices. I have further argued that Hindu concepts are not merely a thin veneer, or only one of many strands of thought making up Balinese religion, but instead permeate all levels of Balinese religious life. I have drawn attention as well to the value of a more nuanced approach to Indian Hinduism, especially Tantrism, in informing our understanding of Balinese religion. And, finally, I have pointed to classic Shivaitic Tantric ideas as a conceptual basis for the vast diversity of Balinese ritual practice.

Certainly much more work is needed to fully flesh out and confirm—or refute—the arguments presented here. With respect to ritual, I have dealt mainly with the *dewa yadnya,* the *bhuta yadnya,* and calendrical observances. What of the *pitra, manusa,* and *resi yadnya*—the sacrifices for ancestors, human beings, and teachers and sages? Can the same arguments be applied to them?[1] My most knowledgeable Balinese sources assure me the same principles apply. Furthermore, Leo Howe's detailed ethnography of the *manusa* and *pitra yadnya* identifies cyclic cosmological notions that appear to be closely related to my arguments concerning emanation and reabsorption.[2] To do justice to the topic, however, would require new ethnographic and textual data—and another book to describe it. Then there is the question of the textual sources. The Balinese *tutur* literature, alone, remains a vast, largely unexplored source. C. Hooykaas' pioneering efforts have resulted in many key texts being made available, but his translations are now in need of reassessment, for his interpretations are sometimes based on misunderstanding of basic Balinese concepts. I mean no disrespect to Hooykaas, whose groundbreaking work has been of the greatest importance to me. Like all scholars of Balinese religion, I owe him a great debt and have drawn extensively on his work throughout this book.

There is the further need to combine ethnographic observation of the rituals with textual evidence and with expert Balinese elucidation of both text and action. In the past, philologists studying texts and anthropologists observing ritual action in the field have usually worked separately. Undoubtedly textual scholars observed rituals and anthropologists consulted texts, but comparatively few have attempted to integrate the two. Now, however, there are various studies exploring new ways to achieve this integration.[3] A large part of the argument presented in this book has been based on relating textual material to observations of ritual in action. I hope I have demonstrated the value of such an approach, yet at the same time I recognize the limitations of my engagement with the texts. I have only skimmed the surface of the relevant material, much of which still awaits systematic study by philologists.

An equally pressing need is to place Balinese religion more accurately within the general traditions of Hinduism. This book has drawn many parallels between Balinese and Indian mythology, mysticism, and ritual practice as well as the basic philosophical principles underlying them. If the first wave of European scholarship was inclined to overestimate Indian influence in Bali and in Indonesia generally, the effort to redress the balance by the next generation of scholars was overcompensating. Textual scholars, it seems, were inclined to assume that because the Indonesian texts were couched in less than perfect Sanskrit (in what has been called rather condescendingly "Archipelago Sanskrit"), the philosophical concepts of Hinduism must have been equally bowdlerized. This impression of a naive borrowing and an unsophisticated syncretism of foreign and indigenous elements was, of course, only likely to be confirmed by actual observations of the overwhelming complexity of Balinese ritual life. In the view of many of these Western scholars, Balinese only thought they were Hindus.[4] Balinese had clearly strayed too far from the letter of the book still to be Hindu. What this view did not sufficiently appreciate, of course, is that for Hinduism there is no book. Western scholars of the time possessed a limited understanding of Hinduism—one that had yet to come to terms with the philosophical nature of Tantrism and yet to pay attention to popular Hinduism in India and its varied ritual expressions.

A central theme of this book has been that Balinese Hinduism is a unique cultural expression, or local variant, of Hinduism emphasizing mystical understanding arising from

Shivaitic Tantrism. The issue for the future, I believe, is to what extent Balinese religion (and Javo-Balinese religion) is a departure from classic Hindu ideas and to what extent its mythology, mysticism, and ritual are a unique creation. This is a direction in which textual scholars are already taking the lead.[5] It involves not pushing the Hindu parallels aside as irrelevant, as in the recent past, but paying new attention to them. I believe it is only by developing deeper and more subtle appreciation of Hinduism as a system of thought that Western and Indonesian scholars will come to understand the deeper reaches of Balinese religious thought.

It is important, too, that Balinese Hinduism be appreciated in its own right as a uniquely beautiful cultural expression of profound mystical and spiritual truths. In this book I have argued that a core of mystical beliefs provides an underlying pattern of significance to public ritual. I have pointed to the correspondence between the public rituals and the rituals performed in the inner concentration of priests and other adepts. The "thrilling mystery of the marriage of fire and water,"[6] I believe, is indeed the central mystery of Balinese Hinduism and the template of ritual practice. If this view is correct, then what we encounter in Bali may be a whole culture organized according to the mystical insights of Shivaism.

In a recent study Stephen Lansing has come close to this position in identifying a "cosmic map" that regulates flows of energy in the inner and outer world.[7] Barbara Lovric has presented an ingenious interpretation linking the well-known legend of Nirartha with the practices of kundalini yoga and a trance possession ritual (Sanghyang Bungbung), thus demonstrating a clear correspondence between rituals performed for the group (Sanghyang Bungbung) and rituals performed in the inner concentration of the individual (kundalini yoga).[8] Raechelle Rubinstein's recent work on Tantric influences in Balinese *kekawin* literature demonstrates the ways in which the mystical understandings of the yogin are translated into cultural forms to influence and shape the daily lives of ordinary people according to these deep principles. Laypersons do not need explicitly stated beliefs or doctrine; simply by following the rituals prescribed for everyday life, they act in harmony with the cosmos. This is much more than acting in a moral or ethical manner. It means nothing less than to be in harmony with the erotic flow and play of the universe: *lalita*.

Certainly the evidence presented in this book demonstrates that there is a much greater correspondence between the written Brahmana traditions and the actual performance of household and temple ritual than has been recognized, or even contemplated, by most Western scholars. The rituals are not simply ad hoc growths that perpetuate themselves willy nilly; they are coordinated with the dual cosmic processes of emanation and reabsorption described in Chapter 5. What we find in Bali may not be paralleled precisely by the teachings of any identifiable sect of Shivaism today or in the past. Yet it is an organized vision reflecting the efforts of sages and priests to shape a consistent worldview. Undoubtedly it involves a mixture of different elements (like Freud's "dream work" or Obeyesekere's "work of culture").[9] Nevertheless, it is a consistent, crafted pattern—not the layers of evolutionary development, with animism at the broad base and Hinduism at the narrow apex, as earlier approaches would have it.

What might be the origins of such a unified vision?[10] Has it existed from the earliest times when Hindu teachings were first introduced to Bali? Or has it developed gradually in situ? Or does it represent a new unified philosophy brought at some specific time to Bali and deliberately propagated there? The Balinese myth of the demonic king Mayadenawa, for

example, might refer to a time of reform when this new vision was incorporated into Bali-
nese life. Or perhaps the story of the coming of the sage Nirartha to Bali marks its intro-
duction. Or it may date from the arrival of the Javanese Majapahit dynasty in Bali in the
fifteenth century. Majapahit kings and ministers needed to impose a new order on their Bali-
nese subjects; presumably they, and their priests, sought to spread their own doctrines and
rituals.[11] The Bali Aga (people inhabiting the mountain regions), located in more remote
areas, might perhaps have continued to maintain earlier forms of social and religious organ-
ization. Yet archaeological and epigraphic evidence of the presence of Buddhist and Shivaitic
Tantrism in Bali dates from as early as the eighth century AD,[12] and much of it has been found
in the mountain regions occupied by the Bali Aga.[13] Furthermore, evidence of direct contacts
between Bali and India go back much earlier to the beginning of the first century AD at
least.[14] My aim is not to resolve these historical questions of origins but only to raise them
with respect to the unified view of Balinese religion that I am proposing.

The different levels of understanding that Balinese themselves have of their own reli-
gion must be taken into account. Clearly one cannot reconstruct esoteric doctrines by ques-
tioning only laity or uneducated priests. What picture of Catholicism might emerge from an
anthropological description based solely on a village congregation of peasant farmers and
their parish priest? If there are at least three basic levels of Balinese understanding—those
who perform the rituals (the ordinary people), those who are responsible for guiding their
actions (the village leaders and village priests), and those who understand the mystical
meanings expressed in the ritual action (the educated scholars and Brahmana priests who
are able to read the sacred texts)—then clearly it is the third group that we must consult if
the underlying principles are to be understood.[15] The view of an essentially Brahmana elite
of scholars is important not because it is an elite but because it possesses an understanding
of the philosophic and mystical principles that underlie Balinese religious practice as a whole.

This is not a matter of the common people and the Brahmana elite following essentially
different religions, as some Western scholars have asserted.[16] The point is that intellectual
understandings are largely irrelevant to ordinary people.[17] Budiana, Mirdiana, and many
others have often stressed to me that Balinese approach religious matters primarily through
"feeling."[18] Howe's extensive ethnography, based on information provided by ordinary
villagers, further convinces me that the views I have described here are part of a cultural logic
that permeates in some way all levels of Balinese thought.[19] Indeed it is this assumptive world
that most people never question or strive to articulate. The important thing for Balinese is
that they participate in ritual actions that are designed to bring about the desired alignment
with the flow of cosmic and spiritual forces to which all are subject. It is the *resi,* the sages,
who determined what these rituals were—or the Tri Semaya themselves if we look to the
mythology—and showed human beings how to carry them out. From this perspective, every
movement of Balinese life might be seen to be choreographed, as it were, according to the
sages' mystic visions of inner spiritual truths.

Persuaded by prevailing Western views that Balinese practices represent a garbled or
naive view of Hinduism, many Balinese intellectuals have turned to India for guidance in
reforming and modernizing their religion.[20] Paradoxically, from the perspective argued in
this book, it may well be that what we find in Bali represents not only a unique cultural
expression of the mystic traditions of Shivaitic Tantrism but even a purer version of it—in

the sense of closer to its original sources—since up to the present Bali has experienced far less external pressure for change and reform than India, and for centuries religion in Bali was left to follow its own course.

Bali, even today, represents a kind of living miracle (although not necessarily a paradise) where a deep metaphysical understanding of an inner world has been projected onto an external world and become a plan for everyday living. At this point it might be thought that having rejected them at the outset, I am now invoking stereotypical images of Balinese culture, especially those promoted in the tourist literature of an island paradise, or falling back on earlier notions of a hierarchical cosmic order projected onto the mundane realm, or perpetuating Clifford Geertz's view of Balinese culture as aesthetic performance. Such is certainly not my intention, yet each of these views holds an element of truth. They point to an indefinable quality that pervades Balinese life—a sense, a feeling, that whatever might be the ugly realities and banalities of daily existence, somehow a vision of a pure realm is brought into being through ritual performance, a vision distilled from the very chaos and ugliness that surrounds us. This unique quality, which continues to permeate and imbue the forms of everyday life, is in my view the secret of the enduring fascination Balinese culture holds for the modern world.

Along with ritual, Balinese art is one of the key means of realizing this vision. The role of the Balinese artist is to give concrete form to insights and intuitions about the pure realm: to grasp the nature of a hidden reality. Artists express their individual perceptions, shaped through their personal histories and characters, of an ultimate reality transcending the self—yet which is to be found within it. Art seeks to realize the world of the spirit, the pure realm beyond the impure realm of physical existence. Or, rather, the Balinese artist seeks to bring about meetings between these two realms, just as Balinese ritual aims to do.

If we, the products of an overly rationalized, secularized, and commercialized age, cannot participate in this achievement as religion, we can respect it and honor it as art and thus enrich our own spirits. The metaphysical complexity and spiritual richness of Balinese Hinduism as it is lived today we have encountered in the paintings of Budiana and Mirdiana. Many of Mirdiana's images are grotesque and monstrous, yet his paintings are imbued with a soft, clear light and a shining purity. For all their dynamic movement, they convey a sense of discipline—of physical energy being transformed into a contemplative consciousness. In the monstrous and terrible, Mirdiana finds a potential for exquisite beauty and spiritual refinement. Thus he points to one of the great central truths and mysteries of Balinese Hinduism. Budiana emphasizes the cosmic movement downward, whereby the spiritually pure and refined becomes material and coarse, finally to degenerate into monstrous, destructive forces. He focuses on the mystery that this degeneration is inherent in the very nature of the divine creativity that gives rise to the material world. Budiana immerses himself—and us—in the horror while at the same time hinting at a divine potential to return again to pure origins. In this time of Kali Yuga, over which the destructive principle reigns, it is only natural that Budiana's paintings impact upon Western sensibilities: his works speak to our troubled times. Together the works of Budiana and Mirdiana reveal to us cycles of cosmic creation and destruction that form the very core of Balinese mysticism and the central dynamic of Balinese ritual life.

Notes

INTRODUCTION

1. See Vickers (1989) for a lively history of the engagement of the West with Bali; see also Picard (1996).
2. Barth (1993, 217–220) gives a clear description of the "decentered" nature of Balinese Hinduism today, particularly as compared with Islam.
3. According to Coedès (1968, 129), epigraphic evidence dating from the eighth and ninth centuries AD reveals that by this time there existed "an Indo-Balinese society that was independent of Java, used a dialect peculiar to the island, and practiced Buddhism and Sivaism at the same time." See also Kempers (1991, 34–38) for a discussion of this evidence. More recent archaeological evidence indicates that direct contacts between India and Bali were taking place early in the Christian era (Ardika and Bellwood 1991).
4. Since each of these assumptions is examined in detail in Chapter 1, I will not locate them in the literature at this point. See Stuart-Fox (1992) for a comprehensive bibliography of the scholarly literature on Bali published from 1920 to 1990.
5. Lovric (1987, 8–9) has drawn attention to a "straitjacket" of assumptions that has strangled Western understanding of Balinese religion. Specifically she challenges Western ideas that Balinese cosmology is structured according to binary oppositions in the form of dualism such as gods and demons, good and evil, mountain and sea; that the sea is the source of evil and disease; that many major periodic and seasonal rituals are concerned with agricultural fertility and represent thanksgiving for good harvests; and that there exists a popular peasant culture significantly different from "an elite scriptural one of the ruling gentry." The arguments presented in the following chapters support her four points. One might add that university-educated Balinese scholars today are themselves still struggling within this same straitjacket in an effort to formulate their own understanding in ways comprehensible to foreign scholars. See also Picard (1999, 40–41) for a discussion of the

reaction of Balinese intellectuals in the 1920s and 1930s to foreign opinion that Balinese religion in fact owed little to Hinduism.

6. My fieldwork was carried out over three years beginning in 1996 and ending in 1999. I am grateful to the Lembaga Ilmu Penelitihan Indonesia for sponsoring the research and to the Australian Research Grants Council for a grant that provided funding for this period.

7. Howe (2001, 1).

8. Ibid.

9. Rubinstein (2000, 3) deals elegantly with the problem of referring to a "traditional" Bali—observing that it cannot be delimited by dates but rather constitutes "a set of nineteenth century or earlier cultural values," pockets of which can still be found today alongside "modern Bali."

CHAPTER 1: DEFINING BALINESE MYSTICISM

1. See, for example, Covarrubias (1994, 260, 275), Swellengrebel (1960, 36ff), Gonda (1975, 42), and Kempers (1991, 57–58). Clifford Geertz (1980, 102) makes a classic statement of this view: "The state cult was not a cult of the state. It was an argument, made over and over again in the insistent vocabulary of ritual, that worldly status has a cosmic base, that hierarchy is the governing principle of the universe, and that the arrangements of human life are but approximations, more close or less, to those of the divine." Recent views along the same lines include Eiseman (1990, 2–10), Lansing (1995, 23ff), and Hobart et al. (1996, 98–99). In opposition to such views, Lovric (1987, 9, 48ff) has drawn attention to various misleading assumptions perpetuated in the scholarly literature and has argued extensively against the established view concerning cosmological order and binary oppositions. Hildred Geertz (1994; 1995) has challenged old stereotypes about hierarchy and order, as well, stressing the importance of transformations of powers.

2. See Vickers (1996), Rubinstein and Connor (1999), and Vickers et al. (2000).

3. M. Hobart (1999, 268).

4. See Stephen (1995).

5. This information, drawn from a wide range of different sources including interviews, field observations, and Balinese texts, has been examined in three earlier articles (Stephen 2001; 2002; n.d.).

6. See Forge (1978), Djelantik (1990, 11–26), Couteau (1999, 42ff), and Ramseyer (2002, 60–64).

7. Couteau (1999, 35) in a recent catalog of the Museum Puri Lukisan collection includes Budiana as a representative of the "post–Pita Maha Ubud School" but also comments on the "modern dimension" of his works.

8. I Gusti Ketut Kobot and I Gusti Made Barat; see Djelantik (1990, 31–32) and Couteau (1999, 28, 65).

9. There is now a growing and important literature concerning the impact of foreign influences on Balinese art and culture. See, for example, Vickers (1989), H. Geertz (1994), Picard (1996), Haks et al. (1999), and Couteau (1999).

10. The religious nature of traditional Balinese art is well established; see Forge (1978), H. Geertz (1994), Couteau (1999), and Ramseyer (2002).

11. Pers. comm., Drs. I Nyoman Suarka, Fakultas Sastra, University of Udayana, Bali.

12. Picard's (1999) study of "Kebalian," Balinese identity, suggests that such metaphors have evolved out of a dialogue among the emerging Balinese elite rather than from indigenous Balinese concepts. See also Howe (2001, 8). Nevertheless, the idea preserves something of the traditional sense of the indivisibility of realms that have only recently become conceptually separate.

13. Barth (1993, 191–220).

14. Ibid., 219.

15. Ibid., 217.

16. Picard (1999, 40).

17. Ibid., 40–41.
18. Direct evidence of Hinduism and Buddhism in Bali, in the form of inscriptions on clay and stone, dates from the eighth century AD (Ramseyer 2002, 35–36). See also Swellengrebel (1960, 18–19) and Kempers (1991, 33–49). But archaeological evidence indicates that direct contacts between Bali and India were already occurring at the beginning of the Christian era (Ardika and Bellwood 1991, 231).
19. Kempers (1991, 33); a similar view is expressed by Bellwood (1997, 139).
20. Covarrubias (1994, 261).
21. See, for example, Swellengrebel (1960, 29–30) and C. Hooykaas (1973b, 1).
22. The diverse nature of what has come to be called "Hinduism" in India often seems to be forgotten by scholars of Balinese Hinduism. See Dalmia and von Stietencron (1995) for a collection of essays describing the multiple constructions of Hinduism as part of ongoing dialogues of national and political identity and modernization in India. Howe's (2001) recent study of religious change in Bali provides a much more nuanced picture showing how Balinese religious reformists selected particular strands of contemporary Hinduism in India as the basis of their reforms.
23. See Soebadio (1971, 8). See also Phalgunadi (1991) for a recent attempt by a university-trained Balinese scholar to assess the relationship between Indian and Balinese culture.
24. C. Hooykaas (1973b, 1); Couteau (1999, 7).
25. See, for example, H. Geertz (1994, 31).
26. Swellengrebel (1960, 28); Lansing (1995, 67); Bellwood (1997, 139).
27. Balinese kinship terminology suggests that reincarnation is more likely to be expected at the level of great-grandchild, since the terms for great-grandfather and great-grandchild are the same—*kumpi*. In the actual examples that people related to me, however, the person in question was thought to be reincarnated in his grandchild. In other cases, much more distant ancestors were involved. Thus the emphasis in practice is not simply on the great-grandchild.
28. Huntington and Metcalf (1979, 85–87).
29. H. Geertz (1994, 2).
30. Writing more than forty years ago, Swellengrebel (1960, 74) referred to an "overestimation" of the contribution of Hinduism to Balinese culture in general. His generation of scholars did their best to counteract such an emphasis.
31. Boon (1977; 1990); C. Geertz (1980); Lansing (1983); and Howe (1980; 2001).
32. Howe (2001, 1).
33. Nihom (1994, 13).
34. Ibid., 15.
35. Creese (2001,13).
36. C. Geertz (1975, 177).
37. The following description is based on fieldwork I carried out—mainly in the Gianyar, Ubud, region of Bali—from 1996 to 1999 as part of the ethnographic study of Balinese concepts of dreaming referred to earlier.
38. See C. Hooykaas (1975, 251).
39. Howe (2001, 148) points to such ideas as characteristic of the reformist views propagated by the Parisada Hindu Dharma. In my view, ideas concerning offerings and other religious symbols "as outward and material signs of inner feelings" (ibid.) are present in older mystical texts and represent a degree of continuity with the past, although previously such understandings were not so widely disseminated as they have been under the influence of the Parisada.
40. Picard (1999, 49) notes the many different names Balinese themselves have employed in a modern context to refer to the highest source of spiritual power. These include Bhatara Siwa, Sang Hyang Tunggal, Sang Hyang Suksma, Sang Hyang Widi, Sang Hyang Widi Wasa, Sang Hyang Widi Wisesa, Sang Hyang Parama Wisesa, Tuhan, Tuhan Esa, Allah, and so forth. See also Ramseyer (2002, 91).

41. Jensen and Suryani (1992, 108–109) note the feeling of inner peace Balinese women derive from presenting offerings at the temple.
42. For general descriptions of the life-cycle rituals see Covarrubias (1994, 120–159), Eiseman (1990, 84–99), and Hobart et al. (1996, 101–126). A detailed account is given in Mershon (1971). The most comprehensive and coherent anthropological account is given by Howe (1980).
43. The death rituals are described by Covarrubias (1994, 359–388), C. Hooykaas (1976), and Eiseman (1990, 115–126). A detailed description is provided by Howe (1980, chap. 12).
44. See Goris (1960a, 85; 1960b) and Ramseyer (2002, 111–119).
45. See Belo (1953) and C. Hooykaas (1977) for detailed accounts of the temple festival.
46. Ramseyer (2002, 112–114).
47. The complex calendrical rituals are described by Covarrubias (1994, 277–287), Goris (1960c, 114–129), and Eiseman (1990, 182–190).
48. The different explanations of the identity of the Barong are discussed in detail in Stephen (2001). The local political significance of Barongs has been revealed in MacRae's (1998; 1999) detailed studies; his view is complementary to mine in that he focuses on the level of local and *adat* concerns rather than mystical understandings. There are in fact not one but several kinds of Barong, a point I return to in the next chapter.
49. Goris (1960c, 126–127).
50. Lovric (1987, 310–313).
51. Swellengrebel (1960, 41).
52. Lovric (1987, 332) argues on the basis of *lontar* texts that Nyepi is essentially a *bhuta yadnya,* or sacrifice to the chthonic forces.
53. See Goris (1960c, 114–129) and Eiseman (1990, 172–192) for descriptions of the Balinese calendars.
54. See Eiseman (1990, 181–182).
55. Ibid., 185.
56. Howe (1980; 1983; 1984) and Lansing (1983; 1995), however, have provided comprehensive views.
57. M. Hobart (1985, 170).
58. See Covarrubias (1994, 320), C. Hooykaas (1978), Howe (1980; 1984), Lovric (1987, 230–267), Wikan (1990), H. Geertz (1994, 49–95), and Stephen (n.d.).
59. See Stephen (n.d.).
60. H. Geertz (1994, 94, 126–127).
61. Ibid., 94.
62. See Korn (1960, 134–138), C. Hooykaas (1966), and Rubinstein (2000).
63. See C. Hooykaas (1973b, 11–18) for a description of the different kinds of priests.
64. See Belo (1960), Connor et al. (1986), and Suryani and Jensen (1993).
65. See Rubinstein (1996) for a description of Balinese *lontar* and how they are made.
66. C. Hooykaas (1978, 2–3); Rubinstein (1996, 140–143).
67. Almost all *balian usada,* whose knowledge depends on studying the texts, are male.
68. Zurbuchen (1987, 60–61) and Rubinstein (2000, 42) stress the importance of oral instruction by a teacher.
69. Barth (1993, 217).
70. See Stuart-Fox (1992, 353–358) for a bibliographic listing of published *lontar* texts; see under "Hooykaas" for his extensive oeuvre.
71. See also Zurbuchen (1987, 50–63) and Rubinstein (2000, 39ff) for descriptions of the mystical qualities attributed to texts and writing.
72. See, for example, Covarrubias (1994, 261) and Swellengrebel (1960, 64–65).
73. Swellengrebel (1960, 29).
74. Connor (1982).
75. Lovric (1987, 190–193).

76. See, for example, C. Geertz (1980), Vickers (1991), Wiener (1995), Schulte Nordholt (1991; 2000). See Howe (2001,113–119) for a discussion of how kings and priests contested power in pre-colonial Bali.

77. Zurbuchen (1987); Rubinstein (2000).

78. Zurbuchen (1987, 60–61).

79. Rubinstein (2000, 32ff).

80. Zurbuchen (1987); Rubinstein (2000).

81. Lovric (1987, 109–111), who worked mainly with healers and medical texts *(usada),* makes similar points about access to esoteric texts.

82. Rubinstein (2000, 30).

83. Ibid., 38.

84. The literary sources of Balinese art in general are of course well known; see H. Geertz (1994, 6), Couteau (1999, 9–10), and Ramseyer (2002, 60–64). Rubinstein (2000, 32) notes that the wood and stone carvers *(sangging)* also have their own text in Kawi: the *Dharma Pasanggingan.*

85. See Howe (1983), Zurbuchen (1987, 44), and Rubinstein (2000, 24).

86. See also H. Geertz (1994, 32) and Couteau (1999, 10).

87. Ramseyer (2002, 9).

88. The Balinese term *"sangging"* is used to refer to "specialists in the art of drawing and painting" (Ramseyer 2002, 60); *"undagi"* refers to architects. In my experience, such terms are used only of those specialists attributed with esoteric knowledge derived from textual sources.

89. Ramseyer (2002, 10).

90. Pers. comm., Drs. I Nyoman Suarka, Fakultas Sastra, University of Udayana, Denpasar.

91. Ramseyer (2002, 9).

92. C. Geertz (1975, 170ff).

93. See Bakker (1993) and Picard (1999), Howe (2001); for religion in the school curriculum see Parker (1992; 2000).

94. Howe (2001, 156–161).

95. Howe (2001, chaps. 8–9).

96. Barth (1993, 219).

97. Howe (2001, 93–108).

98. Ibid., 148–149.

99. See J. Hooykaas (1961, 276) and Soebadio (1971). Ramseyer (2002, 36) refers to archaeological evidence of Tantrism in Bali as early as the eighth century AD.

100. H. Geertz (1994, 32).

101. C. Geertz (1975, 175).

102. Ibid., 174.

CHAPTER 2: FIRE, DESTRUCTION, AND THE POWER OF THE MOTHER

1. See Neka (1989, 57), Djelantik (1990, 70–71 and color pl. 15), Taylor (1991, 57–58), Kam (1993, 118–123), and Couteau (1999, 35, 71). Budiana's works have been acquired by the Tropenmuseum, Amsterdam; Museum of Ethnology, Berlin; Fukuoka Art Museum, Japan; Museum Puri Lukisan, Ubud, Bali; Neka Museum, Ubud, Bali; Agung Rai Museum of Art, Ubud, Bali; Art Centre, Denpasar, Bali; and Rudana Museum, Ubud, Bali. A major exhibition of Budiana's paintings was held by the Tokyo Station Gallery, Japan, from 7 June to 21 July 2003. A superb full color catalog of the exhibition, *I Ketut Budiana: Illusory View from the Balinese Spiritual Cosmos,* illustrating more than sixty of his paintings, was published by the gallery. The themes I identify in this book can be followed through the numerous works illustrated in the catalog and I recommend it to all who would like to see more of Budiana's rich oeuvre.

2. Budiana evidently represents a classic example of the vocational literacy described by Rubinstein (2000, 32), as discussed in the previous chapter. In a recent catalog of Budiana's painting (Tokyo Station Gallery 2003, 14), Jean Couteau stresses, as I do, that Budiana's imagery owes little to "the subconscious" as such. Rather they "are coded works, which cannot be fully appreciated without a good knowledge of the symbols, narratives and philosophy that feed them with meaning."

3. See C. Hooykaas (1980) for a collection of *rarajahan* drawn from Balinese *lontar* texts.

4. The Balinese *lontar* texts are written in several languages. The majority are in Kawi (a mixture of Old Javanese, Middle Javanese, and Javanese-Balinese); some employ a literary High Balinese; others are in Sanskrit or incorporate Sanskrit passages (Rubinstein 1996, 138).

5. My discussions with Budiana took place in Indonesian; he uses many Balinese terms, however, as there are often no effective translations of basic concepts. Budiana is able to read and write Kawi and Balinese.

6. That such ideas are not confined to artists or literati but are well known to ordinary villagers is clearly supported by Howe's detailed ethnography (1980; 1983; 1984), where many parallels can be found with the themes Budiana develops. The importance of Ibu Pretiwi in Balinese cosmological ideas is emphasized by Howe (1980, 167ff), who also observes that a shrine to Ibu Pretiwi occupies the most sacred location in house temples in villages in the Gianyar region (pp. 72–74). Howe explores at length the connection between popular and mythological ideas concerning rice, gold, material riches and the earth, and mother goddesses, such as Ibu Pretiwi, Dewi Sri, and Dewi Uma (pp. 169–179), all of which resonate strongly with the ideas expressed in Budiana's paintings, although Howe's information is based on the opinions of ordinary villagers and observations of ritual performance.

7. For an example see Covarrubias (1994, 323).

8. Lovric (1987, 257), describing similar ideas about perceived female power, notes that women are considered to be more *sakti* because they menstruate, thus clearly indicating a link between menstrual blood and mystical power.

9. See H. Geertz (1994, 81, 83–85; 1995) for a discussion of problems in defining the term *"sakti."*

10. C. Hooykaas (1976, 49). See also Kam (1993, 118–123) for a detailed discussion of the esoteric symbolism of fire and water in another painting by Budiana.

11. Howe (1980, 187, 252–253) describes identical concepts based, not on textual material, but on the opinion of ordinary villagers. Lovric (1987, 79, 81), on the basis of medical texts *(lontar usada),* describes the same concepts. These Balinese concepts seem to have many resonances with Indian Tantric ideas about body substances, especially sexual fluids, as described by White (1996, 4–6).

12. Budiana's demons bear a remarkable resemblance to the strange faces and forms of the fifteenth-century Dutch painter Hieronymus Bosch. See, for example, Schwartz (1997, 7–8, 65, 70–72).

13. Lovric (1987, 253) observes that Durga has assumed all three roles of the Trimurti (Brahma, Wisnu, and Siwa) in Bali and that she is "the creator, the destroyer and the protector."

14. Witches are usually depicted balancing on one leg; see H. Geertz (1994, 72–73) for a series of paintings of a woman transforming herself into a *leyak.* C. Hooykaas (1980, 61, 77, 125, 163, 200) provides several line figures based on Balinese talismanic drawings of *leyak* and their mistress, Durga, dancing on one foot.

15. See also Lovric (1987, 63). I have discussed this issue at some length elsewhere (Stephen 2001, 170–177; 2002, 73–77).

16. See, for example, Howe (1980, 224–236), Stuart-Fox (1982, 29), Lansing (1983,140; 1995, 34–35), Lovric (1987, 132–140), Eiseman (1990, 6, 11), and H. Geertz (1994, 31–32).

17. Lansing (1983,140).

18. M. Hobart (1985, 178).

19. Ibid.

20. Howe (1980, 229ff).

144

21. Zoetmulder (1982, 278).

22. Zoetmulder (1982, 767) gives "wicked, evil, base" as the first meaning of *"kala"*—which at first glance seems to fit well with conventional notions of the *bhuta kala*. But Zoetmulder questions whether the word is an adjective describing the nature of demons or whether it refers to a class of demons. He does not, in fact, offer the latter meaning as a clearly established one.

23. Ibid., 768.

24. Howe (1980; 1984) has described at length the different categories of persons and spirit beings based upon this threefold distinction.

25. The names and stages of development of the *kanda empat* vary according to different *lontar* texts. See C. Hooykaas (1974, 93–128) for extensive comments and translations of texts relating to the four spiritual siblings.

26. See Howe (1980, 260–261).

27. For a detailed discussion of *banas* see Stephen (2001, 159–163). Bosch (1994, 67) notes that in the Indian literature the banyan tree, the Javanese and Balinese *waringin,* is referred to as *"vanaspati"* (lord of the forest). In Balinese texts, Banaspati Raja (king of the lords of the forest) is the name of one of the *kanda empat* and the Barong Ketket. This suggests a possible classic Indian element in the Balinese conceptualization of the powers of great trees, referred to as *"banas"*—an idea that might otherwise be simply interpreted as indicative of indigenous animism in Balinese thought. See also Zoetmulder (1982, 201), who gives this possible meaning of *"banaspati"*: "big tree ('lord of the forest'?)."

28. Zoetmulder (1982, 789).

29. See Bosch (1994) on the importance of plant symbolism generally in Javanese and Balinese mysticism.

30. C. Hooykaas (1974, 105–106, 111, 115–116) tabulates the elaborate classification systems attached to the *kanda empat*. The Balinese directions, as many writers have pointed out, do not in fact correlate with the points of the Western compass except in southern Bali. The four basic Balinese directions are *kangin* (in the direction of sunrise), *kelod* (in the direction of the sea), *kauh* (in the direction of sunset), and *kaja* (in the direction of the mountains).

31. For Balinese, witches are not so much a matter of belief as a matter of cultural logic. The intractable jealousies and rivalries that dominate the life of the Balinese extended family are couched in witchcraft idiom. When people become sick, when babies die, witchcraft used by a family member is seen as the cause. Although witches are commonly thought to be female, witchcraft is not exclusively the prerogative of women. These beliefs are not a thing of the past; in my experience, they are a very present reality for most Balinese. Wikan (1990) has provided a detailed study of the important influence of beliefs in witchcraft and sorcery in contemporary Balinese life. See also Howe (1984) and Stephen (n.d.).

32. Durga's mythic role as the originator of human witchcraft is discussed in Stephen (2002, 82–86). See also Chapter 3 of this book.

33. This monster resembles the *makara* monster familiar in Javanese and Balinese art (Bosch 1994, 20–22).

34. See A. Hobart (1987, pl. 31) for an illustration of the *kakayonan*.

35. Rawson (1973, 45).

36. The equivalence of birth and death in Balinese cosmological understanding is emphasized by Howe (1980, 176).

37. This *sudang* coffin form might also be linked to the *makara* monster.

38. The centrality of such ideas in Balinese cosmological notions in general has been demonstrated by Howe (1980, 170, 252).

39. Rubinstein (2000) has recently drawn attention to the prominence of similar erotic themes in Balinese *kekawin* literature. I will return to these parallels in Chapter 4.

40. The metaphorical linking of warfare and eroticism is a well-known literary device in Old Javanese *kekawin* poetry. See Supomo (2000).

41. Red and white are also the colors of the Indonesian flag. Some Balinese give a mystical significance to this parallel, but I do not think Budiana is making any kind of political comment in his painting.

42. Kinsley (1986, 120 and pl. 121) observes that in Indian iconography Kali is almost always shown as dominant; when depicted in sexual intercourse with Shiva, she is shown above him. I am not suggesting here a historical source but rather a thematic similarity between the Balinese and the Indian conceptualizations of male and female dominance and their consequences.

43. This painting suggested to me the myth of the creation of the *bhuta kala*—all the dangerous, disruptive forces in the world. According to one myth (discussed in detail in the next chapter), the *bhuta kala* were created when the god Siwa and his wife Uma descended to earth in terrible form as Durga and Siwa Kala. Uma transformed into the Panca Durga or Five Durgas and then was met in each of the five directions (north, south, east, west, and center) by Siwa Kala, giving rise to hordes of *bhuta kala* in each direction. When I asked Budiana if his painting could be understood in this way, he agreed it could since the *bhuta kala* were engendered in a situation where the feminine material aspect of creation predominated, as represented in not one but five terrible goddesses. But his intention, he explained, was not to depict the myth but rather any situation in which matter predominates over spirit.

44. See Stephen (2001, 156–157 and nn. 3 and 8) for further discussion of the different kinds of Barong and their significance. According to a Brahmana priest I consulted, four Barongs are symbolically linked to the four directions: white in color, associated with the god Iswara, Siwa, and the direction *kangin* (where the sun rises) is Barong Ketket; red in color, associated with the god Brahma, and the direction toward the sea *(kelod)* is Barong Bangkal (Pig); yellow in color, associated with the god Mahadewa, and the direction in which the sun sets *(kauh)* is Barong Mong (Tiger); black in color, associated the god Wisnu, and the direction of the mountains *(kaja)* are Barong Landung (a pair of giant human figures, one male and one female). From this perspective the Barong figures are emanations, or lower forms, of the gods of the four directions, and thus ultimately all are emanations of Siwa. It is Barong Ketket, however, who is explicitly linked to Siwa and paired with Rangda in dance/dramas.

45. See Stephen (2001) for a detailed discussion of previous interpretations of Barong's encounter with Rangda.

46. The Phallic Mother, who combines the attributes and powers of both parents, is a well-known figure in Western psychoanalytic literature (Rycroft 1977, 117). According to Klein (1994, 131–132) this figure of the Phallic Mother or combined parents is one of the central psychic images in the emotional development of the child, male or female. While it is not my intention in this book to identify the unconscious sources of Budiana's imagery, I think that this image of the mother with a penis, which so far as I know does not have a Balinese cultural precedent, is a representation drawn from the deep unconscious. Although such images might exist in the manuals of magic drawings *(rarajahan)*, I have not found any in the published sources.

47. Rycroft (1977, 123).

48. The role of the kris in the Balinese marriage ceremony clearly indicates its phallic significance: with his kris the groom punctures a small mat on which the bride has just sat; in fact it is held by her as he stabs it. The laughter of the audience that accompanies this action leaves no doubt that the sexual meaning is explicitly recognized.

49. Once again, Howe (1980, 170, 188) cites similar concepts as central to Balinese cultural understanding.

50. These transformations, described in detail in Stephen (2002), are discussed in the following chapter.

51. *The Tantra of the Great Liberation* (Avalon 1972), a classic text of Indian Tantrism, identifies Kundalini as Uma, or the power of Uma, Shiva's spouse, in the human body.
52. The same word, with the same connotations of excessive attachment, exists in Old Javanese (Zoetmulder 1982, 2035).
53. That these ideas concerning the threefold potential of human beings are part of popular understanding is clearly established by Howe (1980; 1984).
54. Howe's (1980, 248–251) discussion of Balinese marriage rituals emphasizes how much effort is devoted to removing animal and negative influences from the couple so that their purified union will give rise to physically and morally superior offspring. Similar ideas clearly inform Budiana's depiction of the part-animal, part-human beings in *Kasih Sayang* (Plate 11).
55. See Stephen (2002, 73–82).
56. See Stephen (n.d.) for a discussion of the different attributions of supernatural power to women and men. I argue that in practice women are identified as *leyak* whereas men are labeled as *anak sakti*. Thus negative attributions of power fall usually on women, as they are associated with its uncontrolled and dangerous aspects.
57. A. Hobart (1987, 138).
58. These cyclic themes expressed in Budiana's works have been clearly identified by Howe (1980, 292ff) in the thought and ritual of ordinary Balinese.

CHAPTER 3: MYTHIC TRANSFORMATIONS OF DESIRE

1. For discussions of the *wayang* style see Djelantik (1990, 11–15), Couteau (1999, 9ff), and Ramseyer (2002, 60–64).
2. The results of this research have been published in two journal articles (Stephen 2001; 2002).
3. The exhibition "The Riches of Balinese Art" was held at La Trobe Gallery in February 1999 and curated by Rhonda Noble, who also arranged for the artists to visit Australia. Appreciating the outstanding qualities of Mirdiana's work, Professor Michael Osborne, the vice-chancellor, purchased seven of Mirdiana's paintings (including the dancing Ganesha referred to earlier) for the university's permanent art collection.
4. Schulte Nordholt (1991, 153) observes that in certain cases of political contestation, various criteria, especially aesthetic considerations, are appealed to in order to establish which *lontar* texts have greater authority. My information does not challenge this observation; my point is that Balinese generally seem open to different interpretations of a text or myth. Where specific interests are at stake, the situation is evidently different.
5. Obeyesekere (1981, 77–78, 122–123).
6. Jung (1964, 61, 68); Henderson (1964, 101ff).
7. In addition to ongoing discussions with Mirdiana as part of our work together, I also questioned him specifically about each painting and tape-recorded his comments for this book. I will not reference each comment, however, as they derived from the same two interviews held in September 2001. Our discussions usually took place in English or a mixture of English, Indonesian, and Balinese. Mirdiana's ability to express himself fluently in English is evident. Indeed he is able to communicate more directly to the reader than through my translation.
8. See Ramseyer (2002, pl. 53 and 56) for illustrations of Sutasoma stories painted on the ceilings of the Kirta Gosa, Klungkung. Couteau (1999, 153–154) describes the Sutasoma stories as used by Balinese artists. See Couteau (1999, 56) for an illustration of a painting by Ida Bagus Buda of Sutasoma about to be devoured by the tiger.
9. Zoetmulder (1974, 342).
10. The Sutasoma story is summarized by Zoetmulder (1974, 329–341) and has been the subject of a considerable scholarly literature by Old Javanese scholars including Ensink (1974; 1978), Santoso

(1975), and O'Brien (1988–1989; 1990–1991; 1993; 2000). The Sutasoma story also forms part of the repertoire of the shadow puppet theater (Hinzler 1981, 29; A. Hobart 1987, 47). In the present discussion, I am concerned with Mirdiana's interpretations of the limited oral version known to him—not with the complex mystical meanings of the poem as discussed by Western scholars. Mirdiana and I did not discuss the Sutasoma story with our Brahmana informants.

11. Howe (1980, 231), however, specifically notes that the purpose of the *caru* rituals directed to the *bhuta kala* is not only to purify the area but also to "facilitate the reversion of the spirit to its divine form."

12. Anantabhoga is a mythological serpent known in Balinese, Old Javanese, and Indian mythology. According to A. Hobart (1987, 47), "Antaboga" is a "snake god who lives in the seventh layer under the earth." See also Howe (1980, 166). The literary version of the Sutasoma story mentions at the beginning a serpent that is not further identified (Zoetmulder 1974, 333); at the end of the story Bhatara Kala transforms himself into a *naga* (p. 341). Thus it is Mirdiana's personal interpretation that the serpent in question is Anantabhoga.

13. The Balinese equation of serpents with the earth, gold, riches, and food—and thus the female element or Ibu Pretiwi—is described by Howe (1980, 179), who further notes that Anantabhoga means "abundance of food." Lovric (1987, 90) refers to a Balinese story in which Brahma descended to the earth during a time of famine as "a Naga Anantaboga (*ananta* meaning 'endless,' *bhoga* meaning 'sustenance')." These accounts support Mirdiana's identification of the serpent with the earth, abundance, food, and nurture. Such things in Balinese thought are inherently female regardless of whether Anantabhoga is referred to in other contexts as a male entity.

14. According to Zoetmulder (1982, 73, 250), *"ananta"* means in Sanskrit and Old Javanese "endless, boundless, eternal" and *"bhoga"* denotes "enjoyment, eating; any object of enjoyment, food; profit, utility, pleasure" (p. 250). Thus "Anantabhoga" might be translated as "boundless or endless pleasure." Whether or not Western philologists agree with this rendition, it is one given by Balinese—as Howe (1980, 179) and Lovric (1987, 90) confirm.

15. This is Mirdiana's version based on stories told to him by his grandfather. The literary source appears to be the Old Javanese *kekawin* known as the *Smaradahana*, which describes the birth of Gana and his overcoming of the terrible demon Nilarudraka. In the literary version (Zoetmulder 1974, 294), the breaking of Gana's left tusk is explained as the result of a blow from the demon's *bajra* (diamond weapon). This *kekawin* is included in the repertoire of the shadow puppet theater (A. Hobart 1987, 47), which is probably the source of Mirdiana's story.

16. Mirdiana himself had experienced the tooth filing ceremony shortly before painting this picture, which is perhaps why it was so prominent in his mind at the time.

17. Hinzler (1981, 158–162); A. Hobart (1987, 32–33).

18. A. Hobart (1987).

19. Ibid., 32–33.

20. See A. Hobart (1987, pl. 7).

21. If this talk about finding what you need inside yourself seems to have a distinctly modern ring about it, we need to recall that this is precisely the meaning of the mystical concepts of the great world *(bhuwana agung)* and the little world *(bhuwana alit)*: all that is contained in the external world is contained in the self.

22. Pott (1966, 122–123) has drawn attention to the mystical significance of this myth: in his view, a difficult journey is used to symbolize the internal yogic process of attaining supreme spiritual insight.

23. A. Hobart (1987, 103) notes this is the symbol of Bima, Hanuman the monkey god, and Bayu, god of the wind. Bayu is the father of both Bima and Hanuman.

24. See Stephen (2001; 2002).

25. Most of the unpublished *lontar* texts referred to in this book were obtained in transliterated form from the Gedong Kirtya *lontar* library, Singaraja. The knowledgeable staff were helpful in locating

material relevant to my interests. These transliterated texts were then translated from Kawi into Indonesian by Drs. I Nyoman Suarka, lecturer in Jawa Kuno (Old Javanese), of the Fakultas Sastra, University of Udayana, Bali, who discussed each text with me and explained important points. Then Mirdiana and I together translated from Indonesian into English, which is how he acquired his knowledge of this material. My aim, as an anthropologist, was to approach this material from the perspective of my Balinese informants.

26. Stephen (2002, 63–66).

27. Howe (1980; 1984). In addition to references to myths similar to those I discuss here (Howe 1980, 163, 224–225), Howe describes many other myths, stories, and folktales that deal with related themes, such as the separation of the earth and sky, the origin of rice, and other forms of wealth such as gold and precious stones. Howe notes that in fact the goddess Uma's name is another term for "rice field." This same information was given to me by a *pedanda Buddha,* from the village of Batuan, who observed that *"uma"* was an old-fashioned term for rice field.

28. See Stephen (2001; 2002) for a detailed discussion of myths concerning Siwa and Uma. Howe (1984, 204–205) draws attention to the prominence in the Javo-Balinese literature of "the motif in which various gods, most frequently Siwa and Uma, metamorphose into their antithetical forms and appear as huge and uncontrollable ogres." Mark Hobart (1985, 170–171) describes the transformative powers and inherent ambivalence of Balinese gods, especially Siwa and Durga, who have both benign and terrible forms. Lovric (1987, 89–90, 133) recounts myths attributing the origin of disease and the origin of the *bhuta kala* to the actions of Siwa and Durga. She concludes: "Clearly, there is a blurring of distinctions between deities and demons, as well as between one form of the demonic and another. Philosophically, *dewa* are *bhuta* are *kala*" (p. 133). Hildred Geertz (1994, 81) emphasizes that in Bali demons are not necessarily malevolent and gods are not totally benevolent; ritual, she says, aims to transform powerful beings from malevolence to benevolence. She also draws attention to the transformations of Siwa and Uma as revealed in the Eka Dasa Rudra rituals (p. 125). Covarrubias (1994, 340–341) briefly refers to the *"krodha"* (angry) transformations of the gods, especially Siwa and Uma, but he notes this in a section on black magic and not as a central aspect of the creator pair; furthermore, he tends to present the Hindu gods, such as Siwa and Uma, as largely irrelevant to most Balinese.

29. See Stephen (2002).

30. See Covarrubias (1994, 291–292) for an account of Kala's birth. See also Howe (1984, 207–208), M. Hobart (1985, 170), and Lovric (1987, 310–311).

31. *Kalatattwa* (unpublished manuscript). See Stephen (2002, 66–73) for a detailed discussion of textual sources of the Kala myths. C. Hooykaas (1973a, 306–311) summarizes a wide range of texts from Bali and Java dealing with Kala. See also Headley (1991) for a discussion of Kala myths in Javanese *ruwatan* exorcisms. There are many different texts and versions of the stories concerning Kala. In this discussion I focus on the specific sources pointed out by my Balinese informants. Thus Ida Bagus Sutarja's oral recitation of the birth of Kala prompted me to look for a textual source. A manuscript I subsequently obtained from the Gedong Kirtya library provides my textual source. That this text continues to be an important one in the Balinese view is indicated by the Kantor Dokumentasi Budaya Bali's publication of an almost identical text in *Tutur Anda Bhuwana, Tattwa Kala, Aji Swamandala* (Kantor Dokumentasi 2000).

32. According to Zoetmulder (1982, 1804), *"somya"* derives from the Sanskrit *"saumya"* and denotes "gentle, mild, benevolent, benign, kind." *"Somyarūpa"* he defines as "with gentle or benign (non-terrifying) appearance." See Stephen (2002, 81–82) for usage of the term by Balinese writers.

33. Indonesian translation by Drs. I Nyoman Suarka of *Kalatattwa* (unpublished manuscript), p. 2. See Kantor Dokumentasi (2000, 1–26) for a Kawi text and translation into Indonesian of a similar manuscript given the title *Tattwa Kala.*

34. Ibid., 2.

35. Ibid., 3.

36. Ibid., 7–8.

37. C. Hooykaas (1973a, 6).

38. See Covarrubias (1994, 314–316) and Eiseman (1990, 172ff) for information about the complex Balinese calendrical systems.

39. Indonesian translation by Drs. I Nyoman Suarka of *Kala Purana* (unpublished manuscript). Many other versions of this story are given by C. Hooykaas (1973a) and are referred to by Headley (1991). When I asked for texts relating to Kala, the Gedong Kirtya staff led me to this one. Mirdiana helped to translate this text and thus became familiar with the details of the story—the general outlines of which he already knew, as I did, from Sutarja.

40. *Kala Purana,* p. 14.

41. These ceremonies are still performed today in Bali for persons born in Wuku Wayang. See also A. Hobart (1987, 39).

42. Representations of the birth of Kala are comparatively rare but can be found in Kamasan (classic Balinese) paintings; see, for example, Forge (1978, no. 13). A drawing by the famous Balinese artist Lempad, reproduced in an article by Jacoba Hooykaas (1961), shows Siwa and Uma riding their bull with Kala to one side. Hooykaas gives a rather different interpretation, but Mirdiana believes Lempad's drawing represents the birth of Kala. In the drawing Kala holds the *kakayonan,* the cosmic tree that marks the opening of a performance of the shadow puppet theater. Hooykaas (p. 278, pl. 2, n.) puts this detail down to Lempad's eccentricity and lack of familiarity with written texts. Mirdiana's view is that the *kakayonan* is an allusion to Kala's birth. According to the story in *Kala Purana,* Siwa and Uma came to earth on their bull to try to stop Kala from devouring Kumara, and Lempad's drawing might refer to that confrontation. I think not, however, since Siwa and Uma are clearly depicted by Lempad in amorous embrace, Siwa touching the breast and vulva of his consort. This amorous play is not in accord with the meeting between Kala and his parents as described in the *Kala Purana* but clearly fits with the story in *Kalatattwa* of Kala's conception and birth.

43. See Howe (1984, 208) and M. Hobart (1985, 178) for Balinese interpretations of Kala as time.

44. This interpretation of the painting was offered not by Mirdiana himself but by I Nyoman Suarka, who translated the text on which the painting was based. Mirdiana, however, agreed with Suarka's suggestion.

45. I have not been able to find a textual source for this story, so I am unable to say where it comes from. Although to my knowledge it has no precise Indian parallel, there are certain intriguing similarities with Indian myths. In the Indian myths, for instance, Uma (Parvati) through the power of her austerities in the graveyard succeeds in obtaining Shiva as her husband (O'Flaherty 1981, 151–155; Kramrisch 1981, 351ff). Thus the Balinese Dewi Rohini does indeed seem to be another form of Uma. Her name, however, echoes that of Mohini, the seductive female form taken by Visnu to tempt Shiva (O'Flaherty 1981, 32; Kramrisch 1981, 372). Regardless of the source (it may even be Sutarja's invention or a mixing of different tales), the story clearly reflects the themes of the divine and demonic transformations of Siwa and Uma—and it evidently fired Mirdiana's imagination.

46. Headley (1991, 90–93).

47. A summary of the twelfth-century Old Javanese *kekawin* known as the *Smaradahana* is provided by Zoetmulder (1974, 291–295). Sedyawati (1994, 127) refers to this text as an account of Gana's (Ganesha's) birth. For an illustration of drawings from a Balinese *lontar* text of the *Smaradahana* see Rubinstein (1996, 143). In Bali the *Smaradahana* is part of the repertoire of the shadow puppet theater (A. Hobart 1987, 47), and it is probably from such performances that Mirdiana first learned the story of Kama and Ratih and learned of the birth of Gana.

48. The burning of Kama is a key episode in the Indian myths of Shiva (O'Flaherty 1981, 143–151; Kramrisch 1981, 351–352). Zoetmulder (1974, 296–298) has discussed the parallels between the Indonesian *Smaradahana* and Indian versions.

49. See Eiseman (1990, 363).

50. The Indian Durga is somewhat different from the Balinese Durga, who more closely resembles the horrific form of the Indian goddess Kali. (See Kinsley 1988, 119–124, for the iconography of Kali.) Durga in India is more often portrayed as a beautiful young warrior goddess who defeats demons (Kinsley 1988, 95–105). Sedyawati (1994, 111, 113, 164, 190, and n. 116) traces the changes of Durga's iconography in Java, where she comes to be seen as a terrible form of Uma. But Durgā Mahiṣa-sūramardinī (Durga the slayer of the buffalo demon Mahiṣa)—in which form Durga is depicted as a beautiful young woman—is known today to Balinese artists and has been represented by Mirdiana in a recent painting (not shown in this book).

51. Both priests were *pedanda Buddha,* not *pedanda Siwa.* For the written text see Stephen (2002, 79, n. 12); see also p. 80, n. 13, for an extract from a book of texts, used for temple recitations *(palawakia)* in the community of Pengosekan, that gives the same story of the Panca Durga.

52. *Siwagama* (unpublished manuscript).

53. Rudra as the fierce form of Siwa is known in Bali in relation to the Eka Dasa Rudra rituals (Stuart-Fox 1982; Lansing 1995, 117).

54. Lovric (1987, 89) quotes from another *lontar* source, *Tutur Kayuktian,* a story of how the Five and Seven Durgas created disease in the world. She also quotes from a *lontar* text, *Purwa Bhumi Kamulan,* another myth of the origin of the *bhuta kala* from Siwa and Uma that closely resembles C. Hooykaas' (1974, 60–71) *Litany of the Resi Bhujangga.*

55. Translation into Indonesian by Drs. Nyoman Suarka of *Siwagama* (unpublished manuscript), p. 96. The rest of the story as related here is drawn from this text.

56. *"Juti,"* according to Zoetmulder (1982, 756), means "assumed deceptive form; delusion, deception; falsehood, treachery." *"Maya,"* derived from Sanskrit, Zoetmulder (p. 1129) translates as "illusion, unreality; deception, fraud; sorcery, magic, unreal or illusory image."

57. See Stephen (2002, 77–79) for a detailed discussion of the mythic explanation of the origin of temple performances. A number of Western scholars refer to the myth of the origin of the shadow puppet theater (J. Hooykaas 1961, 275; C. Hooykaas 1973a, 307–308; A. Hobart 1987, 22; Eiseman 1990, 318) yet pay little attention to its significance. Lovric (1987, 311) refers to a story concerning the origin of the Barong dance as a parody on the actions of Durga and Rudra.

58. A Balinese painting in a very different style of Uma and the cowherd is illustrated in J. Hooykaas (1961, pl. 1, opposite p. 272). There the cowherd is old, bald, and ugly.

59. Translation in Indonesian of *Siwagama* (unpublished manuscript).

60. See C. Hooykaas (1973a, 306–311) and Headley (1991) for other versions of the story of Uma and the cowherd/shepherd. Boon (1982, 184–188) provides an interpretation of this myth in terms of Balinese marriage alliances.

61. This episode of the myth is to be found in older *wayang*-style paintings. An example by the famous Lempad is illustrated in Rubinstein (1996, 145).

62. The text specifies *"teluh, desti, tranjana"* (*Siwagama,* unpublished manuscript, p. 143). Zoetmulder (1982, 394, 1983) gives *"andesti"* the meaning "to bewitch"; *"tĕluh"* he glosses as "(black) magic, witchcraft."

63. Zoetmulder (1982, 1513). C. Hooykaas (1978, 21) translates *"rare angon"* as "young shepherd."

64. C. Hooykaas (1977, 24).

65. *Andabhuwana* (unpublished manuscript).

66. The name "Durgakala" seems anomalous here since "Durga" is the name of Siwa's consort and "Kala" is the name of his son. In other texts we find Siwa in terrible form referred to by the names Siwa Kala, or Kala Rudra. The significance of these different names must await more detailed research by philologists.

67. According to Zoetmulder (1982, 1502) the word *"raṇḍa"* means a widow or widower "whether by death or by divorce."

68. C. Hooykaas (1974, 64–65).
69. Ibid., 67. My ellipses follow those of Hooykaas' text.
70. Lovric (1987, 310–311) has drawn attention to the similarity between the Bhoma mask and Siwa Kala, suggesting that it probably forms the basis of the mask of Barong Ketket. See Stephen (2001, 168–169) for further discussion of the iconography of the Barong and Rangda masks.
71. *Siwa Linga Suksma* (unpublished manuscript).

CHAPTER 4: THE INFLUENCE OF TANTRIC THOUGHT

1. Connor (1982, 156ff), however, has provided valuable information concerning largely secret groups seeking magical and spiritual power that form around so-called *balian kebal* in Bangli.
2. Bakker (1993).
3. Picard (1996).
4. Howe (2001).
5. C. Geertz (1975, 170ff).
6. Howe (2001, 1–2).
7. Many different names are used in the Balinese texts to refer to this original unity; other terms include Sunya and Windu.
8. It is well known that the aim of cremation *(ngaben)* is to return the physical constituents of the corpse to their origins—the *panca maha bhuta*. See C. Hooykaas (1976). Howe (1980, 293–321) provides a detailed description of the death rituals revealing these themes.
9. C. Hooykaas (1974, 64).
10. Eiseman (1990, 318).
11. H. Geertz (1994; 1995).
12. In Budiana's view, all human beings, as creations of the Mother, possess *sakti;* it is not so much a matter of acquiring it as knowing how to use and develop it.
13. H. Geertz (1994, 94).
14. See Soebadio (1971, 16).
15. C. Hooykaas (1973b, 20). This continuing trend of publishing Indonesian translations of Balinese mystical texts has been emphasized in a recent article by Creese and Bellows (2002). Such works might have offered an alternative way of exploring the themes I cite here, but that would require another, very different, book.
16. Lansing (1983, 75–92) describes the importance of what he calls "the sounding of the texts."
17. I had not read Howe's (1980) study at the time I wrote the first draft of this book and therefore was not influenced by his work.
18. For a published *lontar* text referring to the marriage of fire and water see Soebadio (1971, 57).
19. Gupta (1979, 1).
20. Schuhmacher and Woerner (1989, 354).
21. See Goudriaan and Gupta (1981, 2ff) for problems in defining Sakta and Saktism.
22. See Stephen (2001).
23. J. Hooykaas (1961, 276).
24. Lévi (1933, xiii–xiv).
25. See Soebadio (1971), Goudriaan (1978, 57, 94, 126, 134–135, 186, 198–199, 246–247, 298, 326, 328), Gupta et al. (1979, 24, 39, 60n.), Goudriaan and Gupta (1981, 35, 37, 102), and Nihom (1994, 15).
26. Kempers (1991, 53–54, 58–61); Ramseyer (2002, 35–36).
27. Boon (1990, 163–164); see also Boon (1982).
28. Lovric (1987, 426).
29. H. Geertz (1994, 127).
30. See Goudriaan (1979, 3–5) and Nihom (1994, 10–11).

31. As Goudriaan (1979, 3) also observes.
32. Goudriaan (1990, 1). The complexity and elevated nature of Tantric philosophical speculation are clearly indicated, for example, in Dyczkowski's (1987) study of Kashmir Shaivism.
33. Goudriaan (1979, 5). See also White (2000, 7ff) for a discussion of the problems of definition.
34. Ibid., 7.
35. The philologist Max Nihom (1994) has argued on the basis of a reinterpretation of Old Javanese Tantric Buddhist texts—the *Kuñjarakarṇadharmakathana* and the *Yogatantra*—that such Indonesian texts might hold important evidence for reconstructing Tantrism in India in the early and medieval period. He has also examined, from the same perspective, various Old Javanese Shivaite texts (Nihom 1995; 1996; 1997). O'Brien (1988–1989; 1990–1991; 1993; 2000) has also undertaken extensive study of Tantric Buddhism in the East Javanese period.
36. Rubinstein (2000).
37. Zoetmulder (1974).
38. Rubinstein (2000, 125).
39. Ibid., 43–60.
40. Ibid., 43.
41. Creese and Bellows (2002).
42. Gupta et al. (1979).
43. Goudriaan and Hooykaas (1971).
44. Soebadio (1971, 62).
45. But see Picard (1999, 31–32), who notes this meaning and describes the changing significance of the term in Balinese discourses.
46. Schuhmacher and Woerner (1989, 4); Goudriaan (1979, 13).
47. Goudriaan (1979, 13).
48. C. Hooykaas (1964, 198).
49. Soebadio (1971, 59) notes that the agamic dialogue between Siwa and Uma features in much of the *Jñānasiddhânta*.
50. Goudriaan (1979, 39).
51. Ibid., 7–9.
52. Ibid., 7.
53. See, for example, Boon (1990, 158) and Goudriaan (1979, 39).
54. Hooykaas (1975).
55. Goudriaan (1979, 7).
56. See Covarrubias (1994, 320–358); C. Hooykaas (1973b, 9–10); and Eiseman (1990, 127–134).
57. C. Hooykaas (1974, 85–128; 1978; 1980).
58. C. Hooykaas (1978, 2); Lovric (1987).
59. C. Hooykaas (1978, 9).
60. Goudriaan (1978).
61. Lovric (1987, 101); see pp. 64, 101, 127–132 for her discussion of the *usada* texts.
62. H. Geertz (1994, 94, 126 n. 13).
63. Nihom (1994, 10–11).
64. See, for example, Howe (1980; 1984), Connor (1982), Schulte Nordholt (1991), and Wiener (1995).
65. Goudriaan (1979, 24). This point has recently been emphasized by White (2000, 25ff) also.
66. Wiener (1995).
67. For a discussion of the *siddhis* see Schuhmacher and Woerner (1989, 333–334).
68. Goudriaan (1979, 7).
69. Ibid., 39.
70. Soebadio (1971, 79).
71. Goris (1928, 118–119) quoted in Soebadio (1971, 79).

72. Lovric (1987, 320–324).
73. Gupta (1979, 168, 176–179, 181–182); Pott (1966, 7–8).
74. See, for example, *Siwa Linga Suksma; Aji Mayasandi; Tattwa Kala* (Kantor Dokumentasi 2000, 23–25); *Kanda Empat Rare; Tutur Dalem Turaga; Tutur Dalem Gading; Kanda Empat Dewa;* and *Pancamahabhuta.*
75. C. Hooykaas (1966, 84–85).
76. Lovric (1987, 322).
77. Soebadio (1971, 59–62).
78. Goudriaan (1979, 8).
79. See, for example, Eiseman (1990, 6), Lovric (1987, 68–70), and C. Hooykaas (1974, 3).
80. Goudriaan (1979, 39); Rubinstein (2000, 49).
81. C. Hooykaas (1974, 93–128).
82. Goudriaan (1979, 8).
83. See note 74.
84. C. Hooykaas (1964, 36–38); Zurbuchen (1987, 41–81).
85. Rubinstein (2000, 43ff).
86. Goudriaan (1979, 8).
87. Lovric (1987, 116–118).
88. Goudriaan (1979, 8).
89. C. Hooykaas (1966, pl. 1–24; 1973c, 116–164).
90. Eiseman (1990, 4); Kempers (1991, 61–63). See Pott (1966, 132–136) for a description of the mystic significance of the Balinese *nawasanga.*
91. Zurbuchen (1987, 53–54).
92. Goudriaan (1979, 39).
93. C. Hooykaas (1980).
94. Lovric (1987).
95. Rubinstein (2000); Zoetmulder (1974, 181–184).
96. Goudriaan (1979, 8).
97. See unpublished *lontar* texts referred to in note 74.
98. C. Hooykaas (1966).
99. Goudriaan (1979, 8).
100. See, for example, J. Hooykaas (1961, 269), Hobart (1985, 170), Stuart-Fox (1982, 29), Howe (1984, 204–205, 209), and Lansing (1995, 117, 121).
101. H. Geertz (1994, 31–32, 125; 1995).
102. Lovric (1987, 112).
103. Goudriaan (1979, 8).
104. Boon (1990, 164).
105. Lovric (1987, 252–253).
106. Rubinstein (2000, 125).
107. See Lovric (1987, 131–132).
108. Santiko (1997, 223).
109. See Sedyawati (1994, 111, 113, 164) for the special characteristics Durga assumed in Javo-Balinese religion as revealed in Old Javanese texts.
110. Goudriaan (1979, 8–9).
111. In previous publications (Stephen 1989; 1995) I have developed the concept of autonomous imagination as a means of understanding different states of consciousness and the vivid visualizations that may accompany them. Such imagery is in every way real to the person experiencing it, who may in fact interpret the experience as a higher or more valid spiritual reality. Thus what might be described in texts as events taking place in reality cannot simply be understood as a

physical reality. White (2000, 15–18) provides a balanced assessment of how literally Tantric sexual symbolism should be interpreted.

112. Feuerstein (1998, 239ff).

113. Ibid., 237: "The preservation of semen and the energy for which it stands is an important aspect of Tantra that is almost completely ignored in Western Neo-Tantrism, whose votaries take their lead from the *Kāma-Sūtra* rather than the Tantric heritage."

114. At this point we might think back to the discussion of Budiana's painting *Kasih Sayang* (Plate 11), where monstrous parents are shown with their even more monstrous offspring. Human children conceived in animal lust, without appropriate ritual, will be thus. Balinese sometimes say that children conceived out of wedlock—that is, without the appropriate ritual—are less than human. That is to say: of the threefold potential, it is the lowest or *bhuta* level that is accentuated. I suggest that the sexual *tuturs* described by Creese and Bellows are intended to realize the divine potential of the child by ensuring that at the moment of conception the parents are raised to a state of divine bliss—and not sunk in animal lust as in Budiana's *Kasih Sayang*.

115. Goudriaan (1979, 9).

116. Korn (1960, 133).

117. Rubinstein (2000, 32–35).

118. Goudriaan (1979, 9).

119. But see C. Hooykaas (1975) for a brief attempt at comparing Balinese and Indian rituals. *The Tantra of the Great Liberation* (Avalon 1972, 193ff) refers to nine or ten (depending on caste) purificatory ceremonies to be observed for a child (conception, pregnancy, and birth of the child, the giving of its name, its first view of the sun, its first eating of rice, tonsure, investiture, and marriage) that seem similar to the Balinese *manusa yajña* (see, for example, Lansing 1995, 34–35) but confirmation of this parallel would require a detailed comparison of the two.

120. Goudriaan (1979, 9).

121. C. Hooykaas (1974, 3).

122. Lovric (1987, 70–71).

123. Kempers (1991, 59–61).

124. See also Lovric (1987, 72).

125. See note 74.

126. Zurbuchen (1987, 53ff); Rubinstein (2000, 43ff).

127. Goudriaan (1979, 9).

128. Ibid.

129. Ibid.

130. C. Hooykaas (1973b, 4).

131. Rubinstein (2000, 99–126).

132. Goudriaan (1979, 9).

133. Soebadio (1971, 58).

134. See also Korn (1960).

135. Soebadio (1971, 58).

136. Rubinstein (2000, 33–35).

137. Hoens (1979, 72–74).

138. Schuhmacher and Woerner (1989, 202).

139. C. Hooykaas (1964).

140. Ibid., 155.

141. Couteau (1999, 150).

142. C. Hooykaas (1964, 95–96).

143. Ibid., 102.

144. Ibid., 148.

145. Ibid., 150.
146. Ibid., 201.
147. Kempers (1991, 61).
148. Lovric (1987, 426).
149. Rubinstein (2000); Creese and Bellows (2002); see also Supomo (2000).
150. Nihom (1994, 13).
151. Goudriaan (1979); Dyczkowski (1988); White (2000).
152. See Zoetmulder (1982, 2019).
153. Soebadio (1971, 10) argues for a South Indian parallel here.
154. Balinese texts tend to refer to Ardhanareswari, whether intentionally or by mistake I am not sure.
155. C. Hooykaas (1974, 131).
156. Nihom (1995; 1996).
157. Coedès (1968).

CHAPTER 5: BALINESE RITUAL IN A DYNAMIC UNIVERSE

1. O'Flaherty (1981).
2. Davis (1991).
3. O'Flaherty (1981).
4. Ibid., 312, quoting Eliot (1921, lxxxi).
5. Ibid., 141ff.
6. Kama is also referred to as Semara or Smara in Bali.
7. Since I had not myself read the Indian version of the myth at this time, I could not have even inadvertently influenced Mirdiana's interpretation.
8. O'Flaherty (1981, 162).
9. Ibid., 169ff.
10. Schuhmacher and Woerner (1989, 171).
11. O'Flaherty (1981, 318); see also pp. 313 and 317.
12. Rubinstein (2000, 109) has drawn attention to Balinese similarities with the Indian mythology of Shiva.
13. As C. Hooykaas (1964, 156) observes, the Balinese myth of the Linggodbhawa is similar to the Indian myth recounted in the *Īśāna-Purāṇa*. Mirdiana began a large painting of this myth during the time he was painting the other works discussed here, but it remains unfinished.
14. There may be parallels, but it would require an extensive search of the Puranas to determine this. Part of the text of *Kalatattwa* quoted in Chapter 3—where Siwa admonishes Kala to prey upon sinners and spare those who perform the appropriate sacrifices—has close parallels with Canto L of the *Mārkaṇḍeya Purāṇa* (Pargiter 1995, 250–256), although in this case Brahma is the creator of a demon called Duhasa. My thanks to Dr. Greg Bailey of La Trobe University for pointing this out to me.
15. For discussion of the myth of Andhaka see O'Flaherty (1981, 190–192) and Kramrisch (1981, 374–383). In particular, Kramrisch's description of Andhaka (p. 381) seems to capture the essence of the Balinese Kala as described in *Kalatattwa*: "Hideous, black, blind Andhaka acted out his destiny. Born through an act of indiscretion on the part of his mother, abandoned by both parents, and made over by Śiva to the demons, where by looks and disposition, he belonged, legally confirmed in his new status but repudiated by his new family, Andhaka in anguish longed for a mother of supernatural perfection, and desired her who was unapproachable."
16. See O'Flaherty (1981, 228–229) for Puranic accounts of Shiva and Mohini.
17. Almost all the stories of Siwa and Uma discussed in this book have, of course, been filtered through Old Javanese literature and texts. Pigeaud (1967–1970), Zoetmulder (1974), and many other

Old Javanese scholars have provided detailed studies of this material and its possible relationship to Indian sources. My concern here, however, is with those versions of the stories that exist in Bali today and are known to Balinese such as Mirdiana and Budiana. My interest in Indian parallels is not to identify precise historical sources but rather to show important thematic similarities between Balinese conceptualizations and classic Indian mythology.

18. O'Flaherty (1981, 227).
19. Eliot (1921) quoted in O'Flaherty (1981, 312).
20. O'Flaherty (1981, 313).
21. Davis (1991, 42).
22. Ibid., p. 44.
23. Howe (1980, 164) describes, in a similar manner to Davis, Balinese cosmological concepts of creation as moving from "abstract, essence, immateriality, spirituality, all-inclusion, integration, unity, perfection, completion, restraint, above, male, gods" to "concrete, substance, temporality, least-inclusion, dispersion/differentiation, multiplicity/fragmentation, imperfection, incompletion, immoderation, below, female, demons." Although Howe does not at this point describe the movement back to perfection or the process of absorption, later (p. 231) he does note that demons can through ritual action be returned to divine form.
24. Davis (1991, 44–45).
25. Ibid.
26. See, for example, Bosch (1961, 16–17), C. Hooykaas (1966, 155), Soebadio (1971, 10), and Phalgunadi (1991, 120).
27. C. Hooykaas (1966, 141–156).
28. Soebadio (1971, 8).
29. C. Hooykaas (1966).
30. Ibid., 85, 91.
31. See Hooykaas (1966, 141–156).
32. Davis (1991, 47).
33. For the source of these texts see the "Unpublished Manuscripts" section after the Bibliography; for *Tattwa Kala* see Kantor Dokumentasi (2000, 23–25). The texts I consulted were translated from Kawi into Indonesian for me by Drs. I Nyoman Suarka, lecturer in Kawi and Balinese studies, University of Udayana, Bali.
34. Creese (2001, 14).
35. I Nyoman Suarka, in addition to being an expert in Kawi, has a keen interest in the topics I was researching and indeed has written several papers in Indonesian on Barong and Rangda, the Calon Arang dance/drama (in which Rangda and Barong appear), and Balinese mystic symbolism. He was thus a knowledgeable Balinese guide to the mystical texts.
36. C. Hooykaas (1966).
37. Soebadio (1971).
38. Rubinstein (2000, 43ff); Zurbuchen (1987, 51ff).
39. Rubinstein (2000, 60).
40. Creese and Bellows (2002).
41. The staff at the Gedong Kirtya library was able to identify several *lontar* dealing with kundalini for me, but this material has yet to be transcribed and translated.
42. C. Hooykaas (1964, 37).
43. *Siwa Linga Suksma* (unpublished manuscript), p. 5.
44. Soebadio (1971, 57) notes with respect to the *Jñānasiddhânta* that the "most important opposites are male-female, and the *rva-bhineda* is thus primarily connected with the parents." I would point out, however, that the Tantric concepts involved make it evident that the ultimate male-female elements and parents are none other than Siwa and Sakti.

45. This process was discussed in previous chapters.

46. C. Hooykaas (1964, 36–38).

47. Soebadio (1971, 10–14).

48. Zurbuchen (1987, 41–81).

49. Rubinstein (2000, 43ff).

50. Zurbuchen (1987, 53–54).

51. See, for example, C. Hooykaas (1974, 93–128).

52. Rubinstein (2000, 49).

53. Zurbuchen (1987, 95–96).

54. Ibid., 54.

55. C. Hooykaas (1974, 116–117) also draws attention to the numerous *tutur* texts containing speculations on the *panca* and *tryaksara*.

56. *Siwa Linga Suksma* (unpublished manuscript).

57. As Rubinstein (2000, 110) observes, the term *"maya"* is more often used in Balinese texts to refer to the notion of deception and veiling, so that the beauty of nature is felt to veil "a divine presence." But in either case the idea is that behind the overt and manifest forms of the material world lies Sakti in her pure state.

58. Hoens (1979, 93–94).

59. Soebadio (1971, 10–11).

60. Zurbuchen (1987, 56–57).

61. Rubinstein (2000, 55–58).

62. Compare Zurbuchen (1987, 54–55 n. 28).

63. See also Zurbuchen (1987, 56).

64. Ibid., 56–57.

65. Soebadio (1971, 199, 201).

66. The *Jñānasiddhânta* notes many different levels of yogic teachings and attainment (Soebadio 1971, 111–113). Gonda (1975, 54) too refers to various kinds of yogic teachings in Bali.

67. Unpublished texts that mention reversal of the *ANG* and *AH* formula to bring about death (in the self) include *Siwa Linga Suksma, Tutur Dalem Turaga, Tutur Dalem Gading,* and *Aji Mayasandi.* See also Soebadio (1971, 11) for this reversal. Klokke's (1994) reassessment of the mystic significance of the so-called East Javanese portrait statues suggests to me that these royal images might depict these yogic practices to achieve *moksa* (liberation) at death. See Santiko (2000) for similar arguments.

68. C. Hooykaas (1966, 65; 1964, 139).

69. Rubinstein (2000, 58–59) notes that Zurbuchen (1987, 46–48) and Lovric (1987, 75–76) discuss the use of the *dasaksara* in healing rituals performed by *balian usada.* The unpublished yoga texts I have consulted indicate that the process of purification achieved via meditation on the *dasaksara* can also be used to heal physical illness. A published Indonesian text of the *tutur* text *Tattwa Kala* (Kantor Dokumentasi 2000, 25) illustrates this process. In my view, the yoga texts suggest that the adept is able to bring about healing in the self or to use similar manipulations of the *dasaksara* to treat others. This makes more sense when we understand that the aim of compressing the *dasaksara* to become one represents the process of reabsorption of all impurities back to their pure source.

70. Feuerstein (1998, 232–233).

71. Belo (1953); C. Hooykaas (1977); Lansing (1983, 35ff); Eiseman (1990, 249ff); H. Geertz (1994, 25).

72. J. Hooykaas (1960, 427).

73. Howe (1980, 231–232).

74. Some Balinese also use the term *"wali"*—meaning "retribution, compensation" and "to come back, return" (Zoetmulder 1982, 2182). This could be interpreted as a repayment to the gods, but

one *pedanda* told me the term refers to returning the dangerous powers in the world back to their benign form.

75. Although Indologists (O'Flaherty 1981; Kramrisch 1981) usually translate the term "Ardhanarisvara" as "androgyne" or "hermaphrodite," the Balinese texts (such as the *Surya-Sevana*) suggest that Ardhanareswara (Ardhanareswari) refers to the divine couple in sexual union.

76. The term *"pratima"* is from Sanskrit and means "image, figure, statue, doll" (Zoetmulder 1982, 1408). This points to a more thorough Indianization of the temple ritual than many scholars would admit (Swellengrebel 1960, 29), since these are the most holy representations of divine forces kept in the temple.

77. The symbolism of the *babangkit* offering as representing Ardhanariswara is also noted by Kam (1993, 126).

78. Many Balinese informants described the body symbolism represented in the tripartite division of the temple as head, trunk, and feet. The temple as the lower half of the female body represents, I believe, an esoteric level of understanding not known to all.

79. The sexual, reproductive symbolism is continued in the Kori Agung and the split gate (Candi Bentar)—one represents the vagina and the other the legs or thighs. The *jeroan,* the term for the inner part of the temple, is also a word for "womb," which it symbolizes according to this view. Covarrubias (1994, 266–267) notes other interpretations of the two gates that have been offered by Western scholars. (Plate 28 shows the Kori Agung seen through the split gate.)

80. C. Hooykaas (1974, 76).

81. See Howe (1980, 169ff).

82. See, for example, J. Hooykaas (1961, 268–269).

83. Swellengrebel (1960, 28–29). Indeed, in Swellengrebel's view not only the temple structures but all the rituals performed in them represent a pre-Hindu layer of Balinese culture.

84. The interpretation I offer here of the mystical significance of the temple festival *(odalan)* does not, of course, vitiate other interpretations of its significance and function at different levels—such as Lansing's (1983, 7–8) arguments concerning the cultural, social, economic, and agricultural significance of the *odalan* as part of the Balinese temple system.

85. We can see here that Hildred Geertz's (1994, 81) idea that the aim of Balinese ritual is to return powerful beings from malevolence to benevolence better expresses the intent of the ritual in which Barong meets Rangda than any notion of good triumphing over evil.

86. Howe (1980, 234), whose data are based primarily on the understanding of ordinary villagers rather than literati, also notes Barong's role in the pacification of the *bhuta kala.*

87. Mirdiana observed this performance and gave me this information.

88. I Nyoman Suarka, the specialist in Kawi who translated the *lontar* texts for me, also dances the part of Rangda in temple performances in his home community in Tabanan. The lines he recites during the performances derive from *lontar* texts; when Rangda appears she describes herself in words almost identical to C. Hooykaas' (1974, 71, ll. 245–248) text of *The Litany of the Resi Bhujangga.* Lansing (1983) has described in detail the role of temple performances in spreading Indic culture throughout Bali, a process he terms "sounding the texts." The overt level of the performances as an educative medium has long been recognized by Western scholars; often overlooked, however, is that a deeper, mystic significance is also alluded to in the Kawi lines spoken by actors. Eiseman (1990, 317), for example, notes that the actors playing Rangda and Rarung (one of Rangda's disciples) usually know a little Kawi, but he does not speculate on the significance of their lines.

89. Bhairava is the fierce form of Shiva (O'Flaherty 1981, 381), and Bhairavi is the feminine form. In Balinese texts with which I am familiar, the fierce form of Siwa is usually referred to as Siwa Kala or Kala Rudra, but the name "Berawi Durga" sometimes occurs.

90. Some scholars, especially Lovric (1987), have emphasized the exorcistic function of Barong and Rangda performances in averting disease and plagues.

91. Lovric (1987, 311) offers an interesting Balinese interpretation that clearly points to the mystical significance of the meeting of Barong and Rangda in dance as symbolizing the union of water and fire elements in the self. She notes that in Sanur a Barong dance is always preceded by a masked dance of eight *jauk-sandaran* figures, the *jauk* wearing red and the *sandaran* white masks. The red *jauk* are said to represent "embodiments of the mystical syllables *SANG BANG TANG* and *ANG,* that is, the umbilicus, the heart, the kidney and the gall bladder, the fiery elements of the body." The white *sandaran* represent the "watery elements" of the body and the syllables *NANG MANG SING* and *WANG*. With the two remaining syllables, *ING* and *YANG* (which are embodied in the Rangda), these constitute the *dasaksara*. In the dance the four white and four red elements combine to become *anggapati, mrajapati, banaspati,* and *banaspati raja,* the names of the four spiritual siblings *(kanda empat)*. In turn, the first three of these become helpers of Rangda and the fourth becomes Barong. In my view, it is evident in this account that masked dancers, in representing the fiery and watery elements of the body, are enacting in the meeting of Barong and Rangda, the *rwa bhineda,* the union of fire and water, and the reabsorption of the ten sacred letters into the one—in the self.

92. If we consider the emotions generated in the performance—the wild energy of the actors and the excitement of the crowd—it is not difficult to see a correlation with the generating of fire in the self, and the raising of Kundalini to meet Siwa, achieved in the inner visualization of the adept.

93. C. Hooykaas (1974, 2).

94. See Chapter 3.

95. Hooykaas' text is based on a composite of various versions of two *tutur* texts: the *Purvaka Bhumi* and the *Bhumi Kamulan* (Origin of the world).

96. C. Hooykaas (1974, 11).

97. Ibid., 73.

98. Hefner (1985, 182) discovered that the liturgy of the Hindu Javanese Tengger people has a direct counterpart in the Balinese texts referred to by Hooykaas as the *Litany of the Resi Bhujangga*. Furthermore he concludes that the purpose of this "most important of liturgies is to insure the balance of spiritual forces in the world by perpetually transforming Kala, Siva in demonic form, back into his beneficent incarnation as Guru-Siva" (p. 183). Hefner thus presents a totally independent interpretation of the *Litany* that clearly concurs with mine. He also goes on to note that in contrast to the priest who knows the liturgy, the ordinary Tengger villager seems to know little of these deeper meanings of the rituals, much as we might observe of many Balinese.

99. Lovric (1987, 310–313).

100. Howe (1980, 233).

101. See, for example, Eiseman's (1990, 182–184) description of Galungan and Kuningan, although he does discuss the significance of Barong performances during this period (p. 320ff).

102. Lovric (1987, 312).

103. Howe (1980, 234); Eiseman (1990, 319–320).

104. As well as Barong Ketket, the form that meets with Rangda, there are abroad *barong bangkal* (pig/wild boar) and *barong macan* (tiger).

105. Lovric (1987, 312).

106. Ibid., 311.

107. Ibid., 313.

108. Stuart-Fox (1982, 28) explains that the Eka Dasa Rudra ceremony is in essence the pinnacle of purificatory ceremonies held every Balinese lunar year, the Taur Kasanga. Every decade—that is, every Sakta year that ends in a zero—a larger ceremony called Panca Wali Krama should be held. And once a century, when the Sakta year ends in a double zero, the Eka Dasa Rudra should be performed. It is also appropriate to hold it at times of major natural and human

disasters, such as earthquakes, plagues, or war. See also Lansing (1983, 129–139) for an explanation of the reasons for the 1963 and 1979 observances.

109. Stuart-Fox (1982, 29).
110. Howe (1980, 231).
111. H. Geertz (1995, 125).
112. Lansing (1983, 141).
113. Ibid.
114. Ibid., 142.
115. Lansing (1995, 117).
116. C. Hooykaas (1973c, 167–168).
117. Ibid., 185.
118. Ibid., 195.
119. See C. Hooykaas (1973a, 159).
120. C. Hooykaas (1973c, 203–205).
121. Ibid., 217.
122. Lansing (1983, 140).
123. Howe (1980, 231).
124. C. Hooykaas (1973c, 174–175).
125. C. Hooykaas (1975, 255–256) explicitly rejects the opinion of the Balinese scholar I Gusti Ngurah Bagus that *bhuta yadnya* are but variations on the *dewa yadnya* and not a separate category.
126. See Howe (1980, 46–55) and Eiseman (1990, 51–62) for an idea of the complexity of these different kinds of holy water.
127. C. Hooykaas (1973a, 167) identifies two basic forms of holy water: *toya panglukatan* and *toya pabresihan*. See also Hooykaas (1977, 45–46).
128. H. Geertz (2004, chap. 5).
129. Ibid.
130. *Siwagama* (unpublished manuscript), pp. 162–166.
131. I am not suggesting that this etymology is correct but that the similarity between the sounds of the words suggests to Balinese a meaningful link between the entities.
132. My informants stressed, however, that both types of priests could prepare both kinds of holy water and that in the absence of one priest the other could act in his stead in any ritual requiring a Brahmana priest.
133. C. Hooykaas (1973c, 167–168).
134. Ibid., 167.
135. Hooykaas recognizes the importance of *pedanda Buddha* in the past but thinks they are not significant in contemporary Bali. Swellengrebel (1960, 67) links the *"pĕdanda Boda"* to the "left path," which "brings him in contact with graveyards, corpses, and the like—in short with elements which in the Balinese bipartite classification belong in the *kĕlod* sphere" and notes that at rituals he occupies a "lower, inferior place" to that of the *pĕdanda Siwa*—i.e. he sat "more *kĕlod* than his colleague."
136. These include Pott (1966, 120ff), Sakar (1967), Ensink (1974; 1978), O'Brien (1993, 220–224, 330–334), Klokke (1994), and Jordaan (2000). The relationship of the Javanese Siwa-Buddha cults to present-day Bali is an important question but one that goes beyond the scope of this book.
137. Klokke (1994, 189).
138. Rubinstein (2000, 55).
139. Ibid., 57.
140. Zurbuchen (1987, 58).
141. O'Flaherty (1981, 312) quoting Eliot (1921, lxxxi).

142. Davis (1991, 22).

143. See, for example, Covarrubias (1994, 296), Swellengrebel (1960, 36ff), Zurbuchen (1987, 51–54), Lansing (1995, 25ff), and Hobart et al. (1996, 98ff). See Pott (1966, 133–136) for a more esoteric understanding of the *nawasanga*. Howe (1980, 63ff) provides a detailed ethnographic description of how the *nawasanga* is used to orient daily life.

144. See Lansing (1995, 23–24).

145. Zurbuchen (1987, 54), one of the few Western scholars to recognize this point, observes that the *pedanda*'s daily ritual involves a mental revolving of the directions. Thus when the whole system is set "in motion, revolving, the ordered differences can begin their condensation into fewer and fewer forms until the final, single distillation is achieved—the goal of the mystic adept's meditation." She therefore shows how the *nawasanga* is used in meditation to represent the process of absorption back to an original unity.

146. According to Chevalier and Gheerbrant (1996, 907): "The double helix around the Brahman's staff and the twofold movement of the *nadi* around the central *sushumna* artery" symbolize "the polarity and balance of the two opposing cosmic currents." The same notion, they observe, is expressed in the Hindu myth of the Churning of the Sea of Milk (which is the basis of the Balinese story of the *Pemutaran Mandara Giri*). Once again a link between yogic practices and public ritual is evident, since the story of *Pemutaran Mandara Giri* also provides the basis of a shadow puppet play often given at temple festivals *(odalan)*.

147. Some scholars—for example, Soebadio (1971, 11–12)—have been inclined to interpret ritual movements to the left, and reversals such as that of the *ANG AH* formula, as relating to black magic and sorcery. In my view, this involves a misunderstanding of the process of reabsorption, although evidently this process is concerned with the transformation of demonic forces.

148. Gonda (1975, 12) observes that the Buddhist monument of Borobudur is in effect an enormous mandala "representing the whole universe in its process of emanation and reabsorption, developing from an essential Principle while rotating round a central axis and serving the adept as a means of identifying himself with the forces which govern the universe and with the Highest Reality." This mandala seems to be closely related in form and meaning to the Balinese *nawasanga*.

149. See C. Hooykaas (1980, 30) for Balinese drawings of the four mystical siblings and *lega prana*.

150. See also C. Hooykaas (1974, 93–128).

151. This is a popular topic for Balinese artists; see Couteau (1999, 150).

152. Freud (1971, 153).

CHAPTER 6: VISUALIZING PURE REALMS

1. C. Hooykaas' (1976, 46) reference to the mystery of the "union of fire and water" indicates that the themes I have explored are likely to be present in the death rituals classed as *pitra yadnya* (sacrifices for ancestors). Hooykaas himself points to many similarities with the rites performed for the dead person and the rites performed by the priest during his Surya-Sevana observances. My reference in Chapter 5 to the parallels between the *otonan* of the individual and yogic practices points in the same direction. Given the correspondence between the *bhuwana agung* and the *bhuwana alit* (the individual), a correspondence in the rituals performed for each domain seems only to be expected.

2. Howe (1980, chaps. 10–12).

3. See, for example, Howe (1983), Lansing (1983; 1995), Lovric (1987), A. Hobart (1987), Zurbuchen (1987), Rubinstein (2000), and Creese and Bellows (2002).

4. Swellengrebel (1960) represents a classic example. Picard (1999) discusses the negative opinions held by many early Western scholars of Balinese religion.

5. Creese (2001, 13) reviews these developments in the field of Old Javanese studies.

6. C. Hooykaas (1977, 49).

7. Lansing (1995, 117–121).

8. Lovric (1987, 317–325).

9. Obeyesekere (1990).

10. O'Brien's (1993) work on East Javanese kingship suggests to me a unified view: a mystical view of the universe is projected onto external reality, much as I have expressed it here for Bali.

11. Creese (2000), however, has drawn attention to the tendency to overestimation—by Western scholars and Balinese alike—of the importance of the coming of Majapahit for Balinese culture.

12. Ramseyer (2002, 36).

13. Reuter's (2002, 304–307) recent study of the Bali Aga points out the likelihood that these apparently marginal and isolated mountain people might in fact be the heirs to Bali's first Hindu kingdoms. He notes that the earliest direct evidence of Hindu influence—in the form of inscriptions, stone monuments, and statuary dating from the ninth to the eleventh centuries AD—has been found in the Puncak Penulisan region, close to Kintamani. The statues of Balinese kings and queens still preserved in the temple of Puncak Penulisan closely resemble the famous "portrait statues" of Javanese rulers, whose ritual and mystic significance has been described by Klokke and others. Klokke (1994, 188) argues that these figures are not mortuary statues, as previously thought, but instead represent the subject in meditation. This depiction of the ruler in meditation, according to Klokke (p. 191), "implies attainment of the highest spiritual knowledge which entails release of the material world and unification with god." See Kempers (1991, 42, fig. 29) for an illustration of a statue of a royal pair at Puncak dated 1011 AD: both figures are standing, their eyes downcast, and holding what appears to be a lingam in exactly the manner described by Klokke (1994, 190). Thus it appears that even the mystic yogic practices discussed in this book might have been known from these early times.

14. Ardika and Bellwood (1991).

15. As we have seen, there are several levels of esoteric understanding. Thus the myths provide a narrative level that points to the more abstract symbolism of sacred letters and numbers. I have observed a tendency among village priests and local leaders, who are not scholars of the texts, to ponder the meaning of ritual actions. Such speculations are often, I think, offered to foreigners seeking explanations for rituals.

16. See, for example, Covarrubias (1994, 261), Swellengrebel (1960, 64–65), and Connor (1982).

17. Budiana and other Balinese often mentioned to me that there are different kinds of worship appropriate for different persons: *karya* (work), *bhakti* (devotion), and *jnana* (abstract understanding).

18. Wikan (1990, 35–37, 137–141) has discussed with much sensitivity the different emphasis that Balinese place on the role of thinking and feeling compared with Western culture. She argues that for Balinese thought and feeling are not opposed but rather combine to give people deeper insight into their world.

19. Howe (1980).

20. See Bakker (1993), Picard (1999), and Howe (2001).

Bibliography

Ardika, I Wayan, and Peter Bellwood. 1991. "Sembiran: The Beginnings of Indian Contact with Bali." *Antiquity* 65:221–232.

Avalon, Arthur (trans.). 1972. *Tantra of the Great Liberation: Mahānirvāna Tantra*. New York: Dover. First published in 1913.

Bakker, Frederik L. 1993. *The Struggle of the Hindu Balinese Intellectuals: Developments in Modern Hindu Thinking in Independent Indonesia*. Amsterdam: VU University Press.

Bandem, I Made, and Fredrik Eugene deBoer. 1995. *Balinese Dance in Transition: Kaja and Kelod*. Kuala Lumpur: Oxford University Press.

Barth, Fredrik. 1993. *Balinese Worlds*. Chicago: University of Chicago Press.

Bellwood, Peter. 1997. *Prehistory of the Indo-Malaysian Archipelago*. Honolulu: University of Hawai'i Press.

Belo, Jane. 1953. *Bali: Temple Festival*. Seattle: University of Washington Press.

———. 1960. *Trance in Bali*. New York: Columbia University Press.

Boon, James A. 1977. *The Anthropological Romance of Bali, 1597–1972: Dynamic Perspectives in Marriage and Caste, Politics, and Religion*. New York: Cambridge University Press.

———. 1982. *Other Scribes, Other Tribes: Symbolic Anthropology in the Comparative Study of Cultures, Histories, Religions, and Texts*. Cambridge: Cambridge University Press.

———. 1990. *Affinities and Extremes: Crisscrossing the Bittersweet Ethnology of East Indies History, Hindu-Balinese Culture, and Indo-European Allure*. Chicago: University of Chicago Press.

Bosch, F. D. K. 1961. *Selected Studies in Indonesian Archaeology*. The Hague: Martinus Nijhoff.

———. 1994. *The Golden Germ: An Introduction to Indian Symbolism*. New Delhi: Munshiram Manoharlal.

Chevalier, Jean, and Alain Gheerbrant. 1996. *The Penguin Dictionary of Symbols*. Translated by John Buchanan-Brown. London: Penguin.

Coedès, G. 1968. *The Indianized States of Southeast Asia.* Edited by Walter F. Vella. Translated by Sue Brown Cowing. Honolulu: University of Hawai'i Press.

Connor, Linda H. 1982. "In Darkness and Light: A Study of Peasant Intellectuals in Bali." Ph.D. dissertation, University of Sydney.

Connor, Linda H., Patsy Asch, and Timothy Asch. 1986. *Jero Tapakan, Balinese Healer: An Ethnographic Film Monograph.* Cambridge: Cambridge University Press.

Couteau, Jean. 1999. *Museum Puri Lukisan.* Ubud: Indonesia.

Covarrubias, Miguel. 1994. *Island of Bali.* London: Kegan Paul International. First published in 1937.

Creese, Helen. 2000. "In Search of Majapahit: The Transformation of Balinese Identities." In *To Change Bali: Essays in Honour of I Gusti Ngurah Bagus,* ed. Adrian Vickers and I Nyoman Darma Purta with Michele Ford. Denpasar: Bali Post.

———. 2001. "Old Javanese Studies: A Review of the Field." *Bijdragen Tot de Taal-, Land-, en Volkenkunde,* vol. 157(1), pp. 3–33. The Hague: Martinus Nijhoff.

Creese, Helen, and Laura Bellows. 2002. "Erotic Literature in Nineteenth-Century Bali." *Journal of Southeast Asian Studies* 33(3): 385–413.

Dalmia, Vasudha, and Heinrich von Stietencron (eds.). 1995. *Representing Hinduism: The Construction of Religious Traditions and National Identity.* New Delhi: Sage.

Davis, Richard H. 1991. *Ritual in an Oscillating Universe: Worshiping Śiva in Medieval India.* Princeton: Princeton University Press.

Djelantik, A. A. M. 1990. *Balinese Paintings.* Singapore: Oxford University Press.

Dyczkowski, Mark S. G. 1987. *The Doctrine of Vibration: An Analysis of the Doctrines and Practices of Kashmir Shaivism.* Albany: SUNY.

———. 1988. *The Canon of the Śaivāgama and the Kubjikā Tantras of the Western Kaula Tradition.* Albany: SUNY.

Eiseman, Fred B., Jr. 1990. *Bali: Sekala and Niskala.* Vol. 1. Hong Kong: Periplus.

Ensink, Jacob. 1974. "Sutasoma's Teaching to Gajavaktra, the Snake, and the Tigress." *Bijdragen Tot de Taal-, Land-, en Volkenkunde,* vol. 130(1), pp. 195–226. The Hague: Martinus Nijhoff.

———. 1978. "Śiva-Buddhism in Java and Bali." In *Buddhism in Ceylon and Studies on Religious Syncretism in Buddhist Countries,* ed. H. Bechert. Göttingen: Vandenhoeck & Ruprecht.

Feuerstein, Georg. 1998. *Tantra: The Path of Ecstasy.* Boston: Shambhala.

Forge, Anthony. 1978. *Balinese Traditional Paintings.* Sydney: Australian Museum.

Freud, Sigmund. 1971. *The Complete Introductory Lectures on Psychoanalysis.* Translated and edited by James Strachey. London: Allen & Unwin.

Geertz, Clifford. 1975. *The Interpretation of Cultures.* London: Hutchinson.

———. 1980. *Negara: The Theatre State in Nineteenth-Century Bali.* Princeton: Princeton University Press.

Geertz, Hildred. 1994. *Images of Power: Balinese Paintings Made for Gregory Bateson and Margaret Mead.* Honolulu: University of Hawai'i Press.

———. 1995. "Sorcery and Social Change in Bali: The Sakti Conjecture." Paper presented at the Third International Balinese Studies Workshop, University of Sydney, 3–7 July.

———. 2004. *The Life of a Balinese Temple: Artistry, Imagination, and History in a Peasant Village.* Honolulu: University of Hawai'i Press.

Gonda, J. 1975. "The Indian Religions in Pre-Islamic Indonesia and Their Survival in Bali." *Handbuch der Orientalistik,* vol. 3, pp. 1–54.

Goris, R. 1960a. "The Religious Character of the Village Community." In *Bali: Studies in Life, Thought, and Ritual,* ed. W. F. Wertheim et al. The Hague: W. Van Hoeve.

———. 1960b. "The Temple System." In *Bali: Studies in Life, Thought, and Ritual,* ed. W. F. Wertheim et al. The Hague: W. Van Hoeve.

———. 1960c. "Holidays and Holy Days." In *Bali: Studies in Life, Thought, and Ritual,* ed. W. F. Wertheim et al. The Hague: W. Van Hoeve.

Goudriaan, Teun. 1978. *Māyā Divine and Human.* Delhi: Motilal Banarsidass.

———. 1979. "Introduction, Tantrism in History, the Place of Tantrism in Hindu Religious Speculation." In Sanjukta Gupta et al., *Hindu Tantrism.* Leiden: E. J. Brill.

——— (ed.). 1990. *The Sanskrit Tradition and Tantrism.* Leiden: E. J. Brill.

Goudriaan, Teun, and Sanjukta Gupta. 1981. *Hindu Tantric and Śākta Literature.* Wiesbaden: Otto Harrassowitz.

Goudriaan, Teun, and Christiaan Hooykaas. 1971. *Stuti and Stava: (Bauddha, Śaiva and Vaiṣṇava) of Balinese Brahman Priests.* Amsterdam: North Holland.

Gupta, Sanjukta, Dirk Jan Hoens, and Teun Goudriaan. 1979. *Hindu Tantrism.* Leiden: E. J. Brill.

Gupta, Shakti M. 1979. *Legends Around Shiva.* Bombay: Somaiya.

Haks, F., et al. 1999. *Pre-war Balinese Modernists 1928–1942.* Haarlem: Ars et Animatio.

Headley, Stephen C. 1991. "The Javanese Exorcisms of Evil: Betwixt India and Java." In *The Art and Culture of South-East Asia,* ed. Lokesh Chandra. New Delhi: P. K. Goel.

Hefner, Robert W. 1985. *Hindu Javanese: Tengger Tradition and Islam.* Princeton: Princeton University Press.

Henderson, Joseph L. 1964. "Ancient Myths and Modern Man." In *Man and His Symbols,* ed. Carl G. Jung. London: Pan Books.

Hinzler, Hedwig I. R. 1981. *Bima Swarga in Balinese Wayang.* The Hague: Martinus Nijhoff.

Hobart, Angela. 1987. *Dancing Shadows of Bali.* New York: Routledge & Kegan Paul.

Hobart, Angela, Urs Ramseyer, and Albert Leeman. 1996. *The Peoples of Bali.* Oxford: Blackwell.

Hobart, Mark. 1985. "Is God Evil?" In *The Anthropology of Evil,* ed. David Parkin. New York: Blackwell.

———. 1999. "The End of the World News: Articulating Television in Bali." In *Staying Local in the Global Village: Bali in the Twentieth Century,* ed. Rachelle Rubinstein and Linda H. Connor. Honolulu: University of Hawai'i Press.

Hoens, Dirk J. 1979. "Tantric Transmission, Mantra, and Other Constituents of Tantric Practice." In Sanjukta Gupta, Dirk Jan Hoens, and Teun Goudriaan, *Hindu Tantrism.* Leiden: E. J. Brill.

Hooykaas, Christiaan. 1964. *Agama Tīrtha: Five Studies in Hindu-Balinese Religion.* Amsterdam: North-Holland.

———. 1966. *Surya-Sevana: The Way to God of a Balinese Śiva Priest.* Amsterdam: North-Holland.

———. 1973a. *Kama and Kala: Materials for the Study of Shadow Theatre in Bali.* Amsterdam: North-Holland.

———. 1973b. *Religion in Bali.* Leiden: E. J. Brill.

———. 1973c. *Balinese Bauddha Brahmans.* Amsterdam: North-Holland.

———. 1974. *Cosmogony and Creation in Balinese Tradition.* The Hague: Martinus Nijhoff.

———. 1975. *Pañca-yajña-s in India and Bali.* Adyar Library Bulletin 39:240–259.

———. 1976. "Balinese Death Ritual—as Described and Explained from the Inside." *Review of Indonesian and Malaysian Affairs* 10(2): 35–49.

———. 1977. *A Balinese Temple Festival.* The Hague: Martinus Nijhoff.

———. 1978. *The Balinese Poem Basur: An Introduction to Magic.* The Hague: Martinus Nijhoff.

———. 1980. *Drawings of Balinese Sorcery.* Leiden: E. J. Brill.

Hooykaas, Jacoba. 1960. "The Changeling in Balinese Folklore and Religion." *Bijdragen Tot de Taal-, Land-, en Volkenkunde,* vol. 116, pp. 424–436. The Hague: Martinus Nijhoff.

———. 1961. "The Myth of the Young Cowherd and the Little Girl." *Bijdragen Tot de Taal-, Land-, en Volkenkunde,* vol. 117, pp. 267–278. The Hague: Martinus Nijhoff.

Howe, Leopold E. A. 1980. "Pujung: An Investigation into the Foundations of Balinese Culture." Ph.D. dissertation, University of Edinburgh.

——. 1983. "An Introduction to the Cultural Study of Traditional Balinese Architecture." *Archipel* 25:137–158.

——. 1984. "Gods, People, Spirits, and Witches: The Balinese System of Person Identification." *Bijdragen Tot de Taal-, Land-, en Volkenkunde,* vol. 140, pp. 193–222. The Hague: Martinus Nijhoff.

——. 2001. *Hinduism and Hierarchy in Bali.* World Anthropology series, ed. Wendy James and N. J. Allen. Oxford: James Currey.

Huntington, Richard, and Peter Metcalf. 1979. *Celebrations of Death: The Anthropology of Mortuary Ritual.* Cambridge: Cambridge University Press.

Jensen, Gordon D., and Luh Ketut Suryani. 1992. *The Balinese People: A Reinvestigation of Character.* Singapore: Oxford University Press.

Jordaan, Roy E. 2000. "Co-existence of Religions in Ancient Central Java." In *Society and Culture of Southeast Asia: Continuities and Changes,* ed. Lokesh Chandra. Delhi: P. K. Goel.

Jung, Carl G. 1964. "Approaching the Unconscious." In *Man and His Symbols.* London: Pan Books.

Kam, Garrett. 1993. *Perceptions of Paradise: Images of Bali in the Arts.* Ubud: Yayasan Dharma Seni Museum Neka.

Kamus Bali-Indonesia. 1978. *Disusun oleh Panitia Penyusun Kamus Bali-Indonesia.* Denpasar: Dinas Penggajaran Propinsi Daerah Tingat 1 Bali.

Kantor Dokumentasi. 2000. *Tutur Anda Bhuwana, Tattwa Kala, Aji Swamandala.* Denpasar: Kantor Dokumentasi Budaya Bali.

Kempers, A. J. Bernet. 1991. *Monumental Bali.* Singapore: Periplus.

Kinsley, David R. 1988. *Hindu Goddesses: Visions of the Divine Feminine in the Hindu Religious Tradition.* Berkeley: University of California Press.

Klein, Melanie. 1994. *The Psycho-analysis of Children.* London: Virago Press. First published in 1932.

Klokke, Marijke J. 1994. "The Iconography of So-called Portrait Statues in Late East Java." In *Ancient Indonesian Sculpture,* ed. Marijke J. Klokke and Pauline Scheurleer. Leiden: KITLV Press.

Korn, V. E. 1960. "The Consecration of a Priest." In *Bali: Studies in Life, Thought, and Ritual,* ed. W. F. Wertheim et al. The Hague: W. Van Hoeve.

Kramrisch, Stella. 1981. *The Presence of Śiva.* Princeton: Princeton University Press.

Lansing, J. Stephen. 1983. *The Three Worlds of Bali.* New York: Praeger.

——. 1995. *The Balinese: Case Studies in Cultural Anthropology.* Fort Worth: Harcourt Brace.

Lévi, Sylvain. 1933. *Sanskrit Texts from Bali.* Baroda: Oriental Institute.

Lovric, Barbara. 1987. "Rhetoric and Reality." Ph.D. dissertation, University of Sydney.

MacRae, Graeme S. 1998. "Ritual Networks in South Bali: Geographical Form and Historical Process." *Review of Indonesian and Malaysian Affairs* 32(1): 110–143.

——. 1999. "Acting Global, Thinking Local in a Balinese Tourist Town." In *Staying Local in the Global Village: Bali in the Twentieth Century,* ed. Raechelle Rubinstein and Linda H. Connor. Honolulu: University of Hawai'i Press.

Mershon, Katharane E. 1971. *Seven Plus Seven: Mysterious Life-Rituals in Bali.* New York: Vantage Press.

Neka, Suteja. 1989. *The Development of Painting in Bali.* Ubud: Yayasan Dharma Seni Museum Neka.

Nihom, Max. 1994. *Studies in Indian and Indo-Indonesian Tantrism: The Kuñjarakarṇadhar-makathana and the Yogatantra.* Vienna: Sammlung De Nobili.

——. 1995. "Sāṅkhya and Pāśupata Reflexes in the Indo-Javanese Vṛhaspatitattva." *Wiener Zeitschrift für die Kunde Südasiens und Archiv für Indische Philosophie.* 39:203–220.

——. 1996. "Old Javanese Rāmāyaṇa 25.25 and 24.117ab: A Study in Literature and Pāśupata Śaivism." *Asiatische Studien/Études Asiatiques* 3:653–671.

——. 1997. "Dīkṣā, Kalā, and the Stuti of Śiwarātrikalpa 33.1-2." *Bijdragen Tot de Taal-, Land-, en Volkenkunde,* vol. 153, pp. 103–111. The Hague: Martinus Nijhoff.

Obeyesekere, Ganath. 1981. *Medusa's Hair: An Essay on Personal Symbols and Religious Experience.* Chicago: University of Chicago Press.

———. 1990. *The Work of Culture: Symbolic Transformation in Psychoanalysis and Anthropology.* Chicago: University of Chicago Press.

O'Brien, Kathleen P. 1988–1989. "The Mandalas of the Sutasoma Kekawin—Part I." *Journal of the Oriental Society of Australia* 20/21:159–187.

———. 1990–1991. "The Mandalas of the Sutasoma Kekawin—Part II." *Journal of the Oriental Society of Australia* 22/23:92–132.

———. 1993. "Means and Wisdom in Tantric Buddhist Rulership of the East Javanese Period." Ph.D. dissertation, University of Sydney.

———. 2000. "Ignorance and Omniscience in the Old Javanese *Kakawin* 'Sutasoma.' " In *Society and Culture of Southeast Asia: Continuities and Changes,* ed. Lokesh Chandra. Delhi: P. K. Goel.

O'Flaherty, Wendy D. 1981. *Śiva: The Erotic Ascetic.* New York: Oxford University Press.

Pargiter, F. E. 1995. *Mārkaṇḍeya Purāṇa.* Delhi: Shamsher Bahadur Sihgh.

Parker, Lynette. 1992. "The Quality of Schooling in a Balinese Village." *Indonesia* 54:95–116.

———. 2000. "The Introduction of Western-Style Education to Bali: Domination by Consent?" In *To Change Bali: Essays in Honour of I Gusti Ngurah Bagus,* ed. Adrian Vickers and I Nyoman Darma Purta with Michele Ford. Denpasar: Bali Post.

Phalgunadi, I Gusti Putu. 1991. *Evolution of Hindu Culture in Bali.* New Delhi: Sundeep Prahashan.

Picard, Michel. 1996. *Bali: Cultural Tourism and Touristic Culture.* Singapore: Archipelago Press.

———. 1999. "The Discourse of *Kebalian:* Transcultural Constructions of Balinese Identity." In *Staying Local in the Global Village: Bali in the Twentieth Century,* ed. Rachelle Rubinstein and Linda H. Connor. Honolulu: University of Hawai'i Press.

Pigeaud, Th. G. Th. 1967–1970. *Literature of Java: Catalogue Raisonné of Javanese Manuscripts in the Library of the University of Leiden and Other Public Collections in the Netherlands.* 3 vols. The Hague: Martinus Nijhoff.

Pott, P. H. 1966. *Yoga and Yantra: Their Interrelation and Their Significance for Indian Archaeology.* The Hague: Martinus Nijhoff.

Ramseyer, Urs. 2002. *The Art and Culture of Bali.* Basel: Museum der Kulturen.

Rawson, Philip. 1973. *The Art of Tantra.* London: Thames & Hudson.

Reuter, Thomas A. 2002. *Custodians of the Sacred Mountains: Culture and Society in the Highlands of Bali.* Honolulu: University of Hawai'i Press.

Rubinstein, Raechelle. 1996. "Leaves of Palm: Balinese *Lontar.*" In *Illuminations: The Writing Traditions of Indonesia,* ed. Ann Kumar and John H. McGlynn. New York: Weatherhill.

———. 2000. *Beyond the Realm of the Senses: The Balinese Ritual of Kekawin Composition.* Leiden: KITLV Press.

Rubinstein, Raechelle, and Linda H. Connor (eds.). 1999. *Staying Local in the Global Village: Bali in the Twentieth Century.* Honolulu: University of Hawai'i Press.

Rycroft, Charles. 1977. *A Critical Dictionary of Psychoanalysis.* Harmondsworth: Penguin.

Sakar, H. B. 1967. "The Evolution of the Siva-Buddha Cult in Java." *Journal of Indian History* 45/3 (135): 637–646.

Santiko, Hariani. 1997. "The Goddess Durgā in the East-Javanese Period." *Asian Folklore Studies* (Jakarta) 56:209–226.

———. 2000. "The Function of Portrait-Statues of Singasari and Majapahit Period." In *Society and Culture of Southeast Asia: Continuities and Changes,* ed. Lokesh Chandra. Delhi: P. K. Goel.

Santoso, Soewito. 1975. *Sutasoma—A Study in Javanese Wajrayana.* New Delhi: International Academy of Indian Culture.

Schuhmacher, Stephan, and Gert Woerner (eds.). 1989. *The Rider Encyclopaedia of Eastern Philosophy and Religion.* London: Rider.

Schulte Nordholt, Henk. 1991. "Temple and Authority in South Bali, 1900–1980." In *State and Society in Bali: Historical, Textual, and Anthropological Approaches,* ed. Hildred Geertz. Leiden: KITLV Press.

———. 2000. "From Wangsa to Bangsa: Subaltern Voices and Personal Ambivalences in 1930s Colonial Bali." In *To Change Bali: Essays in Honour of I Gusti Ngurah Bagus,* ed. Adrian Vickers and I Nyoman Darma Purta with Michele Ford. Denpasar: Bali Post.

Schwartz, Gary. 1997. *Hieronymus Bosch.* New York: Abrams.

Sedyawati, Edi. 1994. *Ganeśa Statuary of the Kadiri and Siṅhasāri Periods.* Leiden: KITLV Press.

Soebadio, Haryati. 1971. *Jñānasiddhânta.* The Hague: Martinus Nijhoff.

Stephen, Michele. 1989. "Self, the Sacred Other, and Autonomous Imagination." In *The Religious Imagination in New Guinea,* ed. Gilbert Herdt and Michele Stephen. New Brunswick: Rutgers University Press.

———. 1995. *A'aisa's Gifts: A Study of Magic and the Self.* Berkeley: University of California Press.

———. 2001. "Barong and Rangda in the Context of Balinese Religion." *Review of Indonesian and Malaysian Affairs* 35(1) (Winter): 137–193.

———. 2002. "Returning to Original Form." *Bijdragen tot de Taal-, Land-, en Volkenkunde,* vol. 158, pp. 61–94. Leiden: KITLV Press.

———. n.d. "Imaginary Violence and the Terrible Mother: The Imagery of Balinese Witchcraft." In *Terror and Violence,* ed. Pamela Stewart and Andrew Strathern. Forthcoming.

Stuart-Fox, David J. 1982. *Once a Century: Pura Besakih and the Eka Dasa Rudra Festival.* Jakarta: Penerbit Citra Indonesia.

———. 1992. *Bibliography of Bali: Publications from 1920 to 1990.* Leiden: KITLV Press.

Supomo, S. 2000. "Kāma in the Old Javanese Kakawin." In *Society and Culture of Southeast Asia: Continuities and Changes,* ed. Lokesh Chandra. Delhi: P. K. Goel.

Suryani, Luh Ketut, and Gordon D. Jensen. 1993. *Trance and Possession in Bali: A Window on Western Multiple Personality, Possession Disorder, and Suicide.* Kuala Lumpur: Oxford University Press.

Sutjaja, I Gusti Made. 2000. *Practical Balinese–English English–Balinese Dictionary.* Denpasar: Penerbit BP.

Swellengrebel, Jan L. 1960. "Introduction." In *Bali: Studies in Life, Thought, and Ritual,* ed. W. F. Wertheim et al. The Hague: W. Van Hoeve.

Taylor, Alison. 1991. *Living Traditions in Balinese Painting.* Ubud: Agung Rai Gallery of Fine Art.

Tokyo Station Gallery. 2003. *I Ketut Budiana: Illusory View from the Balinese Spiritual Cosmos.* Tokyo: Tokyo Station Gallery.

Vickers, Adrian. 1989. *Bali: A Paradise Created.* Hong Kong: Periplus.

———. 1991. "Ritual Written: The Song of the Ligya, or The Killing of the Rhinoceros." In *State and Society in Bali: Historical, Textual, and Anthropological Approaches,* ed. Hildred Geertz. Leiden: KITLV Press.

———(ed.). 1996. *Being Modern in Bali: Image and Change.* Monograph 43. New Haven: Yale University Southeast Asia Studies.

Vickers, Adrian, and I Nyoman Darma Putra with Michele Ford (eds.). 2000. *To Change Bali: Essays in Honour of I Gusti Ngurah Bagus.* Denpasar: Bali Post.

White, David Gordon. 1996. *The Alchemical Body: Siddha Traditions in Medieval India.* Chicago: University of Chicago Press.

———(ed.). 2000. *Tantra in Practice.* Princeton: Princeton University Press.

Wiener, Margaret J. 1995. *Visible and Invisible Realms: Power, Magic, and Colonial Conquest in Bali.* Chicago: University of Chicago Press.

Wikan, Unni. 1990. *Managing Turbulent Hearts: A Balinese Formula for Living.* Chicago: University of Chicago Press.

Zoetmulder, P. J. 1974. *Kalangwan: A Survey of Old Javanese Literature*. The Hague: Martinus Nijhoff.

———. 1982. *Old Javanese-English Dictionary*. Pts. 1 and 2. The Hague: Martinus Nijhoff.

Zurbuchen, Mary S. 1987. *The Language of the Balinese Shadow Theater*. Princeton: Princeton University Press.

UNPUBLISHED MANUSCRIPTS

Aji Mayasandi. Gedong Kirtya, Singaraja, IIIc.5252.

Andabhuwana. Salinan naskah lontar koleksi, Gedong Kirtya, Singaraja, IIIb.337.

Kala Purana. Fakultas Sastra, Universitas Udayana, Denpasar, no date or number.

Kalatattwa. Fakultas Sastra, Universitas Udayana, Denpasar, transcribed by I Gusti Ngurah Alit, 2 July 1962, no number.

Kanda Empat Dewa. Gedong Kirtya, Singaraja, 332/IIIc/4.

Kanda Empat Rare. Gedong Kirtya, Singaraja, IIIc.362/1.

Pancamahabhuta. Gedong Kirtya, Singaraja, no number.

Siwagama. Pusat Dokumentasi Kebudayaan Bali, Denpasar, Ida Pedanda Sideman, Geria Sanur, Denpasar, typed by Ni Made Sarini, 31 August 1988, no number.

Siwa Linga Suksma. Gedong Kirtya, Singaraja, no number.

Tutur Dalem Gading. Gedong Kirtya, Singaraja, no number.

Tutur Dalem Turaga. Gedong Kirtya, Singaraja, IIIb.4927.

Index

Acintya, 14, 32, 34, 57, 58, 76

Adat (customary practice), 3, 26–27

Agama Hindu, 3, 6, 8, 17, 26, 27, 75, 95;
fundamental beliefs, 18

Amerta. See Holy water

Ancestors, 12, 15, 17, 18, 114, 120–121, 134

Andabhuwana, 69

ANG and *AH* (mystical formula), 71, 106–107,
114; connection with processes of emana-
tion and reabsorption, 125; connection
with Siwa and Buddha, 125; reversed at
time of death, 109, 158n.67, 162n.147

Animism, 2, 11, 19, 86, 135

Anthropological perspective contrasted with
art critic/historian, 8, 74; anthropological
reading of the texts, 59, 84, 105,
148–149n.25

Ardhacandra, 87,108

Ardhanareswari (Siwa and Uma united in one
body), 82, 86, 89, 94–95, 96, 103, 109,
111, 124; meaning of term, 159n.75

Art: and emanation and reabsorption, 125;
modern influences on, 9–10; produced
without thought of gain, 25, 29–30;
and religion, 9–10; as ritual work,
24–25

Artist: and community service (*ngayah*), 24,
29–30; and ritual power, 23–24, 25, 30–31

Attachment and love, 65–66; and compassion,
52, 53; excessive attachment, 45–47, 54, 77

Bakker, Frederik, 75

Bali Aga, 136, 163n.13

Balinese religion: and change 25–26, 75, 136;
cohesive patterns in, 18; decentered, 1, 10;
defining nature of, 10–13, 27–28; five
basic assumptions about, 2

Banas, 36, 38, 46, 145n.27

Barat, I Gusti Made, 9, 49, 50

Barong, 16–17, 71, 76; connection with Siwa,
44, 70, 81, 114, 119, 120; different types
of, 42, 146n.44; at Galungan, 118–120;
mask, 38, 78, 116, 152n.70; meeting with
Rangda, 42–44, 70–72, 104, 114, 115,
160n.91; political significance of, 142n.48;
symbol of the masculine principle of
spirit, 43

Barth, Fredrik, 10

Batuan, Dewa Nyoman, 7, 50, 118

Bellows, Laura, 83, 86, 91, 92, 96, 105

Bhumi Kamulan, 70

Bhuta kala (the chthonic forces, demonic entities), 14, 16, 35, 61, 67, 69, 70, 76, 80, 110, 112, 127; definitions of 36–37, 51–52, 121; and Galungan, 118–120; myth of origin of, 66–67, 110, 151n.54; and Nyepi, 116–118; as transformations of the high gods, 122

Bima, 47, 56–58; as spiritual warrior, 94

Blood, 32, 33, 35, 43, 44, 66

Boon, James, 12, 82, 90

Brahma, 11, 15, 38, 67, 94, 99, 108, 113, 117, 122, 129

Buddha, 51; Buddha priests, 60, 124. *See also* Siwa and Buddha

Buddhism, 2, 11, 12, 18, 36, 51, 52

Budiana, I Ketut, 6, 7, 8, 25, 27, 29–32, 54, 58, 59, 66, 68, 71, 73–74, 76, 78, 79, 86, 91, 94, 100, 105, 113, 125, 127, 132, 137; cosmic view of, 74, 81; explanation of the *ongkara* symbol, 108; publications about, 143n.1; use of color, 32, 34, 38, 45; use of humor, 39, 45; views as representative of Balinese mystical thinking, 74–75

Cakra, 85, 86, 93, 105, 106, 128

Calendrical system, 17, 61–62

Calon Arang, 114

Caru (rituals for the chthonic forces), 16; myth of origin of, 66–67, 80, 109–110; at Nyepi, 116, 117; as process of reabsorbing negative energies, 66, 110, 113, 123; as ritual of purification, 110; Taur Kasanga, 116, 118, 121

Community service (*ngayah*), 24, 25, 29–30

Conception, 33–34, 91; symbolized by *segehan agung* offering, 112

Connor, Linda, 21

Cosmos as dynamic. *See* Emanation and re-absorption; Transformations

Covarrubias, Miguel, 11

Cowherd, 68–69, 151nn.60, 61. *See also* Rare Angon

Creese, Helen, 13, 83, 86, 92, 96, 105

Cremation, 12, 15, 30, 40

Cycles, cosmic. *See* Emanation and reabsorption; Ritual; Transformations

Dasaksara (ten sacred letters), 87, 91, 92, 93, 105–107; and healing, 158n.69; link with processes of emanation and reabsorption, 107, 158n.69; link with the marriage of fire and water, 105, 107; link with the *nawasanga*, 128; link with *rwa bineda*, 107, 160n.91

Davis, Richard, 98, 101–103, 108, 110, 115, 125, 126, 127, 132

Death and dissolution, 39–40, 46, 48, 66, 67, 68, 90, 115

Demons: demonic form, 36–37, 44, 54, 55, 67, 69, 76, 80, 89, 90, 100, 110, 117, 119, 120, 121, 127, 128, 130; as symbolic of the material world, 132; as transformations of the high gods, 122. *See also Bhuta kala*; Durga; Kala; Kala Rudra; Siwa Kala

Desire: as a cosmic force, 41, 43, 47, 59, 65, 77, 100; demonic desire, 67–68; erotic desire, 45–46, 60, 65, 100; instinctual/-animal desire, 37, 44, 46, 47; as Kundalini, 44; material desires, 65; oedipal desire, 43, 63–64, 65; tongue symbol of, 67; wrong desire (*kama salah*), 63–64, 65, 68, 101

Dharma (order) and *adharma* (chaos), 17, 18, 51, 52, 120

Dreams, 6, 7, 8, 33, 56, 57, 132

Durga, 15, 18, 39, 44, 52, 63–64, 65, 69, 70, 71, 77, 81, 90, 101, 102, 110, 114, 117, 119, 120; Berawi (Bhairava) Durga, 115; differ-ences from Indian Durga, 151n.50; the five Durgas (Panca Durga), 66–68, 70, 76, 101, 115, 120; resides in the Pura Dalam, 113

Eiseman, Fred, 77

Eka Dasa Rudra, 104, 121–123

Emanation (emission) and reabsorption, 102, 103, 104, 107, 108, 109, 157n.23; and art, 125; connection with *ANG AH* formula, 125; and holy water, 123–124; as provid-ing the basic pattern of Balinese ritual, 125, 132; reflected in the *nawasanga*, 126–130; and roles of *pedanda Buddha* and *pedanda Siwa*, 124–125; in the self, 130; symbolized in Eka Dasa Rudra, 121–123; symbolized in Galungan rituals, 118–120; symbolized in Kuningan rituals, 120–121; symbolized in meeting of Barong and

Rangda, 114–115; symbolized in Nypei rituals, 116–118; symbolized in the temple festival, 112–113

Female creative principle, 31, 33–34, 41, 43, 45, 70, 71, 76; Mother Earth, 114. *See also* Goddess; Terrible Mother
Feuerstein, Georg, 109
Fieldwork, 6–8, 50, 59, 78, 140, 140n.6, 141n.37
Fire, 32, 34, 35, 36, 40, 41, 43, 46, 53, 70–71, 76, 108; and anger, 64–66, 68–69, 70, 99; sacred syllable representing cosmic element of fire, *ANG*, 71. *See also* Marriage of fire and water
Five senses (*panca indriya*), 65
Five *yadnya* (sacrifices), 14–15, 85, 134
Freud, Sigmund, 63, 132, 135

Galungan, 16–17, 104, 121; myths of, 118–119; reinterpretation of, 118–120; Western interpretations of, 17
Gana (Ganesha), 50, 54–56, 68–69, 77, 94, 119
Geertz, Clifford, 12, 13, 19, 25, 27–28, 79, 137
Geertz, Hildred, 12, 19, 27, 77, 78, 82, 85, 89, 121, 123, 159n.85
Goddess (the Mother), 31, 35, 48, 76, 80, 83; as the creative cosmic principle, 31, 34; her body symbolized by the temple, 111–112; and death and dissolution, 40, 48, 67, 90; and desire, 37; as destructive force, 32–35, 39, 40, 41, 42, 43, 44, 45, 46, 48, 65, 70; as the earth, 31, 32, 35, 36, 37, 144n.6; her essential duality, 48, 68, 77, 90; and greed, 37, 100; as mother, 31, 33, 46, 48, 77, 80, 81; symbolized by the serpent, Anantabhoga, 53–54, 148nn.12, 13, 14; as volcano, 32–35; as the witch, 32–33, 35–36, 39, 40, 41
Godlike/gentle form (*somyarupa*), 60, 63, 67, 117
Goris, R., 12, 83
Goudriaan, Teun, 82, 84, 85–93, 95, 97
Greed, 38, 39, 42, 45, 46, 53, 100
Gupta, Sanjukta, Dirk Jan Hoens, and Teun Goudriaan, 84
Gupta, Shakti, 81
Guru (spiritual leader/teacher), 73, 74, 104; role of, 93, 106

Hanuman, 34, 148n.23
Harmony, balance, and order in Balinese religion, 2, 5, 6, 47, 89, 100, 112, 121, 126, 127, 132, 133, 135, 137, 140n.1; balance achieved through constant movement, 113, 132
Headley, Stephen, 63
Healers (*balian*), 19, 74, 78
Hefner, Robert, 160n.98
Hero, 47–48, 52, 56, 58; myths, 51; the Tantric hero, the *vira*, 93–94, 96, 127
Hinduism, 1, 2, 3, 10, 11, 12, 36, 79, 81, 85, 94, 100, 114, 133, 134, 135
Hobart, Angela, 56
Hobart, Mark, 6, 18, 36–37
Hoens, Dirk, 96
Holy water (*tirta*), 33, 35, 56, 82, 96, 103, 104, 105, 111; produced at temple festival, 111, 112; the sexual fluids of Shiva and Sakti, 109, 111, 124; sprinkler (*lis*), 95; *tirta amerta*, 57, 103, 109, 112, 115, 123–124, 127, 130; types of, 123–124
Hooykaas, Christiaan, 12, 21, 33, 37, 59, 61, 69, 70, 77, 79, 84, 85, 87, 88, 92, 94, 95, 97, 103, 104, 105, 107, 116, 122, 123, 124, 134
Hooykaas, Jacoba, 81, 110
Howe, Leopold, 3, 12, 26, 37, 59, 75, 110, 118, 121, 123, 141n.39; similarities with Howe's description of the Balinese cosmos and ritual, 80, 134, 136, 144nn.6, 11, 145n.38, 146n.49, 147nn.54, 58, 148nn.11, 13, 149nn.27, 28, 157n.23, 159n.86

Incest, 43, 63–64, 65
Initiation (*diksa*), 22, 92
Inversion of fire and water, 41–42, 109
Islam, 1, 10, 12, 96
Iswara, 38, 67, 99, 117, 122

Java, 11, 51, 75, 82, 83, 84, 85, 90, 95, 96, 97, 103, 124, 125
Jñānasiddhânta, 84, 87, 92, 105, 108–109
Jung, Carl, 51

Kala (son of Siwa and Uma), 37, 89, 121, 122; depictions of his birth, 150n.42; Indian parallels with, 156nn.14, 15; myths of, 60–64, 65, 66, 76, 101, 149n.31; symbolizing the earth, 72

Kala Purana, 62
Kala Rudra, 66, 67, 70, 71, 102, 123
Kalatattwa, 60, 62
Kali Yuga (the present age), 42, 137
Kam Garrett, 143n.1, 144n.10, 159n.77
Kama and Ratih (the god and goddess of love), 64–65, 99–100, 150nn.47, 48
Kanda empat (the four mystical siblings), 37–39, 45, 46, 75, 87, 88, 97, 107, 130
Karma, 11, 75
Kekawin literature, 83, 87, 88, 93, 135
Kempers, A. J. Bernet, 11, 93
Klokke, Marijke, 124
Kobot, I Gusti Ketut, 9, 49, 50
Korn, V. E., 12, 92
Kris (dagger): phallic significance, 43; significance of kris dancers 43
Kumara (son of Siwa and Uma), 61–62, 89, 100–101
Kundalini, 44, 76, 81, 85, 86–87, 91, 96, 105, 106, 135
Kuningan, 16–17, 104, 121; reinterpretation of, 120–121; Western interpretations of, 17

Lansing, Stephen, 12, 36, 78–79, 121, 123, 135
Levels of knowledge, 20, 78–80, 136, 163n.15
Lévi, Sylvain, 82
Lingam (symbol of Shiva/Siwa), 96, 103, 130; as axis of the universe, 129; importance in Bali, 94–95
Linggodbhawa: myth of, 94, 100, 129; Indian parallels with, 156n.13
Litany of the Rsi Bhujangga, 59, 70–71, 117, 160n.98
Literacy: and artistic production, 22–23; "literary yoga," 83, 91; and religious knowledge, 21–22, 78–80, 136; "vocational literacy," 21–22
Lontar texts, 3, 8, 17, 19–22, 23, 25, 30–31, 34, 50, 59, 68, 69, 70, 71, 75, 79, 80, 85, 104, 124; erotic texts, 83; link with ritual performance, 80, 114–115, 134, 135, 159n.88; *tutur* texts, 59, 60, 62, 66, 75, 83, 84, 86, 87, 92, 93, 105, 106, 107, 108, 117, 134; unpublished yoga texts, 86, 87, 93, 104–109, 148n.25
Lovric, Barbara, 17, 21, 82, 87, 88, 89, 90, 93, 96, 118–119, 135, 139n.5, 160n.91

MacRae, Graeme, 142n.48
Magic, 85–86; black magic, 90, 91; drawings (*rarajahan*), 23, 31, 34, 35–36, 88
Mahabharata, 47, 56
Majapahit period, 87, 136
Male creative principle, 32, 33, 41, 43, 46, 70, 76; Father Sky, 114
Mandala, 88; and the *nawasanga*, 128–129
Mantra, 88, 103, 104
Marriage (meeting) of fire and water, 33, 41, 43, 44, 57, 70–72, 76, 80, 86, 105–106, 109, 114, 115, 135, 144n.10, 160n.91; Budiana's depiction of this meeting in the self, 44, 71, 106; compared with Kundalini yoga, 106; link with the *dasaksara*, 105, 160n.91; mystical formula *ANG* (fire) and *AH* (water), 106
Maya, 102–103, 108, 115, 158n.57
Meditation, 31–32, 71, 74, 83, 87, 88, 91, 93, 99, 105, 107, 109, 111; and visualization, 88, 91, 103, 105, 111, 115, 130
Microcosm and macrocosm, 38, 47, 48, 72, 87, 92, 107, 115, 117, 130
Mirdiana, I Gusti Nyoman, 6, 7, 8, 25, 27, 49–50, 74–75, 78, 79, 81, 86, 94, 99, 100, 101, 137; use of color, 54, 62, 64, 66, 68, 69, 105; views representative of Balinese mystical thinking, 75
Moksa (liberation), 44, 57, 71, 74, 75, 109
Moon, 72; as symbol of the Goddess, 67
Mother. *See* Female creative principle; Goddess; Terrible Mother
Mudra, 88
Mysticism, 25, 27, 28, 31, 58, 71, 74, 79, 85, 105, 133, 135, 137; "alphabet mysticism," 83, 87–88, 91, 105–109; mystical nature of speech, 87–88, 107; mystical themes expressed in Budiana's works, 75–78; mystical themes expressed in Mirdiana's works, 75–78; mystical union, 92, 95, 103, 104, 105, 106, 109, 113, 114, 115, 121, 127, 129, 130, 137; patterns in Balinese mystical thought, 73–80, 137; Tantric mysticism, 85–93; temple festival (*odalan*) as celebrating a mystical union, 111–114, 120–121. *See also* Holy water; Marriage of fire and water; Meditation; Yoga
Myths, 76, 79, 89; hero myths, 51; multiple interpretations of, 50; origin of *bhuta kala*,

66–67; origin of *caru* rituals, 66–67, 116; origin of sickness, 70; origin of sorcery and witchcraft, 69; origin of *wayang kulit* and temple entertainments, 67; origin of world, 77; Rare Angon, 68–69, 77; of Siwa and Uma, 59–72, 75

Nada, 87, 96, 108
Naga (serpent), 47, 53–54, 56, 58; Basuki, 130
Nawasanga (the nine directions), 88, 104; as cosmological grid, 126–127; dynamic nature of, 127–129; in the form of a lotus, 128, 130; illustration, 126, 128, 129, 130; as model of the self, 130; as reflecting process of emanation and reabsorption, 126–130, 162n.145
Nihom, Max, 13, 85, 96, 97, 153n.35
Nyepi, 16–17, 104, 121; as a means of controlling the processes of emanation and reabsorption, 116–118

Obeyesekere, Ganath, 50, 135
Offerings (*banten*), 14, 16; and textual knowledge, 23
O'Flaherty, Wendy, 98–102, 126, 132
OM (ONG) (mystical sound), 108
Ongkara, 87, 96, 108; illustration, 108
Oral instruction, 93, 104
Oscillating universe, 101–102, 108, 113. *See also* Emanation and reabsorption

Padmasana (lotus seat), 94–95
Panca maha bhuta (the five physical elements), 36, 39, 47, 65, 121
Parallels and differences with Indian thought, 2, 3, 4, 10, 11–13, 21, 27, 81, 83, 108, 109, 114, 132, 133, 134–135, 136–137; myths of Shiva and Uma, 99–101, 150nn.45, 48; Tantrism, 85–95, 96–97
Paramasiwa (Paramashiva), 76, 95, 103, 108, 127, 129
Parisada Hindu Dharma, 26, 58, 95, 120, 141n.39
Pasupata, 97
Pemutaran Mandara Giri (churning of the ocean), 130, 132; illustration, 131
Phallic Mother, 43, 146n.46
Picard, Michel, 10, 75
Pilgrimages, 93

Power of the Mother, 31, 33, 35, 36, 37, 42, 44, 48, 81; in the human body, 44. *See also* Female creative principle; Goddess; Terrible Mother
Pradana, 104, 106, 109, 112, 113, 120
Pratima (images of the gods), 111, 113, 116; symbolizing *purusha* and *pradana*, Siwa and Uma, 113
Priests, 15, 16, 19, 21, 88; *bhujangga* (exorcist priest), 117; Brahma priests (*pedanda*), 22, 24, 59, 67, 69, 75, 78, 81, 86, 89, 93, 103, 105, 111, 112, 116, 127, 136; Pedanda Buddha, 104, 123–125, 161n.135; Pedanda Siwa, 104, 123–124; temple priests (*pemangku*), 15, 16, 69, 78, 79, 110, 111, 112, 113, 116
Purification, 16, 35, 40, 44, 61, 71, 72, 103, 104, 109, 110, 116, 121, 124
Purusha, 104, 106, 109, 114, 120

Rangda: connection with Durga, 44, 70, 71, 114; mask, 38, 78, 116; meeting with Barong, 42–44, 70–72, 76, 81, 104, 114, 115, 160n.91; as the Terrible Mother, 42, 81
Rare Angon: myth of, 68–69, 77; and Galungan, 120
Rawson, Philip, 39
Red, 32, 33–34, 41–42
Redundancy of ritual symbolism, 132
Reincarnation, 11, 76
Reuter, Thomas, 163n.13
Rig-Veda, 100
Ritual: calendrical rituals, 16–18; *caru* rituals, 16; description of contemporary ritual life, 13–19; five sacrifices (*yadnya*),14, 134, 142n.42; importance in Bali, 13; as a means of controlling processes of emanation and reabsorption, 112–113, 115, 117–118, 120–121, 123, 125, 130, 132; as a means of redirecting destructive forces, 76, 99, 110, 112; mortuary rituals, 76, 142n.43, 162n.162; underlying pattern of, 80, 125, 126, 133, 135, 136. See also *Caru*; Eka Dasa Rudra; Galungan; Kuningan; Nyepi; Temple festival (*odalan*)
Rohini, 63, 101, 150n.45
Rubinstein, Rachelle, 21, 22, 83, 84, 86, 87–88, 90, 92, 93, 96, 105, 107, 135
Rudra, 77, 121–122. *See also* Kala Rudra

Rwa bineda, 68, 71–72, 80, 93, 97, 106, 108, 115, 125; and the *dasaksara*, 107, 114

Sacred texts: and artistic production, 22–23, 30–31; nature of, 19–21; and spiritual authority, 19–21
Sacrifice, 51–54, 61, 66, 76, 118, 123
Sadashiva (Sadasiwa), 103, 108, 128
Saiva-Siddhanta, 98, 101, 103–104, 107
Sakti (consort/energy of a god), 46, 77, 81, 86, 89–91, 94, 100, 101, 103, 104, 106, 108, 109, 111, 129, 132
Sakti (mystical or magical power), 32–33, 40, 46, 55, 68, 77–78, 83
Sang Hyang Widi, 14, 141n.40
Santiko, Hariani, 90
Saraswati (goddess of knowledge), 31; Saraswati day, 17
Serpent (*naga*): as symbol of source of all material things and riches, 53; as symbol of the Mother, 54
Sexual fluids, 33–34, 60, 70, 91, 109, 112, 144n.11
Sexual union and divine creation, 41, 46, 48, 76, 77, 81, 83, 91–92, 95, 104, 106, 108, 109, 130, 132
Shiva, 41, 63, 94; cycles of activity and quiescence, 98–100, 101, 102; mythology of 98–101; Shiva as Kama, 100
Shivaism, 12, 13, 27, 73, 81, 94, 95, 97, 103, 104, 114, 133, 135, 136; basic pattern identified by Davis, 125
Sickness, 109, 115; myth of origin of, 70
Sin, 40, 44, 61, 71, 72, 109, 115; the *sad ripu* (six vices), 65
Siwa, 11, 14, 15, 17, 44, 51, 55, 58, 59, 61, 63, 64, 65, 66, 67, 68, 69, 70, 71, 72, 76, 77, 89, 90, 95, 103, 106, 107, 108, 109, 110, 113, 114, 117, 121, 122, 127, 132; as Bhatara Guru, 92; as lingam, 94–5; as *purusha*, 113, 114; and Sakti in the self, 107; as Surya, 94
Siwa and Buddha, 124–125; Siwa-Buddha cult in Java, 124
Siwa and Uma: myths of, 59, 60–72, 84, 114, 120, 149n.27; compared with Indian myths of, 99–100; transformations of, 149n.28; transformations of depicted in drawings displayed at Eka Dasa Rudra,

121, 123; unique character of Balinese myths, 101
Siwagama, 66, 68, 124
Siwa Kala, 64, 66, 110, 117, 128, 129, 130
Siwa Linga Suksma, 71, 86, 88, 104, 105, 107, 108
Siwaratri, 17, 95
Soebadio, Haryati, 83, 84, 87, 93, 103, 107
Somyarupa (godlike/gentle form), 60, 63, 67, 117, 149n.32
Sorcery and witchcraft, 18–19, 38, 82, 115; myth of origin of, 69
Soul (*atma*), 21, 43, 44, 48, 71, 74, 76, 83, 95, 103, 104, 105–106, 108, 109, 114, 121
Stuart-Fox, David, 121, 160n.108
Styles of Balinese paintings, 9, 49
Sunya (the void), 108, 113, 117, 127; and Nyepi, 117, 118
Surya-Sevana, 87, 88, 92, 95, 103, 105, 111
Suarka, I Nyoman, 44, 140n.11, 143n.90, 148n.25, 150nn.39, 44, 51n.55, 157nn.33, 35, 159n.88
Sutarja, Ida Bagus, 60, 63, 64, 78–80, 81, 119, 127
Sutasoma, 51–53, 66, 147n.10
Swellengrebel, Jan, 17, 21

Tantrism, 4, 12, 13, 18, 27, 39, 73, 81, 94, 95, 96, 99, 108, 109, 114, 127, 133, 135, 136; in Bali, 82, 83, 84–95, 97; a Balinese Tantrism, 95–97; defining Tantrism, 82; key features of, 84–95; Tantric texts in Bali, 84, 87; Tibetan Tantrism, 91, 96
Teeth (fangs), 34, 38, 40, 41, 55, 65, 66, 68, 71; tooth filing, 55
Temple festival (*odalan*), 15–16, 109–114, 120, 132; as a birth, 111–112; as a mystic union of Siwa and Sakti, 111–114, 127
Temple, 11, 15, 16; Besakih, 121, 122, 123; Kayangan Tiga, 113, 114; Pura Dalem, 90, 113, 115; as symbolizing the Goddess, 112, 114, 159n.79
Terrible Mother, 34, 35, 39, 40, 43, 44, 45, 46, 47, 52, 65. *See also* Goddess as destructive force
Tiger (panther): as symbol of animal power and ferocity, 38, 40, 52; tiger *barong*, 42
Tongue, 33, 38, 40, 41, 42, 43, 44, 45, 65, 66, 67

Transformations: cosmic, 40, 43, 44, 48, 59–61, 69, 72, 74, 76, 89, 98, 100; of destructive forces, 34, 43, 52, 53, 54, 59, 66, 67, 70–72, 80, 99, 102, 110, 122, 123–124. *See also* Emanation and reabsorption; Ritual

Tunggal, 14, 56, 58, 71, 76, 107, 108

Uma (consort of Siwa), 31, 44, 55, 59, 60, 61, 63, 64, 66, 67, 68, 70, 71, 72, 76, 77, 86, 89, 95, 102, 110, 114, 115, 117, 122; cursed by Siwa, 69, 114, 120; as *pradana*, 113, 114

Water, 34, 41, 70, 71, 76, 108, 115; sacred syllable representing water, *AH*, 71. *See also* Marriage of fire and water

Wayang kulit (shadow puppet theater), 39, 47, 49, 56, 61, 62, 79, 88, 132; myth of origin of, 67, 151n.57; *wayang lemah*, 80

Weck, W., 83

White, 32, 33–34, 35, 41, 44

Wiener, Margaret, 86

Windu (Bindu), 87, 96, 108

Wisnu, 11, 15, 38, 67, 99, 108, 113, 117, 122, 129

Witch (*leyak*), 19, 32, 33, 34, 38, 39, 40, 44, 46, 52, 68, 69, 78, 90, 115, 145n.31

Yoga, 28, 71–72, 76, 82, 83, 104, 105, 125, 130, 133, 163n.13; Kundalini yoga, 86–87, 91, 96, 160n.92; link to public ritual, 72, 111, 114–115, 121, 125, 127, 130, 135, 160nn.91, 92, 162nn.1, 146; "literary yoga," 83, 87–88, 91; "sexual yoga," 83, 91–92, 105, 155n.114; unpublished yoga texts, 86, 87, 93, 104–109, 148n.25

Zoetmulder, P. J., 37, 38, 83, 88

Zurbuchen, Mary, 21, 22, 93, 105, 107

About the Author

MICHELE STEPHEN—senior lecturer in anthropology at Latrobe University, Melbourne, Australia—worked for many years on Papua New Guinea among the coastal Mekeo people before turning her attention to Bali in 1996. She lived on the Indonesian island for three years (1996–1999) and has visited frequently since then. Her research interests include religion, witchcraft and sorcery, dreams, trance and possession, and psychoanalytic approaches to cultural fantasy and creativity. In Bali these interests have expanded to include a passion for Asian art. She is the author of *A'aisa's Gifts: A Study of Magic and the Self* (1995), the editor of *Sorcerer and Witch in Melanesia* (1987), and co-editor with Gilbert Herdt of *The Religious Imagination in New Guinea* (1989). This is her first book on Bali.

Production Notes for Stephen, *Desire, Divine and Demonic*
Book and jacket design and composition by Diane Gleba Hall
Text set in Apollo, with display type in Frutiger
Printing and binding by The Maple-Vail Book Manufacturing Group
Printed on 60 lb. Text White Opaque